SCULPTURE

A STUDIO GUIDE

CONCEPTS, METHODS, AND MATERIALS

Lorraine Balmuth Widman

PRENTICE HALL

Englewood Cliffs, New Jersey

Library of Congress Cataloging-in-Publication Data

Widman, Lorraine Balmuth, (date)
 Sculpture : a studio guide, concepts, methods, and materials /
Lorraine Balmuth Widman.
 p. cm.
 Bibliography: p. 289
 Includes index.
 ISBN 0-13-796590-7
 1. Sculpture—Technique. I. Title.
NB1170.W54 1989
731'.028—dc19 88-25295
 CIP

Editorial/production supervision and interior design: Virginia Rubens
Cover design: Rudi Milpacher
Manufacturing buyer: Ray Keating
Page layout: Martin Behan

Opposite: Bronze relief portraits of author's
children Matthew, Michael, and Gabrielle.
Lorraine B. Widman, 1970.

 © 1989 by Prentice-Hall
A Division of Simon & Schuster, Inc.
Englewood Cliffs, New Jersey 07632

Printed in the United States of America

10 9 8 7 6 5 4 3 2 1

ISBN 0-13-796590-7 01

Prentice-Hall International (UK) Limited, *London*
Prentice-Hall of Australia Pty. Limited, *Sydney*
Prentice-Hall of Canada Inc., *Toronto*
Prentice-Hall Hispanoamericana, S.A., *Mexico*
Prentice-Hall of India Private Limited, *New Delhi*
Prentice-Hall of Japan, Inc., *Tokyo*
Prentice-Hall of Southeast Asia Pte. Ltd., *Singapore*
Editora Prentice-Hall do Brasil, Ltda., *Rio de Janeiro*
Whitehall Books Limited, *Wellington, New Zealand*

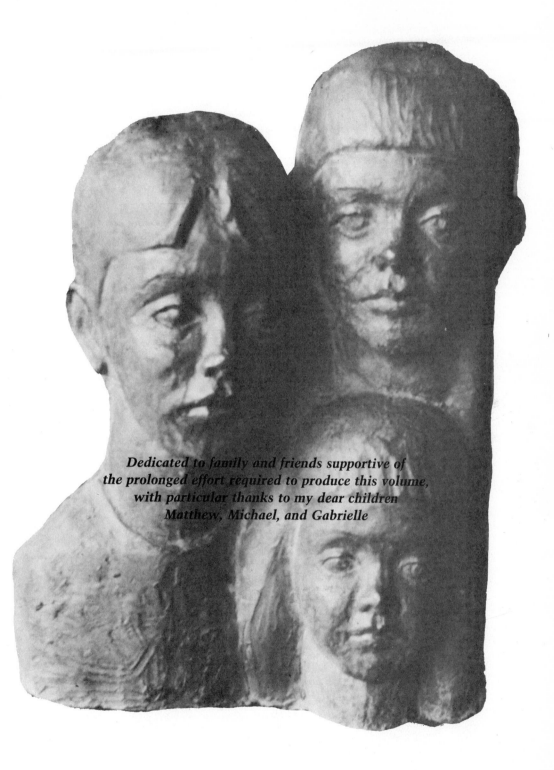

Dedicated to family and friends supportive of
the prolonged effort required to produce this volume,
with particular thanks to my dear children
Matthew, Michael, and Gabrielle

Contents

5

Clay: Surface Finishes and Firing 65

6

Modeling from Life in Clay: The Figure and Portrait Study 84

7

Rigid and Flexible Molds 106

8

Cold Casting (Plaster, Concrete, Clay) 123

9

Cold Casting (Plastics) 134

10
Casting of Metals 147

11
Direct Fabrication of Metal and Plastic 169

12
Carving in Stone 193

13
Woodcarving and Fabrication 212

14

Direct Viscous Materials: Plaster, Cement, Plastics, and Paper 235

15

Assemblage and Installation: Combined Media—Background and Recent Developments 250

16

Mounting, Presentation, and Documentation (Photography) 258

Notes to the Text 267

Appendix 269

Suppliers 273

Glossary 283

Bibliography 289

Index 295

Sculptors — Illustrations 305

Foreword

Professional sculptors, teachers, and art students will find a rich source of up-to-date information in Lorraine Widman's thorough research of sculptural modes and processes. This is an area of the visual arts that has too often been dealt with in a piecemeal fashion with respect to specific media. This publication, however, gives a much needed comprehensive view of new and traditional sculptural methods and processes. Sculpture does not accommodate casual or frivolous interest. It is difficult to learn the craft skills and the very many laborious, time-consuming, and equipment-demanding processes that accompany the creation of sculpture. This book presents a compendium both of technical information and of historical references that takes care to illustrate not just technical proficiency but the qualitative concerns of the many material applications and processes that are subordinate to sculptural expression.

Through the ages, sculpture and civilization have been inextricably bound. Each culture leaves for posterity a material witness in the form of its concrete arts. Each age reflects its rise and decline in the form of sculpture. This silent song, from promontories to sequestered tombs, is an anthem to the continuum of the human spirit. Sculpture is the essence, the sublime distillation of the character of each historical epoch.

As with many other visual arts, sculpture today is at a historical juncture. We are in an age when art reflects the prevailing democratic cultural concepts. Art has long since been delivered from authoritarian patronage. Artists of our epoch are the initiators of cultural concepts and are more autonomous than any artists in any period of human history. Artists are confronted with an array of new materials, technical processes, and sophisticated tools and equipment, the likes of which artists of previous ages could not have conceived. This presents both a formidable confusion and a mixed blessing for artistic quality. Virtuosity with materials and process can become an end in itself when new materials and processes, by virtue of their invention, vie for the ultimate regard as an expression of high artistic achievement. Given such circumstances there is a great need for a book such as this. Lorraine Widman's book gives a comprehensive treatment to the creation of sculpture, both past and present, and deals with a qualitative overview with regard to the processes, tools, equipment, and artisanship which will more properly serve the qualitative objectives and the spiritual content of sculptural expression.

We are in a new age in the throes of its cultural adolescence. Since the turn of the century the communications media have become increasingly a part of every human equation. The sculpture of the ages has been compressed into books of graphic elegance. Certainly all things seem possible. The impatience of young artists is, as always, overwhelming; zeal often outstrips the means and skills of attainment. To illustrate the necessary artistic development, the following pages present a wealth of processes and materials used by many artists. It is a work of considerable scope to keep pace with the creative volition of our time.

James Lee Hansen
Professor of Art
Portland State University

Preface

The origins of this text stem from the manual *Beginning Sculpture*, written to accompany a television course of that name which I taught for Oregon Public Television from 1971 to 1973. When asked to consider expansion of that slim volume, I concentrated on nontechnical areas heretofore neglected in sculpture texts—the concerns of developing personal expression and imagery; a survey of design and sculptural themes; twentieth-century movements, techniques, and materials; as well as a considerable coverage of anatomy and the traditional construction of the human figure. Each chapter on a material is prefaced with historical background for purposes of greater depth of understanding of the material's potential, both traditionally and experimentally.

As a teacher and sculptor for over thirty years, it still surprises me that a field as old and complex as sculpture has depended on so few volumes for its written sources. Though much information has been available in a variety of scattered and separate volumes, the best sources for the student lay in the few attempts at a comprehensive survey, books such as Jack C. Rich's *The Material and Methods of Sculpture*, or the texts of the notable sculptors William Zorach and Malvina Hoffman. It is because sculpture encompasses so many areas and requires such complex processes that it becomes such a formidable task to create a comprehensive text.

The attempt here is to meet that challenge so that beginning students, whether in college courses or working on their own, can gain enough information to feel some confidence, while advanced students can find ample information on techniques and materials to enlarge their scope and stimulate new ideas. Amply supporting the text are illustrations and photos, many representing sculptors of the northwestern United States.

A new information revolution must come about in sculpture, commensurate with the vast recent technological advances of this art, opening the exciting world of three-dimensional creation to even greater possibilities. I am delighted to have the opportunity of contributing to this information explosion.

ACKNOWLEDGMENTS

Many thanks to the following individuals and institutions for their invaluable help in this project: Jean Auel for her information on prehistoric sculpture; Paul Buckner for his life studies and wood-carving series; Joel Meisner for his slides and tour of the Joel Meisner Foundry; James Lee Hansen for reviewing the manuscript, particularly the chapter on bronze casting; Harry Widman for help in editing, insightful critiques, and superior diagrams; Victoria Russell for her excellent diagrams and careful labeling; former Prentice Hall editor Tam Mossman for efficient editing; Al Monner, photographer and printer without equal; Diane Kornberg for her photography; patient typists Jan Eckelmann and Rhoda Stodd; Ann La Riviera of Gallery West, and the Fountain Gallery, both of Portland, Oregon; and the support from family, friends, and artists who took the time to give me data and photos of their work.

Lorraine B. Widman

1

Introduction to Sculpture:
The Form Language

THE BEGINNINGS:
AMULETS AND MONUMENTS

From the beginning, 30,000 years ago or more, people have attempted to connect to their own species through a language of concrete symbols, using it to communicate the meaning and knowledge of a particular culture through space and time. Constituting a rich and varied legacy, such symbols were either architecturally related or developed as personal magical amulets or small sculptures. From the process as well as the results of their creation people gained scientific knowledge about the makeup of the natural world, while at the same time interpreting their inner world of spiritual needs.

Building on this legacy of visual imagery, every significant society in history has contributed a unique world of forms peculiar to its culture and reflective of the time and space in which that culture developed. So diversified, in fact, are the forms and styles humans have created that the biological commonality of the creators is difficult, at times, to accept. However dissimilar these forms in interpretation, the recurrence of certain themes demonstrates the collective need of all people to commemorate such major events in life as birth, death, puberty, and the victories of warriors, kings, and athletes.

The images symbolizing these events—*mother and child, monarch or king, god or goddess, the bestial forces of procreativity, the ancestor,* have represented humanity's strongest religious and spiritual impulses, and as such have been called *archetypal* or universal (see Figure 1–1). Shaped by the sculptor's will into a specific organization or schema of forms, the image might or might not reflect the outward, perceived reality. Substitution, imitation, or reproduction of perceived reality for its own sake rarely occurred, but served, rather, as a magical means of evoking and invoking the earthly and spiritually powerful.

With its potential for achieving ultimate realism, sculpture could, more than any other art form, recreate the simulacrum of living reality. Its primary historical function, however, was to document and inspire rather than deceive or delude; the role the sculptor played was less that of the god capable of duplicating the human image than that of the toymaker who fashioned reassuring

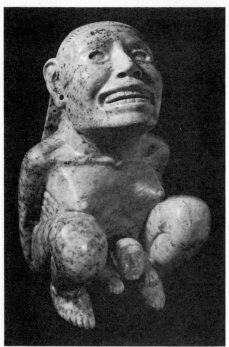

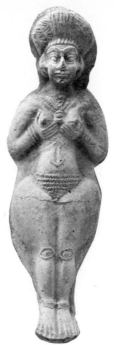

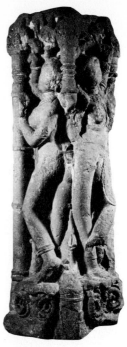

Figure 1-1
Birth Goddess. Aztec, c. 1450–1500.
Aplite (stone).
Robert Woods Bliss Collection, Dumbarton
Oaks, Washington, D.C.

Figure 1-2
Female figure from Susa. Iranian,
3rd cent. B.C. Terra cotta, 7 in.
Metropolitan Museum of Art,
New York, Rogers Fund, 1951.

Figure 1-3
Two Yaksi figures (feminine
"tree spirit"). 8th cent.
Pink sandstone, H. 48 ¾ in.
Baltimore Museum of Art.

objects, instruments controlling our fears and reinforcing our visions.

Such an instrument was the portable charm or amulet, usually shaped as an animal or female figure (Figure 1–2). Immediately upon its creation, cult figures or fetishes were endowed with magical powers, the powers then confirmed by belief in the object. Those having faith in the fetish were automatically empowered with protection from evil and the probability of fertility. Free of formalistic restrictions, the fetishes were often naturalistically rendered, possessing a variety and vitality missing in the hieratic monument style of the ruling state or religion.

The first monuments were universally built as temples to life and as tombs for the afterlife, the expressions of early religion and social organization. Originally excavated from natural caves or formed of pilings of stone, these sacred monuments were later built in shapes derived from the great natural forms of the universe. Spherical mounds imitated the form of the sun and the moon, pyramidal structures simulated the mountain, and cylindrical monuments were inspired by trees and phallic forms. As a symbol of fertility such phallic forms, in all likelihood, became the prototype for the tall, narrow Indian pagoda.

Created as sculptures rather than architecturally conceived structures, the monuments contained little in the way of interior space. Usually they housed small chamber rooms, not large enough for a worshipping crowd but designed to accommodate the sacred altar only, its spirit or god, and the priests who served it. The altar usually was a natural stone form which, because of its prominence or some unusual characteristic of shape, was endowed with the presence of God. Originally composed of a single stone, such as the legendary pillar of Jacob at Beth-El, the temple later took on multiple pillared forms, such as that of Stonehenge in England. Within the early Eastern traditions of India and the Orient, the temple remained basically a sculptural monument, a mass upon which sculptures were carved (see Figure 1–3). This attitude later made itself felt in the Gothic style, an organic integration of sculpture and architecture which represented the antithesis of the classical mode—that of the geometrically inspired architectural construction to which sculpture was added as external or surface adornment (see Figure 1–4).

The Greeks, creators of this new rational system of construction, were among the first to explore man's significance as a thinking and feeling

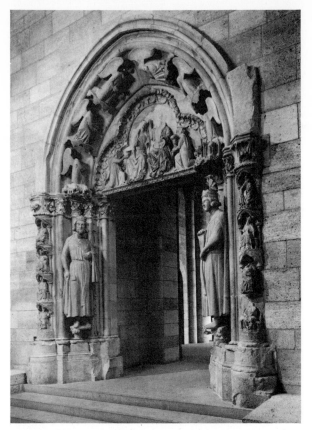

Figure 1-4
Detail of Romanesque Hall. French, 13th cent.
Doorway from the Abbey of Moutiers-Saint-Jean in Burgundy,
showing statues of the Merovingian kings Clovis and Clothar in
place. Metropolitan Museum of Art, New York. Cloisters
Collection, Purchase, 1932 and 1940.

Figure 1-5
Caryatid from Erechthion in Athens.
Greek, 420–413 B.C.
British Museum, London.

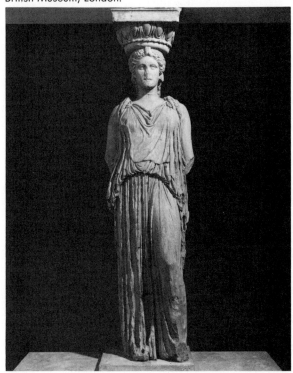

creature, developing a magnificent humanism which placed man at the center of the universe. Affecting all modes of art, the new attitude was perhaps best symbolized by the application of human proportions to the design of the Greek temple (Figure 1–5). Evolving from the Egyptian pictograph (a conceptual image describing events in a factual, repetitive fashion), the Greeks also changed the nature of the narrative relief, which ornamented temple surfaces, by telling a visual story in a chronological cumulative sequence.

From the introduction of the sequential story there arose expanded perceptions of space, form, color, and gesture, the combination of which resulted in highly sophisticated representational skills. Within both the Eastern and Western traditions, architecture and sculpture were to remain integrated art forms until the Renaissance, when the first figure intentionally designed to stand free of specific architectural placement, the bronze *David*, was executed by the Italian Donatello (Figure 1–6).

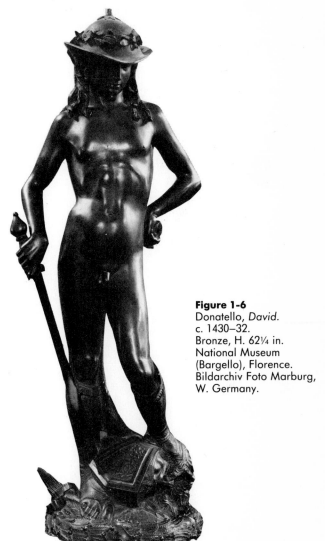

Figure 1-6
Donatello, *David.*
c. 1430–32.
Bronze, H. 62¼ in.
National Museum
(Bargello), Florence.
Bildarchiv Foto Marburg,
W. Germany.

THE LEGACY—RECURRING THEMES AND IMAGES

The primary images were those of people in many guises and of the animals vital to their survival. These were shaped and projected onto altars, shrines, sanctuaries, fountains, temples, tombs, and cathedrals. The most frequently portrayed subject was the *single standing figure*, usually a monumentally scaled portrait of a powerful public personage. The figure was shown in repeated gestures and poses which became understood as the sacred symbols of life, death, and power. In addition to its commemorative purpose, the figure usually fulfilled an architectural function, as a structural column or caryatid (see Figure 1–7).

Related in commemorative and architectural purpose, the subject of the *single seated figure* was also incorporated into the building structure, generally as a supporting column. Intended primarily for use as a shrine, such figures were approached exclusively from the front, with the pedestal serving to separate the figure from the spectator. Pedestal height indicated status—the higher the pedestal, the more exalted the rank. In Oriental and Indian Buddhas, pedestals varied in design and significance according to the symbolism of the particular seated posture (see Figure 1–8). The same

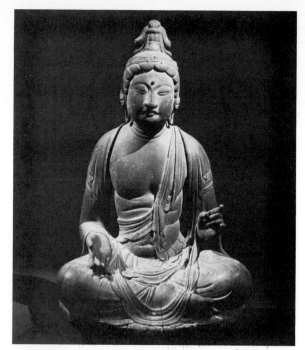

Figure 1-8
Nikko, the Sun Bodhisattva.
Japanese, early Heian period, c. 800 A.D.
Carved from one block of taxus cuspidatus, Japanese yew, H. 18⅜ in.
The Cleveland Museum of Art, Purchase,
John L. Severance Fund.

stylistic tradition continued during the Romanesque period as the convention of the rigid, frontal, seated Virgin and Child which predated the later naturalistic compositions in the round of the same subject.

Single figures were combined in *group arrangements*, separate or attached figures which were either stationary or mobile. Genre groups such as the charming and decorative Tanagra figures of the Hellenistic period reflected the tranquil and civilized domestic life of the period. Group arrangements were primarily designed as commemorative works—mourners surrounding a tomb, saints and worshippers in altarpieces, warriors in combat and conquest, royal rulers and their wives, and gods and goddesses in sanctuaries and temples (see Figure 1–9).

When motion was introduced into the archaically rigid single seated or standing figure, it signalled the beginnings of a more humanistic and less hieratic attitude. The *figure in motion* in the form of warrior, dancer, athlete, and deity took on the rhythmic poses of the specific culture and religion (see Figure 1–10). In Indian sculpture, the dance symbolized the cosmic energies manifested in the cycle of life, death, and renewal. Contrasted to this violent movement is the lyricism of the Greek and Renaissance and the restraint of the Gothic and Neoclassical periods. Baroque and later nineteenth-centure Impressionist sculptors Degas

Figure 1-7
Assurnasirpal II from Nimrud.
Neo-Assyrian period, 883–859 B.C.
Limestone, H. 41¾.
British Museum, London.

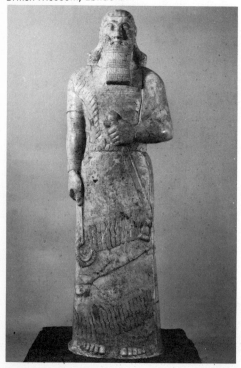

4

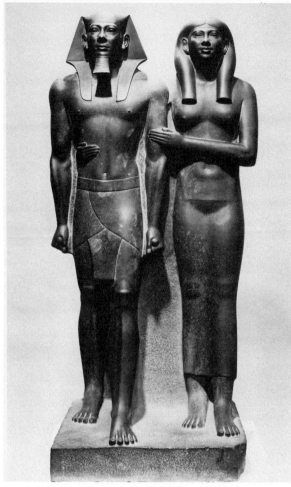

Figure 1-9
King Mycerinus and his queen, Kha-merer-Nebty II.
From Giza, Dynasty IV, 2599–2571 B.C.
Slate schist, H. 54½ in.
Courtesy Museum of Fine Arts, Boston. Harvard University
and Museum of Fine Arts Expedition.

Figure 1-10
Dancer, statuette, veiled and masked. Late 3rd cent. B.C.
Bronze, H. 8¹⁄₁₆ in.
Metropolitan Museum of Art, New York.
Bequest of Walter C. Baker, 1971.

and Rodin exploited movement through the fleeting gesture, the latter opening the way to the abstract, *kinetic*, or *gestural* form in space.

Among all the figurative images, the most central has been that of the *nude*. Appearing initially as a symbol of fertility, bestial in concept, the later guises of the nude were that of athlete, god, or goddess. The manifestation of physical beauty, for the first time, became its own reason for being (see Figure 1–11).

The emotive and expressive power of the nude first discovered by the Greeks was revived in the sensual nudity of Donatello, and fully realized in the superhuman male nudes of Michelangelo in such subjects as the *David* and *Bound Slaves* (Figure 1–12). The Renaissance established the nude as subject matter and, in so doing, the artistic validity of exploring and observing the human body and its anatomical structure. Naturalism of the moving body was so supremely achieved by Rodin in his 1877 figure *The Age of Bronze* that he was accused of casting the work from life.

Figure 1-11
Praxiletes, *Hermes*. 330–310 B.C.
Marble.
Olympia Museum, Bildarchiv Foto Marburg, W. Germany.

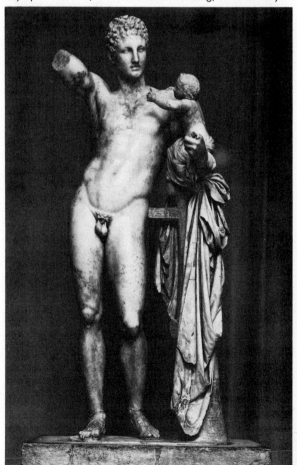

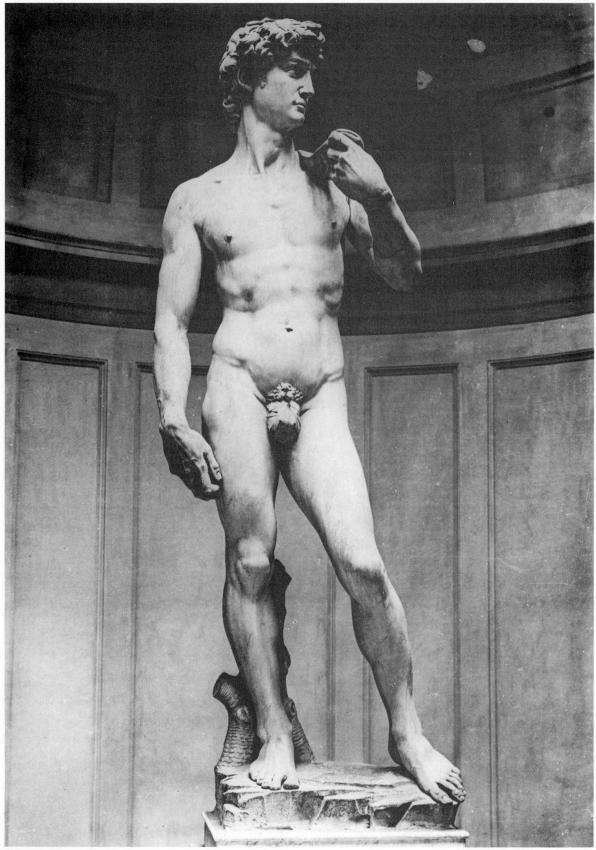

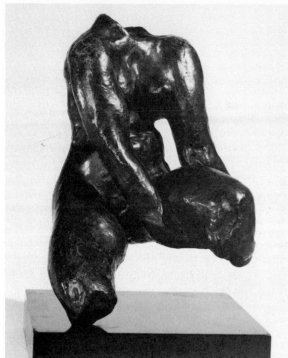

Figure 1-13
Auguste Rodin, *Torso Assis.* c. 1890–91.
Bronze, 36.9 × 26.7 × 24.1 cm.
Courtesy Art Gallery of Ontario, Toronto.
Gift of Sam and Ayala Zacks, 1970.

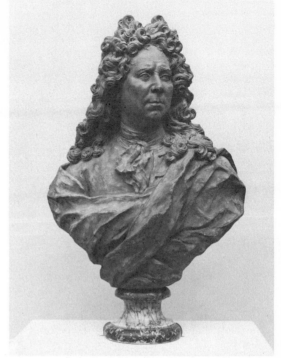

Figure 1-14
Charles Antoine Coysevox, *Self-Portrait.* Early 18th cent.
Terra cotta, H. 28 in., D. 12½ in.
By permission of The Fine Arts Museums of San
Francisco, Gift of Mr. and Mrs. Grover Magnin.

Rodin's naturalism gave rise to the acceptance of the *fragment* as symbolic of the whole body. The effect of fragmentation was the evocation of the body's inner structure or rhythm, by representing not the whole, but a significant and expressive part. Though anatomically convincing, the partial figure took on a unique identity, transformed into an abstract object by virtue of its separation from the head or lower limbs (see Figure 1–13). Twentieth-century sculptors such as Arp and Brancusi took this idea a step further by reducing the fragment to a pure, nonobjective form.

A type of fragmentation, the *portrait head* also intensified expression by isolating the part from the whole. Portrait busts flourished during the Hellenistic and Roman period, reaching the apex of realism. After a decline during the Middle Ages, due to the submergence of individualism, the portrait form was revived by the Renaissance artist and has continued as the most visible expression of the scultor's art (see Figure 1–14).

Though less important in the West than in the traditons of the East, Africa, North American Indian, and pre-Columbian, the *mask* is another rich area of sculptural expression (see Figure 1–15). Taking on the countenance of the birds and animals significant to the particular culture, the mask functioned in religious and cultural rituals as both a magical image and a means of conveying a range of characterizations, moods, and emotions. The most conspicuous expression of the mask in the West is the fierce medieval helmet devised by armorers to protect, but also to frighten and intimidate.

The predominance of the *animal* as subject in sculptural imagery reflects the interdependent re-

Figure 1-15
Human mask, Mexican Highlands, c. 1000.
Serpentine stone.
Dumbarton Oaks, Washington, D.C.

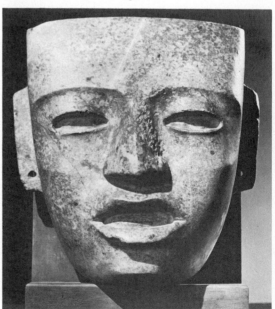

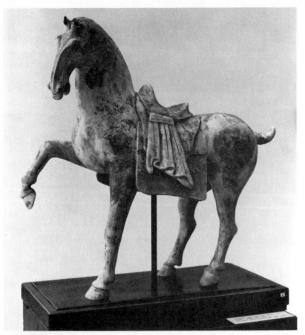

Figure 1-16
Horse. Chinese, Tang Dynasty, 618–907 A.D.
Ceramic, traces of color, 21½ × 24 in.
Collection, The Portland Art Museum, Portland, Ore.
Purchase from funds from Mrs. Ferdinand Smith, Mr. Jack
Meier, and Mrs. H. L. Corbett, Sr.

bull, the cow, the horse, the lion, the deer and related species, and the cat and dog. The bird, like the serpent, was represented in many forms and types, sometimes in composites with other animals and humans. The horse was often portrayed in conjunction with a human figure as his servant or friend. Horses found as tomb figures represented the former power and possessions of the deceased. Humans and animals were also depicted confronting each other in the legendary subjects of St. George and the Dragon; more often the interaction demonstrated compatibility and respect.

Incorporating all the imagery of human and animal, single and group, real and ideal, the *relief* offered a more pictorial means than sculpture-in-the-round for commemorative and historical narrative (see Figures 1–17 and 1–18). Integrated into the architectural embellishment of the tomb, temple, and cathedral, the relief provided surface adornment for ceremonial and ritualistic objects —urns, chalices, sarcophagi, baptismal fonts, and altars.

lationship which has existed historically between animals and people (see Figure 1–16). Animals have always occupied a necessary and significant place in the human world, universally symbolizing fertility, divine protection from evil, regeneration, etc. Animal forms depicted frequently were the

Figure 1-18
Wall panel from the Palace of Ashur-nasir-apal II at Nimrud:
Winged being pollinating the sacred tree.
9th cent. B.C.
Incised low relief, alabaster.
Metropolitan Museum of Art, New York.
Gift of John D. Rockefeller, Jr., 1931.

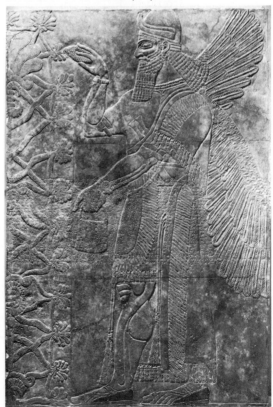

Figure 1-17
Double Funerary Portrait—Yarkhai, Son of Ogga, Balya
his Daughter. Palmyrene, c. 150–200 A.D.
Half-round high relief, limestone, 22 × 32 in.
Collection, The Portland Art Museum, Portland, Ore.
Gift of Mr. Aziz Atiyeh.

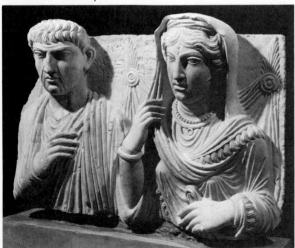

A NEW FORM VOCABULARY— A LOOK AT TWENTIETH-CENTURY MOVEMENTS

The early years of the twentieth century experienced an aesthetic revolution in which traditional forms and influences were reexamined and, to a great degree, rejected. The reevaluation which occurred reflected the enormous changes brought about by technology and science in the social, political, and economic systems of the world.

The movements which were to revolutionize the form and content of painting and sculpture broke from classical traditions and looked for their *raison d'être* to the primitive non-Western traditions and to scientific, technological influences which were beginning to reshape society. Painters asserted their emancipation from proscribed concepts of perspective, space, and recognizable form and color. Sculptors rejected surface imitation and attempted to return to their ancient pursuit of scientific investigation employing, in lieu of the figure, abstract concepts of interacting planes and lines in space, inventing forms which reflected new age ideals.

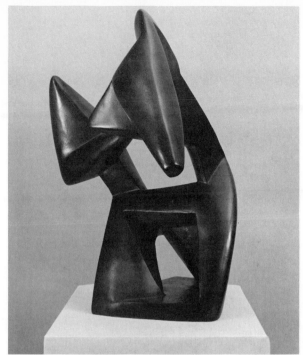

Figure 1-20
Alexander Archipenko, *Boxing*. 1914.
Bronze (cast 1966), 23¼ × 18¼ × 15⅞ in.
Collection Museum of Modern Art, New York. Given anonymously.
A Cubist work inspired by the angular, thrusting forms of African sculpture as typified by the Sudanese woman and child.

Figure 1-19
Woman and Child. African, Western Sudan style.
Ivory Coast, Korhogo District, Senufo Tribe (Siena), c. 1930.
Wood, H. 25 in. The Cleveland Museum of Art, Purchase, James Albert and Mary Gardiner Ford Memorial Fund.
Highly geometric and stylized, the forms of African sculpture served as a major source of inspiration for Cubism.

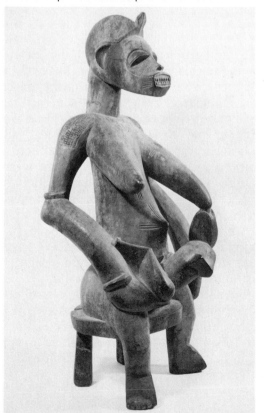

The movement called *Cubism* began in 1911, synthesizing theories derived from Cézanne of geometricizing objects into cylinders, spheres, and cones, with a system of simplified solids influenced by African carving (see Figure 1–19 and 1–20). In Cubist painting, surfaces of three-dimensional forms were rendered as if flattened to fit into the picture plane, then reassembled in shallow space to reveal multiple, rather than single views of the object. The synthetic Cubism which followed involved constructing parts of the plane or surface using bits of papers and cardboard, alluding to the function expressed by the material (surfaces representing newspaper texture are represented by actual newspaper, not painted to imitate it). The concept of double meaning established sculptural assemblage as a valid technique which had the unique and timely characteristic of allowing an abstract composition to imply specific meanings and sentiments through the found materials it incorporated. The technique has gained increasingly in acceptance and usage in many combinations of materials and media since its invention by the synthetic Cubists.

In 1912 the Futurist sculptors of Italy declared in their *Futurist Manifesto of Sculpture* that it was necessary to reject the old and enhance the technology of the future. The new romanticism of youth and the reaction to the tired classicism of Italian

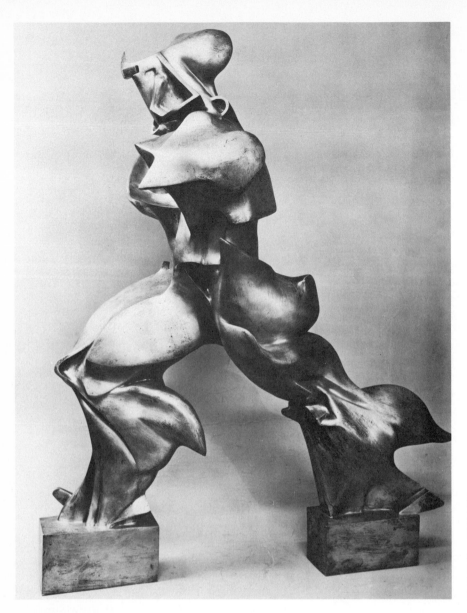

Figure 1-21
Umberto Boccioni, *Unique Form of Continuity in Space.* 1913. Bronze (cast 1931), 43⅞ × 15¾ in. Collection Museum of Modern Art, New York. Acquired through the Lillie P. Bliss Bequest.

nineteenth-century art called for a sculpture of speed, space, and energy, the manifesto declared. Looking to the camera, the Futurists attempted to incorporate the sensations of time or motion and light, using simultaneity, that is, showing parts of objects repeated in successive stages, unfolding, as it were, in time (see Figure 1–21).

The first of the self-conscious avant-garde movements, the Futurists were considered aggressively rightist for their belief in the inevitability of a technocratic dictatorship which was possibly devoid of human rights. They prophesized that the artist would become the technician in a technological society. The anti-art, protechnology views espoused by the Futurists, merging with the discoveries of the synthetic Cubist assemblages, spawned such "ready-mades" of the Dada movement as the first mobile sculpture, a bicycle wheel attached to a stool by Marcel Duchamp (1913).

The introduction of real materials into art would, according to this view, thereafter change the role of the artist from that of maker of the object to one of assembler or "finder" (hence the term "found object"), the attempt being to choose objects which illuminate and give us a philosophical, albeit sometimes ironic insight into our condition. The importance of the intellectual element was the basis of the *Dada* and *Surrealist* movements which included Marcel Duchamp, Max Ernst, Francis Picabia, Man Ray, Hans Richter, Tristan Tzara, and Jean Arp (see Figure 1–22).

In the Russian movement known as *Constructivism*, which emerged in 1920, the separation of object representation from art was absolute. Using a variety of materials, the first true constructions removed from the canvas were those of the earliest theoretician of Russian Constructivism, Vladimir Tatlin (1885–1953). Establishing a parallel force in painting, the theorist Kazimir Malevich

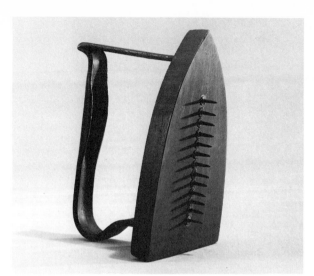

Figure 1-22
Man Ray, *Cadeau.* c. 1958, replica of 1921 original.
Painted flatiron with a row of thirteen tacks, heads glued to
bottom, 6⅛ × 3⅝ × 4½ in. Collection Museum of Modern
Art, New York. James Thrall Soby Fund.

(1878–1935), calling his movement *Suprematism,* was the first painter to propose use of basic geometric form and its potential. His black and white and white on white canvases were regarded as purifying gestures when they were exhibited in 1915. Related to Cubism and Malevich's reductionism are the vertical and horizontal compositions of Piet Mondrian, who, with Theo van Doesburg, founded the Dutch *De Stijl* movement. Concepts of this movement, the use of pure and abstracted form and color without reference to objects, and the belief in a collective rather than individual style, related to the Constructivist principles of Antoine Pevsner (1886–1962) and his brother, Naum Gabo (1890–1977), the latter the author of the theoretical tract *The Realist Manifesto of 1920.* The sculpture of both Gabo and Pevsner successfully synthesized the materials and the methods of the new technology and a personal expressiveness into an avant-garde art which was ahead of its own time but has since become a prophetic symbol of a dynamic civilization.

In 1919 Constructivist ideas of visual fundamentals were reflected in the design school organized in Germany under the leadership of Walter Gropius. The basic tenets of the *Bauhaus,* as the school was called, were to become a major influence in the art of subsequent decades. The ideas of the movement revolved around acceptance of the machine and the elevation of quality in mass-produced goods through promotion of contemporary design concepts. Through teaching of basic

design principles in which the crafts were considered equal to the arts, the Bauhaus attempted to socialize art for the purpose of serving not just the elite, but the majority of humanity. Bauhaus teachers, many of whom migrated from Germany during World War II, included such distinguished contemporary and recently renowned painters, sculptors, and architects as Paul Klee, Wassily Kandinsky, László Moholy-Nagy, Oskar Schlemmer, Mies van der Rohe, Lyonel Feininger, and Gerhard Marcks (see Figure 1–23).

While Cubism was given its dimensional expression by such experimental sculptors as Henri Laurens, Ossip Zadkine, Jacques Lipchitz, and Alexander Archipenko, the Romanian sculptor Constantin Brancusi (1876–1957) was synthesizing other non-Cubist ideas of the modern movement into his work. The sculpture of Brancusi represented a dramatic reaction to late nineteenth-century Romanticism and took two divergent directions, forms which were highly polished and elegantly simplified on the one hand and, on the other, roughhewn carvings of stone or old pieces

Figure 1-23
Laszlo Moholy-Nagy, *Light-Space Modulator.* 1922–30.
Metal, glass, and plastic, H. 151.1 cm.
Collection Busch-Reisinger Museum, Harvard University,
Cambridge, Mass. Gift—Sibyl Moholy-Nagy.

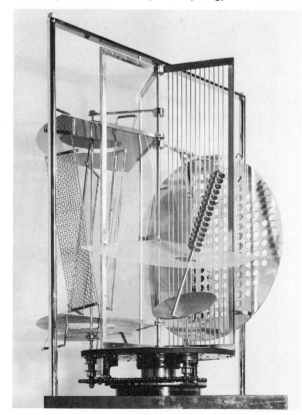

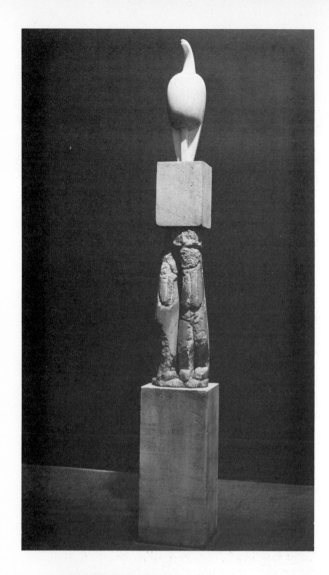

Figure 1-24
Constantin Brancusi, *Magic Bird (Pasarea Maiastra)*, Version I (1910).
White marble, H. 22 in. On limestone pedestal in three sections, H. 70 in; the middle section is the *Double Caryatid* of limestone, H. 29⅝ in. (approx. 1908).
Collection Museum of Modern Art, New York.
Katherine S. Dreier Bequest.

Figure 1-25
Jean Arp, *Human Construction*. 1935.
Original plaster, 19½ × 18¾ in.
Collection Museum of Modern Art, New York.
Gift of the Advisory Committee.

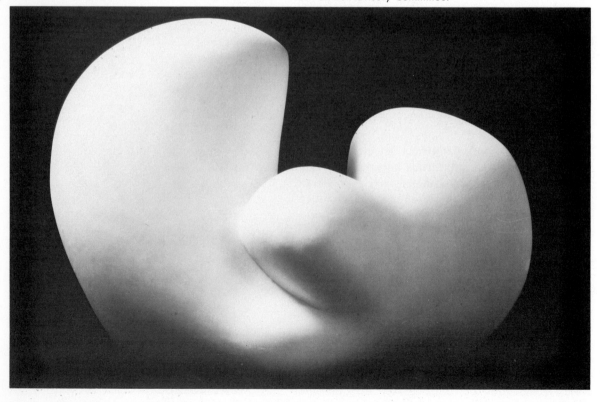

of wood which combined elements of primitive African and native Romanian folk carving. The latter primitive style is that of the stone-carved memorial sculpture *The Kiss*, thought to have influenced the sophisticated primitivist carvings of the early twentieth-century painter Amedeo Modigliani. Brancusi introduced what came to be regarded as the concept of *significant form*, that is, form reduced to its purist essence, the most characteristic of which was the ovoidal form, which he explored in dozens of variations in both cast bronze and marble (Figure 1–24). Seemingly formalistic, emphasizing surface beauty and perfection for its own sake, Brancusi's forms operate as meaningful symbols of life, the ovoidal egg, bird, and fish forms carrying deep into our sensibilities. Sculpturally, the ovoid relates metaphorically to the plant, bone, and organic formations adapted by the sculptors who have come to be known as *Vitalists*, the most prominent of whom were Jean Arp and Henry Moore. The polished surfaces of the form can be interpreted as one of the almost metaphysical and spiritual ideas of the Vitalists, as expressive of an inner light, the surface appearing to be worn and polished, not artificially, but by the elements.

Working during the same period as Brancusi, Jean Arp (1887–1966) developed a rhythmic, organic shape reminiscent of the human torso which he called *Concretion*, defined by the dictionary as the "act or process of growing together." As a direct carver, Arp, like Brancusi, was responsible for a revival of a skill which had been gradually going into eclipse since Canova (see Figure 1–25).

The outstanding carver of our century, Henry Moore, introduced the Vitalist concepts of the archetypal—mother and child, family, the female "earth mother" among others—themes derived from the primitive, primarily pre-Columbian and African sources which were to become major influences in his work (Figure 1–26). Direct carvers such as John Flannagan, Elie Nadelman, and Barbara Hepworth established new directions in clarity of form, expression, and architectural order, the integrity of their work reflective of the ideal of "truth to the materials." Diverging from the Vitalist attitude, the predominantly *Impressionistic* and *Expressionistic* approach of English sculptor Jacob Epstein, the German Wilhelm Lehmbruck, and the later periods of Jacques Lipchitz, followed the stylistic tradition of Degas and Rodin (see Figure 1–27). As in the sculpture of their nineteenth-century predecessors, the imprint of the individualistic character of their work was overriding.

In the United States a group of figurative carv-

Figure 1-26
Henry Moore, *Mother and Child*. 1938. Elmwood, 30⅜ × 13⅞ × 15½ in. Collection Museum of Modern Art, New York. Acquired through the Lillie P. Bliss Bequest.

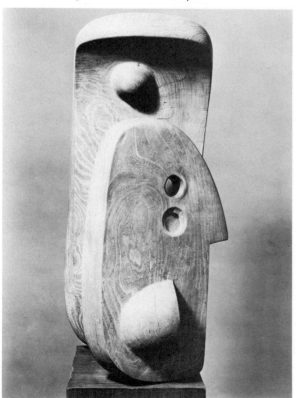

Figure 1-27
Jacques Lipchitz, *Sketch for Sacrifice*. 1947. Bronze, H. 18⅞, D. 12¾ in. The Portland Art Museum, Portland, Ore. Helen Thurston Ayer Fund.

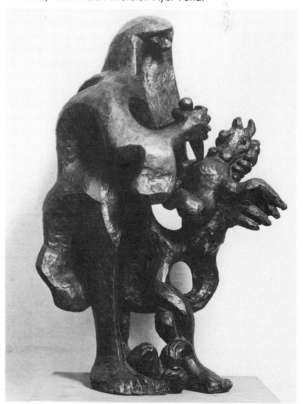

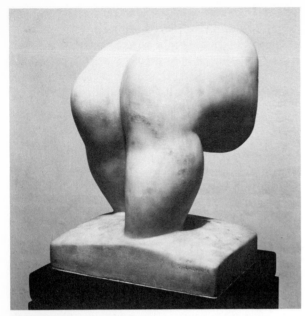

Figure 1-28
Gaston Lachaise, *Knees.* 1933.
Marble, H. 19 in. at base. 13¼ × 9½ in.
Collection Museum of Modern Art, New York.
Gift of Mr. and Mrs. Edward M. M. Warburg.

ers and modelers emerged in the 1920s, 30s and 40s, men and women such as William Zorach, José de Creeft, Chaim Gross, Malvina Hoffman, and Gaston Lachaise (see Figure 1–28). Contemporaries (or somewhat younger) of Rodin's assistants, the Frenchmen Maillol, Despiau, and Bourdelle,

among others, they represented the strongest generation of sculptors yet produced by America. At the same time and into the postwar period, Italy experienced a revival of figure sculpture which referred back to that country's ancient Etruscan and classical heritage, evident in the works of Marino Marini, Giacomo Manzu, and Emilio Greco (see Figure 1–29).

After World War II the Vitalist idea was adapted by sculptors working in direct welded metal such as Theodore Roszak, Ibram Lassaw, Seymour Lipton, David Hare, and Herbert Ferber (see Figure 1–30). For these sculptors the botanical forms of shells, thorns, and flowers acted as metaphors for the new life and the new art which was generated after the war. With the use of direct metal the containment of the solid piece gave way to aggressive thrusts into space, smoothly polished forms were transformed into spiky, rough surfaces, and mass and weight capitulated to space and weightlessness. The Expressionistic forms of these American sculptors of direct metal were not unrelated to those of their European and English counterparts—Spaniards of the earlier generation—Pablo Gargallo (1881–1934) and Julio González (1876–1942); the French sculptor César; and the Englishmen Reg Butler, Kenneth Armitage, and Eduardo Paolozzi, artists who were more directly affected by the Surrealistic movement than their American colleagues. Though never as strong

Figure 1-29
Giacomo Manzu, *Portrait of a Lady.* 1946.
Bronze (cast 1955), 59¼ × 23¼ × 44⅜ in.
Collection Museum of Modern Art, New York.
A. Conger Goodyear Fund.

Figure 1-30
Theodore Roszak, *Thorn Blossom.* 1948.
Steel and nickel silver, H. 33½ in.
Collection Whitney Museum of Art, New York.
Purchase.

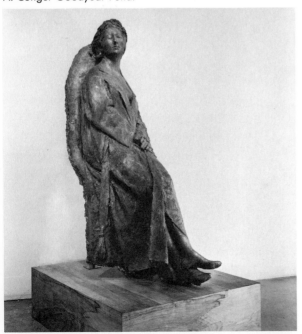

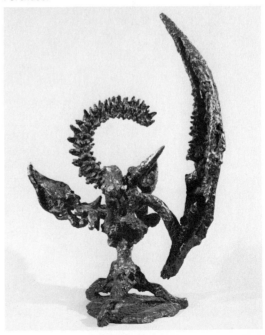

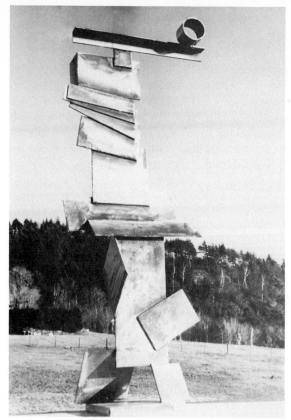

Figure 1-31
David Smith, *Lecturn Sentinel*. 1961.
Stainless steel, H. 101 ¾ in., W. 33 in., D. 20½ in.
Collection Whitney Museum of American Art, New York.
Gift of the Friends of the Whitney Museum of American Art
(and purchase).

an influence in the United States as in Europe, Surrealism was embraced by the prolific American metal sculptor David Smith (Figure 1–31). Working in the 1950s, Smith rendered his dream-like motifs and personal symbolism into exuberantly open linear compositions. In the 1960s Surrealist and Cubist elements merged; Smith's fabricated stainless steel constructions, restricted to squares and rectangles, represent a breakthrough in the realization of a totally geometric composition free of outside references or associations.

The other American heirs of the original Surrealist and Dadaist movements were the kinetic sculptors of the post–World War II period and such sculptors of the assemblage as Louise Nevelson (see chapter 2, Figure 2–20), Marisol, and Joseph Cornell. Highly original and inventive, they developed very personal statements from the juxtaposition of specialized found materials. Others, concerned with the rejected residue of mass production and problems of individual anonymity, used the discards of urban life and the machine age to produce a new generation of "ready-mades" which were less ironic and more passionate than

the original Dada works. Richard Stankiewicz, John Chamberlain, Mark di Suvero, David Smith, and, to a lesser degree, Lee Bontecou, all incorporated discards in some form into their sculpture; expressionistic in the intensity and individuality of their style, they were the sculptural counterparts of the *Abstract Expressionist* painters of that time, gesture painters such as De Kooning and Hans Hoffman (see Figure 1–32).

The work of the *primary Structuralist* and *Minimalist* sculptors of the 1960s and 70s is characterized by large, often baseless assemblages of steel or construction discards consisting of heavy wood beams and planks. Environmentally oriented, the monumental-size steel structures of Anthony Caro and Tony Smith, of necessity, had to be industrially fabricated more in the manner of architectural elements than sculpture. Primary Structuralists such as Sol Le Witt created assemblages in the conventional materials of wood and metal, at the same time employing conceptual "illustration" of their ideas. Related to primary structures in approach, the assemblages of the American sculptor Gabriel Kohn consisted of wood sections laminated into architectural forms which reflected the hard-edged, classically Constructivist, Cubist ideal emerging in the 1960s (Figure 1–33).

The new geometric abstraction manifested itself in varying combinations of metal, wood, and plastics, often using flat relief forms which referred back to the early playful wood reliefs of Arp.

Figure 1-32
Lee Bontecou, Untitled. 1961.
Canvas and welded metal, H. 72 in., W. 66½ in., D. 26 in.
Collection Whitney Museum of American Art, New York.
Purchase.

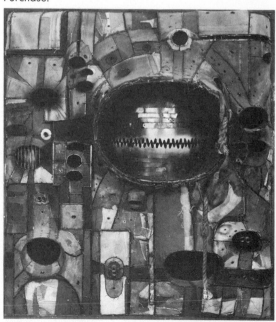

Figure 1-33
Gabriel Kohn, *Square Root.* 1958.
Laminated wood, H. 28 in., W. 40 in., D. 14¾ in.
Collection Whitney Museum of American Art, New York.
Purchase.

The reciprocity of painting and sculpture developed during this period, with sculpture painted in bright colors and paintings becoming austerely structural in composition, sometimes relief-like.

Kinetic sculpture inspired by Alexander Calder's mobiles also included the playful, or sometimes sinister machines of Jean Tinguely, the wind-propelled sculpture of George Rickey, and the wryly humorous, slightly ominous mechanical games of Pol Bury (Figure 1–34). Mechanized electric power activated the new light sculpture (in which light was the primary element) and animated soft materials such as foam or polyurethane, creating pulsations and rhythmic motions which attempted to simulate living matter.

The potential of the new materials and technology has expanded the object orientation of sculpture into one which is increasingly environmentally oriented. Projects have been organized by groups such as Museum of the Media and SITE, Sculptors in the Environment, involving the conceptual areas of engineering and audio, photographic techniques, and graphics. Appropriate solutions are sought by these groups for structures to be placed in parks, beaches, or building interiors, with evaluations for each project made through coordination of interdisciplinary factors such as ecology and traffic (see Figure 1–35). The collaborative group idea is a spinoff of the architecturally and environmentally oriented work of the primary Structuralists, but goes further in favoring materials which are less traditional and more industrial in type, such as inflated vinyl (see Figure 1–36). Technological awareness, though rather recent, has been intense, inevitably involving the artist in ecological theory and the manipulation of the large environment through earthworks, lasers, mirror optic systems, earth coverings, etc. The systems and information aesthetic attempts ideally to overcome artists' resistance to technology for the purpose of replacing object making with a participatory, informational aesthetic, an aesthetic which also has been dismissed by some as mind manipulation. Other areas of technical exploration are the use of chemicals, as in refrigeration tubes which melt and refreeze, and incorporation of heavy fiber as "soft sculpture" (see Figure 1–37).

At this writing figurative sculpture is still pursued in many different styles, from the Surrealist-Expressionist woodcarvings and bronzes of Leonard Baskin to the Naturalistic-Expressionist plaster life castings of George Segal (see chapter 15, Figure

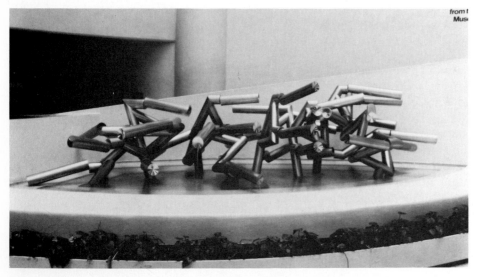

from t
Mus

Figure 1-34
Pol Bury,
Fountain. 1979–80.
Stainless steel, 98⅜ × 196⅞
× 94⅜ in.
Collection Solomon R.
Guggenheim Museum,
New York. Gift of the artist.

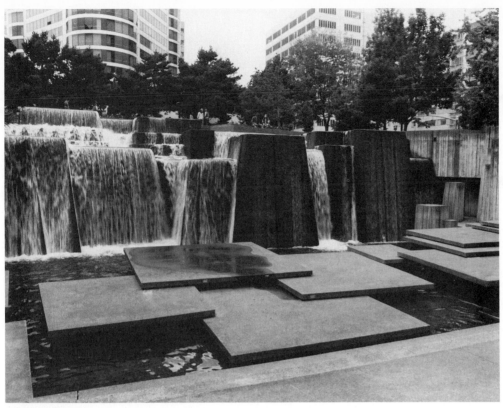

Figure 1-35
Ira C. Keller Memorial Fountain, Portland, Oregon. 1971.
Angela Danadjieva, designer, associated with Laurence Halprin, Inc., San Francisco.
Commissioned by the Portland Development Commission, Portland, Ore. Photo by author.
Cubist masses translated into an architecturally sculptural fountain.

Figure 1-36
Jean Van Harlingen, *Inflatable Sculpture with Dance.* 1975.
Laminated vinyl, H. 12 ft., L. 36 ft., D. 24 ft.
The photo shows the piece behind the Philadelphia Museum of Art during the
"Sculpture '75" show. The work was used for 11 dance performances in 1975 in
Philadelphia and Pittsburgh, 8 on-stage and 3 outdoor performances.
Photo by Howard Bossen.

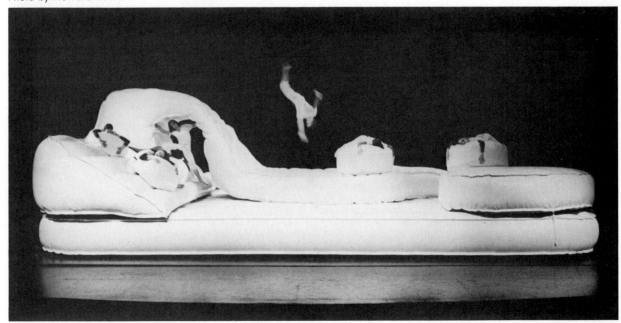

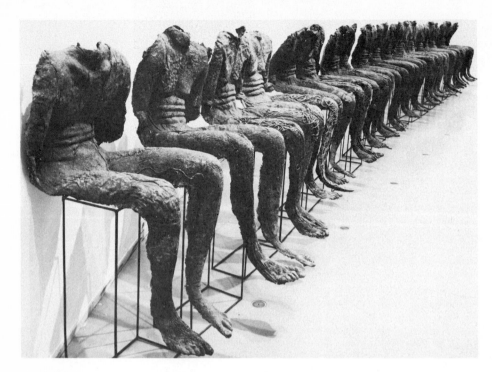

Figure 1-37
Magdalena Abakanowicz,
Seated Figures. 1974–76.
Burlap and glue, lifesize.
Collection of the artist.
Photo by Artur Starewicz,
Warsaw, Poland.

15–3) and the slick and cool plastic simulations of John de Andrea and Frank Gallo (see chapter 9, Figure 9–25). Duane Hanson creates an ironic imagery which reflects the pathos of real life in its consummately realistic technique. Edward Kienholz (see chapter 15, Figure 15–2) and Hanson (see chapter 2, Figure 2–21) set up tableaus which document the spirit as well as the facts of our time, moving statements of our condition. Others working with the figure image translate man into machine or robot. Sculptors such as Ernest Trova and Eduardo Paolozzi have created humanoidlike figures which are sculptural correlations of science fiction stories. Though transformed into a machine, a tour de force of super-Realism, and/or a kind of pop symbol, the image of man remains an evocative symbol for the sculptor and a meaningful one for the viewer (see Figure 1–38).

It appears possible that the transient, rapidly changing abstract graphic images, codes, and signs which are becoming the records of our contemporary society will replace the concrete, stable connections we now know as sculpture, making them obsolete and archaic. From a more reassuring view, the traditional function of sculpture, that of creating concrete reminders of our humanity, may prove to be surprisingly durable, perhaps even elemental.

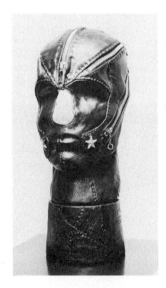

Figure 1-38
Nancy Grossman, *Head.*
1968.
Epoxy, leather, and wood,
H. 16¼ in., W. 6¼ in.,
D. 8½ in.
Collection Whitney Museum
of American Art, New York.
Gift of the Howard and Jean
Lipman Foundation, Inc.

2

Sculptural Design and Expression—
Developing a Form Concept

DESIGN: THE STRUCTURAL PATTERN OF FORM

Design in art, as in nature, may be thought of as the underlying structural pattern. In sculpture, design is the structural pattern resulting from the relationship of the plastic elements of mass, space, plane, line, texture, light, and color. To effectively organize these elements, principles are applied which have come to symbolize desirable aesthetic qualities in all the plastic and performing arts (for that matter, nature as well): principles of proportion, balance, rhythm, movement, emphasis, and dominance. Related are auxiliary organizational principles of transition, unity, opposition, distribution, and variation.

Though it shares the same figural tradition, unlike the illusory art of painting, sculpture is distinguished primarily by its physicality—its concrete, three-dimensional quality. Like architecture, sculpture deals with the relation of mass to void and surface to volume. To Rodin, sculpture was the art of the "hole and the lump"[1] Andrew Ritchie called it "the relationship of volume and void."[2] Mass is defined by the space surrounding it and within it, the lines or edges which articulate the planes, the light which clarifies the mass, and the textural activity of the surface which gives it tactile appeal.

Working with these design principles the sculptor repeatedly juxtaposes the plastic elements out of the same material substances to recreate a fresh and meaningful image. While arousing pure sensations such as quiet, strength, and tension on one level, on a deeper level visual design may evoke the powerful passions and emotions which comprise man's world of subjective knowledge and thought, such as love, awe, and fear. Through the play and interplay of design principles and elements, the same basic form may be translated realistically, abstractly, or surrealistically. With the vehicle of the plastic elements and their infinite possibilities for variation, the sculptor can actualize the deeper expressive and intellectual aspects of the form language.

THE ELEMENTS OF DESIGN

Mass

A mass may be a closed volume displacing its surrounding space or contain penetrations which allows space to flow through it. Affected by the surrounding form which shapes it, these interior spaces, or negative areas of a form, become as important as the positive or outside mass in their effect on the total composition.

While interior spaces draw our attention to the absence of mass and the shape it creates, primarily closed units make us aware of the substance and weight of the mass and its outer contour silhouetted against space. Infinite possibilities exist for the different shapes a mass may assume through its contours, planes, lines, spaces, and textures. All shapes, whatever their uniqueness, can be traced to a few basic shapes, those being the cone, the pyramid, the sphere, the cylinder, and the cube, each of which has its origins in nature. Modifica-

tions and combinations of these few shapes have been the basis of architecture, the source of such architectural structures as the Byzantine dome, the Gothic spire, and the Indian pagoda, among others.

Like architecture, a sculpture may be based on a limited range of forms—for example, an ovoid and column—juxtaposed in any number of ways, with the addition of smaller forms for scale, balance, variety, etc. (see Figures 2–1, 2–2, and 2–3). Reducing sculptural composition to pure and simple forms, as practiced by Brancusi and Arp, was a means of achieving *significant* form, that which distilled the essence of a complex living organism without trying to imitate its surface appearance. In our time the concept of mass was best understood by the great epic sculptor Henry Moore (see chapter 1, Figure 1–26), the carver of monumental organic forms. His powerful, often figurative works succeeded in combining the eternality of primordial earth forms with the elegance which brings to mind the great classic styles of history.

VARIATIONS OF THE OVOIDAL FORM ON A COLUMN

Figure 2-1
Amedeo Modigliani, *Head.* 1912. Limestone, 25 × 5⅝ × 8¼ in. The Solomon R. Guggenheim Museum, New York. Serene elegance through vertical symmetry, containment, and elongation of form.

Figure 2-2
Henri Matisse, *Tiara with Necklace.* 1930. Bronze, H. 8⅛ in., L. 5½ in. Collection Baltimore Museum of Art. The Cone Collection, formed by Dr. Claribel Cone and Miss Etta Cone of Baltimore, Maryland. Cascading volumes build in crescendo rhythms off a conical column, the whole transformed into a growth-like cluster of organic forms.

Figure 2-3
Constantin Brancusi, *Mlle. Pogany, Version I.* 1913, after a marble of 1912. Bronze, H. 17½ in. Collection Museum of Modern Art, New York. Acquired through the Lillie P. Bliss Bequest. The major compositional motif of the S-curve is repeated in the curvilinear treatment of the volumes and edges.

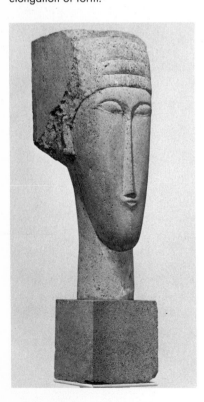

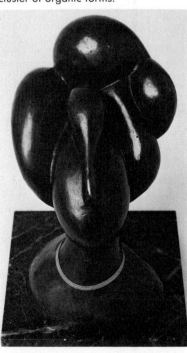

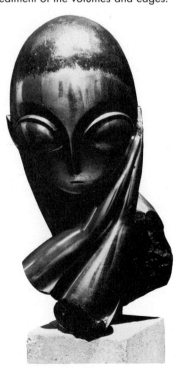

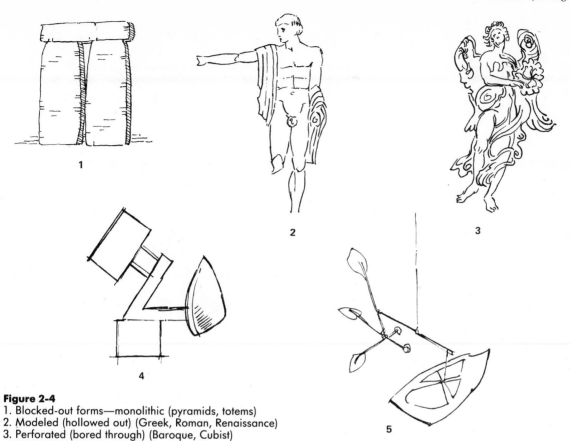

Figure 2-4
1. Blocked-out forms—monolithic (pyramids, totems)
2. Modeled (hollowed out) (Greek, Roman, Renaissance)
3. Perforated (bored through) (Baroque, Cubist)
4. Equipoised (suspended) (Gabo, Lippold)
5. Kinetic (moving) (Calder, Rickey)

Space

Early in the twentieth century, the sculptor Henri Laurens defined sculpture as "that which was essentially occupation of space, construction of an object with hollows and solid parts, masses and voids, their variations and reciprocal tensions, and finally their equilibrium."[3]

In his book *Vision in Motion*[4] László Moholy-Nagy traces the historical development of sculpture from mass to motion, from a solid form to one incorporating space. He cites the following historical stages (Figure 2–4):

1. blocked-out forms—monolithic forms of pyramids, totems

2. modeled (hollowed out)—Greek, Roman, Renaissance

3. perforated (bored through)—Baroque, Cubist

4. equipoised (suspended)—Gabo, Lippold

5. kinetic (moving)—Calder, Rickey

The Cubists were the first to perforate the traditionally solid plane and give the negative space a shape which established it as a form. Penetrations were incorporated into the internal mass of the Vitalists Arp, Henry Moore, and Barbara Hepworth, among others (see Figure 2–5). Demonstrations of space-time concepts by the Cubists and Futurists attempted simultaneity by showing multiple views of the object at once, and, in both

Figure 2-5
Barbara Hepworth, *Sea Form (Porthmeor)*. 1958.
Bronze, 32⅛ × 45¼ × 12 in.
Art Gallery of Ontario, Toronto.
Gift of Sam and Ayala Zacks, 1970.

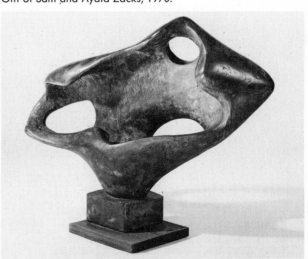

painting and sculpture, by breaking into the solidity of the object to represent the concept of an inner as well as an outer form. The Surrealist sculptor Giacometti de-emphasized mass in favor of space to achieve such psychological effects as timelessness and isolation in his dioramatic compositions.

Further explorations in space were made by sculptors exploiting the structural strength and immediacy of direct welded metal. The iron and steel fabrications of Julio González and Pablo Gargallo took on a diagrammatic character, the metal acting as a gestural line in space. Delicate, cantilevered, and floating forms, allowed by the material's tensile strength and ease of fabrication, completely emancipated the sculptor from the anchor of the base. Calder floated whimsical metal shapes, Richard Lippold assembled brass rods into a mathematically arranged assemblage in space, George Rickey utilized wind currents to keep parts of his sculpture in constant circulation, Tinguely built machines to make changing patterns in time and space; Otto Piene inflated polyethylene balloons and sections of hose with helium and floated them in the sky in a marvellous extravaganza which, in his later work, was recorded on video tape, to be "caught in time" (see Figure 2–6).

Environmental art returned sculpture to its architectural liaison, not solely as the embellishment of a structure, but as an architectural space-defining form in its own right. The viewer became physically involved—walking on, through, and under the parts of such works as the Robert Morris room construction of interlocking wood beams and the wood constructions of Alice Aycock (see

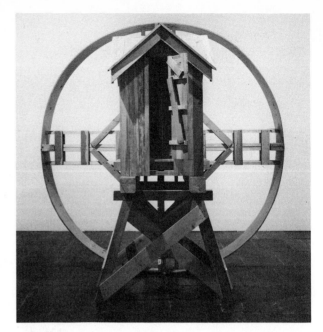

Figure 2-7
Alice Aycock, Untitled (*Shanty*). 1978.
Wood, 54 × 30 × 30 in.
Promised gift of Mr. and Mrs. Raymond J. Learsy to the Whitney Musuem of American Art, New York.

Figure 2–7). Giant earthwork sculptures represented the ultimate in spatial relations, a contemporary resurrection of ancient sanctuaries. With ritualistic rather than practical functions, both ancient and modern forms served a spiritual purpose of inspiring awe and wonder and giving reality to our physical relationship with the earth.

Given the freedom in contemporary sculpture to incorporate space, the possibilities for exploration become endless. Space might encompass one or two penetrations in a mass, a network of regular or irregular penetrations, a movement felt to be pushing around the irregular silhouette of the mass, or an active element, such as wind currents, which constantly changes the relationship of the work to the viewer (see Figure 2–8). In all the above contexts space is a variable, an abstract element in relation to mass which must constantly be reconsidered with each new form arrangement.

Planes and Surfaces

Mass is visually defined by its multiple, changing outer edges silhouetted against the surrounding space. Planes are the interior surfaces connecting and relating the silhouettes; they are the distinctive forms distinguishing sections of mass from each other through shape, tension, and direction or movement. Planes intersect sculpturally through

Figure 2-6
Alexander Calder, *Big Red*. 1959.
Painted sheet aluminum, steel rods and wire, H. 74 in.,
W. 114 in.
Collection Whitney Museum of American Art, New York.
Gift of the Friends of the Whitney Museum of American Art.

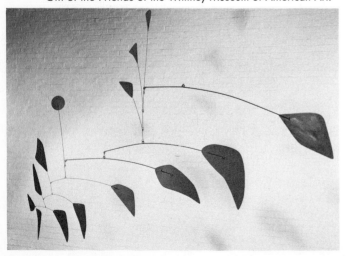

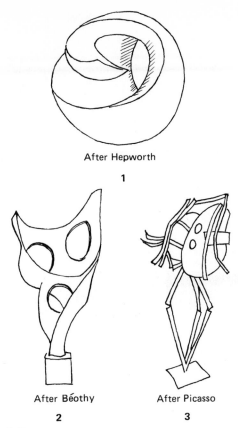

After Hepworth

1

After Béothy

2

After Picasso

3

Figure 2-8
1. Incorporating 1-2 penetrations (after Hepworth)
2. Incorporating several regular penetrations
3. Incorporating a network of irregular penetrations

the varied edges formed by ridges and grooves, heights and depressions. Soft, hard, regular, or irregular, these edges or junctures are the cues to the character of the planes they define and the primary means of carrying the structure of the planes around the mass (see Figure 2–9).

Planes may be flat or curved, concave or convex, simple or complex in character. Curved planes tend to be dynamic in directional movement, forcing the eye in the direction of the curve, while the directions of flat planes are more dispersed. A sequential progression of planes helps to gradually lead the eye in a particular direction. A progression of sloping planes around a penetration unfolds or reveals an entry into the interior of a form more effectively than straight planes, which give the effect of a flat hole. As a plane shifts positions it undergoes a change in its directionality, consequently in its relationship to surrounding planes.

In addition to visible lines, textures, and color treatment, plane directionality is also established by axis or force lines. Force lines function as implied directional or axis lines on the surface planes of the human body, suggesting the complex move-

ments of the underlying skeletal and muscular systems. The emphasis on the multiplicity and separation of surface planes results in complex, impressionistic surfaces, as in a Rodin or Degas; pulling planes together into an integrated whole is the concise approach, represented in the surfaces of Brancusi and Maillol.

Underlying the deceptively simplified appearance of the integrated surface is the evolution of the form through preliminary fragmentation and articulation to the final stages of clarification and crystallization. It was this required process of analyzing planal structure and design which the Cubists found to be a fertile field for a new type of scientifically inspired form experimentation and invention.

The four modes of abstraction below, identified primarily with contemporary art, have been employed to some degree by artists of all ages and cultures (see Figure 2–10 on next page).

Four Modes of Abstraction

1. *Displacement*—Rearranging the natural position of the parts, often achieved by slicing the form along a central axis line and sliding one part up, one down;

Figure 2-9 Plane Directionality
1. Planes intersect through edges formed by ridges and grooves, heights and depressions.
2. Character of planes—flat and curved (head).
3. Character of planes—multiple, complex, planal surface.
4. Curved and flat planes—sequential progression in a circular direction.
5. Axis lines demonstrating direction of planes.
6. Axis lines in circular direction.

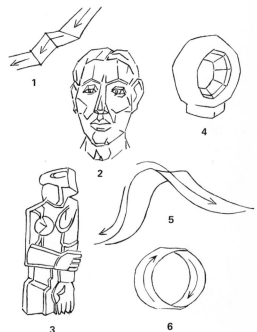

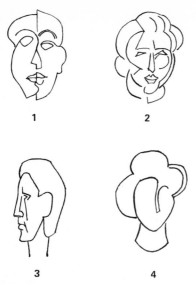

Figure 2-10 Compositional Devices (Form Inventions)
1. Displacement
2. Fragmentation
3. Distortion
4. Reduction

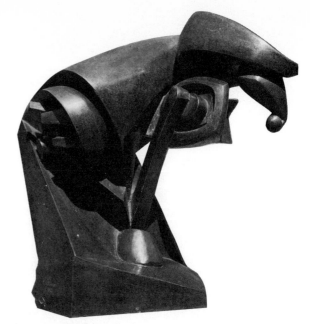

Figure 2-12
Raymond Duchamp-Villon, *The Horse*. 1914.
Bronze (cast c. 1930–31), 40 × 39½ × 22⅜ in.
Collection Museum of Modern Art, New York.
Van Gogh Purchase Fund.

other possibilities lay in reversing the form on either side of the axis line, one side as a convex, the other a concave.

2. *Fragmentation*—The geometric breakup and separation of forms into planes.

3. *Distortion*—The radical change of naturalistic proportions, as in the widening or elongation of parts or the whole of a work.

4. *Reduction*—The most basic device, the simplification of all forms to their fundamental geometric or organic shape.

Figure 2-11
Umberto Boccioni, *Development of a Bottle in Space*. 1912.
Silvered bronze (cast 1931), 15 ft. × 12⅞ in. × 23¾ in.
Collection Museum of Modern Art, New York.
Aristide Maillol Fund.

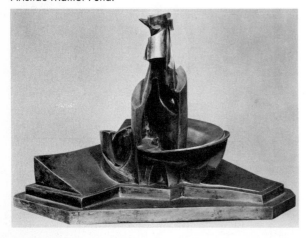

The first fully dimensional Cubist sculpture, Picasso's *Head of a Woman* (1909–10), employs three methods of abstraction—displacement, fragmentation, and distortion. Influenced by the same concepts, the cast bronze 1912 work *Development of a Bottle in Space* by Umberto Boccioni was composed of repetitive spiral rhythms imposed on concave planes, the intention being to create a dynamic, cinemagraphic illusion from a static object (Figure 2–11). The choice of a bottle as subject of a sculpture set a precedent in transferring a still-life theme to a three-dimensional work. Such painterly themes had already been experimentally transferred by the Cubists, but to assemblage relief form only. Another dynamic sculpture, *The Horse* by Raymond Duchamp-Villon, executed in 1914, synthesized machine, primitive, and Cubist forms to convey the force and power of the machine as the new work animal (Figure 2–12). A similar message is carried in the *Rock Drill* by Jacob Epstein, an experimental work which achieves its great impact through the metaphor of man becoming machine and the expressive power of its distorted, fragmented, and displaced forms.

Line

Line in sculpture is the defining edge or contour of a form. Implied or actual lines act to separate planes and give rhythmic unity and continuity to

Figure 2-13 Line
1. Simple curved and straight—tranquil vertical-horizontal relationship
2. Zigzag, jagged, diagonals
3. S-curve—serpentine
4. Arabesques—Baroque

the whole by directing the eye within and around the form. The directional function of lines may lead the eye in, pull it out, stop and start it. The system of linear perspective devised during the Renaissance utilized the directional function of lines to create an illusion of endless space on a two-dimensional surface.

All design becomes a variation and combination of simple curved and straight lines which, when compounded, take on complex characteristics: the zigzag with its jagged, nervous quality; the spiral with its endless, flowing rhythm; and the tranquillity of vertical-horizontal relationships. The character of a line has become symbolic of a style; the S-curved line is the distinctive feature of the zoomorphic animal style which also relates to the serpentine line of the Romanesque and Oriental styles. Contrasted to this is the verticality and angularity of the Gothic *broken style*, called after its manner of portraying drapery, the flowing arabesques we identify with the Baroque, and the vertical, horizontal line relationships which predominate in Classic art (see Figure 2–13).

In the bold and spare contemporary composition, line defines spatial patterns which operate as contrasting lights and darks. With a minimum of mass the linear composition takes on the form of a pattern or sign—a diagrammatic configuration in space, conceding little or no need for mass and weight to communicate its message of space-age form and dynamics (see Figure 2–14).

Texture

Like the mass which it modifies, texture increases the visual sensations aroused by the material and form of sculpture. In general, surfaces which are extremely smooth and neutral have the effect of diminishing the particular quality of the material and flattening the form, while roughly textured surfaces act as tonal and linear cues to form and the sense of volume.

Figure 2-14
Robert Grosvenor, *Tenerife.* 1966.
Fiberglass, lacquer, plywood, and steel, H. 66 in., W. 276 in., D. 6¾ in.
Collection Whitney Museum of American Art, New York.
A diagrammatic configuration in space with little mass or sense of weight communicates its message of space-age form and dynamics.

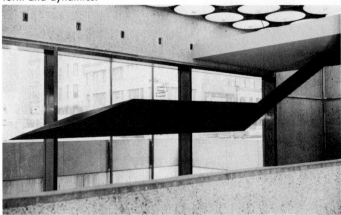

Textural effects may be imposed by the sculptor or exploited from the indigenous texture of the materials, which, in sculpture, always is present to some degree. Textural effects of a purely visual nature, such as the vein markings coloring a stone, tend to arouse our tactile as well as visual senses. Tool marks from wood gouges, bush hammers, chasing tools, wire scraping tools, stone drills, etc., create textures which reflect the forming process, as does a technique such as the sand casting of metal, which leaves a fine granular surface. Texture can be used as accent or as an overall pattern, though surfaces which become too active tend to overwhelm the form. Such was the case during the Baroque period when the practice of textural imitations of hair, skin, and drapery emphasized illusory effects over the construction of the mass, with even the hard materials of stone treated in a fluid pictorial manner.

With the capability of being more freely manipulated than stone, the modeling materials of wax and clay are particularly susceptible to impressionistic or chiaroscuro (light–dark) textural effects. An extreme example of such treatment may be seen in the figurative compositions of Medardo Rosso, a late nineteenth-century Italian sculptor whose sensitive and painterly modeling style is thought to have influenced Rodin (see Figure 2–15). With a command and range of form infinitely greater than Rosso's, it is Rodin who is given the credit for revitalizing the surface of nineteenth-century sculpture. Rejecting the look of Neoclassical neutrality and anonymity, Rodin permitted his completed surfaces to reflect the interior bone and muscle structure of the figure, while at the same time retaining the spontaneous look of the artist's touch.

Following in the same spirit, twentieth-century carvers such as the American John Flannagan valued and maintained the intrinsic textural qualities of the stone; Arp and Brancusi used the stone to simulate the strongly sensuous textural quality of such forms as pebbles, bones, and eggs. Unlike Rodin, they sought to minimize evidence of the artist's hand and maximize the concept of organic connections between art and nature. To emphasize this, Brancusi initially exhibited his marble carving *Sculpture for the Blind* enclosed inside a bag with holes to touch but not see the work.[5] In 1916 this appeal to direct sensation and minimum shape was revolutionary and marked the beginning of textural qualities used as a tool to connote psychological meaning as well as physical sensations. The encrusted surfaces of the Surrealist sculptors Giacometti, Germaine Richier, and Theodore Roszak effectively convey the horrors humanity has inflicted upon itself, and the difficult times the sculptors had witnessed. In contrast, contemporary hard-edged and minimal structures such as those of Ronald Bladen and Clement Meadmore exclude the personal touch of the creator and reflect, in their smooth machine finishes, the industrial processes which formed them.

Figure 2-15
Medardo Rosso, *The Bookmaker.* 1894.
Wax over plaster, 17½ × 13 × 14 in.
Collection Museum of Modern Art, New York.
Acquired through the Lillie P. Bliss Bequest.

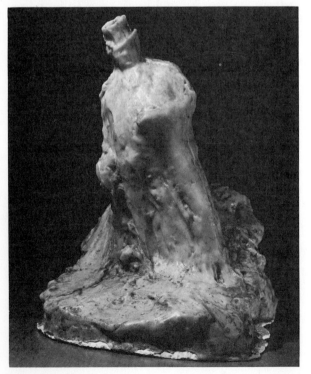

Light

Light is a tool for the sculptor, necessary for both constructing and viewing the work. The absorption and reflection of light produces the tonal range from light to dark, or chiaroscuro, which establishes the form of the work and articulates all other elements—the masses, the spaces, the lines, and the textures. Deep undercuts naturally become strong darks, slight concaves are gray, convex forms pick up the highlights, subject to the fluctuations of light sources.

Since it plays such an important role in form definition, interior lighting must be carefully controlled to avoid gross distortions. The lighting

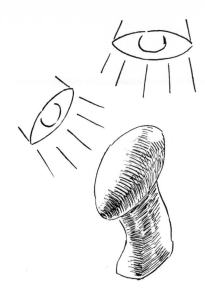

Figure 2-16
General overhead lighting supplemented with side lighting.

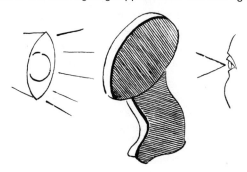

Figure 2-17
Side lighting dramatically silhouettes contour.

defines light."[6] He attributes to the modern art critic H. Focillon the distinction between the kinds of light which appear to be produced by different surfaces; those with simple contours and smooth, compact surfaces define light as broad and calm, and the atmosphere around them as heavy and quiescent. To put his statement in functional terms we might say that work defined by full sunlight tends to need clearly articulated, full, volumetric form to withstand exposure to bright light and its consequent strong shadow (see Figure 2–18). Examples of such forms are the presidential heads of Mount Rushmore and the carvings of the Egyptian pharoahs. An imposing sense of power and timelessness is conveyed by both the size and the broadly rendered exaggerated planes of these works.

Carrying the idea further, Seymour states the converse, that "deeply undercut and irregular forms . . . tend to define light as a flickering movement and the atmosphere as a restless force. . . ."[7] In contrast to the simpler, flowing forms of the brighter southern climates, the stylistic treatment of the grayer northern climates tends to elaboration and broken forms. The patterned relief of the Gothic facade under the bright sunlight would tend to fade and lose the subtle contrasts which result from diffused lighting conditions. Indirect theatrical lighting was often used to dramatize the restless surfaces of Baroque sculpture. The mobile, transitory look favored by the Impressionist sculptors, for example, Degas, Rodin, Rosso, and Bourdelle, like the Baroque, also depended on controlled lighting for its effect.

Departing from the Impressionist approach, twentieth-century sculptors clarified and unified the surfaces of their forms. Abandoning the tra-

conditions of viewing should be similar to those of working; ideally that of general overhead light supplemented with additional lighting from above and one side (see Figure 2–16). Side lighting alone dramatizes the form but fails to show up subtleties (and possible errors). Work placed against a side light will dramatically silhouette the contours and leave the mass in shadow, making it an effective method for judging the correctness of the drawing, the balance, and the general proportions of the large masses (see Figure 2–17). Light thrown directly from the front destroys shadow and tends to flatten the form. Undercuts or concave forms may be transformed into convexes if a light is directed solely from above or below—a good device, occasionally, for checking the work or deliberately causing distortion.

Lighting conditions, it is conjectured, may have affected the forms produced by different historical styles. The writer Charles Seymour has expressed the idea that sculpture "is both defined by space and defines space, and is both defined by light and

Figure 2-18

1. Simple contours and smooth compact surfaces may withstand exposure to bright light and its consequent strong shadow.
2. The subtlety of deep undercut and irregular forms benefits from diffused lighting conditions.

1

2

dition of dark, antique surface color, they favored instead the polishing of metal to a smooth and reflective finish. They opened up the interior of the mass to admit light and began constructing with the optically sensitive materials of plastics and sheet metal. Light could be seen through negative shapes, between cantilevered, linear forms, and through the transparent material itself. With its potential as a medium becoming evident, light was pioneered as a subject in the neon and Plexiglas works of the contemporary artist Chryssa and the neon and fluorescent lighting installations of Dan Flavin (see Figure 2–19). The versatile medium of the transitory, electronically produced, and manipulated image was also discovered and adopted, combining with forms of performance art in such pieces as the *Electronic Light Ballet* by Otto Piene, in which color and light were electronically mixed.

Lightness and brightness seemed to signal the emergence of a new age of clarity, modernity, and optimism for the contemporary artist. In the spirit of enthusiasm which followed the Second World War, modern sculptors, deprived of an architectural place in the sun, desired to locate their work outdoors, to be seen against the landscape. As a result, the contemporary scene has witnessed an increasing number of large architectural and nature-related forms installed in such varied settings as campuses, parks, playgrounds, and malls.

Figure 2-19
Dan Flavin, Untitled (*for Robert, with fond regards*). 1977. Pink, yellow, and red fluorescent light, 6 ft. square across. Collection Whitney Museum of American Art, New York.

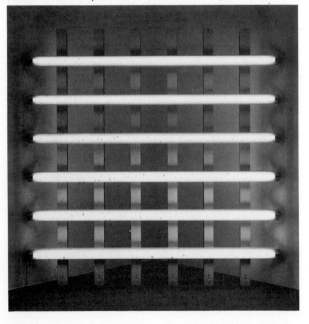

Color

Sculpture today is characterized by an explosive, painterly use of surface color—painted, baked, chemically integrated, monochromatic, polychromatic, realistic, or illusionary in effect. The fact that color now is as important in sculpture as in painting is perhaps an indication that painting and sculpture lines have crossed. Works do not have to be clearly designated as one or the other. A combination of phenomena have been responsible for this turnabout in what had been, not too long ago, a very conservative and suspicious attitude toward color in sculpture.

Though color had been an integral element in Greek and Egyptian sculpture, Roman marbles were uncolored, a tradition continued in all of post-Renaissance Western sculpture, with the exception of the Spanish and the architecturally decorative, small terra cotta glazed works which were often copies of uncolored marbles. During the seventeenth- and eighteenth-century Baroque and the Art Nouveau period of the late nineteenth century, interest in color was channeled mainly into the dramatic effects achieved by combinations of richly textured materials.

Modern experiments in applied surface color were first initiated by Gauguin in his wood reliefs; his color was applied innovatively, for expressive rather than representational purposes. Like Gauguin, the Cubists were influenced by colorful examples of primitive and exotic art. Rejecting the modeled form in favor of the clarity of separate planes, they painted their surfaces flatly, in pure hues. Applied to both reliefs and sculpture-in-the-round, the bright color served to accentuate the planes and counter the incidental light which could diffuse the clear, geometric organization. The ancient art of painting over gessoed wood surfaces was another technique of using color introduced by Elie Nadelman in his elegant folk-influenced wood carvings.

Brightly painted surfaces have been conspicuous in the large contemporary sculptures of fabricated steel and laminated wood created by George Sugarman, Anthony Caro, Ellsworth Kelly, Alexander Calder, Robert Murray, and many others. A whimsical polychromy of local color was adapted by Marisol for her wood, cast, and found object assemblages. Louise Nevelson, another contemporary sculptor of assemblages, painted walk-in rooms and wall-size reliefs in monochromatic hues of black, white, gray, or gold (see Figure 2–20). Ceramic sculpture has seen an exciting resurgence of all types of glazes and lustres in a parody of the sentimental porcelains of the past. A meticulous

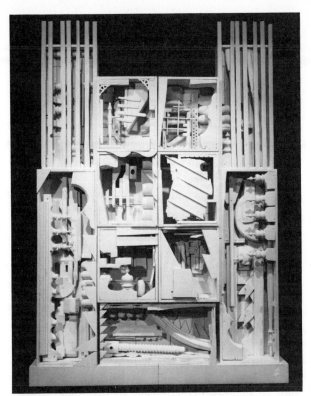

Figure 2-20
Louise Nevelson, *Dawn's Wedding Chapel* II. 1959.
Painted wood, H. 116 in., W. 83½ in., D. 10½ in.
Collection Whitney Museum of American Art, New York.

Figure 2-21
Duane Hanson, *Woman with Dog.* 1977.
Polyvinyl, polychromed in oil, lifesize.
Collection Whitney Museum of American Art, New York.
Gift of Frances and Sydney Lewis.

rendition of color is employed in the super-realistic cast resin sculptures of Duane Hanson and John de Andrea (see Figure 2–21). With the possibilities endless, color now is integrated in plastics, fiber, glass, and light sculpture, anodized or painted metals, wood, ceramics, cement, and plaster—with stone appearing to be the only material spared.

ORGANIZING THE ELEMENTS— THE PRINCIPLES OF DESIGN

Proportion

The scale or proportion of a form is the natural, ideal, or distorted relationship of height, width, and depth to the surrounding space. Proportions have been significant in conveying an expressive message. In the prehistoric human figure fertility is conveyed by the exaggerated fullness of the reproductive areas; the proportion of 8 heads in the height of the Greek God established an ideal, the elongation of the Byzantine indicated saintliness, compactness demonstrated the power of Aztec and African sculpture, while roundness reflected the serenity of the eastern Buddha; in modern Expressionism the Surrealistic thinness of Giacometti

existed at one extreme, and the resplendent forms of Gaston Lachaise at the other (see Figures 2–22, 2–23, and 2–24 on next page).

Traditionally, size was a means of conveying importance and power. Size differential or scale is an obvious device for organizing a multi-unit composition. The units may start from a modular system which assembles into a larger mass, or the reverse, that of a single unified mass from which smaller units are made. The relation of space to material affects proportion, as in the design of a work for a particular architectural setting. Environmental factors affect proportion; the endless vistas and bright sun of the Egyptian desert require bold, assertive forms on a large scale. In contrast, the narrow, vertical totem forms of the Northwest Indian are repeats and variations of the skyward-reaching tree forms of the locale.

Systems of measuring the proportions of the human body have been devised as modular units in which parts are submultiples of the whole height or else multiples of a small division of height. One multiple was the face; 3 equal parts of the face equal 9 faces (or 27 face subdivisions) to the entire body; another, devised by Alberti, being the foot, which was calculated as ⅙ of the body. The Greeks' system of architecture as well as their vase con-

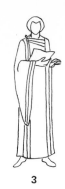

1 2 3 4 5

Figure 2-22 Proportion
1. Exaggerated fullness connotes fertility.
2. Greek proportion of 8 heads established the ideal.
3. Elongation of the Byzantine indicated saintliness.
4. Compactness demonstrated power (Aztec, African); roundness reflected serenity (Buddha).
5. Modern Expressionism represents a wide range of form from the Surrealistic thinness of Giacometti to the resplendently full forms of Maillol or Gaston Lachaise.

struction was based on the proportions of a man's body, according to the canons of Polycleitus, of 8 heads to the body. The Renaissance revived the classical orders based on the first-century writings of Vitruvius in which a man's outstretched body formed a circle or square within which the sections of the body were geometrically related (see Figure 2–25). One historical relationship of proportions known since Euclid has been designated the *golden section* or *mean* because of the intrinsic, universally harmonious aesthetic qualities it was thought to possess (see Figure 2–26). The section is the proportion resulting from the division into two unequal segments so that the ratio of the lesser to the greater is equal to the ratio of the greater part to the whole expressed in the ratio 8:13. A contemporary version of the module, based on the golden section and devised by the architect

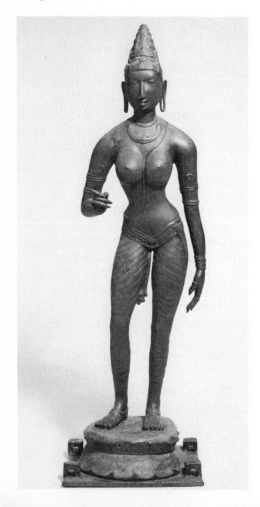

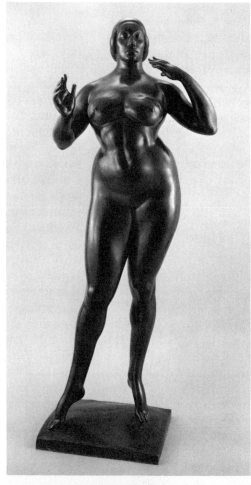

Figure 2-23
Deified Queen. South Indian, late 11th or early 12th cent. Bronze.
Courtesy of the Freer Gallery of Art, Smithsonian Institution, Washington, D.C.
Characteristically Indian, the arrested movement and elegant slimness of the figure give it a youthful sensuality.

Figure 2-24
Gaston Lachaise, *Standing Woman.* 1912–27.
Bronze, H. 70 in., W. 28 in., D. 16 in.
Collection Whitney Museum of American Art, New York.
Though strongly contrasting in mass to the linear delicacy of the Indian figure, the Lachaise shares its grace, femininity and sensuality.

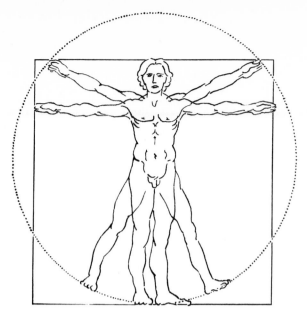

Figure 2-25
Vitruvius: Man's outstretched body formed a circle or square within which sections of the body were geometrically related.

A is to B
as B is to A + B

Figure 2-26
Golden mean or section. Segments with a ratio of 8:13—ratio considered "divine" due to its prominence in nature and its mathematical relationship.

Le Corbusier, used for its measurement the height of a six-foot man in various positions. For the artist the value of a system of proportions does not lie in a complex system of geometry or arithmetical calculation, but in scale—the relationship of parts to the whole and to each other, and the rhythms or patterns generated by these relationships.

Balance

The visual comprehension or perception of a form depends on its completion as a visual whole, or its spatial organization. The simplest form of balance is that of bilateral or formal symmetry, in which a form is balanced on both sides of the axis line, as in archaic Greek or much of Egyptian sculpture. Bilateral symmetry may be changed by subtle variation of contour, and movements away from the strictly vertical, horizontal relationship of the axis. Contrapposto postures of later Greek figures were characterized by counterpoint movements of diagonals which replaced earlier archaic verticality and established an asymmetrical balance (see Figure 2–27).

In asymmetrical balance the fulcrum is not as obvious as in symmetric balance, particularly in

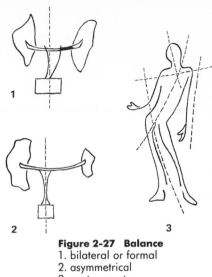

Figure 2-27 Balance
1. bilateral or formal
2. asymmetrical
3. contrapposto

compositions with large empty spaces such as mobiles. As dynamic or informal equilibrium occurs, more spatial tension develops, for example, one large form balanced by two small forms or a small heavy form balanced by a large light one placed at a distance from the central axis. Units grouped close to each other make connections and form contours which give distinct configurations and create a commonality or similarity. If the units also have a similar direction the resulting repetitive rhythms tend to form even closer bonds.

Movement

Movement is the term for the action which establishes the essential directions of a work. Repetition of movement forms rhythmic patterns which develop both the harmonies and the contrasts or complements, chords, and dissonances. Lines are the most effective directional devices but value, shape, form, space, and texture allow effective means of leading the eye. The flow of action may be across a surface, may penetrate into space, or move with forms which swing, spin, revolve, rotate, radiate, converge, or spiral.

As in nature itself, dramatic contrasts of effects can be achieved with a major sweep of movement, evident by comparing the sleek, smooth flowing movement of an Arp with either the sharp, spiky angularity of a Theodore Roszak or the interrupted and abrupt rhythms of an African carving.

Rhythm/Repetition

The major rhythms of a work are created when the varied parts or forms are interrelated and combined into a harmonious whole. Repetition and continuity of regular and irregular rhythms develop from the grouping and combining of similar shapes, masses, lines, and spaces. Counterpoint or

Figure 2-28 Rhythm
1. Organic serpentine rhythms (Greek)
2. Constant flowing rhythms—moderate (Greek) to extreme (Baroque)

complex melodies, the shapes and forms of the plastic arts, with the intervals between, "play" around the main lines of the form, echoing in their similarity and contrasting in their differences of size, position, direction, angles, curves, and intervals. Advancing or receding, expanding, contracting, creating tension, or response, action may be balanced by transition or rests. Unity is created by regular and alternating repeats of similar units. Sequences of duplicated forms may be made of units which diminish, increase, or change in position or function. These can suggest sequential action and the passage of time, as in the separate frames of photography. Rhythms form spiraling lines and shapes which rotate around an axis in three dimensions, flowing in and out, to and from, much as the rhythms of a dancer extend from the body's gestures.

Basic rhythms unite art from diverse periods and styles, as, for example, Chinese and Romanesque with their respective organic, serpentine rhythms. Movement as an expression of body gesture (as opposed to movement to describe events or activities) began with the exquisitely rhythmic figures on the Greek Parthenon frieze; it later achieved unparalleled expressiveness in the Winged Victory of Samothrace and during the Renaissance (see Figure 2–29). Rhythmic movement reached its apex in the Baroque, when attitude and surface activity affected perceptions of mass. Restored by modern sculpture, mass was interpreted by its own intrinsic, abstract rhythms and governed by the needs of the construction or composition rather than the necessity to resemble nature. Finally, when mass gave way to the spatial and kinetic, rhythmic movement was completely unleashed, no longer contained, but literally moving in time.

opposition of rhythmic patterns occur when straight units counter curved, small contrast to large, short oppose long, smooth versus rough, etc (see Figure 2–28).

The rhythmic passages formed by the repetition of units are called patterns. Complex rhythmic patterns or structures are based on several types of repetition: *Simple repeat; alternating repeat using more than one element; inversion by reversing or inverting units* (turning upside down); *irregular or random;* and *radiating* patterns.

The movements of rhythms of art stem from two main sources—nature and mathematics, representing dynamic and static organizations, respectively. In music and dance, rhythm refers to notes and movements recurring in time. The plastic arts, which derive their sources from the shapes and structures in the space around us, can be seen as analogous to music and the rhythmic possibilities construed from the point and counterpoint of sound structure. Just as lines of tone are points which interact with each other to form simple or

Emphasis, Dominance

Emphasis results from the focus or climax of a rhythm which, though harmonious, may become repetitious and monotonous. The following methods are used to achieve focus: size differences (scale and proportion); tone and color contrasts (dark versus light); shape (plane) variation and transitions; lines (angular versus curved, bold versus delicate), or through a point directed by lines; or through distribution of textures and spaces. The placement of a form, whether in a peripheral or central location, will also make it dominant or subordinate in relation to the whole.

Figure 2-29
Bartolommeo Bellano, *Virgin and Child.* c. 1435–1496 / 7.
Marble relief, 21½ × 14⅝ in.
The Cleveland Museum of Art, Purchase, General Income Fund.
The soft, intertwining rhythms of the madonna's drapery encircle and unify
the composition, forming a bond between mother and child while articulating
the volumes of both figures.

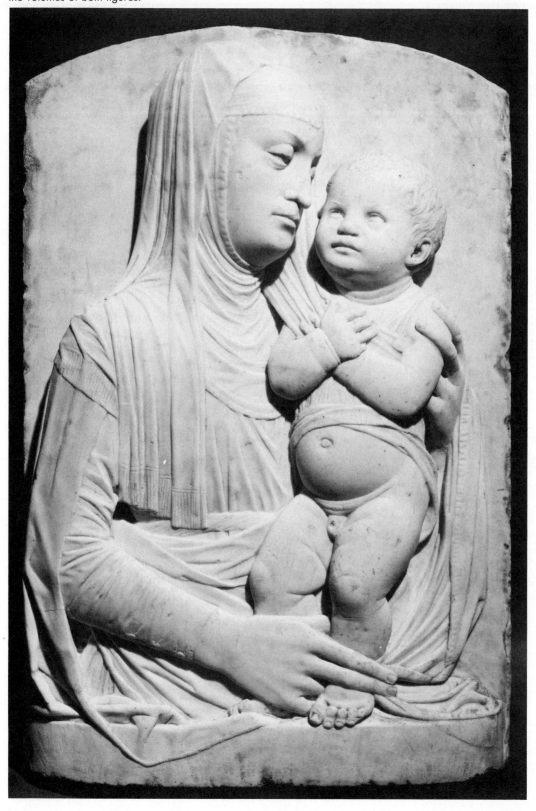

FORM AS TECHNIQUE (PROCESS AND MATERIAL)

The Challenge of the Material and Process

The art of the sculptor, more than the painter, has traditionally been craft oriented, dependent on concrete materials and the tools and processes which shape them. The physical substance of such materials as stone, wood, metal, and baked clay insured the permanence of the idea or symbol which the culture wished preserved. The nature of the materials and the process in turn often affected the concept and form of the idea, for example, the hard granite and basalt of the Egyptians disposed the form to compactness and simplicity, the softer pentelic marble of the Greeks allowed more freedom, while the hardwoods of the northern Gothic carvers could be carved with yet more delicacy and detail. According to the scholar Stanley Casson, the invention of the boldly striated style of drapery developed by the sixth century (B.C.) sculptors of the eastern Greek islands of Naxos and Samos was due to the employment, in the abrasive process, of the abundant supply of native emery.[8]

Driven by the necessity to control his materials, the sculptor developed into the scientist-technician of his day, exploring and experimenting with new materials and processes which eventually enriched all aspects of civilization. Unifying these artist-scientists over the centuries was the basic challenge of technically coping with elemental materials, and impressing them with a personal vision of the individual or the culture. Differences in time and space dissolved as sculptors, faced with the immediate challenge of their material, looked, and continue to look admiringly to the ingenious solutions of the past for inspiration.

The Sculptor as Architect-Designer and Artisan

Though individual sculptors have become renowned, sculpture historically has functioned as a group or institutional enterprise, coming under the framework of the two contributing traditions of *architect-designer* and *artisan*. Multiples or large-scale works were conceived in the architectural tradition by the sculptor-designer but not executed by the individual but rather by artisans or apprentices. An institution in Italy, particularly, and one that continues to this day, these artisans were skilled in techniques of sculptural reproduction such as molding for the casting process and adeptly reproducing a stone carving from a sculptor's plaster model. Recently, the range of artisans' skills have expanded to include fabrication specialists in welded metal and plastics who engineer monumental work from the sculptor's original model.

The "Spirit of the Process"

Reviewing this connection between the sculptor and the artisan brought about the recognition that each material, with its unique organic qualities, could elicit a different and valid response. Rejecting the eighteenth- and nineteenth-century classicism and romanticism of ideals which arbitrarily imposed itself on materials, the twentieth-century artisan related back to nature. Sensitive to natural forms and materials, Henry Moore translated from stone, wood, and bone through the creative process, turning his new interpretations back into the same or similar earth materials of stone, plaster, and wood, as well as clay, metal, and concrete.

The "truth to materials" ideal which guided the purest Vitalist sculptors such as Henry Moore, Arp, and Flannagan, also gave birth to the mystique called "the spirit of the process," whereby each material is allowed, through the realization of its natural qualities, to guide the concept to new forms. In the carving of wood and stone, the necessity of containing the forms within the boundaries of the material and the resistance of the hard matter slows down the image-making process so that the form seems to be pulled from the material—also referred to as the releasing of the "imprisoned" form. As forms are released, new forms are suggested, expanding the original concept.

Within the carving process, the qualities of each material—the resiliency and grain of wood and the granular and crystalline structure of stone, for instance—stimulate particular sensibilities. In contrast, the formlessness and plastic character of clay permits rapid reshaping of images, which is accomplished by freely adding or subtracting, the only constrictions being structural. In this case, limitations must be imposed, and a system of forms found to control or mold the material to the will. New materials, such as plastics, and new processes, such as vacuum forming, have given rise to forms unique to plastics, exploiting qualities such as light sensitivity, moldability, and relative directness of execution. Potential forms are being

recruited from the environment—the sky, mountainside, desert, and sea, as well as the elements of water, wind, and sun. Photography, both moving and still, electronic lighting, and movement of systems are also expanding the forms systems of traditional materials, ironically casting the sculptor into the role of director or designer rather than artisan.

TRADITIONAL AND NEW METHODS— A CHANGING DYNAMIC

The methods of traditional sculpture are the following: *glyptic*, carving and subtracting from a hard material; *manipulation*, the generally additive approach of building or shaping of wax, clay, plaster, cement, or plastic; *fabrication*, the shaping of a material by cutting, gluing, and pressing, of metal by cutting, beating, and heating; and *reproduction* by moldmaking and pouring or pressing hot or cold materials into negative molds for duplication. All of these methods were discovered thousands of years ago and are carried on today much as in the past. In fact, though materials have expanded, techniques improved, and styles changed, basic sculptural processes have remained technologically rather stable for centuries. Stone and wood were and still are cut by hand, even when the tool is power driven; clay is shaped and fired or transferred through molds into wax, plaster, cement, or bronze; and plaster, like the stucco of the past, is still applied directly.

The scientific and aesthetic revolutions provided stimulation for change and introduced opportunities for radical departures from the traditional techniques, materials, and processes of the arts to those primarily industrially derived. Assimilating forms from non-Western culture and synthesizing them with contemporary scientific methods and ideas, artist-theoreticians of the early twentieth century brought about a complete reevaluation of sculptural form, content, and materials. Modeling their ideas on the technology of aerodynamics, the Constructivists of the 1920s must be given credit for most actively exploring sculptural applications of industrial processes such as metal welding and brazing, and successfully adapting the new materials and technology of plastics to their formalistic principles. Though advocacy of the artist as architect-designer remained an ideal, the Constructivists, along with the many experimental visual and performing artists of that period, recognized that possibilities engendered in

the material can be discovered only by working directly. Stone was thus directly carved and polished with a sensitivity to its intrinsic sensual appeal. Even cast bronze, polished to a mirror finish, was treated with a new regard for its potential as a bright, hard, reflective material rather than a petrified version of the clay from which it originally took its shape. The prototype for this new approach to bronze is the Brancusi sculpture *The Muse* and/or *Mademoiselle Pogony* (Figure 2–30). Both in form and in concept an early product of the philosophy of direct involvement with materials, there is irony in the fact that the examples of immaculately hand-polished surfaces and basic form provided by both works were to foreshadow and influence contemporary concepts of minimal forms arrived at by indirect industrial processes.

Steel was to become one of the major industrial materials adapted to sculpture because of its directness, strength, economy, and simplicity. Sculptors experimented with the design possibilities permitted by the tensile strength of steel rods and sheet and the immediacy of the welding and brazing process. The comparative ease of welding an armature which conformed to extreme gestures without losing tensile strength also inspired new sculptural applications of direct plaster, cement, and plastic on a large scale. The availability of materials and relative simplicity of the welding process brought opportunities to make large, per-

Figure 2-30
Constantin Brancusi, *The Muse*. 1918.
Bronze on stone base, head 19½ × 10 in., base 11½ × 10½ × 9 in.
Collection, Portland Art Museum, Portland, Ore. Gift of Miss Sally Lewis.

Figure 2-31
Jean Van Harlingen, *Three Land Forms* (at night). 1978.
Corten steel and vacuum-formed Plexiglas, 5 × 38 × 12 ft.
Bethel Park, Penn. Photo by Lynette Molnar.

manent outdoor works directly rather than through lengthy casting methods. Through innovators like David Smith, plate metal replaced linear rod and sheet metal. Welded sculpture literally moved off the pedestal (a trend that had started with Rodin) and moved outdoors as monumental, architectural sculpture (see Figure 2–31).

Monumentality dictated resumption of the indirect approach. Specialists in fabrication such as the Lippincotts' studio carry out designs which, of necessity, are simplified and architectonic in character. The spare nonobjective form designed for large-scale direct fabrication has become an accepted direction for public sculpture. The sculptor's role has come full circle, with a return to that of the architect-designer rather than the artisan. With more private and public funding allocated, the future for such large-scale sculpture, though always somewhat questionable, at this writing seems brighter now than in the mid-twentieth century.

As the opportunities for experimentation on a large scale for public and corporate commissions continue, knowledge is expanding to the cutting edge of technology in the fields of electronics, lasers, computerization, aerodynamics, and the environment. Sculpture is taking many directions, leading to a return to complexity of composition and an increasingly enriched diversity of abstract forms.

FORM AND EXPRESSION: THE PERSONAL VISION

The Motivation and Response

Design and technique are the formalistic means, the actualizing process invented out of a human elemental need to express an idea. As structural tools aiding and facilitating that expression, they are, ultimately, inextricably bound up with the idea; without a command of the means, the message, no matter how vital, will fail to endure. We relate to and appreciate great works of diverse cultures and of the past, primarily through the emotional force of their forms rather than their specific symbols or narrative subject matter. Thus it is that African art, vastly removed from the contemporary world in space and time, succeeds in communicating to us universal truths.

The constant quest of the artist is for the formation of a personal style or vision which will be effectively transferred into the object through mastery of techniques and materials. Educated to the past, blending the pragmatic and theoretical, the artist searches unceasingly for his or her private interpretation. The flourishing expression of the individual which we now take for granted, even in public works, reflects a complex synthesis of formal considerations and personal expressiveness. In the contemporary world, open to any and all possibilities, the freedom exists as never before to explore unique combinations of materials and concepts, to stay with the traditional or to venture into untried frontiers of technology. The search is a multilayered, progressive one which starts with the will to recognize and act upon an intuitive perceptual awareness of the nature of the problem, and the motivation or *will* to respond to what needs to be said or solved. From this intake comes a delineation or clarification, a blending of the intellectual understanding of the limitations of the materials and processes with the emotional responses of the personal and imaginative world. Finally, a new plan emerges which is built on faith in its validity and is a balance between aesthetic, intellectual, and expressive content. It is a complete synthesis of the material's qualities, process and design factors, historical and cultural influences, and personal imagery and symbolism.

The final work may not be radically different from what had been done before, but simply a fresh reorganization of all the old principles and ideas. The artist acts not only as designer, but as engineer and inventor, with each new work leading to growth and another level of development. In the contemporary world, these three roles of the artist-sculptor have been revitalized. The freedom exists to sustain and revive the traditional, to synthesize the traditional and experimental by exploring unique combinations of materials, and to venture into totally untried frontiers of technology.

THE AGE OF INDIVIDUALISM

In the past, formal considerations antithetical to the personal vision dominated large-scale and public sculpture. The academy and the patrons of the period dictated established and predictable methods for carrying out the subjects and the aesthetic attitudes considered essential for the recognition and glorification of these subjects. Though individuality was valued to some degree, in all but the greatest periods of sculpture originality was less desirable than skill in celebrating a nation's institutions, heroes and heroines, and religions. Sculptors were expected to serve their institutions as loyal citizens and were rewarded for so doing by the proliferation of their public works. Such quantities of large-scale work required established methods and materials to assure technical proficiency.

A breakthrough came with Rodin's contributions to the naturalistic and psychological study of the human without the romantic encumbrances of generalized mythological or historical metaphor. Rodin's factualism opened the way for the invention and adaptation of new subjects and form concepts, and the pioneering of heretofore unexplored dimensions in materials and processes.

Modern twentieth-century art represents the triumph of personal iconography over traditional considerations, that is, the classic or romantic sense of beauty of form. In the powerful 1913 bronze *Rock Drill*, Jacob Epstein introduces machine-type forms as a metaphor for man becoming machine (Figure 2–32). In describing the work's origins, Epstein writes,

> It was in the experimental pre-war days of 1913 that I was fired to do the rock-drill and my ardour for machinery (short-lived) expended itself upon the purchase of an actual drill, second-hand, and upon this I made and mounted a machine-like robot, visored, menacing and carrying within itself its progeny, protectively ensconced. Here is the armed, sinister figure of today and tomorrow. No humanity, only the terrible Frankenstein's monster we have made ourselves into. Later, I lost my interest in machinery and discarded the drill. I cast in metal only the upper part of the figure.[9]

Much later in his career, chronologically and stylistically, Epstein comments on his earlier rejection by the art academies and his later rejection by the abstractionists, as follows:

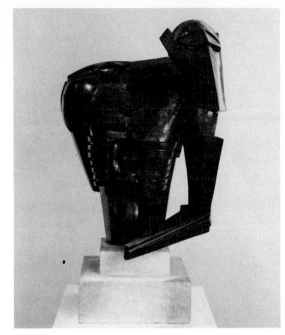

Figure 2-32
Sir Jacob Epstein, *Rock Drill*. 1913–17.
Bronze, H. 28 in.
Collection National Gallery of Canada, Ottawa.

> There are infinite modes of expression in the world of art, and to insist that only by one road can the artist attain his ends is to limit him. The academic mind violates this freedom of the artist to express himself as he knows best. Personally, I have always been for freedom of expression, and I am amused at the intolerance of our later abstractionists who, claiming the utmost freedom of expression for themselves, yet look with disdain upon all who diverge from them. I dare say to the dancing dervish the monotonous twirlings have their ecstasy, but not to the onlookers.[10]

The irony of Epstein's above remarks lay in the isolation he experienced as an individualist too radical and abstract in his early career and too conservative, that is, figurative in his later years to be accepted by the newly established and passionate practitioners of abstraction. Epstein and the early abstractionists of the twentieth century rejected the literal representation of figure or animal as no longer credible; naturalism was translated into a series of rhythmic movements, or took on the character of architectural, machine, or geological parts. Reduction to the purest design symbols represented concepts of speed, motion, growth, etc., and revitalized the use of purposeful and expressive fragmentation and primitive forms. These concepts applied to the figure transformed it from a stylized into an abstracted object. The conceptualizing process continued with the representation of outer contours giving way to the rendering of the inner gesture, reducing the figure still fur-

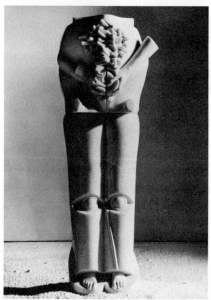

Figure 2-33
Jean Ipousteguy, *La Grand Règle*. 1968.
Marble, 2 parts, 20 × 39½ in.
Solomon R. Guggenheim Museum,
New York.

take on ritualistic qualities which evoke deep feelings concerning humanity and conditions of isolation, humanity and technology, and the meaning of one's life and existence (see Figure 2–34). Ideas such as these might occur on several levels; on one level the meanings are not inherent in the work but in symbols external to the form and in associations which are brought to the form by the maker, to be shared by the viewer. On another level, a sensitive evocation of nature or the human figure has the capacity to penetrate below the thought and feeling levels to the intuitive perception of inner meanings. Whether abstract or realistic, such works emanate a sense of magic, subliminally arousing sensations which function as poetic analogies and comparisons.

The modern sculptor Seymour Lipton has developed a personal iconography of metaphor based on strong feelings for nature and the human experience, emphasizing the hidden processes of growth and life forms (see Figures 2–35 and 2–36).

ther to an essential gesture or sign. To this reduction the application of architectonic and geometric principles of proportion and structure (with roots in Greek concepts of the figure as proportional ideal) brought about the phenomenon of structure itself becoming the subject and symbol.

The range of abstract discovery was further enlarged by the introduction of elements of fantasy and satire. The latter elements, evident in the Surrealistic sculpture of Giacometti, Picasso, Arp, and Miró, were expressions of the antirational, antistructural, antigeometric attitudes characterizing Surrealist thought; contemporary examples of such attitudes are the works of César, Eduardo Paolozzi, John Chamberlain, and Jean Ipousteguy (see Figure 2–33).

Abstraction climaxed at the end of the mid-century, signaling the development of yet another, opposing view, one in which the metaphor, private vision, or myth was no longer valued as a viable and meaningful expression. What could be communicated was a sign free of personal references, an object already processed and complete, with no visible evidence of that forming process remaining. Generalized, anonymous, technologically feasible, the work refers only to itself, its process, and the immediate world, ignoring history, literature, and the romantic myth of the artist's creative struggle.

Other contemporary sculptors reassuringly found that the object had not lost the capacity to

Figure 2-34
Leonard Baskin, *Hephaestus*. 1963.
Carved wood, H. (with base) 46¼ in., base 21 in. sq.
Collection, Portland Art Museum, Portland, Ore.
Purchased with funds provided by the Matching Grant from the National Endowment for the Arts and anonymous donors.
A sensitive evocation of the human figure has the capacity to take on ritualistic qualities. By bringing to the work symbols and associations external to the form, the artist subliminally arouses sensations which function as poetic analogies and comparisons.

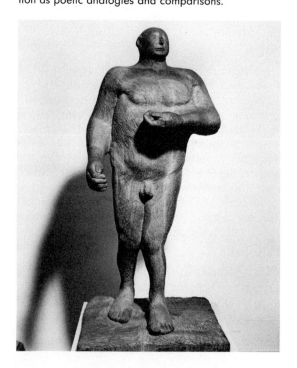

Figure 2-35
Seymour Lipton, Drawing—Study for *Sorcerer*. 1959.
Charcoal, 11 × 8½ in.
Collection Whitney Museum of American Art, New York.
Gift of the Terese and Alvin S. Lane Foundation, Inc.

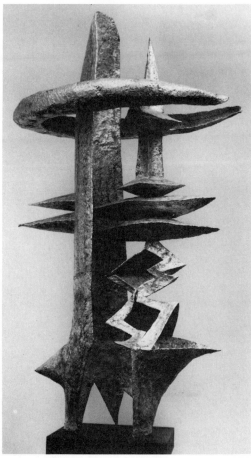

Figure 2-36
Seymour Lipton, *Sorcerer*. 1957.
Nickel silver on monel metal, H. 60¾ in., W. 35 in.,
D. 25½ in.
Collection Whitney Museum of American Art,
New York.

His imagery includes a synthesis of organic and geometric forms which, like *Rock Drill*, convey a sense of the range, complexity, and mystery of reality. He writes,

> Whatever the metaphor, in some way the life of man enters into the biological mood: sex, growth, struggle, death and rebirth. The search, the aspiration in terms of the history of art, is a nonanatomical humanism with a deep regard for what I should call the intensity of experience. I believe this results from the tensions between various aspects of the work. This is very important to me; the forms as aesthetic objects and their expressive symbolism in nature. Intensity is the drama of oppositions. It is the irony in things, ultimately that of unresolvable forces pitted against each other that become complementary unities.[11]

Lipton describes the mystique which involves the transforming of a cold material into a significant object. . . .

How does a feeling, a meaning, come through? The sculpture is a composite, cumulative experience for me, as it is made with a strong initial unanalyzed mood. Gradually it gathers meaning and articulates into art values. But the beginning is frequently a vague, intense, overall feeling, a unified mystical fusion of all kinds of feeling, all coming together as a single experienced feeling.[12]

To determine whether the idea is carried out, Lipton makes drawings or sketches.

> If I don't respond to my drawing (or my model sketch) as something more than a formal spatial arrangement, it is inadequate, it is stillborn. The pleasure and love of forms in space are important only when accompanied and given vitality by real feelings, such as bitterness, anger, warmth, triumphant peace or relentless struggle, as felt by me in man and nature.[13]

While Lipton's imagery of metaphoric abstraction refers to ideas alluding to distinct and private

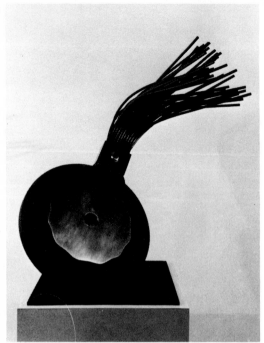

Figure 2-37
Claes Oldenburg, *Typewriter Eraser.* 1977.
Aluminum, cement, stainless steel, H. 36 in. on base
18 × 18 in.
Courtesy of Leo Castelli Gallery, New York.

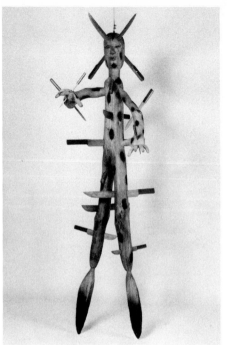

Figure 2-38
James Surl, *Me and the Butcher Knives.* 1982.
Oak and mahogany, H. 101 in., W. 37 in.,
D. 37 in.
Collection Whitney Museum of American Art,
New York.

symbols, other sculptors such as Claes Oldenburg and Robert Arneson, for example, adopt and re-create clearly recognizable objects for their art of social commentary (see Figure 2–37). Transformed through enlargement, incongruous material, or super-Realism, these objects reflect society's pop and consumer culture—that is, the real world of materialism over the romanticism of personal associations. Such social, political, and psychological commentary, though biting, maintains the cool and ironic approach we identify as a contemporary attitude.

Sculpture, because of its physicality, is particularly capable of transmitting a strong sense of mood—elegiac, passionate, outrageous, paralleled in effectiveness only by film and theater. The ravaged figures of despair by the post–World War II Expressionist sculptors fall into this category, as do environmental installation and performance art, the latter crossing the line between the plastic and theatrical arts. Humanistic but without the moral indignation of the above, the Neo-Expressionists of the 1980s also explore and expose humanity's condition through that particular province of the sculptor, form and gesture (see Figure 2–38). The strongly individualistic statements made by the experimental sculptors of our time, each creating in his or her chosen idiom, reveal still unknown facets of existence and personal truths expressed in sculptural terms.

3

Clay: The Plastic Earth

THE HISTORY OF CLAY

Through the fashionings of potters and sculptors alike, the material of clay has been utilized almost universally for over 8,000 years of human history. This material's contribution to culture certainly could not be measured by its intrinsic worth, for a more universally abundant material could scarcely be found. That it has been civilization's workhorse for centuries is evidenced by the shards of baked clay of the Neolithic period (6000 B.C.) which date back to the agricultural settlements along the Nile and Euphrates rivers and to the urban community of Catal Hüyuk in Anatolia (modern Turkey).

"Terra cotta" or "baked earth" refers to the ability of this plastic earth to be permanently hardened by heat. Once fired, the material will not redissolve in water but forever maintains a stonelike hardness. The imperishability of terra cotta shards accounts for our rich sampling of ceramics from the past, which has contributed enormously to the understanding of human historical development (see Figure 3–1).

In ancient times, the Egyptians and Mesopotamians used terra cotta for small statues as well as pottery. Bright low-fired glazes decorated and protected the surfaces of wall tiles used on the famed Babylonian Lion Wall and Ishtar Gate of King Nebuchadnezzar II (650–562 B.C.) and the Frieze of the Archers from Susa (fifth century B.C.). The Greeks, Etruscans, and Romans all made significant use of terra cotta in their statuary. The Greeks made piece molds, negatives of fired clay known as bisque molds, into which small clay figurines were pressed. Called *Tanagra* figures (200 B.C.), after the historical site where they were discovered, they were charming mass-produced sculptures of domestic and genre subject matter that were apparently in great demand by the public of the time (see Figure 3–2). The Etruscans employed terra cotta for their life-size funerary sculpture (sixth and seventh century B.C.) which stylistically grew out of earlier terra cotta funerary urns. Terra cotta sculpture of over life-size scale decorated the rooftops of Etruscan temples. An example remains in the Temple of Apollo at Veii, just north of Rome.

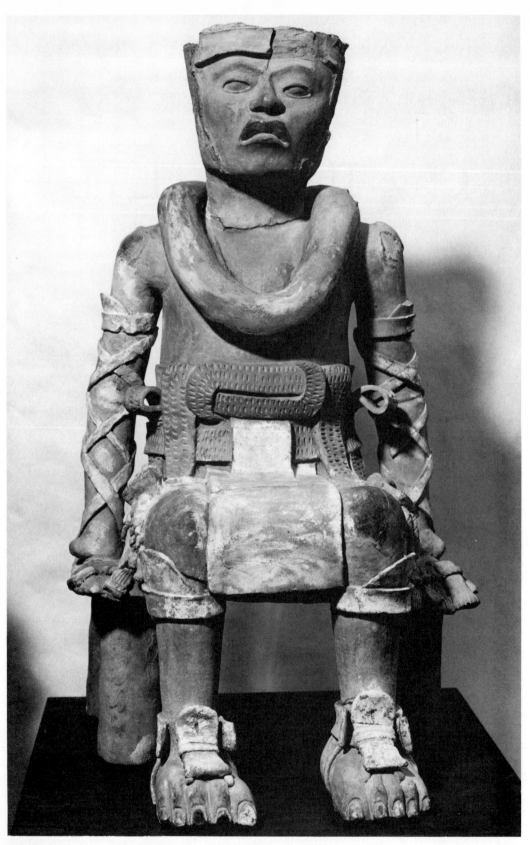

Figure 3-1
Seated figure (dignitary). Pre-Columbian, Mexico, Olmec, A.D. 600–900.
Clay, H. 35¾ in., W. 19½ in., D. 26 in.
Collection, Portland Art Museum, Portland, Ore. Gift of E. M. Nagel.

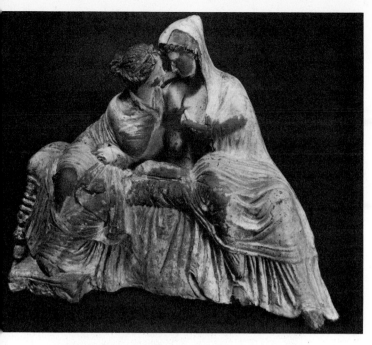

Figure 3-2
Two Women Gossiping. Tanagra, 2nd cent. B.C.
Terra cotta from Myrina.
British Museum, London.

Chinese earthenware tomb figures of court ladies and dancers, warriors, and horses of the Three Kingdoms and Six Dynasties (from the third to sixth century A.D.) and the T'ang Dynasty (seventh to tenth century A.D.) represent a high point in ceramic sculpture. In particular, the intensely lively, hollow-built sculptures of horses reveal a consummate mastery of the material. Executed with grace and sensitivity, the works, decorated with clay slips and paints, are true to the nature of the material in the solidity of their construction.

In the Middle Ages, terra cotta was displaced by wood, stone, mosaic, and tapestry. However, during the Italian Renaissance, as a result of a desire to emulate the ancients, it found favor again, particularly as a portrait medium. After firing, the portraits were often polychromed with rubbed paint, or in the case of Luca della Robbia's *Madonna and Child*, a lead-tin glaze was applied to imitate porcelain or marble.

The peoples of pre-Columbia, North, Central, and South America never discovered glazes, but decorated instead with colored slips and stains and burnished the natural clay surfaces. Indian pottery vessels of approximately the first to fourteenth centuries A.D. often took the form of birds, animals, or figures, sometimes rendered in a whimsical and humorous style. A functional vessel occasionally took the form of a surprisingly realistic and expressive portrait (see Figures 3–3, 3–4, 3–5, and 3–6).

In Africa, terra cotta portraiture from Benin (A.D. 1500–1700) reached a high naturalism—a departure from the totemistic, primitively designed works of terra cotta based on earlier wood carvings and gourd forms.

After the Renaissance, the figurine dominated much of European ceramic sculpture of the seventeenth, eighteenth, and nineteenth centuries,

Figure 3-3
Stir-up. Moche IV.
North Coast, Peru, A.D. 400–1000.
Ceramic and paint, 11 × 8 in.
M.H. de Young Endowment Fund. By permission of The Fine Arts Museums of San Francisco.

Figure 3-4
Seated figure. Moche III or IV.
North Coast, Peru, A.D. 400–1000.
Ceramic and paint, 8½ × 5½ in.
M.H. de Young Endowment Fund. By permission of The Fine Arts Museums of San Francisco.

43

Figure 3-5
Stir-up, Moche III.
North Coast, Peru, A.D. 400–1000.
Ceramic and paint, 8½ × 5½ in.
M.H. de Young Endowment Fund. By permission of The Fine Arts Museums of San Francisco.

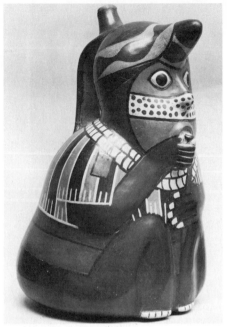

Figure 3-6
Effigy vessel, Nazca.
South Coast, Peru, A.D. 400–1000.
Ceramic and paint, 9¼ × 5¾ in.
M.H. de Young Endowment Fund. By permission of The Fine Arts Museums of San Francisco.

strongly influenced by the refined and glazed figures of the Ch'ing Dynasty (1662–1796). Due to the absence of a long and vital tradition and poor design standards in the mass-production techniques of industrialized Europe, ceramic sculpture of the twentieth century for the most part inherited the sentimental figurine tradition. Often these figures were copies of large classical sculptures of marble or bronze.

Fortunately, the quarter century between 1950 and 1975 has witnessed a return to vigorous forms and methods in ceramic sculpture, and an experimental attitude has enlarged the range of approaches to the material. The ceramicist and the

sculptor often merge roles. Functionalism and a traditional sculptural theme may be abandoned entirely in favor of a ceramic "object," often of Pop Art derivation, which features richly colored surface decoration, bizarre and startling "spoofs" of real objects, and materials quite alien to ceramic, such as lace or canvas. For contemporary works of this nature, the terms *"funk"* or *"illusionist realist"* have been coined.

Ceramic sculpture has also taken an abstract direction that features the earthy qualities of clay as an inherent part of the work. Nature and primitive traditions inspire the ruggedness of these works. Slabs and boulder forms are assembled in

Figure 3-7
Mary Frank, *Swimmer.* 1978.
Ceramic, H. 17 in., W. 94 in., D. 32 in.
Collection of Whitney Museum of American Art, New York. Gift of Mrs. Robert M. Benjamin, Mrs. Oscar Kolin, and Mrs. Nicholas Millhouse.

growthlike clusters, calling to mind the primordial, organic origins of the material (see Figure 3–7).

THE NATURE OF CLAY (CHEMICAL AND PHYSICAL)

Pure clay is made up of 1 part alumina, 2 parts silica, and 2 parts chemically combined water. Its formula is $Al_2O_3 \cdot 2SiO_2 \cdot 2H_2O$, or *hydrous aluminum silicate*. Both silica and alumina are plentiful elements, with silica making up more than half of the earth's crust, and alumina found in 15% of the earth's surface. Originally, the cooling of the earth's surface resulted in a thin upper layer of uniformly igneous rock. A layer of basalt separated this surface from the earth's core. As the surface cooled, varieties of pressures during the crystallization process gave rise to numerous minerals. The most common of these is feldspathic rock, a granitelike material making up 59% of the earth's crust.

The decomposition of feldspathic rock through the action of water and wind results in a pure clay called *kaolin*. Pure feldspars, in contrast to pure clays, contain other elements such as *potash* (K_2O), *soda* (Na_2O), or *lime* (CaO). These are of an alkaline and fusible nature and vary somewhat with the particular origins of the feldspar. In the formation of kaolin, these soluble elements are leached out, leaving the most refractory elements of alumina and silica chemically combined with water. Pure feldspars are utilized not as clay, but as an important ingredient in high-fired glazes.

Common red clays, much less pure than kaolin, are similar in chemical composition to earth, sharing the same elements (*silica, alumina, iron oxide, calcium oxide, magnesium, sodium, potassium, titanium,* and *water*, in roughly that order or percentage) in somewhat different proportions. Slight differences in chemistry make for clay's unique *plasticity*, or ability to hold any shape given to it. The thin, elongated particles of clay, chemically attracted to one another, cling when wet and stay together in the same shape after drying. The organic, carbonaceous material in common red clay contributes to plasticity, although too much of it may cause excessive shrinking.

CLAY TYPES

Clays may be categorized by their geologic origins and chemical makeup. The two main groupings are (1) *primary* or *residual* clays, which remained on the spot where they were formed; and (2) *secondary* or *sedimentary* clays, formed and transported by the action of streams, winds, and glaciers. Sedimentary clays are generally more plastic than residual clays.

Of the residual clays, **kaolin** is the purest, firing pure white to extremely high temperatures (2300°F or 1260 °C) due to its high concentration of alumina and silica in the form of feldspar and quartz. Because kaolin is found in stationary pockets formed by rocks weathering on the site rather than in stratified beds, it is free of mineral impurities that lower clay's maturation temperatures. But since these same impurities contribute plasticity, kaolin by itself is coarse grained and must be mixed with additives to increase plasticity and lower firing temperatures. Kaolin is used most effectively in the slip casting of ceramic sculpture from molds, because of its low shrinkage rate. The resulting dense, glasslike body provides a perfect ground for brilliantly colored glazes. Kaolin's hardness and purity also make it a valuable glaze material. (A high-fired glaze may be made of just 3 parts porcelain, or kaolin, to 1 part calcium.) The English combined kaolin with feldspathic Cornwall stone and bone ash, creating a clay body of particular whiteness known as bone china.

Ball clay is a highly plastic secondary or sedimentary clay chemically similar to kaolin but finer grained. Though dark in color due to organic material in its composition, it fires white at generally high temperatures. Due to its high rate of shrinkage and distortion, ball clay is not used by itself, but is added to clay bodies (in proportions of approximately 10% to 20%) to increase plasticity in earthenware and stoneware bodies.

Stoneware and **fireclay**, both high-fire clays, are geologically and chemically similar. Though often interchangeable, fireclay is the more refractory (heat resistant) because of its higher proportion of silica and alumina. Also less plastic and lighter in color than stoneware, fireclay is not used by itself but as a main component in a high- or intermediate-fired body. Stoneware clays contain plastic impurities such as calcium, feldspar, and iron, which lower firing temperature and give the clay a rich range of color from buff to dark gray or brown. Since its firing temperatures are of a high range (cones 6 to 10),* stoneware is usually the primary component of high-fire ceramic. Additives to stoneware in the form of *ball clay, sil-*

*Pyrometric cones are clay bodies equivalent to the ceramic bodies being fired in their reaction to kiln temperature and duration of firing, and are used for the determination of temperature and duration of firing. (See chart at end of chapter 5.)

ica, (flint), *feldspar*, *fireclay*, or *earthenware* increase plasticity and serve to adjust firing temperatures, color, or texture.

Earthenware clay is the most abundant and widespread, and the primary source for early folk potters and sculptors. Its rich yellow, brown, and red colorations arise from the large amounts of iron in its makeup. The iron in earthenware also serves as a *flux*, or a *low-melting compound*, which keeps the clay from vitrifying at a high temperature. Earthenware temperatures range from cones 08 to 02, or 1751°–2048°F, with deformation over 2100°F (1178°C) (at about cone 1). Though extremely plastic, earthenware also tends to a high rate of shrinkage, which may be corrected by adding sand and less plastic clays, such as fireclay and stoneware.

Bentonite is yet another plastic clay of volcanic dust origin. This fine-particled clay is added in small amounts to clay bodies to increase plasticity. It increases adhesiveness in glazes and is used in very small amounts in glaze formulas.

Terra cotta refers to a coarse, structural low-grade fireclay suitable for large works. *Slip clays* are natural clays which form a glazelike coating when fired at their maturation temperature, usually cones 6 through 10. These clays have enough natural fluxes to form glazes without the addition of other materials, and are usually of earth tones of browns, tans, and yellows. *Clay bodies* are specific combinations or formulas of materials: a base of natural clay, plus additions that influence plasticity, firing temperature, color, and texture. For example, *ball clay* is added for plasticity, *china clay* for whiteness, flint (quartz or silica sand) for density, tensile strength, or a higher firing temperature. Feldspars may be added as a flux for density and hardness at a desired temperature. *Grog* is a fired clay that has been pulverized with varying degrees of coarseness (referred to as meshes), and introduced into a clay body for porosity and strength. It also adds texture and reduces shrinkage and warping. *Grog* comes in meshes ranging from sandlike particles to medium particles (60 to 30 mesh) to very coarse (9 mesh), the choice of mesh depending on the method, size, and desired surface texture.

A satisfactory clay body for sculpture may be purchased already prepared. However, ceramic sculptors in particular should adjust the commercial product to their own purposes. The physical properties of a good, workable clay body consist of (1) *plasticity*; (2) *density*; (3) *porosity*; and (4) *minimal shrinkage*.

Plasticity may be tested by pulling clay into a

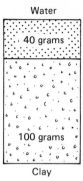

Figure 3-8
Water of plasticity: proportion of clay to water (average).

thin cylinder the size and shape of a pencil and looping it around. If the clay cracks easily, it is "short"; if not, it is considered plastic. Aging improves plasticity, breaking down organic matter in the clay as well as wetting all the particles. Wedging or kneading clay to remove air pockets realigns particles, and increases plasticity. Plasticity is determined to a large degree by the fineness of the clay grain, and the amount of organic matter present in the clay. A drop of vinegar may improve plasticity, as will the addition of 10% ball clay, or 1% to 2% bentonite.

Water of plasticity refers to the percentage of water added to make the clay plastic, averaging a proportion of 100 grams of dry clay to about 30 to 45 grams of water (Figure 3–8). The more water a clay will absorb, the more plastic it is.

Density means clay's ultimate hardness and nonporosity at a particular firing temperature indicated by the clarity of the tone when the fired clay is tapped. If underfired, the clay will be soft and porous rather than dense. Earthenware clays have high rates of absorption and porosity (4% to 10%), stoneware less (1% to 6%), and porcelain the least (0% to 3%). For functional ware, porosity above 10% is excessive since liquids will absorb into the body of the fired ware. Test porosity by weighing an unglazed, fired sample, soaking it in water for 12 hours, and then weighing it again. For calculating absorption, wet weight minus dry weight over the dry weight, times 100, equals the percentage of absorption. For example,

$$\frac{\text{wet } 6 - \text{dry } 5}{\text{dry } 5} = \frac{1}{5} \times \frac{100}{1} = 20\% \text{ absorption rate}$$

Distortion, warping, and cracking of ceramic ware is caused by a lack of porosity, or a tightness of surface, which prevents the evaporation of chemical water in the clay. Very plastic clay often lacks porosity and must be "opened up" without

Figure 3-9
Slumping test.

losing its plastic qualities. Two nonplastic materials may be used for this, flint or sand up to 20%, or grog (fired pulverized clay) 10% to 20%. To test for slumping and firing temperatures, make test strips of clay approximately 6″ by 2″ by ¼″ thick (see Figure 3–9). Fire these tile strips to a predetermined temperature, resting them on kiln props. If the clay slumps, appearing "overfired," increase porosity by additions of high-fire clay (fireclay), silica (flint), sand, or grog. If maturation is beyond the firing temperature and the clay remains soft and underfired, lower the maturation temperature of the clay by adding fluxes, from 2% to 5%. These include *feldspars; nepheline syenite* (similar to potash feldspar, but fires to a lower temperature); *talc; iron oxides;* or even ground-up glass (glass cullet). Earthenwares generally mature more abruptly than stoneware, therefore earthenware which matures at cone 04 may be overfired at cone 02, while stoneware may be stable for several cones between cone 1 and cone 10.

Shrinkage occurs at all stages; first from moist to bone dry, second in bisque firing, and again in a glaze fire. In commercial functional ware and for works designed to fit architectural specifications, control is extremely important. Accurate tests should be made with clay bodies before attempting the final works. Shrinkage varies with the plasticity; the more plastic clay shrinks the most, due to many more water-filled spaces between small particles. Weight generally reduces about one-fifth during drying and firing; normal shrinkage rate is 1″ per foot or 12% total shrinkage, from wet to bisque ware, and sometimes higher

if clay is glaze fired (see Figure 3–10). Test shrinkage by making a clay tile and marking and measuring it between two points. When completely dry the tile is measured again, fired, and measured a third time. To calculate final shrinkage use the following formulas:

$$\frac{\text{original length minus fired length}}{\text{original length}} \times 100 =$$

$$\% \text{ of shrinkage}$$

Example:

$$\frac{AC20 - CD18}{20} = \frac{2}{20} = \frac{1}{10} \times \frac{100}{1} =$$

$$\frac{100}{10} = 10\% \text{ shrinkage}$$

Shrinkage in large clay forms will be reduced by introducing 30-mesh grog, or coarser, into the clay body. Since grog has been previously fired, it will not shrink and will serve to open up air canals for even drying of thick portions that might otherwise crack. Other materials that increase clay's porosity are perlite, and organic matter such as sawdust, coffee grounds, and ground-up fruit pits—all of which burn out completely, leaving a richly textured surface. Potter Daniel Rhodes[1] has utilized fiberglass for porosity, texture, and structural strength. He imbeds fiberglass in the surface,

Figure 3-10
Scale of clay shrinkage from wet to bisque ware.

Unfired clay

Fired clay

using a proportion of 1% to the weight of the clay. (Further information on texture and color through the use of oxides will be described more fully in chapter 4.) Clay body formulas for the ceramic sculptor are listed below (measurement in units of 100 allows for greater accuracy and flexibility):

#1. Betty Feves' formula: Cone 9 reduction ceramic sculpture clay.

green stripe fireclay (plastic fireclay)	70 parts
coarse-grained local brick clay	30 parts
feldspar	4 parts added to above
optional—½% barium carbonate (a flux)	
fine to coarse grog, depending on the size of sculpture	20–30 parts

#2. Betty Feves' formula: Cone 9 oxidation clay.

green stripe fireclay	50–70 parts
coarse-grained local brick clay	50–30 parts
fine to coarse grog	20–30 parts added to above

#3. Clay body for intermediate temperature (cones 4, 5, and 6).

50 parts any stoneware
50 parts any earthenware
30 parts 20–40-mesh grog added to above

#4. Cone 6 body.

3 parts fireclay
1 part ball clay
1 part 20–40-mesh grog

#5. Cone 1–5 body.

ball clay	20 parts
red clay	35 parts
stoneware	25 parts
fireclay	10 parts
flint	10 parts
fine to coarse grog	<u>20–30 parts</u>
	120–130 parts

#6. Cone 8 stoneware.

fireclay	65 parts
stoneware	25 parts
nepheline syenite	5 parts
flint	<u>5 parts</u>
	100 parts
Add 30-mesh grog	20–30 parts
60-mesh sand	5–10 parts

#7. Cone 8–10 stoneware.

fireclay (15 parts each of 4 fireclays)	60 parts
ball clay	30 parts
feldspar	10 parts
	100 parts

Add 1% red iron oxide
20%–30% fine to coarse grog

#8. Cone 04 body (low fire).

ball clay	30 parts
red clay	40 parts
talc	30 parts
fine to coarse grog	20–30 parts added to above

PROCESSING AND PREPARING CLAY

Clay may be found exposed along riverbeds. Its presence is detected by stickiness when it is mixed with water, in contrast to the nonplastic or sandy consistency of ordinary sand and loam. Process as follows (see Figure 3–11):

1. Break up the thoroughly dry clay and screen the fine particles through a coarse (approximately ⅛″ mesh) screen.
2. Add the dry clay to a pail partially filled with water, and break up the lumps.

3. When the powder saturates the water and forms islands on top, stir the mixture and let it settle.
4. Remove the slip by pouring it through the screening into another barrel, allowing sand and impurities to remain undisturbed at the bottom.
5. If consistency is overly gritty, repeat the pouring process.
6. Allow the slip to settle to the bottom. The clear water that rises to the top may be siphoned at intervals.
7. Spread the thick processed slip on dry plaster bats (slabs) to evaporate excess water. The clay is then ready to be wedged.

Figure 3-11
Making slip.

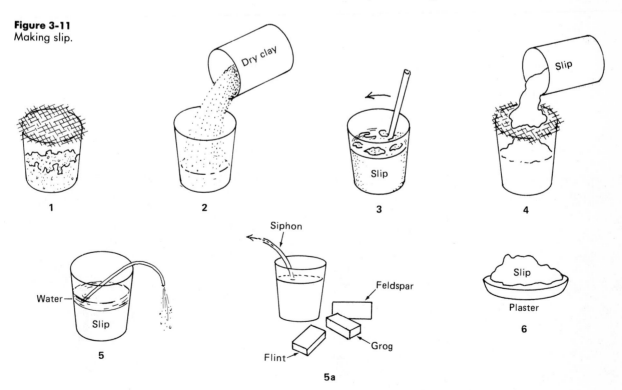

8. Nonplastic materials (flint, grog, feldspars) should be added after the clay has received the maximum amount of water it needs for plasticity. Mixing machines such as blungers, or plaster or dough mixer machines, help combine materials in the slip stage, particularly for large batches. If clay is mixed from sacks of refined powders, the dry ingredients may be mixed on a cement floor with a spade or hoe, and water sprinkled in gradual stages. The mixture may then be "pugged" (deaired) in a pugmill, or aged in plastic or rustproof containers. Making the fluid slip wets the surface of the clay particles more effectively than does the direct mixing of dry ground clay, but plasticity may be increased by aging the clay in bins before bagging in plastic. Accelerate aging by adding small amounts of old clay, such as ¾ of a cup to a 5-gallon can or 100 lbs. of new clay.

Wedging Techniques

Final deairing takes place when the clay is ready for use by *kneading* or *wedging* (see Figure 3–12). How thoroughly this is done depends on whether the clay will eventually be fired. If the clay is only an intermediary for eventual casting in another material, wedging need only be minimal to rid the clay of stickiness and promote the suppleness and elasticity which is so conducive to the modeling or additive process. Clay to be used as a temporary material for moldmaking will be discussed in the sections on moldmaking and casting.

Wedging is the process of cutting and forcefully throwing one section of clay over another to obtain a uniform, air-free consistency (see Figures 3–13 and 3–14). For cutting, attach a #20 piano wire at a 45° angle to the side of a heavy canvas-covered board or table. Stretch the wire taut with

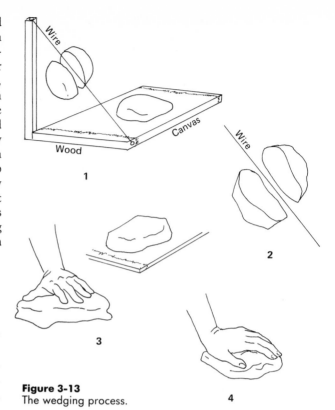

Figure 3-13
The wedging process.

a wing-nut and screw-eye arrangement anchored to a sturdy wood upright. Three basic steps of wedging are as follows:

1. Slice the clay.
2. Throw one section forcefully over the other with the cut sections turned away.
3. Lift the entire piece and drop it on the surface to squeeze out the air, at the same time forming a wedge

Figure 3-12
Screens, plaster wedging table for clay.

Figure 3-14
The wedging process. Betty Feves. Photo by author.

shape. Cutting should be carried out 20 times or so, with the layers cut across the same direction each time. Multiple layers are thereby alternated, effectively mixing the clay.

Kneading the clay may be done prior to wedging, or as an alternative to wedging, as is done in Japan. Press an oval slab of clay with the heel of the right hand. At the same time, rotate the slab to the right as on a pivot, and turn and lift with the left hand. The result is a shell shape, with the clay folding in rolls and layers around a center. To make a single roll, and then a ball, close the clay carefully to avoid forming new air holes. The ready-to-use clay should be pliable and resilient as putty, not too sticky and wet, not too firm and stiff. It should keep a thumbprint made on its surface.

4

Clay as a Modeling Material

CLAY AS A BASIC SKETCH MATERIAL

Although drawing is excellent for developing sculpture compositions, physically handling the clay offers an opportunity not encountered in two dimensions. Before starting a large-scale work, preparatory sketches in clay or some other flexible material such as wax are almost always necessary. The three-dimensional *"maquette"* can lead to the discovery of new forms and ideas through direct manipulation, or can bring the design to resolution enabling its translation into a larger concept.

Four Sketching Methods in Clay

1. Pinch and press a small amount of clay, adding small coils or wads. Exploit the accidental creases and crevices, allowing them to suggest figure and animal forms in motion, and abstract compositions that might never occur as preconceived ideas. Being surrounded by interesting organic objects such as bones, beach pebbles, driftwood, shells, and plants, and making drawings of these, can stimulate form associations.

Numerous sketches in clay will reinforce these associations and become a steady resource of ideas.

2. Roll out a thick slab approximately ⅜" thick and make of it a simple, hollow form, animal, human, or abstractly organic, without adding to the slab or changing its thickness. This forming is done very much from the inside out, much like a piece of pottery (see Figure 4-1).

3. Press the clay into a variety of shapes: cylinders, cubes, pyramids, and ovoidal forms in a range of sizes and proportions. Juxtapose these shapes to form vertical, diagonal, and horizontal relationships. Groups of architecturally related blocks may suggest figures or animals or become a geometric or constructionist composition. Soften them with a flowing rhythmic curve, or accent them with smaller transitional forms. Often two well-related forms are sufficient for an exciting composition.

4. Cut into a firm clay block using a knife or wire-ended tool. The block should be treated as a hard material. Carving and cutting away from the mass tends to promote a clarity in the treatment of planes and volumes, which in turn establishes the strong silhouette and structural organization so necessary to sculpture's visual impact (see Figure 4-2). Suggestiveness plays a part here as it does in the pinching and forming methods.

Figure 4-1
Slab method of construction.

Figure 4-2
Ernst Barlach, *The Crippled Beggar*. 1930.
Terra cotta, H. 221 cm.
Busch-Reisinger Museum, Harvard University, Cambridge,
Mass. Museum purchase.
The sculpture is formed on three sides and has a flat back.
It was intended for a niche in a cathedral.

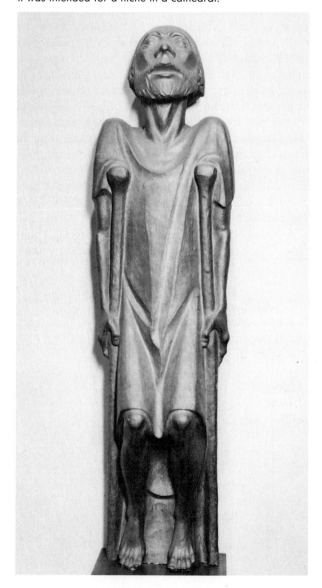

EXERCISES IN RELIEF

The sketch, or small model, promotes an understanding of both the protruding, volumetric, or *convex* form, and the flattened or depressed *concave*. Discover the relationship of one form to another, soft edges contrasted to hard edges, dark undercuts contrasted to full forms that catch the light, and the effects of texture and pattern.

Relief sculpture, building the work from a flat surface or plane, provides an effective method of exploring sculptural forms without the structural and design problems of a three-dimensional piece (see Figure 4-3). Dramatic differences may be obtained by making shallow or deep cuts into the surface, by building upon the surface to varying heights, or by combining incising and building on the same surface.

A design cut below the surrounding surface is called *intaglio*. The opposite, in which the background is cut away leaving a raised design, is a *cameo* relief. For a simple relief or linear design, use a wire loop tool, sharp knife, or linoleum or wood-cutting gouge to sharply incise the smoothed, firm surface of almost leather-hard clay. From the initial incising, cut and scoop rounded concaves, angular planes, soft and hard edges, and concave-convex combinations. Compound these effects by

Figure 4-3
Relief methods.

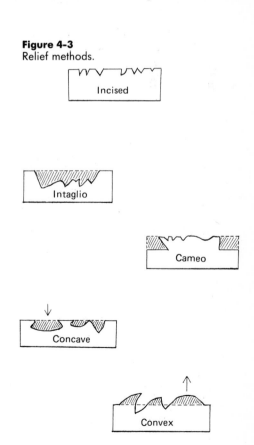

Figure 4-4
Cross-contour scraping (refining surface):
(a) Adding and pressing pellets of clay;
(b) Surface finishing—cross-contour scraping.

Figure 4-5
(a) Proportional calipers (enlarging and reducing);
(b) Measuring with proportional calipers.

adding clay to build up convex forms and edges. Relief emphasizes angular or rounded *edges* rather than volumes. If the effect of fullness is desired, building is concentrated on the form's mass rather than its edge. Small pellets of soft clay pressed against one another will accent the volume. To finish the forms and *"pull them together,"* use pellets of clay to fill out a contour, then refine it with a wire tool gently scraped *across* the contour (see Figure 4-4).

Enlarging a relief from a model is not as complex as enlarging a three-dimensional work, since fewer views need to be developed. But relief presents its own demands, such as effective use of light and the need for precise drawing skills.

ENLARGING FROM THE MODEL

The large *terra cotta* work developed from a small model usually goes through a metamorphosis. It grows and changes in the process, ideally becoming a unique form and not simply an enlarged model. Particularly when the model is very complete, its forms often need reinterpretation, or the large piece will appear stiff and inflated. Most small models are not specific enough, requiring the *adding* and *subtracting* of forms, changes of *directions* and *proportions*, and more decisive *articulation* to make the enlargement complete and satisfactory.

A small model serves as a taking-off point. To obtain its approximate character in a larger context, *proportional calipers* can enlarge up to five times (or reduce to one-fifth) the size of the original. The central screw is adjustable, changing the ratio but keeping the proportional relationship stable. Reversing the calipers into a spreading position allows them to take a contour's inside measurement (see Figure 4-5).

Enlargement by eye and confirmation by ruler and caliper can be facilitated by two simple wood sticks placed at right angles to both the model and the enlargement. The sticks are calibrated with the scale of the large work in multiples of the smaller. This device, invented by the Renaissance artist Vasari,[1] can measure particular parts of the work and check the horizontal and vertical lineup (see Figure 4-6). Calipers may then be used to transfer measurements. More complex is the framework devised by the Renaissance metalsmith and sculptor, Benvenuto Cellini.[2] The model is enclosed by four upright posts that form a rectangular open cage (see Figure 4-7). A larger-scale version of this framework is repeated for the prospective enlargement. Measurements are taken from calibrations marked on the uprights and horizontal bars, in combination with plumb lines dropped from the overhead crossbars.

A legend derived from Vasari effectively illustrates Michelangelo's relief-like method of carv-

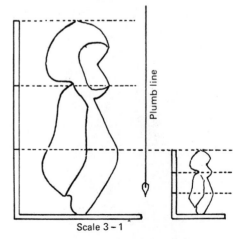

Figure 4-6
Proportional enlargement.

Figure 4-7
Proportional enlargement
using Cellini-type box with
scaled measurement.
Photo by author.

ing (see Figure 4-8). Making a small wax model for his sculpture, he immersed the model on its side in a basin of colored liquid. As he poured off small amounts of liquid, the forms were gradually revealed as if emerging from a block of stone. Though the story is meant as an analogue, the method could be used to visualize forms in relation to a block.[3]

Unfired clay models should be kept in a stable, moist state or shrinkage may produce inaccurate proportions in the larger work. If allowed to dry bone hard, the model is particularly vulnerable to breakage and should be fired. Enlarging from the model into terra cotta intended for firing may be carried out by either method described below:

BUILDING THE SOLID CLAY PIECE

Support the work without an armature on a solid board of ½" to ¾" thick Formica, tempered plywood, or masonite that has been coated with lacquer or shellac. To condition the clay and translate it into a workable condition, roll thick (1") coils between the palms of both hands, or between a board and the palms of the hands (see Figure 4-9). The clay should remain supple, losing its stickiness but not its elasticity. Once a stack of coils is prepared, a mass can be built quite speedily over an established core of firm clay, just under the intended full height. Direction of thrust is established by alternately paddling and adding clay. The core should firm up, but take care that it does not become too hard, or it will separate from the layers of soft clay subsequently added. Coils placed on the core should be adhered firmly by slapping hard with the heel of the hand or a wooden paddle or block (see Figure 4-10). Packing the clay in this manner eliminates air pockets that might expand during firing and cause cracking or even total destruction and adheres the layers of clay together, making the work structurally stronger and self-supporting. The multiple planes which the block's

Figure 4-9
Rolling coils.

Figure 4-8
Michelangelo's water bath method (exposing sections of form for carving).

A

B

Figure 4-10
(a) Application of coils to core: packing coils with block. (b) Maintaining even walls (approximately ½–1" thick) for firing when hollow building.

Figure 4-11
Temporary clay support.

Figure 4-12
Repairing clay cracks.

pressure imposes on the mass give a "tightness" and a sense of control to the form from the very beginning.

Build the work with equal attention to all sides, each view developing its shapes, directions, and proportions at about the same time. Turn the work frequently. To help solve design problems, draw directional lines freely into the clay with a wood tool. As the weight of the soft clay increases, a certain amount of vertical sinking naturally occurs. You can compensate for this by adding to the height from the start, in addition to using firm clay at the base. If necessary, delicate or overhanging parts can be temporarily supported with a block of wood and/or packed clay (see Figure 4-11). If allowed to dry rapidly, these more delicately designed parts may develop cracks at their points of attachment to the larger mass. Protect these parts by keeping them moist but stable, allowing them to dry only after the bulk of the mass is leather-hard.

Cracks develop when the outside surface dries and contracts too quickly. Gently spraying the clay during the work session will keep the surface from drying out (see Figure 4-12). Repair cracks by pressing soft clay deep into the fissure, scoring

with a knife and wetting the area thoroughly to blend new and old clay. Keep repaired areas particularly moist to prevent separation from the old clay. At the end of each work session cover the piece overall with wet cloths and plastic.

Temporary internal armatures for large clay works are designed to be removed or burned out before firing. A thick metal pipe, heavy wood strip, or dowel may act as a support around which the

Figure 4-13
(a) Wood, pipe, or dowel—temporary internal armature; (b) Temporary wood armature for vertical clay form planned for firing.

A B

core may be pressed (see Figure 4-13). Butterflies may be hung from the main support for increased strength. Armatures for works to be fired should be designed for easy removal, and need not be as strong or structurally complex as armatures used for works to be cast (see chapter 8). If left inside the drying piece, armatures of wood and metal may cause cracking as the clay contracts. Shellac wood armatures to prevent their excessive expansion during the building of the piece and to make removal easier (see Figures 4-14, 4-15, and 4-16).

A nylon bag filled with sand and mounted on a wood or pipe support is a temporary armature which may be useful for simple volumes, eliminating the need to hollow out the work. A string tied tightly around the bag prevents the sand from

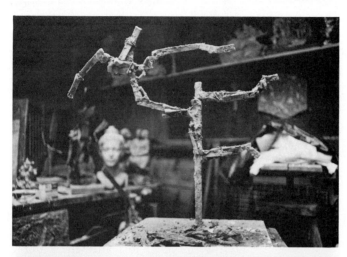

Figure 4-14
Metal wire armature for clay figure to be cast.
Photo by author.

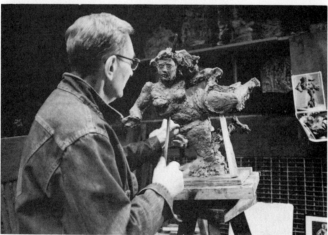

Figure 4-15
Modeling clay figure *Mistral* over armature. Fred Littman, 1980.
Photo by author.

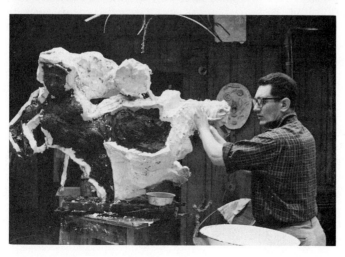

Figure 4-16
Casting enlarged version of clay figure *Mistral* by Fred Littman.
Photo by author.

Figure 4-17
Temporary armature—nylon bag with sand.

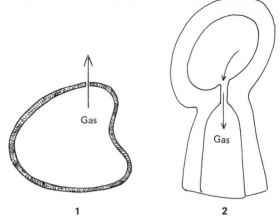

Figure 4-19
Air passage from enclosed hollow.

Figure 4-18
Rolled paper armature.

spilling out. The protruding string can be pulled or cut to allow the sand to pour out through an opening prepared in the base of the piece. The remaining nylon cloth can be removed before firing or left to burn out (see Figure 4-17).

Newspaper can be successfully used as an armature that is burned out before or during the firing. To prevent the clay from working into grooves and pockets of the newspaper, causing possible air traps, roll the paper neatly and tie it at intervals with string so it stays intact and does not work itself into the clay body (see Figure 4-18). This type of firm support may be useful inside slender extensions of the composition, such as arms or legs. It is preferable to burn out most of the newspaper when the piece is bone dry, to prevent too much heat from building up in the interior during firing.

Wall Thickness and Air Exits

All solidly built sculpture, over ¾" thick in moderate size pieces, 1½" to 2" thick in large works, must be hollow to allow the clay to contract evenly as moisture evaporates. Since air trapped in the interior will expand and cause internal pressures, a passage to the outside must be assured. Each enclosed hollow in the work must be designed so that gases can escape to the outside, or to a passage with an exit to the outside (see Figure 4-19). Very thin walls of ¼" or thereabouts are porous enough to require only a pinhole in a closed form. Completed work should be leather-hard to avoid damage through handling. Another approach is to hollow the piece just after the general forms are roughed out, but before finishing, while the clay is soft and more easily removed.

In this case, there should be a clear concept of the finishing process, to avoid radical changes in the structure afterward.

Hollowing Out the Solid Clay

1. Lay the work on its side on soft cushioning and scoop out the clay interior from the base. In many instances, you will also have to enter the work near the top or center in order to reach inaccessible areas. Choose a section that is least damaging to the detail and make an oval cut (oval or round shapes avoid corners that might chip) wide enough—about 1" to 4"—to allow the entry of a tool. The cut should be oblique, at a 45° angle, as this gives more scoring surface than a 90° cut—helpful when the section is replaced.

2. Scoop out the clay from the top entrance (if necessary) as well as the bottom, leaving walls about ½" to 1" *thick* (on works up to 18"), and 1½" to 2" on larger works (see Figure 4-20). Keep thickness of the

Figure 4-20
Scooping out clay interior through base.

Figure 4-21
Cutting section, replacing it
(hollowing out).

Figure 4-22
Slab-cutting device.

walls constant to avoid uneven drying, which might cause cracking. For scooping, a long spoon or a large wire tool can be lengthened by binding to a stick of wood.

3. A long, narrow shape or one that narrows in the center may have to be cut into two separate sections to reach all parts (see Figure 4-21). Heads are usually hollowed by cutting into the hair section in the rear, in addition to hollowing from the bottom of the work (see chapter 6, Figure 6-27).

4. If handled with care, the section can be replaced with a minimum effort. Replace it by wetting and scoring the surface of both the section and the cut area on the piece and adhere them.

BUILDING HOLLOW FORMS

Building clay walls of slabs or coils avoids the tedious operation of removing clay from the interior of a solid piece. Very large works designed for architectural settings outdoors can be constructed with interior supporting walls or buttresses to support the outer walls.

Hollow building relates sculpture more to pottery than to direct modeling or carving. As in pottery, the sculpture is formed from inside as well as out, contributing to a structural tightness and a volumetric form. The ceramic works of many earlier cultures made no distinction between the practical vessel and the sculpture, successfully merging the utilitarian and decorative-symbolic needs of the culture.

Cutting and Joining the Slabs

The thickness of the slab used will vary with the size of the work. Slabs for large works, 24" and over, require very coarse clay with a high percentage (30%) of 20- to 40-mesh grog. The resulting porosity allows for a wall up to 2" thick. For medium-size works (about 1' to 2' high) a wall from ½" to ¾" gives strength without bulk.

Regular slabs can be cut with a wire from a large block of clay that has been measured and marked. For cutting many slabs, stretch wire or cord between two wood blocks at measured intervals. As both blocks are slid along, the wire is pulled into a block of clay the same height as the wood blocks, cutting slabs of identical sizes (see Figure 4-22).

Slabs may also be rolled between two ½" to ¾" thick wood strips nailed to the sides of a canvas-covered board (see Figure 4-23). Clay loaded onto the board may be cut flush to the strips by means of a wire held taut. The slabs may then be joined by scoring and moistening the edges, then welding the scored sections together by pressing the joint with a tool or with the thumb (see Figure 4-24).

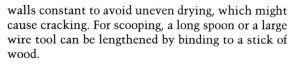

Figure 4-23
Board with clay strips.

Figure 4-24
Welding slabs.

1

2

3

Reinforcement of Clay Walls

This is possible with open-weave cheesecloth or fiberglass strands, using a proportion of 1% to the weight of the clay. The moist clay is well worked into the strands, dried and fired with the material remaining inside. The cheesecloth burns away completely while the fiberglass melts at high temperatures (cone 6) into glassy threads, actually increasing the strength of the clay walls.[4]

Material such as lace or cheesecloth dipped into a clay slip will burn away and leave its texture or pattern in the fired clay.[5] Organic or fibrous material such as straw, sawdust, or wood chips added to clay in moderation will also burn out when fired, producing a porous texture.

Forming the Hollow-Built Work

1. As the slabs are joined, be sure that inside and outside joints are welded together to insure a good bond. The walls should be even in thickness and the top of the walls kept flat and solid looking. In large pieces, inner supports—interior walls or buttresses—may be necessary (see Figure 4-25). Overbuild slightly in height to compensate for the slow settling of the walls.

Figure 4-25
Interior and outside buttresses supporting clay walls.

2. Shape the work by supporting the form from the inside while pressing the outside with a small wood block or the smooth side of a section of hacksaw blade (see Figure 4-26).

Figure 4-26
Shaping the hollow work inside and out.

3. The clay should be firm but workable so that the walls will stand without slumping. Before adding the next tier of slabs, allow the soft clay walls to stand without wraps for an hour or two or until firm.

4. Thin edges break and crack and should be avoided, particularly at the baseline where the work is most exposed to air and carries the greatest weight (see Figure 4-27). The soft spreading edge that tends to develop at the base should be firmed up and defined by pressing with the spatula end of a wood tool, forming a slight undercut.

Avoid

Figure 4-27
Firming base at edge.

Design of the hollow-built piece is definitely dictated by this very controlled method of building. The method promotes *clearly delineated* forms tending to convex fullness in contrast to the complexity and fragmentation that might result from the external application of clay. Hollow building generally promotes simplification and smooth, unbroken contours. Contemporary ceramic sculpture is beginning to exploit the hollow character of the work, playing positive or closed forms against negative or open areas within the work (see Figures 4-28, 4-29, 4-30, and 4-31).

GENERAL DESIGN CONSIDERATIONS FOR TERRA COTTA

Treatment of Forms and Edges

It is important to become sensitive to a range of choices so that your work never becomes stagnant but constantly refreshes itself with new form combinations such as the following (see also Figure 4-32):

1. Graduated concavities or convexities, flowing in a continuous manner in and out of the surface.

2. The same basic form delineated with incised, undercut, or a planal definition of edges.

3. Combinations of hard and soft edges in the same piece or even in the same form. Reversals and com-

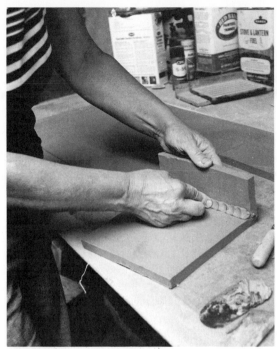

Figure 4-28
Welding clay slabs. Betty Feves.
Photo by author.

Figure 4-29
Handbuilding with terra cotta slabs. Betty Feves.
Photo by author.

Figure 4-30
Handbuilding hollow-built terra cotta forms.
Betty Feves. Photo by author.

Figure 4-31
Hollow-built ceramic sculpture by Betty Feves.
H. approx. 4–6 ft. Photo by author.

Figure 4-32
Diagrams—(1) concave, (2) convex, (3) soft edges, (4) hard edges.

1 2 3 4

binations made by utilizing incised lines with or against concave or convex forms, for a positive-negative effect.

4. Planal treatment of the edges that give the work definition and the appearance of weight and fullness—sculptural qualities consistent with the stony qualities of fired terra cotta.

Surface Treatment

1. Spray the piece frequently during the work session, since air constantly dries the surface, inducing cracking. Allow surface water to be absorbed into the clay evenly and slowly, rather than saturating it heavily all at once.

2. Before storing work, apply wet cloths, wringing them out so excess water does not mar the detail. Secure a plastic wrap tightly at the base with clothespins. To preserve dampness while keeping the work's surface untouched, make a cage of wood lath somewhat larger than the work, over which moist cloths and plastic have been pulled and tacked (see Figure 4-33).

Figure 4-33
Plastic cage around wet clay to retain moisture.

3. Fingers used on slick or tacky surfaces produce irregularities and often lumpy, grooved patterns that detract from the form. Refinement of the surface is achieved by clearly articulating each form and by carefully modeling the entire contour, never by a slick, homogeneous skin "pulled" over all the forms.

4. Work while the clay is in wet, plastic condition, using small bits of buttery clay that have been rolled between the fingers. Press these pellets into the surface with the wood spatula. The surface contour may be scraped with a wire tool moving across the contour. Often this scraped or pellet texture may be left in whole or in part as the final surface.

Texture and pattern can be incorporated in the surface treatment, but should be used selectively in limited accented areas. Wire or wood tools may be manipulated to stipple, press, push, and cut different marks on the clay. The texture made by a hacksaw blade in place of a wire tool to define

the form, or "pull it together," may also be retained for texture. Apply these marks deliberately to avoid an accidental look. An excessive or misplaced texture may animate the surface at the sacrifice of form.

You can delay the application of texture until the work has been hollowed out, since handling at that stage might mar the surface. Whenever texture is applied, the clay should be firm and the forms almost complete. The leather-hard stage just before drying is an excellent time for *burnishing*, rubbing the surface of the clay with a smooth wood spatula or the bowl of a metal spoon, until it is luminous. The burnished effect is lost above cone 08 or 1733°F, (945°C), the approximate temperature at which unglazed Indian ware is fired. During firing the surface sometimes dulls due to the formation of a thin white "bloom," but may be restored by buffing the fired surface with clear wax.

The Relief

In building a relief to be fired, follow the same guidelines for wall thickness as in free-standing works. For a relief, a safe cross section is about ½″. Projection of the forms from the surface may be 2″, 3″, or 4″ high or more, as long as excess clay is removed from the back so that the total wall is no thicker than about 1½″ (see Figure 4-34).

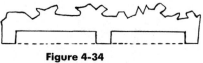

Figure 4-34
Cross section of relief.

Start the relief by building on a slab of clay supported on a firm board of Formica, shellacked masonite, or wood at least ½″ thick. The board must be waterproofed and free of warping or buckling which might distort or crack the relief surface. To construct a simple easel, nail a heavy wood strip under a wood board, so that the board slants at a 30° to 45° angle. A wood strip or molding at the board's lower edge will prevent the relief from sliding.

Transferring the relief design from a drawing of the same size is a simple matter: Place the drawing over the surface and trace the outlines lightly in the clay with a pointed tool. A drawing smaller

Figure 4-35
Carved brick relief by Harold Balazs. Exterior of library, Burien, Washington.
Architects Durham, Anderson, and Freed. Bricks carved green at
Interpace plant at Mica, Washington. Photo courtesy Gallery West, Portland, Ore.
An alternative to conventional clay relief methods.

or larger than the intended scale can be transferred with a grid system of 8, 12, 16, or more divisions. A corresponding grid is then drawn on the clay, and the design is translated section by section (see Figure 4-36).

Like tiles, reliefs to be fired are susceptible to warping and cracking if dried too quickly or allowed to dry on a surface that might warp, buckle, or not provide enough air circulation underneath. In work containing very thick and very thin parts, another cause of cracking is the stress and strain

that occurs if the thinner areas are allowed to dry too rapidly.

The relief should be cut from the back, leaving depressed areas framed by raised borders on the edges and through the center sections (see Figure 4-37). The depth of these cut sections and the width of the supporting borders depend on the relief's size and depth. Besides giving a more consistent overall thickness to the relief, the depressed areas allow for greater air circulation and more even drying.

Figure 4-36
Grid system of transferring relief design.

Figure 4-38
Paper, air, at base of the
drying work.

Figure 4-37
Incising back of relief.

2. After the leather-hard stage, when the color begins to fade, the clay has reached the *dry stage*. The *bone-dry stage* is reached when the work no longer feels damp to the touch or to the cheek. The work is then safe for firing, but very fragile, and handling should be minimal. If the work is not thoroughly dry during firing, interior steam builds up and sometimes causes the work to explode.

Figure 4-39
Paul Buckner, *Zostera Marina*.
Terra cotta and walnut, H. 18 in.
Photo by Paul Buckner.
The combining of terra cotta and other materials may be accomplished after firing, though keys and other joining devices should be integrated in the moist clay.

Drying the Terra Cotta

1. Drying of clay must be gradual to avoid cracking and minimize shrinkage. Allow approximately two weeks for the initial slow drying of an average size work (between 12″–18″ in height). This will vary somewhat with the thickness of the piece, the temperature and humidity of the drying room, etc. Keep it away from extreme heat. Retain a plastic wrap loosely on the surface during the drying period. Remove it gradually, keeping it over the thinnest parts. Delicate sections or joints where clay parts are attached should be under wraps longest, to prolong the drying process. After exposure to the air for one to two weeks, the work should be allowed to dry with all wraps off for another week or longer. While drying, rest the work's base on a flat surface covered by a sheet of heavy paper (see Figure 4-38). The paper will contract as the clay shrinks and provide an absorbent surface. A hard, nonabsorbent surface resists the drying process by not "giving" with the shrinkage, causing possible fissures in the base. Baseboards under the work should be checked for warping, since this will force the piece to distort. Remedy cracking by moistening and scoring the injured area only and covering with a plastic to keep it moist.

5

Clay:
Surface Finishes and Firing

SLIPS, ENGOBES, AND OXIDES

Clay adapts itself to all manner of surface experimentation through the use of slips, glazes, and textural accents. Every major culture throughout history appears to have contributed a new and unique approach to the surface treatment of ceramic pottery and sculptural forms. This limited discussion touches on some decorative possibilities for the sculptor. Further information is abundantly available in books dealing specifically with ceramic glazes.

The use of color and decorative techniques on clay surfaces depends upon the particular stage or condition of the body to be decorated. *Greenware* is dried clay ready for firing. *Bisque* is ware that has gone through its first, usually preliminary, firing (cones 010–04). Though unglazed, bisque ware may have had slips, engobes, or underglazes applied before firing. A *glaze* fire follows the bisque at generally higher temperatures, and results in the vitrification of applied glazes.

Slips are simply clays in liquid suspension. Since clays contain natural oxides that give a wide range of earth colors, contrasting natural clays in reds,

tans, browns, and even blue tones are a simple means of decorating a surface. Slips must be applied to a damp or leather-hard surface so that they may dry or shrink at the same rate as the body. The slip is applied as a thin cream (thick application will separate and crack from the body as it dries). If slip is used in accent areas only, shrinkage is no problem. A slip coating over a large surface, however, should contain small amounts of silica (2%–10%) to help reduce shrinkage. A slip does not vitrify and so remains porous and nonwaterproof unless a glaze is applied over it.

Some natural clays that contain sufficient fluxes (melting compounds) are called *slip glazes*. *Albany slip* is a deep brown slip glaze which was used extensively on early American folk and country pottery. Slip glazes fire high, from approximately 2200°F (1222°C) to 2400°F (1305–1330°C), cones 6–10, and are vitreous. Vitreous glazes are complete in themselves without the application of an overglaze to guarantee insolubility and permanence. Like slips, slip glazes should be applied to leather-hard ware.

Engobes, primarily colored slips, have the look of a mat, underfired glaze. Often very satisfactory

Figure 5-1
Robert Arneson, *Mask of George Moscone.* 1982.
Glazed ceramic.
16 × 13 × 7 in.
Collection of Robert Arneson,
courtesy of Fuller-Goldeen
Gallery, San Francisco.

for the more mellow qualities on a sculptural surface, engobes usually consist of a clay, a flux, a filler, a hardener, and a coloring and opacifying agent in a water medium. An engobe applied to damp clay may consist of 50% clay and 50% oxides such as flint (filler), borax (glassifier), frits and/or feldspars (fluxes). Oxide colorants are also added, ranging from the dark colors of iron, manganese, and cobalt oxide, to the lighter vanadium stain (yellow), and the white-burning china and ball clays. The flux binds the clay slip to the clay surface on which it is applied, and will vary with firing temperature and type of ware. Feldspar or cornwall stone (similar to feldspar but containing more silica) are high-fire fluxes, while intermediate- and low-fire engobes utilize nepheline syenite, talc, and/or frits. For stoneware, a simple engobe that is complete without a glaze covering

combines 80% kaolin and 20% feldspar with added oxides. Metal filings may replace oxides for color and texture.

If an engobe is to be applied to a dry but unbisqued surface, two-thirds of the raw kaolin should be calcined clay, or raw clay which has been heated to drive off the carbon dioxide, gases, and chemical water, and the resultant fused material pulverized. Substituting calcined for raw clay insures better fit and adhesion of engobe to the dried surface. The engobe applied to a bisqued surface should have its clay content cut from 50% to 40%, half of which should be calcined clay. Engobe mixtures are prepared by first weighing the dry materials, adding water, and screening the slurry first through a 50-mesh, then a 100-mesh sieve.

Oxides are compounds of oxygen and some other elemental substance, in this case metallic oxides

which act as colorants. They are added beyond the 100% of the basic formula, ranging from ½% to 10%, depending upon (1) type of flux used; (2) firing temperatures; (3) proportion of clay to flux; and (4) condition of the surface on which they are applied. High temperature helps deepen the oxide color; lower temperatures generally require a higher percentage of oxide. Percentages of oxides should be raised if oxides are mixed with glazes, as greater color saturation is needed to sustain intensity under the glaze.

Test tiles for experimentation can be made and stored for future reference (see Figure 5-2). Paint leather-hard strips in bands with several engobes (approximately 4″ × 8″ or 6″ × 8″). After bisque firing, brush a transparent or lightly colored glaze across the engobe. Identify the tiles by marking the back with a black underglaze pencil or a mixture of cobalt and iron oxide with a brush.

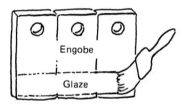

Figure 5-2
Test tiles (engobe and glazes).

Oxides may also be used in the above percentages to color clay bodies, but it becomes rather expensive to incorporate color into large quantities of clay. The mixture of oxides with a small quantity of the clay body to be used as a surface application is more economical and equally effective. Since most oxides act as fluxes as well as colorants, shrinkage of the clay coating is a problem unless offset by the introduction of 15%–30% grog to the coloring slip. The grog itself may be colored with oxide for textural enrichment. To make grog, mix oxided clay and water, dry and pulverize the mixture, and sift it through a 20-mesh screen. Place the granules in bisque bowls and fire low—1750°F (955°C) to 1940°F (1060°C) to cone 08–04. If the grog is incorporated into stoneware and fired high at 2305°F (1263°C) to 2381°F (1305°C) at cones 8–10, it melts (being a lower-temperature clay) and forms a rich dark texture. Brushing leather-hard ware with a sponge before firing, or grinding the surface with an emery stone after firing, will expose the particles and intensify the texture. For the grog mixture slip glazes such as Michigan or Albany slip may be used instead of clay.

OXIDES IN GLAZE STAINS: UNDERGLAZES AND OVERGLAZES

In addition to direct coloring with raw oxides, a still wider range of colors may be obtained from *commercial glaze stains* in amounts ranging from 10%–20% of the basic engobe formula. A glaze stain is made more stable and refined than an engobe by heating (calcining) oxides, silica, and fluxes together, and pulverizing them into a powder. This stabilizing process reduces the amount of crawling or running which often results when engobes are covered by glazes. The glaze stain can be painted on the surface much like watercolor and used in place of an engobe, an underglaze or overglaze, or it may be mixed as the coloring agent directly with a transparent glaze. *Underglazes* are oxides to which fluxes, silica, and calcined clay have been added— in effect, a commercially ground engobe. Designed primarily for use on bisque ware, they will have glazes applied directly over them before firing. *Overglazes* are similar in makeup, but are often applied as a decorative accent over a raw glaze, or on ware which has already been glazed and fired. Overglazed ware must be fired at a lower temperature than the original glaze. The lower maturation temperature of overglaze firing—temperatures ranging from 1377°F (747°C) to 1566°F (852°C) (cones 017–013)—is a result of low-melting fluxes. Due to their low melting point, overglaze colors remain clear and may be subtle and delicate in effect. Since they use colorants which would otherwise burn out at high temperatures, overglazes allow for a decorative range not possible with more muted and earthy higher-fired underglazes.

GLAZES

The ceramic sculptor who incorporates intense surface color in his work must do so with caution and sensitivity. Incorporation or integration is the key here: A glaze applied too heavily, inappropriately bright and glossy or drab or muddy, could detract from the form. Preliminary testing of glazes or slips is imperative, since variations in clay bodies, firing temperatures, and thickness of glaze application all influence a glaze's appearance and appropriateness. Brush the glaze on leather-hard or bisque clay, cut into rectangles approximately 2″ × 2½″. Before firing identify each rectangle on the back with underglaze pencil and pierce the tile to hang on the wall for reference.

Chemical and Physical Composition

Glazes are made up of three basic components: silica, a glass former and an acidic oxide; flux, a melting agent; and alumina, a basic clay oxide which promotes the congealing or viscosity of the fired glaze, thereby strengthening the material. Bernard Leach, the English potter who revived contemporary Western ceramics, called silica (the glassifier or hardener) the bones or skeleton of a glaze; alumina (binder, thickener, opacifier) the glaze's flesh; and flux (catalyst, melting agent) its blood.

Silica, also called flint or quartz (SiO_2), is made of ground flint or quartz sand with a melting point of 3100°F or 1700°C. Since this temperature is beyond the firing point of most kilns, a flux is introduced to lower the melting point of the silica anywhere from 2400°F (1320°C) or cone 12, down to 1085°F (585°C) or cone 022. To stabilize the flux and keep the glaze from running off the surface, alumina in the form of clay and feldspar is added. Alumina also contributes strength and opacity to a glaze. To this silica-alumina-flux combination oxides are added for color and texture. Though up to 50% silica may be required in a glaze, only a portion of this amount need be filled by the pure form; the rest is satisfied by the feldspar and clay already in the formula. Pure silica is generally added from 15% maximum for low-fire glazes to 30% maximum for high-fire glazes. Pure silica is sold in coarse and finer grades of 200 and 325 meshes.

Alumina (Al_2O_3) is very rarely added to a glaze in its pure form because it is readily supplied in the raw materials of feldspar and clays. Clays used to introduce silica in a glaze are china clays or kaolin, such as EPK, a plastic kaolin from Florida, and ball clay. Kaolin introduces silica as well as alumina into a glaze in amounts up to about 25%. The calcined form of this clay in which the volatile gases have been burned off is frequently used to make the glaze or engobe more stable. Ball clay aids the suspension of glaze materials in water. *Bentonite,* a plastic form of ball clay, is often used for this purpose in small amounts (2%–3%). Alumina in the form of pure alumina hydrate is used as a kiln wash to prevent glazes from sticking to shelves.

Fluxes are numerous and wide ranging in their melting temperatures and effects on glazes. Many fluxes such as magnesium, zinc, barium, colemanite, and dolomite affect a glaze's color and texture as well as the melting point. Glazes are classified according to their main fluxes into high- or low-fire categories. High-fire groupings mature at cone 6–14, utilizing feldspars of potash, soda, alumina, and lime (calcium carbonate or whiting). Intermediate temperatures use zinc oxides and forms of magnesium and silica known as talc. Fluxes for low fire are lead and the alkaline compounds of borax and soda ash, both melting at 016–02.

It is hypothesized that the first glazes were a byproduct of glassmaking efforts in which chemicals melted in bisqued clay crucibles left a glass coating on the sides and bottom of the pot. The first known glazed objects were small Egyptian sculptures glazed with the soluble alkaline oxides, using copper oxide as the turquoise colorant. The combination of the low-firing fluxes of soda ash and potassium lime (ground limestone or calcium), lead oxide (PbO), and borax melts into a glass which may, in turn, be ground into a frit. Such fritted forms of glazes are preferable to the raw forms when lead or the soluble alkalies are employed in the glaze. First melting and then cooling the oxides removes much of the lead oxide's toxicity and transforms soda ash, borax, and potassium into their nonsoluble forms. Lead, the lowest melting oxide, produces brilliant color in low-fire, earthenware glazes, but volatizes at higher temperatures (cone 6—2232°F or 1222°C) and blackens and blisters in reduction firings. Lead silicates or frits, with a 2-to-1 proportion of silica to lead, lose their toxicity. Adding calcium, alumina, and silica to a lead glaze will increase its hardness and durability.

The primary fluxes of an alkaline glaze are *sodium oxide* (Na_2O) and *potassium oxide* (K_2O). Chemically similar, they produce slightly different colorations in a glaze. Due to their solubility, these oxides' high expansion causes crazing and surface deterioration unless they are used in the form of frit. Insoluble forms of these oxides are present in feldspar which, however, melts at medium and high temperatures. There are several varying types of feldspars, each containing the essential oxides of sodium, potassium, alumina, and silica. Feldspar may be a secondary flux at low temperatures, but at high temperatures can comprise as much as 80% of a stoneware glaze. By itself feldspar melts at approximately 2336°F (1280°C), cone 9 or cone 10, and becomes a natural frit or glaze without additional oxides. A stoneware glaze melting at 2264°F (1240°C) to 2399°F (1315°C), cones 7 to 11, may utilize feldspar as the only flux at about 20%–30%. Combinations of

feldspar with whiting, flint, wood ash, kaolin, talc, or natural red clays provide additional sources of silica, alumina, and color. In high-fire feldspar glazes, the higher the ratio of flint or silica to alumina (provided in the clay of the formula), the glossier the glaze. Since alumina is an opacifying and refractory material, the converse is true: a matte quality results from a high alumina (or clay)-to-flint ratio.

A secondary flux further lowers the temperature at which materials will fuse. *Eutectic* designates the proportion of oxides in an oxide mixture which has the lowest melting point. The interaction of several chemicals, rather than the action of a single chemical, brings a glaze to the melting point. The combination will have a melting point lower than the melting points of its individual components. For instance, a combination of 94% lead with a melting point of 1641°F (876°C), and 6% silica with a melting point of 3092°F (1710°C), will have a common melting pint of 980°F (526°C).

Secondary fluxes, barium carbonate, colemanite, dolomite, zinc oxide, magnesium carbonate, and talc, added in amounts ranging from 5% to 20% of a glaze, work along with feldspar and may in part replace whiting. Secondary fluxes aid in the glaze-forming process as well as contributing unique characteristics of their own.

Whiting is calcium carbonate ($CaCO_3$) obtained from ground-up chalk, marble, or limestone. A prime high-fire flux as well as a secondary flux, it is used in small amounts to harden low-fire alkaline and lead glaze. It contributes insolubility to a glaze, and with barium promotes celadon (gray-green) colors from small amounts of iron (1%–4%) in reduction firings.

Barium ($BaCO_3$) produces a matte surface with satiny to dry qualities, depending on conditions. The presence of barium helps develop intense blues in high-fired glazes containing copper oxides, both in reduction and oxidation. Barium is toxic and is a stronger flux at low temperatures. Additions of 1%–3% barium to a clay body will prevent the ireregular white patches (caused by the action of soluble sulphates in the clay) which often show up after firing.

Borax ($Na_2O\cdot2B_2O_3\cdot10H_2O$), containing sodium and boric acid, is an active flux at all temperatures. Like the alkaline oxides of sodium and potassium, it is soluble in its natural state. Insoluble forms of boron may be obtained by using the fritted form of the oxide, or a form of calcium borate called *colemanite* ($2CaO\cdot2B_2O\cdot5H_2O$)—a strong flux at low temperatures (used up to a maximum of 40%)

and a secondary flux at high temperatures (maximum 15%). Borax, lead, and the alkaline oxides make up the three main flux groupings of low-temperature glazes.

Dolomite ($CaCO_3\cdot MgCO_3$), incorporating magnesium and calcium, is used in glazes to satisfy both materials at once. Both oxides contribute density, hardness, and insolubility to a glaze.

Zinc oxide (ZnO), used in small quantities as an active flux from medium to high temperatures, gives glossy, smooth surfaces interrupted by matte patches. Color changes are produced in zinc glazes; turquoises from copper, browns, oranges, and grays from chrome, and pinkish and sometimes crystalline effects from rutile oxide.

Talc ($3MgO\cdot4SiO_2\cdot H_2O$), another name for the natural mineral *steatite*, is a source of both magnesium and silica, used in glazes and white clay bodies at low and intermediate temperatures (cones 04–6) as both a flux and a source of silica. Besides lowering the firing temperatures of kaolin, ball clays and feldspars, talc also opacifies a glaze slightly.

Wood or vegetable ash are active fluxes at high temperatures and are a rich source of silica (30%–70%) and alumina (15%), some potash and lime, plus iron oxide, magnesia, sodium, titanium, and calcia. Volcanic ash, formed from the dust of volcanic glass, is made up of eight such elements and is chemically related to forms of feldspathic rock such as Cornwall stone. Complete glazes may be made of 40% ash, 40% feldspar, and 20% clay. Early high-fired Chinese glazes of the Han period used the ash of the wood-fueled firings, which acted as a natural flux. Melting at high temperatures, cones 8 to 11, the ash formed a rich and subtle glasslike surface coating the dark clay. The surface effects possible with ash glazes are further enriched by additions of small amounts of coloring oxides and the use of reduction firings (see Figure 5-3). Mixed wood and vegetable ashes can be obtained directly from the fireplace or wood stove. These may be mixed and sieved dry, or soaked first to release the soluble, caustic salts. Contemporary sculptor Betty Feves uses the subtle glazes of wood and volcanic ash on her large ceramic forms.

Glazes on Greenware and Bisque

Glazes may be applied to greenware in the leather-hard or bone-dry stage or after a low-temperature bisque firing (cones 06 to 04). Application to

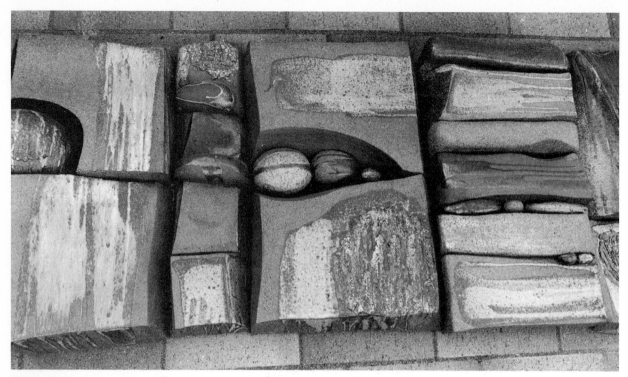

Figure 5-3
Betty Feves, detail of relief glazed with wood ash glazes and high fired.
Photo by author.

greenware is somewhat hazardous due to the need for uniform shrinkage between body and glaze. Firing a glazed greenware piece is also considerably more risky than firing unglazed work. Exploding glazed ware sticks to the kiln walls and shelves and is difficult to remove. A greenware glazed piece saves time and effort, however, since it requires only one firing. It also produces a desirable, unique surface quality in which form and glaze are particularly harmonious and well integrated.

Application Methods (see Figures 5-4–5-7)

Weigh glaze materials dry on a triple-beam gram scale. Mix ingredients with water to a pouring cream consistency, and sieve through first a 60-mesh then an 80-mesh sieve. Surfaces should be dust and grease free to avoid crawling of the glaze, and dampened slightly just before glazing. A slightly roughened surface receives and holds the glaze better than a totally smooth one. Glazes may be brushed or poured on a sculpture. Use a soft flat or round Japanese brush, brushing quickly and with overlapping strokes since the body absorbs moisture rapidly. Several coats are usually necessary for required thickness, but each coat should dry slightly before the next is applied. If small cracks or pinholes appear on the surface, they may be rubbed over with the tip of the finger when dry. In pouring a glaze, set the work on sticks placed across a basin to catch excess glaze.

Dipping is another option if the work is small and a container is large enough. Maximum thickness for a matte, opaque glaze should be about 1/16", for a glossy glaze only about 1/32".

Spraying the glaze (30 to 40 lbs. pressure) must be done with safety precautions taken to prevent inhalation and in a well-ventilated room, preferably equipped with a fan. A good deal of glaze is wasted when spraying, so large quantities are needed. Spraying must be even, as saturation in one area will cause peeling of the glaze from the surface.

Defects of application may cause scaling, crawling, running, or bubbling in the fired glaze. Pinholes result from air trapped in the surface pores of the underlying clay, and may be alleviated by moistening the body slightly before glazing and firing. Dust and oil on the surface may cause pinholes or scaly surfaces. Heavily applied glaze will run excessively, or possibly flake off during firing. Too thin an application, particularly of matte glazes, may result in dry, uneven coverage.

GLAZE APPLICATION METHODS

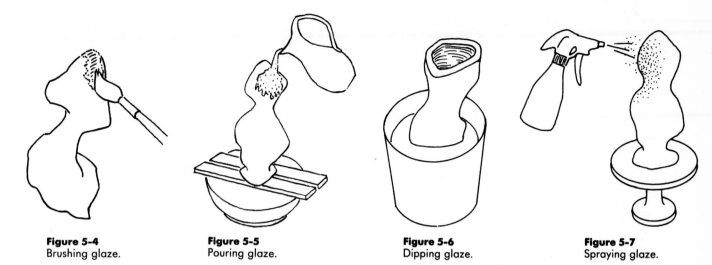

Figure 5-4
Brushing glaze.

Figure 5-5
Pouring glaze.

Figure 5-6
Dipping glaze.

Figure 5-7
Spraying glaze.

DECORATING WITH SLIPS, ENGOBES, AND GLAZES
(see Figures 5-8–5-11)

Mishima refers to the application of slip to incised leather-hard ware. The slip is then scraped away from the raised areas, leaving the color in the incised areas only. In the converse technique known as *sgraffito*, the slip is applied first, then lines are cut through the surface to reveal the clay below. The term also applies to scratching into the glaze surfaces of bisque ware before firing. Engobes ap-

plied to large deep-cut areas, are known as *inlay*. Another decorative variation is the *wax resist* technique, applied by dripping or brushing hot liquid wax (melted microcrystalline paraffin or beeswax) on greenware or bisque ware. The technique used most frequently is to follow the wax design on a surface with a coat of engobe or stain. The wax repels the stain and melts in firing, revealing the color of the clay body or subsequent glaze color and often producing a rich, mottled surface. The sgraffito technique may also be used in the wax, allowing for a crisp, linear decoration.

DECORATING TECHNIQUES

Figure 5-8
Mishima.

Figure 5-9
Inlay.

Figure 5-10
Sgraffito.

Figure 5-11
Wax resist.

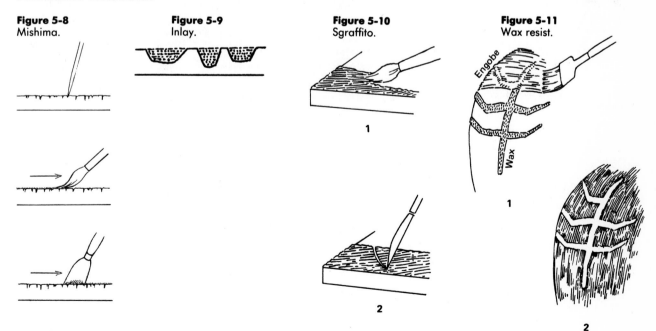

Figure 5-12
Ronna Neuenschwander, *Queen Semiramis' War Elephant #4.*
Slipcast and hand-built construction. Earthenware, terra sigillata.
Sawdust fired to cone 05, then airbrushed with acrylics.
H. 12 in., L. 14 in., D. 7 in.
Photo courtesy of the artist.

Special Glaze Effects

Raku is a low-fire glaze which is melted quickly on the ware in an enamel-like fashion. The object is thrust into a red-hot kiln at about 1341°F or cone 018, and fired quickly (10–15 minutes depending on the steadiness of the heat, the glaze used, and the size of the work) until it glows and appears to be luminous and shiny—a sign that the glaze has melted. The ware with the incandescent glaze is suddenly withdrawn from the red heat, and either left exposed to the air, or *reduced* by being submerged in an organic material like straw or sawdust. Since the clay must be particularly porous to withstand the shock of sudden exposure and heat, a combination of fireclay, stoneware, and 20- to 40-mesh grog is generally preferred. Ball clay may be added for plasticity at 15%, and 5% feldspar for density. The work is bisqued at cone 04 prior to raku firing. Handsome surface effects may be achieved on clay bodies without glazes, animating the clay surface with textural imprints from the straw or the organic material in which it is smothered. The contemporary potter Paul Soldner is best known for the techniques he developed in unglazed raku forms.

Terra sigillata is an ancient decorating technique developed by the Etruscans and later used by Greeks and Romans in their black and red figured vases. A surface application of an extremely refined slip or engobe was produced by decorating with the finest slip particles of an iron-rich clay. The slip was then burnished and the bisque ware fired at low temperatures. The burnished engobe took on an extremely smooth, glazed appearance, turning a rich black, while untreated surface areas remained the color of the original red clay.

Until rather recently it was a mystery why the red body did not turn black at the same time as the engobe, or how reduction of the engobe to black could remain localized (see section on firing).

The answer lay in the three-stage oxidation, reduction, oxidation firing methods used by the ancients and some primitive cultures. After a preliminary oxidation period, a reduction fire was introduced to the kiln, turning the entire work black. During the next stage the porous red body was affected, returning to its original color when oxygen was readmitted. The dense engobe, having been sintered* into a thin, skinlike surface coating by the initial reduction cycle, did not accept the

*Sinter: a fusion of compounds which, upon cooling, are solid but not vitrified.

oxygen and remained black. Since burnished black surfaces lose their shine above approximately 1751°F (955°C), cone 08, all terra sigillata ware is low fire and somewhat porous (see Figure 5-12). Contemporary experimentation does not make much use of this decorating technique, favoring high fire and the more extensive glaze colorations now available.

Low-fire lusters, reds, and frits. Luster glazes are thin metallic coats fused upon a glazed surface, functioning more often as surface enrichment or decoration than as complete glazes in themselves. Depending upon their metallic composition and the glazes over which they are applied, lusters range from rainbow and pearl-like effects to metallic lusters in reds, yellows, and greens, both transparent and opaque (see Figure 5-13). Totally opaque lusters have a metallic appearance, while transparent lusters resemble glass. Lusters can be obtained ready-made or mixed by combining 3–5 parts resin (gum damar) with 1 part metallic salts (chlorides or nitrates) and 7 to 10 parts oil of lavender as a medium. The luster is sprayed or painted on a glazed piece cleaned with a cloth moistened in denatured alcohol or lighter fluid. Accidentally placed luster must be wiped off immediately with alcohol. To fire, warm the work and heat slowly in an oxidizing low-fire kiln to cones 018 to 020 (1175°–1300°F, or 635°–717°C). For the first 2 hours leave kiln door slightly open to vent gases and burning oils. (Firing should be done in a well-aired room to dissipate the toxic fumes.) The carbon in the resins reduces the metallic salts to pure metal. Bismuth nitrate is the active flux in the metal salts—a combination of bismuth nitrate, zinc and lead acetate, alumina, and coloring salts such as chrome alum (yellows), cobalt sulphate, nickel nitrate, manganese sulphate, iron chloride (browns), gold (red), and platinum (silver).

An ancient method of firing lusters is reduction firing, an alternative to local reduction by means of the carbon in the resin. One part of the carbonate form of metal (copper, silver carbonate instead of salts) is mixed with 3 parts ochre and a binder such as gum tragacanth. An oxidation fire is started until low red heat is reached, at which point reduction is started until kiln temperature reaches 1200°–1300°F (649°–704°C). A less frequent method of luster glazing is to incorporate metal salts plus bismuth into the original glaze formulation and fire to the melting level of the glaze in an oxidation atmosphere. The kiln is cooled until the temperature reaches 1200°–1300°F (649°–704°C) and held at that temperature in a reduction atmosphere for a short time (½ hour).

Figure 5-13
Ronna Neuenschwander, *Ancient Egyptian Secret.* 1978.
Slip cast molds and hand-built earthenware. Low-fire glazes, underglazes,
and lusters. W. 16 in., H. 8 in., D. 10 in.
Collection of Dr. Dennis Schiller.
Photo courtesy of the artist.

Lusters may be introduced in this manner to high-fire as well as low-fire glazes.

Bright red low-fire glazes are achieved by adding either chrome oxide or soluble chromium salts to a high-lead glaze firing at cone 010 to cone 08. For an opaque red, a frit made of cadmium sulphide and selenium forms a red glaze stain to be added to alkali frits.

Crackle, polychroming with overglazes. Frits (remelted, ground-up glaze resembling glass) can be added directly to a glaze to produce crackle lines, called crazing, caused by the expansion of the glaze due to the additional action of the alkalies in the frits. Colored inks or oxides may be rubbed into the cracks, heightening the effect. Enamel lumps, broken glass, or low-melting frits can be placed into depressed areas of a surface and low fired into a transparent, jewel-like surface. Overglaze and enamel-like low-fire glaze may be applied to previously high-fired glazed ware. Overglazed

enamels were much used on the figurines of eighteenth- and nineteenth-century Europe (see Figure 5-14). Painterly application of the glaze produced a polychromed surface that used many brilliant colors in detailed areas.

Salt glazes, distinguished by their speckled and earthy-looking surfaces, are produced by introducing common salt (NaCl) into the chamber of a gas, wood, or oil (not electric) kiln. As the kiln reaches the maturation temperature of the clay, about 5 lbs. to 12 cu. ft. of salt is thrown directly in and vaporizes. The sodium in the salt combines with the silica in the clay to form glassy sodium silicate. Reduction firing turns the red and buff clays into browns and blacks. As with all glazes, a salt glaze reacts to heat in the clay body and darkens without the use of a colorant. Add color to the basic salt glaze by brushing oxides on leather-hard ware before firing: cobalt oxides for blues, irons for browns, and rutiles for ochres. Salt glazes

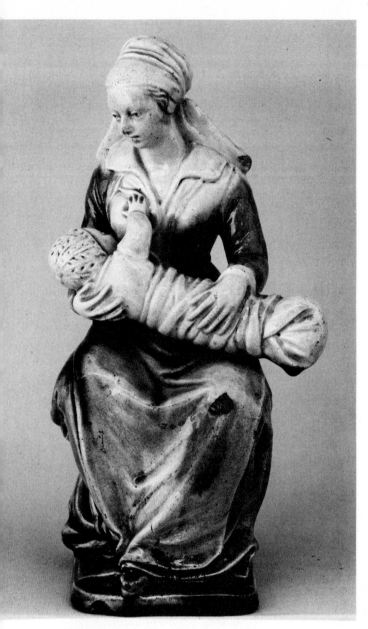

Figure 5-14
Claude Barthelemy, *Nurse and Child*.
French, Avignon, early 17th cent.
Glazed earthenware.
Metropolitan Museum of Art, New York, Gift of J. Pierpont Morgan, 1917.

emit poisonous chlorine gas as the salt vaporizes, and a glasslike coating of silicate forms over the entire interior of the kiln. Salt glazes have a wide range and may be fired from low fire (cone 02) to high fire (cone 12).

Photographic transfers and images can be printed on the ware directly with stamps, rollers, or silk screens. Designs engraved on rollers or stamps are printed on paper using an "ink" of underglaze colors mixed with an oil medium like varnish or linseed oil and thinned with turpentine. The still-moist paper print is then transferred by pressure to the ceramic surface. Using the silk-screen method, photographs may be applied to ceramics directly or by transferring the screened image to paper, and from paper to the ceramic surface. The photographic silk-screen process requires a screen made photographically sensitive through the application of photographic emulsion. A positive transparency of the photo is made incorporating dotted halftones, and projected on the photographically sensitive screen. When light passes through the transparent areas, exposed areas harden and remain fixed while the softer positive or unexposed areas are washed away. In the case of ceramics, underglazes mixed with an oil medium are then printed through the screen's open mesh areas (see Figure 5-15).

Direct screening on ceramics is limited to printing on flat or slightly curved surfaces, necessitating a decal for most ceramic objects. The decal is printed on a stiff paper with a gelatinous coating which helps adhere it to the ceramic surface. After immersion in water for about 20 seconds, the decal is applied face up to the moistened ware and pressed gently until it slides off the backing paper. After 8 to 12 hours of drying, a preliminary short firing burns away the oil medium before a glaze coat is applied. Some photographic transfers use overglaze enamels on a previously glazed surface, also requiring a low firing (cone 018). One way to use photography without firing is to lift photographic or printed images through an acrylic

Figure 5-15
Photo silk-screening on clay.

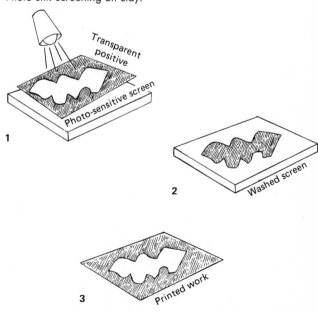

medium. After application, the medium is allowed to dry and the paper removed with water, leaving the image seemingly printed on the surface.

Simulated photographic effects utilize offset printing mat impressions of newsprint or photographs. The mat is pressed directly into the moist clay, after which oxides painted into the relief surface are allowed to settle into the depressed areas to emphasize the image. The effect may be intensified by the application of a glaze.

No-glaze surface enrichment can be achieved simply by applying sealers on the fired surface: thinned lacquers, shellac, clear floor wax (carnuba), or boiled linseed oil. A French polish may be made combining shellac, linseed oil, and beeswax. Incorporating colorants, these can be applied to the surfaces after firing (see Figure 5-16). Color may be added in the form of thinned oil washes (oil pigment cut with turpentine); thinned colored clay slip, producing a stain; or dry pigment dusted over a slightly moist color wash. Acrylic paints will give a hard, strongly colored surface. A clay surface burnished while leather-hard will take a more even high polish than a surface left porous and rough.

To Color-Finish Fired Clay:

1. Rub on sealer with cloth (oil paint may be mixed with shellac, linseed oil, or turpentine), or apply thinned oil stain color washes, or a stain of thinned colored clay slip.

2. While color coat is still damp, dust on dry powdered pigment, powdered clay, talc, or flint. Let dry, or allow the color coat of oil to dry and paint over it with moistened clay slip.

3. Rub slip and/or talc or dry pigment with soft cloth or brushes, allowing the "patina" to enhance the form by emphasizing edges and contours.

It is important that the form of the work be considered when applying color and finishing the surface. Color intensity and evenness, texture, or whether the surface is shiny or matte will influence the total effect of the work. Inappropriate surface treatment will detract from the original forms of the piece.

Figure 5-16
Henry VIII, King of England (1509–47).
Painted terra cotta bust, probably by Pietro Torrigiano.
Metropolitan Museum of Art, New York, Fletcher Fund, 1944.

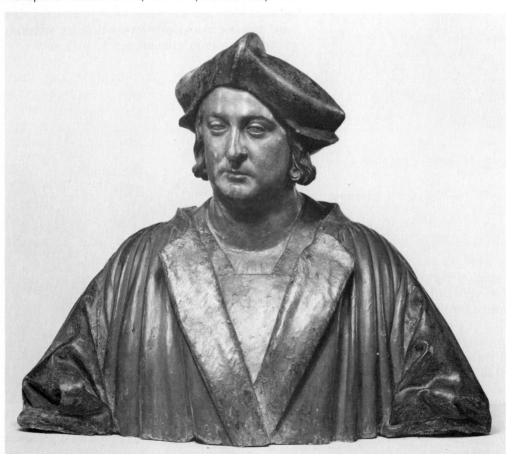

FIRING

Types of Kilns

The bewildering assortment of kiln designs available today are a far cry from the primitive mountainside dugouts that served as kilns for the ancients. Firing lasted for days in these kilns, which could reach stoneware temperatures using wood or charcoal for fuel and with constant attendance (see Figure 5-17). Flat stones were eventually replaced by a more efficient fired-clay lining. *Kiln sitters*, *pyrometers*, and *pyrometric cones* now replace the kiln watcher's personal skill, experience, and at times, guesswork. Clean burning of natural or bottled gas or electricity have eliminated the drudgery of stoking coal or wood-burning fires. Nevertheless, the outcome of heat upon clay and glazes is often unpredictable, even under rather controlled conditions. If firing is to be a result of choice rather than chance for the sculptor of clay, some knowledge of kiln operations is imperative.

Kilns are simply chambers in which heat is produced and held, or is passed through and up a chimney. Modern kilns come in a wide range of shapes and sizes, opening either at the top or the side. Many different designs exist within the gas-burning variety alone, some of the updraft type, others using a downdraft system (see Figure 5-18). Gas kilns are considered more versatile because they allow for the reduction firing that transforms clay into rich, variegated tones. But electric kilns are cleaner, more portable, and easier to control.

Electric kilns conduct heat by currents passing through electric elements, ranging from low-fire *nickel-nichrome* wire (maximum temperature 2000°F) to the high-fire *kanthal* element, firing up to 2300°F (see Figure 5-19). *Globar* and *silicon carbide* elements reach as high as cone 18 and 15,

respectively, but are expensive and fragile, requiring special transformers. These kilns come in front or top-loading styles and require a 220-volt line and a separate fuse and switch box. Automatic temperature controls, usually an automatic

Figure 5-18
Outdoor gas kiln built by Betty Feves. Photo by author.

Figure 5-19
Skutt electric kilns. Photo by author.

Figure 5-17
Ancient kiln.

shut-off known as a *kiln sitter*, are available in larger kilns or may be purchased separately. A switch within the kiln is held open by the insertion of a pyrometric cone chosen to correspond with the desired firing temperature. When the cone starts to bend, it activates a spring, dropping the outside switch to an off position, and shutting off the power. There is no consumption of oxygen during the firing, which eliminates the need for airflow through a chimney. Since no chimney or fuel lines are needed, the electric kiln is convenient to install or construct.

Gas kiln designs display many different locations and distributions of burners in relation to stacks. Sizes and shapes range from straight roofed to arched squares or rectangles, depending on manufacturer, or builder, if the kiln is constructed on the site. High-fire kilns require as much as a 9"-thick insulated lining wall of refractory brick. Fired to 2800°F, refractory brick is superior to the older linings of hard firebricks, whose nonporous composition lost much of their heat by conduction. Hard firebricks are now used exclusively for the kiln's outside facing with the inside of porous, refractory fireclay and fireclay bricks.

In *updraft* gas kilns, flames enter at the front, back, or sides and heat the chamber while passing up the sides and out the top of the kiln through the chimney (see Figure 5-20). Secondary chambers (muffles) protectively wall off the ware from direct flame. The flames travel in tubes or openly between the muffle and the kiln lining.

Downdraft kilns utilize fuel economically with a multiple jet system allowing for more complete circulation of heat in the center of the kiln (see

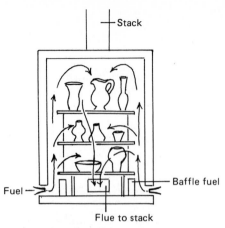

Figure 5-21
Downdraft gas-fired kiln.

Figure 5-21). As in the updraft kiln, flames enter the back, sides, or front, but hit a baffle or bag wall that guides them upward. Hot gases are pulled down around the ware, out through flues in the floor and/or walls at the rear of the kiln, and up through the chimney. The bag wall can be eliminated or reduced if the burners are positioned to move the heat in a circular pattern around the ware. A movable damper controls the rate of gas flow. If direct contact with the flames is not desired (as in oxidation firing), the ware is placed in refractory bins called saggers. In a downdraft kiln the hottest spot is at the top, while in a muffle updraft kiln the opposite is true—the hottest part is in the back and the coolest in the top front section. Gas entering the kiln comes from a "venturi" chamber, a pipe in which gas and air have been previously mixed via an air valve placed in the gas line (see Figure 5-22). The lines should be of 1½" pipe, utilizing ¼ lb. pressure (residences use ½" gas lines, which are insufficient for the volume a kiln needs). The air through the venturi

Figure 5-20
Updraft gas-fired kiln.

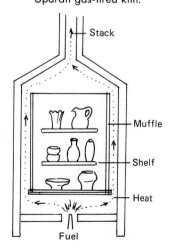

Figure 5-22
Venturi chamber.

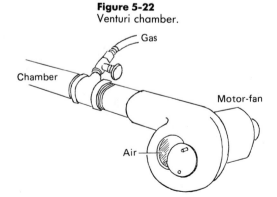

jets, plus secondary air vents situated near the gas and air inlets, also control the kiln atmosphere. For a complete oxidizing firing, all vents and dampers must be open; they must be partly open or closed at times during a reduction firing. Because of the greater number of control systems in the downdraft kilns, they make a more even reduction firing.

Two types of kilns are used for industrial purposes. The *trolley* or *car kiln* consists of a kiln floor and door on wheels, which pull out of the firing chamber on tracks for speedy and easy loading. In *tunnel* kilns, ware is moved through a large firing chamber on fireproof trolleys, exposed first to rising, then to falling temperatures.

Solid fuels like wood or coal require periodic raking to keep fuel in the burning chamber and allow the ashes to fall in a pit below the floor. Medium-size wood-burning kilns require about 2 cords of wood for a high firing, but will reach stoneware temperatures (cone 10) in about 12 to 15 hours. They produce beautiful surfaces (as evidenced by the outstanding works of the past) and are economical, but require constant attendance throughout a firing. Bottled gas is expensive and the storage tanks need protection to keep the gas from freezing. A somewhat more complex setup is necessary for oil-burning kilns; storage tanks must be set up and connections to the kiln must stay clean or pump and lines may clog. Oil-burning kilns also require electrically driven blowers.

Kiln Temperatures

Pyrometric cones start at cone 022 and end at 42; from a low temperature of 1100°F (605°C) to a high of 3659°F (2015°C). The total range may be divided into 4 stages or series: low fire, intermediate, medium high, and refractory. The *low stage* (022–011) is primarily used for firing overglazes, lusters, enamels, and raku (about 018—1341°F or 727°C), with the kiln a dull red. The kiln color changes to cherry red at cone 014 (1530°F) and to orange at cone 010 (1680°F). From 010 to 01 (2090°F), soft pottery such as flowerpots, brick, and roof tiles, etc., of earthenware and shale clay, are fired. Cone 05–03 is a maximum heat limit for electric kilns with nichrome elements.

Medium- to high-fired ware ranges from cones 1 through 10 or 2120°F–2380°F, (1160°C–1305°C), fired when the color reaches bright yellow. Of these temperatures, the lower-range cones 1–6 include quarry tiles, facing brick, some stoneware and terra cotta pottery, sculpture, and some dinnerware glazes. Higher-range cones 7–10 include high-fired stoneware, soft porcelain (Belleek), English bone china, and vitreous china. From cone 11–18, 2420°F–2720°F (1330°C–1495°C) the fire is white and includes hard porcelains, spark plugs (cone 16), and Royal Copenhagen porcelain (cone 18, 2720°F). Refractory firebrick and silica are fired at cones 19 and 20. The practical refractory limits of clay are reached at cone 35, with pure alumina firing at cone 42.

Firing Phases

The first phase of firing is the "water smoking" period in which chemical water is driven out of the clay, from 660°F or 350°C. For previously unfired ware, the temperature rise must be very slow. At 940°F (500°C) clay begins to dehydrate, no longer capable of disintegrating in water. At 1060°F (573°C), a critical transformation of the quartz crystals begins with the expansion of silica. Breaking may occur more easily now and again during the period of cooling, when contraction takes place. At 1120°F (600°C), cone 021, the kiln is cherry red and overglaze colors and lusters may be fired. With bisque ware, the firing may be speeded up from this point on, but in a glaze fire, the increase should be gradual. After red heat, a sintering of glazes, or rough caking, begins. Actual melting of glazes begins 4–5 cones below maturation temperatures, moving from a rough to smooth, thick, and sticky surface.

Firing a Gas Kiln

1. Clean kiln of particles from the last firing.
2. Apply kiln wash, consisting of equal parts flint and kaolin. Mix to a cream consistency and apply to kiln shelves and floor. Avoid walls and roof, as kiln wash flakes off and may drop into ware.
3. Stack kiln carefully, placing shelf supports on stress points to avoid warping shelves. Glazed areas should be wiped clean if in contact with shelf surface.
4. Place pyrometric cones on shelves in front of upper and lower peepholes.
5. Close air valve, turn gas until pilot light ignites it. Keep gas on low for the early part of firing.
6. Open the air valve slowly—if too fast, flame will balk up, and both gas and air should be turned off and the process started again.
7. Increase gas and airflow gradually. Flame color should be a transparent blue, not yellow, and should not

burn up into the flue. When gas enters the venturi chamber, pressure pulls the air into the vent, mixing air and gas and resulting in combustion.

8. The firing should be slow for the firing and cooling process, taking at least 8 hours to reach cone 04, longer still for larger kilns. As maturation temperature nears, slow down firing and maintain a constant temperature for ½ hour to soak ware. After cooling begins, keep kiln shut and damper closed, as there is danger of cracking—called *dunting* (cracking of fired ware in a cooling kiln as a result of cooling too rapidly) at this stage. Open kiln at about 400°F (200°C). Cool for as long as heating period—24 hours.

Reduction

The combustion in an oxidizing firing produces carbon dioxide, water, and nitrogen gases which exit from the flue. With air vents shut and damper partially closed, the flames burn yellow, indicating that the gases are not burning completely. Oxygen is reduced and a carbon surplus occurs, resulting in an atmosphere of carbon monoxide gas and free carbon. The free carbon craves oxygen and pulls it from the minerals in the ware's body and glazes, transforming their chemistry and appearance. Bright, clear, obvious colors and tones become muted, variegated, and darkened, although some minerals, like copper, transform into their brilliant complements (from blues in oxidation to copper reds in reduction).

Reduction firing is done in high-fire ware in gas kilns to produce celadon (gray-green) glazes from iron oxides, and sang de boeuf (copper red) from reduction of 1% copper carbonate glazes. Rich, cool brown body colors replace the pale orange or tan produced by the oxidation atmosphere. Reduction should be practiced in gas kilns only, since electric kilns will not reduce without permanently damaging the elements. However, a local reduction may be practiced in electric kilns: add small amounts of silicon carbide to alkaline glazing oxides, producing copper reds from copper oxides.

Open Pit Firing

Firing small sculpture in an open pit is a primitive but exciting low-temperature firing method that results in rather fragile but handsomely reduced ware (see Figure 5-23). Cover the bottom of a pit with 18"–24" of sand, lay the dry sculpture in the sand, and protect it with a cover of steel mesh or

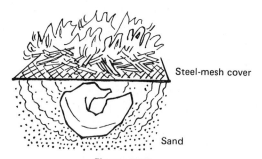

Steel-mesh cover

Sand

Figure 5-23
Open pit firing.

sheet held off the work by bricks or cans. Branches and twigs, straw, or dried cow dung may be piled on top of the cover and ignited. After firing for 2–3 hours, distribute the ashes while keeping the work completely covered with hot ashes, and let cool while covered for 12 hours.

BASIC ENGOBE FORMULAS
(also called VITREOUS SLIPS)

Basic Engobe
(On dry greenware keep 50% clay but substitute calcined clay for 2/3 of the raw clay.)

50% clay	{	10% ball
		40% kaolin or china clay
20% flint		(refractory silica sand prevents shrinkage —keeps color from running)
5% borax		(glassifier)
5% zircopax		(opacifier—intensifies and keeps color distinct)
80%		

Engobe Variations: Leather-hard Surface
(Add oxides over the 100% of the basic formula or ilmenite or metal filings for dark specks.)

To 80% basic formula add:

High fire cones 4–10	20% feldspar or cornwall stone
Intermediate cones 1–4	15% nepheline syenite
	5% talc
Low fire cones 04–1	15% leadless frit
	5% talc

Engobe Variations: on Bisque Surfaces
(For applying to bisque ware, small amounts of binder may be mixed with the engobe. These may be acrylic, a glycerine, or a gum tragacanth. A transparent glaze may also be used. It is best to burn off the carbons in the binders at a red heat before firing or adding a glaze over the engobe.)

Add oxides over the 100% of the basic formula.

High fire
(Cut clay to 40%—
as on formula
above, substitute
calcined clay for
2/3 of the total
40% clay.)

	40% clay	{	10% ball
			15% raw clay
			15% kaolin

Add 35% feldspar
15% nepheline syenite
5% borax
5% zircopax

Intermediate fire
(Cut clay to 40%
as above.)

40% clay
Add 20% nepheline syenite
15% talc
15% frit
5% borax
5% zircopax

Low fire
(Cut clay to 40%
as above.)

40% clay
Add 30% frit (leadless)
20% talc
5% borax
5% zircopax

GLAZE FORMULAS

A sampling of low-keyed glazes (for bringing out clay earthtones):

Betty Feves' Glaze Formula—cone 9 reduction

Locust or other wood ash		35%	
Kingman feldspar		35%	
China clay		15%	
Talc		15%	
Local red clay	30%		20%–40%
Volcanic ash	30% or feldspar		40%–20%
Wood ash	30%		30%–40%

Ingredients of above may be varied.

A Basic Low-fire Ash Glaze (04)

Volcanic ash	60%
Borax, lead combination	40%

Glossy Transparent (cones 4, 5, 6)

50% of any feldspar
50% colemanite (calcium borate)

Warm Buff Mat—Opaque (cone 9 reduction)

Kaolin	24%
Flint	8%
Nepheline syenite	21%
Whiting	17%
Talc	4%
Kingman spar	21%
Rutile	5%
	100%

Pumpkin Orange (cone 9–10 reduction)

Subtle, medium warm brown

Kingman	56.1%
Nepheline syenite	15.4%
Whiting	10%
Kaolin	8.6%
Barium carbonate	6.6%
Rutile	7%
Iron	5%
	108.7%

Glossy Semitransparent (cones 9–10 oxidized)

Will reveal oxides beneath

Kaolin	10%
Whiting	20%
Flint	30%
Kingman	20%
Nepheline syenite	20%
	100%

OXIDE CHART

Oxide	Color	Kiln Atmosphere	Kiln Temperature	Percentage
Cobalt carbonate	Blues	Reduction or oxidation	Any	¼% (light) to 1% (strong blue)
Copper carbonate	Copper red (sang de boeuf or oxblood)	Reduction	Any	½%–1%
	Blue-green (with alkaline flux)	Oxidation	Any	3%–5%
	Intense blue-green (with 30% barium)	Either	High (below cone 8)	2%
	Greens	Oxidation	Any	1%–5%
Chrome oxide	Browns (high zinc)	Either	Low	2%–5%
	Greens (zinc-free, low lead)	Either	Any	½%–3%
	Pinks (with tin)	Oxidation	Any	5%
Iron oxide	Celadon greens	Reduction	Any	1%–4%
	Reds (high silica, potassium, calcium)	Oxidation	Low	2%–5%
	Tans	Either	Any	2%
Nickel	Blue (with zinc)	Oxidation	Low	1%
	Greens	Oxidation	Low	3%–5%
	Brown (with zinc)	Either	Any	2%–4%
	Gray	Either	Any	0%–1%
Manganese	Black (with 1%–2% cobalt)	Either	Any	2%–4%
	Purples (alkaline flux)	Oxidation	Any	3%–5%
	Browns	Reduction	Any	4%
	Tans	Either	Any	2%
Rutile (impure titanium oxide)	Browns	Reduction	Any	5%
	Tans	Either	Any	2%
Antimony yellow (in high-lead glazes)	Yellow	Either	Low	3%–5%
Vanadium stain (fritted with tin)	Yellow	Either	Any	4%–6%

**TEMPERATURE EQUIVALENTS
ORTON STANDARD PYROMETRIC CONES[a]**

Cone Number	Large Cones		Small Cones		Seger Cones (used in Europe) Degrees C
	150°C[b]	270°F[b]	300°C[b]	540°F[b]	
020	635	1175	666	1231	670
019	683	1261	723	1333	690
018	717	1323	752	1386	710
017	747	1377	784	1443	730
016	792	1458	825	1517	750
015	804	1479	843	1549	790
014	838	1540			815
013	852	1566			835
012	884	1623			855
011	894	1641			880
010	894	1641	919	1686	900
09	923	1693	955	1751	920
08	955	1751	983	1801	940
07	984	1803	1008	1846	960
06	999	1830	1023	1873	980
05	1046	1915	1062	1944	1000
04	1060	1940	1098	2008	1020
03	1101	2014	1131	2068	1040
02	1120	2048	1148	2098	1060
01	1137	2079	1178	2152	1080
1	1154	2109	1179	2154	1100
2	1162	2124	1179	2154	1120
3	1168	2134	1196	2185	1140
4	1186	2167	1209	2208	1160
5	1196	2185	1221	2230	1180
6	1222	2232	1255	2291	1200
7	1240	2264	1264	2307	1230
8	1263	2305	1300	2372	1250
9	1280	2336	1317	2403	1280
10	1305	2381	1330	2426	1300
11	1315	2399	1336	2437	1320
12	1326	2419	1335	2471	1350
13	1346	2455			1380
14	1366	2491			1410
15	1431	2608			1430

Flower pots 1580°–1850°F (014–011)

Common brick 1600°–1800°F (010–06)

Drain tile 1700°–1900°F

Terra cotta 2070°–2320°F (03–8)

Stoneware 2300°F up

Firebrick—Clay 2300°–2500°F

Refractories 2300°–3992°F

Fireclay—Face brick 2100°–2300°F (9–15)

[a]From the Edward Orton, Jr., Ceramic Foundation, Columbus 1, Ohio.
[b]Temperature rise per hour.

CONVERSION FORMULA

Centigrade to Fahrenheit

Example: $100°C \times \dfrac{9}{5} = 180 \quad 180 + 32 = 212°F$

Fahrenheit to Centigrade

Example: $212°F - 32 = 180 \quad 180 \times \dfrac{5}{9} = 100°C$

6

Modeling from Life in Clay: The Figure and Portrait Study

THE FIGURATIVE TRADITION

In the myriad guises of god, goddess, hero, saint, or demon, the human figure has been the preeminent subject in most of the world's sculpture. Where representation of the figure has been thought blasphemous, as in Moslem culture or during the eighth-century Christian enforcement of the *Iconoclastic Edict*, sculpture has been replaced by highly developed decorative arts: metalsmithing, ceramics, ivory and woodcarving, etc. Only when the unadorned human form becomes the subject itself, overriding religious and political associations, does the study of its expressive potential become a major pursuit. In Western culture this phenomenon first occurred among the Greeks, who completely transformed the primarily rigid, hieratic styles of the Mesopotamians and Egyptians, envisioning their gods as men with ideal proportions and elevated expressions of pathos and ecstasy.

The ideal physical type made its first appearance in the mid-fifth century B.C. in the form of the marble *Doryphorus* (Spearbearer) (see Figure 6-1). Carved by Polycleitus about 450–440 B.C.,

known to us through Roman copies and descriptions by the author Pliny, the *Doryphorus* was for centuries considered to represent the prototype of perfect proportions (eight heads to the figure), after the lost book on proportion attributed to Polycleitus. The *Doryphorus'* stance, its graceful and relaxed gesture, was another radical departure. In contrast to its upright, "arrested," symmetrical predecessors, which still suggested the block from which they were carved, the *Doryphorus* has been totally freed from the block and stands contrapposto (counterpoised), balancing the weight on one hip and leg—a pose that subtly changed the relationships of body parts and animated the inner forms as never before.

The *Dying Niobid*, carved about the same mid-fifth-century period, was also innovative in its unusually expressive treatment of the female body. The first known completely nude image of *Aphrodite* was by Praxiteles (330 B.C.). Unfortunately, Roman copies of sculpture often are all we know of the Greek originals. Most Roman sculpture was, in fact, replication of the Greek with the exception of portraiture and architectural relief.

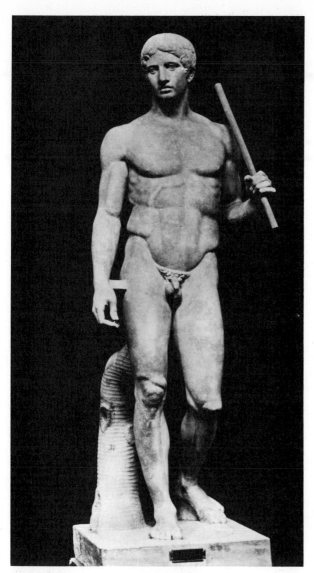

Figure 6-1
Polykleitus, *Doryphorus*. 450–440 B.C.
Marble copy after Greek original.
Naples National Museum. Bildarchiv Foto Marburg,
W. Germany.

Classical sculpture had not yet been destroyed during the early centuries of the Byzantine period, but the art of that time, rooted in the symbolism of the early Christian church and the traditions of the Middle East, served to schematize the human figure, dematerializing the body and evoking the spirit. Mosaic and stained glass, by their intrinsic richness and semitransparent nature, conveyed this new spiritual conception.

Architectural stone carvings of the human figure decorated the facades of the great cathedrals (Chartres, Reims, Lincoln, etc.) from the thirteenth to the fifteenth century A.D. Carved for the most part by stonemasons, they may have directly influenced early Renaissance work such as Don-atello's carving of St. George (1415–17). The classical and Renaissance idea of achieving a unity rather than a separation of body and soul reached its highest expression in Michelangelo's *David*. Both Michelangelo and Cellini merged the reawakened classic tradition with church iconography by representing Christ nude for the first time. (The portrayal of Christ with a loincloth had been allowed only since the twelfth century.)

The first century author Vitruvius described the Greek system of architectural proportions as based on the human body as a geometric configuration. Translations of Vitruvius in the sixteenth century inspired many Renaissance drawings of "Vitruvian man" graphically demonstrating that the body with arms or legs extended formed geometric configurations, a scientific basis of art pursued by Italian Renaissance artists like Vasari and da Vinci. Dürer later modified the classical ideal, concluding that ideal proportions could not be arrived at mathematically but were relative to one's interpretation of beauty. Indeed, the nude was less frequently used as a subject in northern climates, the classical ideals of the Italian Renaissance never taking strong hold in the North or displacing its native tradition of Gothic expressiveness, which continued even to the twentieth century in the sculpture of Barlach, Lehmbruck, and Marcks.

The nude tradition also never established itself in Oriental art, though Greek influence did make its way east to northern India during the first to the fourth century A.D., appearing in the form of the Apollonian Buddha and a variety of spirits and goddesses. Ivory cult statuettes from first century India found in the ruins of Pompeii prove the early interconnection between Classical and Indian culture. In the elaborate carvings decorating the walls of Brahmanic temples of Northern India during the tenth and eleventh century, the nude form, though often extremely sensual, was highly stylized. Intertwined with symbolic objects and shapes, it was part of a formalized system for transmitting religious ideals.

After the Renaissance, the nude became firmly established in sculpture, resulting in an outpouring of allegorical works from the studios of such Mannerist and Baroque sculptors as da Bologna and Bernini (late sixteenth and seventeenth century). During the late eighteenth century, Houdon and Canova reflected a Neoclassical return to "pure" classical form—a sterile, empty repetition of pseudogods and goddesses, fortunately put to an end by the emergence of the Romantic movement. Auguste Rodin's dynamic sculpture brought vitality back into what had evolved into an empty

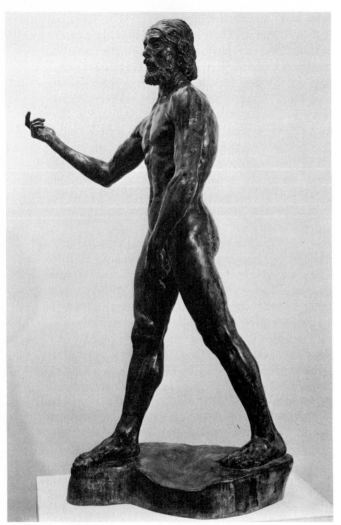

Figure 6-2
Auguste Rodin, *St. John the Baptist Preaching*. 1878–80.
Bronze, 66¾ in.
Collection Museum of Modern Art, New York. Mrs. Simon
Guggenheim Fund.

modeling, Rodin's romantic style became an anachronism amid the monumental changes of the early twentieth century, but was to regain popularity later in the century.

Rodin's students, the influential sculptors Maillol, Mestrovic, and Bourdelle, contemporized the heroic nude; Despiau refined the portrait head. Twentieth-century figure sculptors such as Marcks, Lehmbruck, Lachaise, and Epstein developed their own forceful styles using particularly expressive distortion (see Figure 6-3). The nude took on a biomorphic surrealistic context in the hands of Arp and Moore, was reduced to its purest form by Brancusi, and was fragmented, flattened, and rearranged by Cubist and Constructivist sculptors Archipenko, Pevsner, and Lipchitz. Carl Milles, Marino Marini, and Giacomo Manzu each developed stylisms that looked to the classic and archaic traditions for their inspiration.

Starting in the 1960s, sculptors began casting directly from the live model. These new realists

Figure 6-3
Gerhard Marcks, *Girl with Braids*. 1950.
Bronze, 45½ in.
Collection, Portland Art Museum, Portland, Ore.
Helen Thurston Ayer Fund.

craft (see Figure 6-2). One of the supreme Expressionists of his time, Rodin projected a sense of torment, mortality, and psychological complexity in his figures and portraits. The imprint left in the clay of his fluid, active modeling gave the work a continued sense of being in the "making." He often left rough masses deliberately unfinished or simply suggested, dramatizing the finished forms and pointing up their elemental, earthbound origins. The quality of fluid clay was transferred to stone mechanically by Rodin's apprentices (Rodin is said never to have carved), often producing forms inimical to the hard stone. (Arbitrarily transferring forms originally modeled in a soft material to a glyptic or hard material is a method regarded by the contemporary sculptor as lacking in commitment and meaning.) Though admired for its

colored plaster modeled over individual human skulls, using embedded seashells for eyes. Though not as realistic, the relatively contemporary skulls created in the Sepik River region of New Guinea are also thought to have been used for funerary purposes. Extreme stylizations characterize the cult images and masks of most so-called "primitive" peoples, with the exception of the twelfth-century portraits of the Ife tribe of Nigeria. These subtle, masterful works are so animated and realistic that they appear to be modeled directly from life (see Figure 6-5).

Mesopotamian and Egyptian portraiture was, for the most part, grand and formal. The intractable basalt, diorite, and obsidian chosen for these images was worked with extraordinary skill and often very realistic effect. When the softer materials of wood, chalk, and sandstone were used, the forms mellowed and the portraits tended to become more individualized. Attempts to attain convincing realism may be seen in the effect of the rich paint applied directly over the hard stone, or (in the case of wood and soft stone) over a coating of gesso or fine plaster. Eyes were animated by paint, quartz, or glass set in bronze rims; it is

Figure 6-4
Cesar (Baldaccini), *La Victoire de Villetaneuse.* 1955.
Bronze.
Courtesy Art Gallery of Ontario, Toronto. Gift of Sam and Ayala Zacks, 1970.

Figure 6-5
Head of Queen Mother (Iyobu). Benin, S. Nigeria, 12–13 cent.
Bronze.
Courtesy British Museum, London.

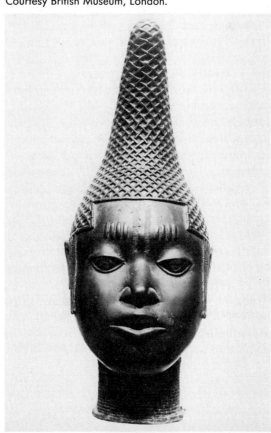

employ a variety of surface treatments, ranging from George Segal's white untouched plaster to Duane Hanson's elaborately painted and clothed cast resin figures. Nudity, in these compositions, is presented as a statement of our human condition, rather than an ideal of beauty (see Figure 6-4). As sculptor Reg Butler has stated, " . . . The whole idea of man as being the center of the universe and, therefore, as man being a fitting subject for a godlike sculpture I think is something that no longer exists—at least not in my world."[1]

THE PORTRAIT

For over 9000 years, the characterization of a particular person as a mask, effigy, bust, or full-length figure performed an important function in public worship and private memorial.

The earliest forms of portraiture, found in Jericho and dating from the Neolithic period (7000 B.C.), were actually reconstructions of heads with

hypothesized that real hair and clothes may have been added. We also know that the first plaster death masks dated from the sixth dynasty (2270 B.C.). During the reign of Akhenaton (approximately 1360 B.C.), concepts of monotheism were introduced, bringing all the gods under the single god, Aten. A new humanism permeated the dynastic art of the time, softening the austerity of the regal portraits.

The portraits of Greek sculptors were a radical departure from the Egyptian. The Greeks chose for their portraits humans whose power was that of the mind and spirit rather than position, conveying to us the character of their great philosophers and writers—Homer, Socrates, Sophocles, and Demosthenes. Idealized and expressive (if lacking distinct individualism), Greek portraits reflected the highest aspirations of that new human-centered society.

As religion declined during the late fourth to first century B.C., individual Hellenistic portraits became more intensely personal and expressive, while, conversely, images of the traditional gods were formularized into lifeless stereotypes. Dating from the fourth-century portrait coins of Alexander the Great, the portrait became the renewed vehicle for the divine ruler concept, later realized in the Roman sculptures of Augustus and the emperors to follow.

Roman marble portrait heads served more as visible records of ancestors than as aesthetic objects; they may have been made from war death masks which acted as effigies in ceremonies and family shrines. Early Etruscan art (seventh to sixth century B.C.) centered on its funerary effigies and tomb figures resting on their sarcophagi. During the third century B.C. the Etruscans excelled in metal work and bronze portraits thought to have been influenced by the Greeks.

Through the years of the early church, sculpture was scaled down to miniature reliefs in ivory, employing such symbols as the peacock (symbolizing the soul), the vine (the church), and the phoenix (the resurrection). When the Church of St. Sophia was built in the sixth century, mosaics rather than sculptural reliefs made use of the human figure, and even these were plastered over in the eighth century due to the Iconoclastic Edict of Emperor Leo Isaurian. (The plaster, ironically, helped preserve the mosaics.)

Effigy sculpture revived most forcefully during the fourteenth century. Thirteenth-century effigies were merely engraved stone and bronze slabs that were later elaborated into portraits in the round. The bronze effigies may have been patterns made from the wood carvings carried or wheeled in funeral processions. The Black Death caused a preoccupation with mortality, reflected in the morbid sculpture of that period. Effigies were made surrounded by figures of death and weeping figures, or accompanied by a second effigy of a rotting corpse.

In England it was the fashion for many people to have themselves immortalized by tomb effigies of gilded bronze, sandstone, alabaster, marble, and wood (mainly oak) with a gesso overlay. As the work of the "imagère" or "image maker" became more valued, skilled Italian sculptors migrated to England and France to fulfill commissions by wealthy merchants and noblemen (see Figure 6-6). During the Renaissance a new realism emerged, celebrating the rising power of the individual. The subject of Verrocchio's bronze *Colleoni* (1483–88), like Donatello's earlier *Gattemelata* (1445–50), was a Venetian army commander. The works of these two sculptors ushered in the new age of the powerful noble banking families, the Sforzas and Medicis, who now shared with the church the patronage of the arts. The Renaissance portrait reached its highest expression in Michelangelo's idealized Brutus, David, Moses, and Christ.

The Baroque period marked an increase in every kind of portraiture, full figure, bust, and head. Bernini highlighted the eye by leaving small points of marble in the iris, or cutting into the iris for deep color, a departure from the straightforward sculptural treatment of the past. During the eighteenth century, Houdon, best known for his delicate portraits of children, rivaled Canova (1757–1822) in Neoclassical renditions of noblemen and women. Canova's portrait of Pauline Borghese was idealized and impersonal, reducing the shock effect of its seminudity. Canova's full-size plaster models were translated into carvings by assistants, a procedure necessitated by his immense number of commissions. After assuming prominence in the eighteenth century, this procedure, with further refinement, became accepted nineteenth-century practice.

Rodin's great portraits of Balzac, Victor Hugo, and Clemenceau reveal a new spontaneity and search for the inner personality of the subject. After Rodin the naturalistic portrait became an academic exercise, but despite the demise of the large, commemorative portrait, the works of Despiau, Epstein, and Manzu reaffirm the intimate, expressive rendition of the individual (see Figure 6-7).

Figure 6-6
Desiderio da Settignano, *Portrait of a Lady* (Marietta Strozzi). 1428–1464.
Marble, 22⅜ × 20⅜ × 9⅝ in.
Photo courtesy National Gallery, Washington, D.C. Widener Collection.

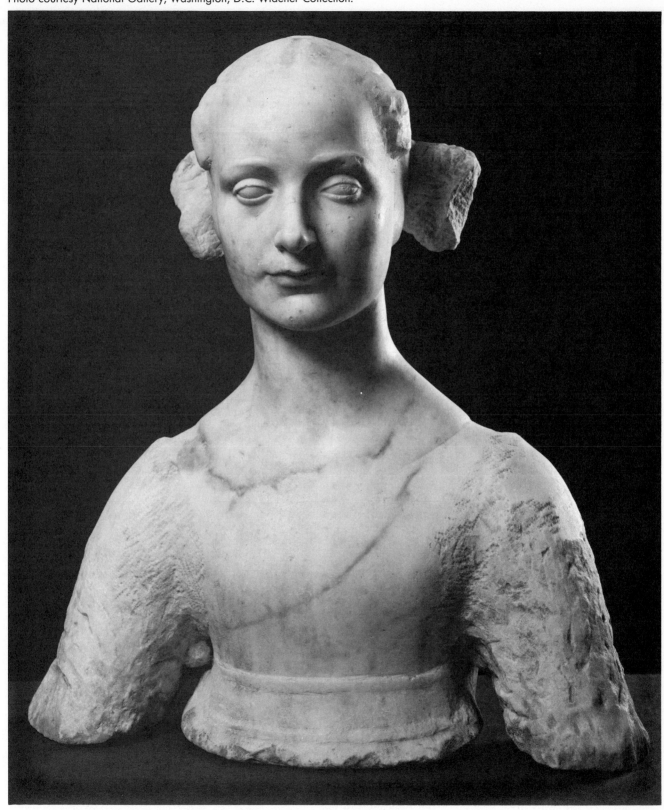

Figure 6-7
Charles Despiau, *Buste de Mme. Yannick (La Suissesse)*.
1943.
Bronze, 19 × 16½ × 10¾ in.
Art Gallery of Ontario, Toronto. Gift of Sam and Ayala
Zacks, 1970.

THE PORTRAIT HEAD

Drawing as a First Step— The Basic Ovoid

The human head is more readily available for constant viewing than any other part of the body, explaining in part why artists usually do several self-portraits in the course of their careers. With its proportions, expressions, planal structure, and anatomy, the head capsulizes many basic sculptural problems (see Figure 6-8).

If working independently, choose as a subject for your portrait study someone you are familiar with and whose head possesses interesting or distinctive qualities. Make a series of small, quick line drawings of the changing character of the head from full face, profile, and silhouette (see Figure 6-9). These will not necessarily be working drawings, which may involve another diagrammatic set with measurements, but they are a valuable introduction to the head's unique forms and gestures.

The first portrait studies attempted should be slightly over lifesize and in a vertical position. This limitation in size and position will enable

you to grasp basic proportions and relationships without the problems of distortion and foreshortening introduced by a tilted axis or scaling up or down in measurement. Determine the tendency of the head shape—oval, square, or elongated—and develop a general idea of the proportions within the ovoid. Particularly at the start, ignore the specific features and surface forms and work with a vision of the whole shape and silhouettes composing it. If the head's basic design is established from the start, you can avoid slavish dependence on the model and have much more freedom to develop your interpretation.

Figure 6-8
Fred Littman, *Portrait of Ann Ramos*. 1973.
Wax intended for bronze. H. 17¼ in.
Collection of the artist's estate. Photo by Fred
Littman.

Figure 6-9
Head—4 views.

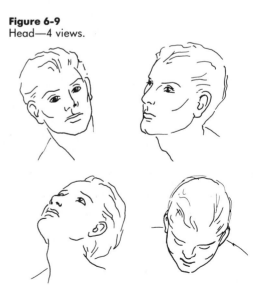

The Armature

Most armatures function as an internal support carrying the load of clay, cement, plaster, etc., and often become a permanent part of the structure. In this description, the armature will support works in clay from which a mold will be made, freeing the armature for reuse once the original clay is removed. The requisites are strength, because casting puts severe strains upon the clay, and flexibility that allows for initial changes of position.

An armature for a life-size head can be made from a ½″ to ¾″ galvanized pipe, 10″ to 12″, screwed to a steel flange. The flange is anchored to a 14″ square, ¾″ wood base mounted on cleats to allow air circulation underneath and facilitate lifting. Either thread the upper end of the pipe and attach a tee joint into which wires are inserted, or fasten a cage of heavy galvanized wire directly to the upright without the tee joint. A portion of the wire cage can be inserted inside the pipe, with the cage wires on the outside attached securely to the pipe with binding wire. Wood wedges pushed between the wires and the pipe will help keep the wires taut, but use of the tee guarantees a stronger joint. Small pieces of wood ½″ wide and 2½″ long wired together in the form of a cross are suspended from the cage at different levels. Called *butterflies*, they support the clay and prevent cracking (see Figure 6-10). A simpler armature which omits the cage is a pipe with holes drilled in it from which two butterflies are hung, the one in front closer to the pipe than the one in the rear. Wood armatures may be made of 1½″ squared wood vertical 12″ to 18″ in height attached to a baseboard by a mortise-tenon joint, angle irons, or wood blocks (see Figure 6-11). Butterflies or a wire cage can be nailed or screwed to the wood. Make the armature rust- and warpage-resistant with two coats of shellac. A

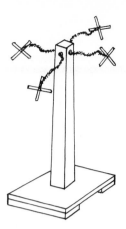

Figure 6-11
Wood armature.

cageless armature of wood or metal is the best if the work is to be removed from the armature for firing.

Building the Basic Ovoid

The basic clay ovoid should be constructed without the model, since the urge is to put in the features and expressions before the solid form has been established. Start the core by packing a 4″- to 5″-high base of firm clay over the armature, taking care that the butterflies are distributed near the mass they must support. Use a paddle or block to compact the clay and let it firm up, while preparing a stack of kneaded clay coils, rolling them first in the hands before pressing them over the roughened clay core. The armature should be kept well in the center of the column so there is freedom to cut into the front of the neck (see Figure 6-12). Now start a general silhouete of the profile, face, head, and neck, keeping the clay rolls tightly controlled in application.

At this point you can employ a system of measurements to establish proportions and relationships of parts. The method described below should allow for freedom of interpretation, with the aim of achieving an expressive work, not a mechanical likeness.

Basic measurements can be taken with simple calipers made of two pieces of contoured wood or heavy cardboard held together with a rivet or screw and nut. Proportional calipers are not necessary, though these are helpful when enlarging or reducing. Describe the placement of the features by drawing a vertical line and use the base of the line for situating one point of the caliper. With the other leg of the caliper, draw arcs intersecting

Figure 6-10
(a) Wire armature with attached wood butterflies.
(b) Butterfly cage with elbow armature.

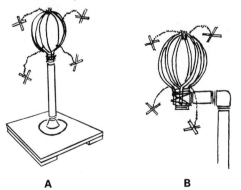

A **B**

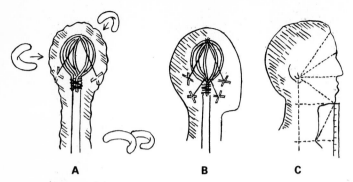

Figure 6-12
Building over armature.

the vertical representing the distances between the main features. Measurements can be recorded on full face and profile diagrammatic drawings of the head for later reference, and may be indicated on the clay by adding bits of clay, cutting, or drawing. Matchsticks pushed into the clay make clear indicators but should never be used for work to be fired as they may cause air holes.

Profile Measurements (see also Figure 6-13)

1. Locate the base of the neck—the suprasternal notch at the top of the sternum (the bony projection where the cervical vertebrae meet the collarbone). Even if the neck is later shortened, this is a stable point from which to make initial measurements.

2. Measure distances from the suprasternal notch to the chin, and the projection of the chin from the neck.

3. Measure distances from the chin projection to a vertical drop (use a plumb line or right angle) from the lower notch of the ear. The notch may also be located by measuring back from the suprasternal notch to a vertical drop from the ear—a good way of confirming the first measurement. Located just above the lobe, the notch is the lowest point of entry to the concha, the shell which leads into the ear canal.

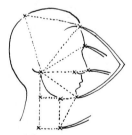

Figure 6-13
Profile measurements.

Frontal Measurements

4. Having established the relation of the ear notch (the distance back and the height on the side of the head)

to the chin and sternum, take the horizontal width between the ear notches. Check for uniform level of the two ears, which are not always symmetrically located. From front and back, observe how the ears attach to the head and do not lie flat against the skull but angle out about 15°–20°.

5. From the front, measure the vertical distances from the chin to the center of the hairline and to the point of the nose. These distances can be rechecked by measuring from the ear notch to the hairline, nose, and chin, as described below. The measurement from chin to eyebrow may be taken by drawing an arc for the brows and measuring from the center and outer extremeties of the brows to the chin (see Figure 6-14). Later measurements may be taken from the chin to the corners of the mouth and wings of the nose.

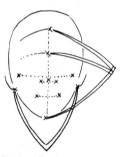

Figure 6-14
Measuring arc from chin.

Profile

6. Take the measurement from ear notches to hairline, describing the two arcs which intercept for the center of the head.

7. Measure from the tip of the nose to each ear and line up the base of the nose in relation to the notch of the ear using a straight edge held horizontally at arm's length. Since the tip of the nose is the center of the face, check the two profiles to get the nose centrally located.

8. Measure from ear notch to chin extremity, rechecking the distance from chin to nose taken from the front.

9. Less essential but useful measurements can include the width from ear tip to tip, the width of the cheekbones, jawbones, mouth, and nostrils.

General Rules of Proportion

1. For an adult, make a center line of the face by drawing through the inner corner of the eye, just below the top of the ear. The line falls halfway between lines drawn under the chin and across the top of the head. In the head of a child or old person the eyes are located below the halfway point. As Dürer noted in his drawings, facial proportions vary a good deal from this general rule (see Figure 6-15).

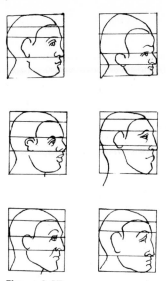

Figure 6-15
Facial proportions after Dürer.

2. The distance from the ear to the point of the nose is equal to that from the chin to the eyebrow. It is also approximately the same width as the distance between the ears.

3. The direction of the ear is generally parallel to the direction of the nose, while the top and bottom of the ear line up with the high point of the eyebrow and the nostrils.

Setting Up the Model

1. Adjust the heights so model and work are at the same level. Consider the lighting, described below.

2. Both model and sculpture should be turned regularly. A three-dimensional form is the sum of infinite silhouettes, and even the slightest change of position will reveal nuances in form.

3. While working out the form, it might help to make a small clay model of the head. By turning the small head in the hands, one can grasp the entire form and the gesture more readily, particularly if the head is turned or tilted.

Lighting. Lighting should be checked constantly, particularly toward completion, as changing conditions may cause confusion in deciphering form.

1. The model and sculpture should be lit from the same direction with a general light above, supplemented by a light from the side.

2. Experiment with the effects of changing light conditions on your work, evaluating your forms in this way.

3. Side lighting used alone dramatizes forms, but fails to show up subtleties. Light thrown directly on the work from the front destroys shadows and tends to flatten the form.

4. Light thrown directly from above, a single dramatic spotlight, or the light of a candle will show up inconsistencies in modeling such as lack of symmetry, etc.

5. Placing the work against a side light that casts a shadow lets you check the silhouette from profile and three-quarter views.

6. Deep undercuts produce strong darks, convex forms lights, and slight concaves form grays. In other words, a tonal range or palette is produced by the fluctuations of light sources. A concave, for instance, may be transformed into a convex if the light is directed solely from below, and vice versa. Work should be finally judged under normal lighting conditions similar to the working light. Avoid isolated darks which rivet the eye to one spot, taking care to balance them by other dark accents which carry the eye around the work.

Developing Bone and Muscle Structure
(see also Figure 6-16)

1. While observing the model, hollow out the orbits for the eyes. Follow this by adding clay to the ovoid and building up the cheekbone, nose, upper and lower jaws, the corners of the mouth, and the triangular neck muscles (the sterno-mastoid muscles) which pull from behind the ears to the sternum. The head shape and projection of the ears can be indicated at this time.

2. Place the eyes in as spheres that move in their orbits, the lids laid on the spheres like shutters which open and close. Check the placement of the inner corners of the eyes by measuring between the eyes (usually about the width of one eye) and up from the nostril, so the inner corners will not be too deep, low, or far apart, any of which would throw off other proportions. Outer corners will always be higher than the inner corners. Measuring from the outer corner of

Figure 6-16
Developing structure of the head.

A　　　　　　　　　　**B**

the eye to the ear notch helps determine cheek contour.

3. Maintain symmetry by making a medial line and comparing the sides, covering all but the forms you wish to examine. Use straight edges to line up forms horizontally or vertically. A mirror will immediately show up errors in structure.

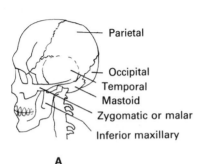

A

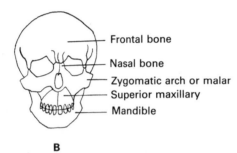

B

Figure 6-17
Skull—(a) Profile; (b) Front view

Figure 6-18
Human skull. Photo by author.

Large Bone and Muscle Formations

Familiarize yourself with the skull if you have not already done so (see Figures 6-17 and 6-18). Notice the large area occupied by the orbits of the eyes and their downward arch from the center of the face. The cheekbone (*zygomatic arch*) sweeps back and over the mandible or lower jaw, while the dome of the skull indents in the temporal region and swells as it moves back and up. The angle of the jaw formed by the *mandible* (*inferior maxillary*) as it turns up to fit into the temporal bone, is more acute in an adult than a child or an old man. The upper jaw (*superior maxillary*) moves under the zygomatic bone, also called the *malar bone*, while connecting above to the nasal and frontal bone. Completing the skull are the *parietal* (dome), *occipital* (back), *temporal* (side) and its *mastoid process* (surrounding the ear).

Bone structure is of primary importance for the sculptor, but the muscle groupings of the head and neck are also a valuable study (see Figure 6-19). The two scalp muscles are joined into one, the *occipito-frontalis* muscle (forehead) which functions to draw the scalp backward (occipital part), elevate the eyebrows, and wrinkle the forehead (frontal). Movements of the eyelid are controlled by an oval muscle, the *orbicularis palpebrarum*, surrounding each eye. The mouth is surrounded similarly by an oval muscle called the *orbicularis oris*, from which radiate the *buccinator* (from the corners of the mouth along the upper and lower jaw bones), the levators of the upper lip and wings of the nose, the zygomatic muscles (attached to zygomatic arch and malar bone) and the *depressor*

Figure 6-19
Muscle sections of the head.

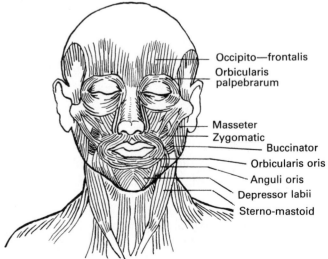

Occipito—frontalis
Orbicularis palpebrarum
Masseter
Zygomatic
Buccinator
Orbicularis oris
Anguli oris
Depressor labii
Sterno-mastoid

labii and *anguli oris* as well as the levator of the lower lip which make up the muscles of the chin. Under the zygomatic muscles, filling out the cheekbones, is the large *masseter* muscle. In the neck, upward and turning movement is produced by the large *sterno-mastoid* muscles. These insert into the mastoid process of the temporal bone and the base of the occipital bone, attaching to the sternum and clavicle.

Defining Planes

The definition of form depends on the clear articulation of the separate surfaces that come together to make the edges within the volume. At these junctions, whether the forms recede or rise up, the particular direction of the plane surfaces themselves determines the formation of the coherent sculptural image from the amorphous lump (see Figure 6-20).

By combining bone and muscle forms, the head becomes a series of planes which make up its front, top, or bottom surface. The head's planal structure may be grouped or broken up with an emphasis on particular planes (curved planes may be dominant in one case, flat planes in another). The *raison d'être* of Cubist sculpture was to experiment freely with planal organization, constantly reversing and reinterpreting planes and edges.

Although it may at first be difficult to distinguish planes in the head's rounded contours, silhouettes offer clues to the planal structure which may be developed. Observe the jaw, the main front plane of the forehead flanked by the two side planes of the temple, the curved planes of the cheekbone meeting the curving planes of the mouth muscles, and the concave and convex central surfaces of the nose, lips, and chin. Drawing cross-contours, as if the face were a topographic map with mountains and valleys, helps in understanding planes, directionality, and the transitions between them. Each form should be analyzed for its planal organization so that the nose, for instance, is planal

in ending, not merely rounded off. The three muscles of the top lip should be sharply described, as well as the raised edge around the lips. Eyelids, ears, and hair should be defined initially by planes, separating the large masses of the hair by planes that become stronger as they recede from the hairline.

Expressive Qualities—Color and Repeats

Strengthen all features by exaggeration, making them slightly larger than lifesize. If color is dramatic, deep undercuts in the hair, eyes, and brows may be used. An awareness of the rhythms and repeats (apparent in some heads more than others) adds greatly to the work's expressive quality. Simplified forms repeated rhythmically characterize the Egyptian portrait, giving it great force. Stylizing and abstracting a portrait becomes a logical approach once forms are fully assimilated and the artist feels free to experiment with many versions of the same head (as was done, for instance, by Picasso and Matisse) (see Figures 6-21–6-27).

THE FIGURE STUDY

The basic design of the pose might better be called the *gesture*. Once you grasp the essentials of the pose, you can construct the armature so that it captures the final gesture even in its linear spareness. Your first studies should be based on clear gestures which are not overly complex in rhythms and directionality. So first analyze the dynamics of a traditional pose and its variations. Remember that the pose may be held for a prolonged time without much difficulty and that it should transmit an expressive quality, imply a continuity of rhythms, and be effective from *all* views. Draw schematically or make small clay sketches observing several sides, familiarizing yourself with proportions and distribution of the main masses and their projections. Simplify and reduce the figure into geometric forms which encounter, encompass, and contain space (see Figure 6-28). As masses thrust into space, their outer edges form the contour or silhouette that gives the volume its particular shape and character, affected also by the interior spaces, or negative forms between and inside the masses.

Distribution of the volumes comprises the balance of the pose, determined at the start by the choice of an equally or unequally balanced figure. A standing figure is balanced equally if weight is

Figure 6-20
Developing planes.

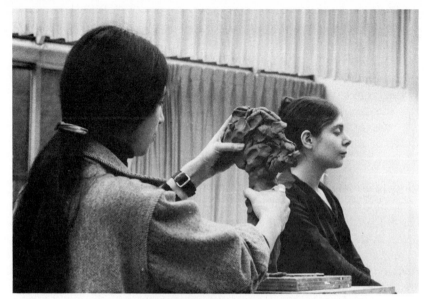

Figure 6-21
Starting a portrait—clay on metal
armature. Lynne Oulman Johnston.
Photo by author.

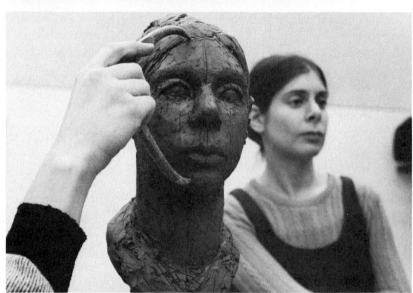

Figure 6-22
Measuring with calipers—drawing
measurements on the surface of the
clay. Photo by author.

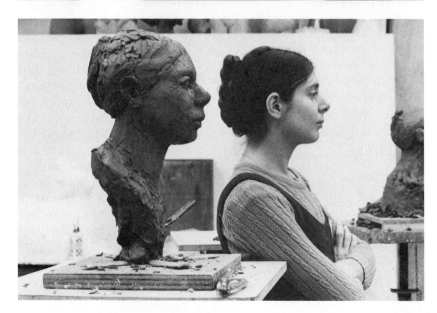

Figure 6-23
Intermediate stage of clay portrait—
side view. Lynne Oulman Johnston.
Photo by author.

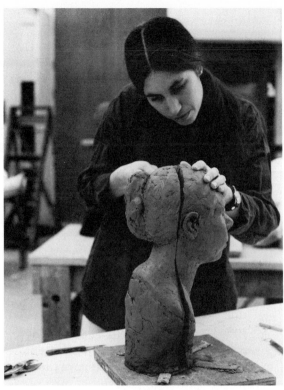

Figure 6-24
Cutting clay down center for hollowing out. Photo by author.

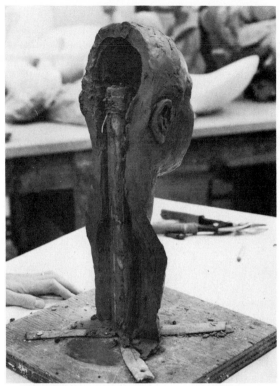

Figure 6-25
Cross section exposing interior armature prior to hollowing. Photo by author.

Figure 6-26
Joining the two halves with soft clay and slip after cutting. Photo by author.

Figure 6-27
Alternate method of hollowing by cutting crown section of head. Photo by author.

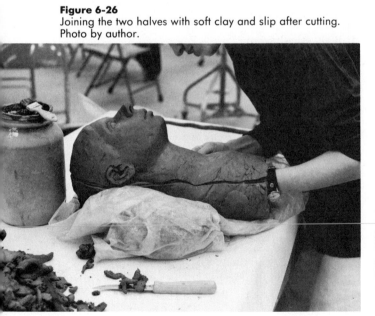

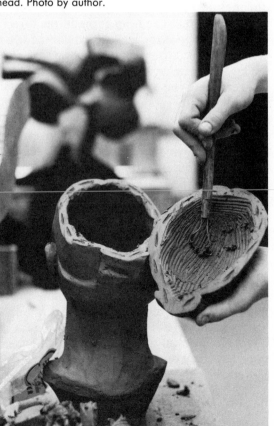

Figure 6-28
The figure as geometric form.

A **B**

Figure 6-29
(a) Contrapposto versus (b) vertical
at-ease posture.

evenly distributed on both legs, the hips remaining level. Unequal balance distributes weight on one leg, resulting in a radical change in the symmetry of torso and shoulders. To keep the balance, the upper part of the body pulls toward the leg bearing the weight, lowering the shoulder on that side and making two opposing lines of direction—hip versus shoulder. The head turns in the direction of the nonsupporting leg, the axis of the eyebrows and eyes contrasting to the line of the shoulders, but on an axis parallel to the hip line. The projections of the hips differ, the ilium pushing forward over the supporting leg, the back over the free leg. The shoulders contrast to the hips in projection, with the lowered shoulder (over the supporting leg) moving back and the raised shoulder over the free leg moving forward.

A variation of the *contrapposto* (meaning "the opposition of parts") pose described above is the vertical "at-ease" position, in which the torso curves toward the free leg in the vertical at-ease posture, as opposed to the contrapposto posture in which the torso curves toward the supporting side. The hip movement is less radical in the vertical at-ease posture, with the pose becoming more contrapposto as the movement in the hip increases (see Figure 6-29).

To best understand the structure of the bones and muscles, carry out the directions of the arms and legs to the extremities of the hands and feet. The gesture of a hand or the stance of a foot will

have an effect on the compositional rhythm of the whole work, serving as counterpoint or accent, as well as increasing the expressive range of the pose.

Proportions

After establishing the basic pose, study the figure's relative measurements, concentrating at first on the general proportions (see also Figure 6-30).

1. Body length from 7½ to 8 heads.
2. Center of figure is at the pubis.
3. The 4-quarter division of the figure length: 2 heads to the base of the fourth rib, or the breast (base of pectoralis major), 2 heads to the pubis, 2 to base of kneecap (patella) and 2 to heelbone (os calcis). The waist is 3 heads from the top.

Figure 6-30
Figure proportions.

Figure 6-31
Golden sections of the figure.

4. The arm is 3 to 3½ heads from the shoulder, reaching (with outstretched fingers) ¾ head down from the pubis, almost ½ way down the thighs. (The forearm and upper arm are the length of 2 hands, including wrists.)

5. The elbow joint (olecranon process of the ulna) is at the waist, 1½ heads down from the shoulder, 1½ heads up from the first joint of the fingers.

6. The width of the hips (pelvic bone at pubis) is 1½ heads wide, wider in the female.

7. The width across the shoulders is 2 heads.

8. A child is one-third of its height at maturity, one-half its height at age 3, two-thirds its height at age 7, and three-fourths of its height at age 10. Its body at age 1 is 4 heads high, 6 times at age 9, and 7 times in adolescence. A child's limbs are shorter, with the middle of the body lower than the pubis (at 21 it is at the pubis). The child's head has a small face and a large cranium. The female skull is somewhat smaller than the male. As compared to the male, the female has narrower shoulders, shorter arms, longer torso, shorter legs and smaller waist.

Proportions of the body have been mathematically divided into *golden sections* after the classic canons described by Vitruvius and rediscovered in 1415. A golden section is the division of any length into two unequal segments so that the ratio of the lesser to the greater is equal to the ratio of the greater part to the whole (see Figure 6-31).

The Armature

To make a figure one-third life size (24"–32"), thread into a flange a 1" to 2" galvanized pipe. It should be from 18"–20" or half the length of the figure, including 3" for the clay base. This allows for lengthening the legs later if necessary. For balance and flexibility the armature should enter the rear of the figure just above the pubis, or middle height (see Figure 6-32). (Too low and it becomes top-heavy, too high and the flexibility to adjust the position of the torso is reduced.) From the vertical, project a horizontal pipe at least 6" long using an elbow at the joint. To the end of the horizontal, screw a tee joint into which two wires, each bent in half, are inserted. One 6' wire will serve for the legs, head, and torso, and another, 52" to 54" long for the legs and arms. Fasten these together with copper or galvanized wire and reinforce by driving in wood wedges or pushing a small amount of plaster into the tee. Hang butterflies from the shoulders and over the hip portion. Leave the legs free from the base for position change or lengthening, and allow room on the armature for filling out the figure and movement of the joints. A large figure may be reinforced with wood slats, shellacked plaster and burlap, or polystyrene or urethane foam.

Establish the chief lines of the pose, observing from the back the line of the spinal column and its continuation by the direction of the supporting leg (in a standing pose) (see Figure 6-33). To trace the main direction in a contrapposto standing pose, take a vertical line from the front, dropping from the suprasternal notch down the center of the figure, and touching the inner ankle bone (the internal malleolus) of the supporting leg. The plumb

Figure 6-32
Figure armature.

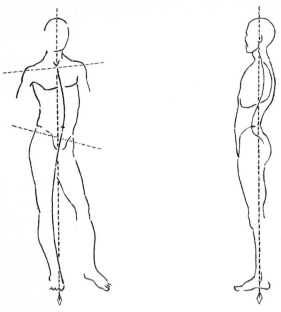

Figure 6-33
Lines of pose—front, side.

line will give the vertical median line from which to judge the slant of the torso and the contrasting lines across the vertical of the pelvic block, shoulders, head and neck, buttocks, calf, and ankle muscles. Check the projection of parts by examining the armature from all sides, moving hips and shoulders, arms and legs—forward and back, as well as side to side. Note the balance of the pose from the side view by dropping a plumb line from the center of the neck: it should pass the outer ankle bone of the supporting leg. The curving contours of the sternum, pelvis, front of thigh, and supporting leg will give the main directional lines forming the counterpoint rhythms of the vertical. Bend the armature wire to resemble the curved contours of the main lines and bones, suggesting the spirit of the pose in linear form.

Building the Masses

Prepare the clay, adding rolled coils that are then well packed together. Establish the following points:

1. The pelvic block, located directly below the thorax at right angles to the lumbar vertebrae.
2. The suprasternal notch, neck, shoulders, rib cage, and thorax. To keep a sense of volume the thorax must be consistently built up equally on both sides of the sternum.
3. The joints of the knees, ankles, elbows.
4. The bones and muscles of legs and arms, neck, chest,

abdomen, and the forms of the shoulder blades and lumbar region.

Develop all parts schematically at first, with no one part moving ahead of the others. After the main masses are indicated, draw the vertical directional lines directly on the clay. Start with the line from the center of the sternum and umbilicus or navel down the inside contour of the supporting leg, following the curve of the pose. Follow this by drawing the cross-contour lines of the pelvic block, shoulders, brow line, knees, and ankle bones (see Figure 6-34).

Measurements

As with the head, a system of measurements will train the eye initially by setting up a methodical manner of observation. Using such a system eliminates the trial-and-error groping encountered with first attempts at modeling, but can be discarded when the eye grasps these relationships with only an occasional confirmation by the caliper. Dependence on mathematical measurements would eventually divert the modeler from the gesture of the pose and result in a lifeless study.

The measurements below are translated from the model to appropriate scale.

1. The main distances forming the geometric plan of the torso are those across the front, back, and sides

Figure 6-34
Developing masses with blocks of clay.

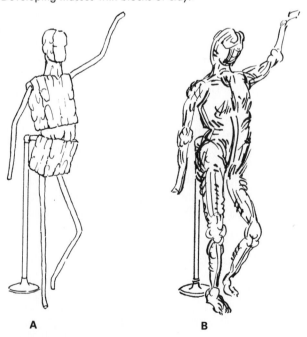

A B

Figure 6-35
The pelvic bone.

of the pelvic block, forming the four stable points of the *iliac process*, the forward and back projections of the iliac crest of the hipbone (see Figure 6-35). Not as obvious from the back as from the front, the iliac process occurs at the point where the hipbones join with the sacrum, forming two small dimples on the surface.

2. The distance between the suprasternal notch in front and the *seventh cervical vertebra*, the protrusion at the base of the neck in back, gives the depth of the neck. These two points are placed above the section of the pelvis, forming the top of the thoracic block.

To obtain the proportion between these major forms and the extremities, take the following measurements (see also Figure 6-36):

Front:

1. From the arch of the sole of the supporting leg to the top of the kneecap (patella) and from the patella to the ilium (front projection) above the supporting leg.

2. Across to the ilium of the free leg, down the ilium to knee and heel. With a horizontal line, determine the distance between the higher ilium point of the supporting leg to the lower point on the free leg.

3. From the ilium of the supporting leg to the suprasternal notch (top of sternum) and ear notch.

Side:

1. Again using a horizontal line as a guide, check the levels of the hipbone between front and back of the iliac, the anterior and posterior process from both profiles.

2. For the thoracic block, check the distances between the suprasternal notch and the seventh cervical vertebra. As with the pelvis, check the relationship of heights between the two.

Back (see also Figure 6-37):

1. Relate the two points of the posterior iliac process, the distance between the points, and the horizontal levels.

2. Measure from the higher posterior iliac point to the seventh vertical.

3. The length of the arms (outstretched, etc.) from the shoulder at the acromion process (furthest projection of the scapula), to the elbow (head of ulna), from the elbow to the first joint of the index finger.

Figure 6-36
Front and side main measurement points.

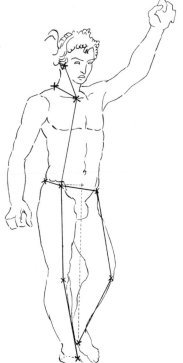

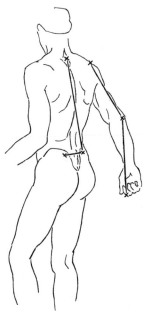

Figure 6-37
Back main measurement points.

Basic Bone and Muscle Structure

The vertical spinal column is the primary structure of the body, from which the two major volumes, the thorax and pelvic sections, are hung. Its 24 vertebrae may be divided into three sections: 7 *cervical* (neck); 12 *dorsal* (ribs); and 5 *lumbar* (between dorsal and pelvic block) (Figure 6-38). Movement takes place in the cervical and lumbar region, with the dorsal vertebrae supporting the rib cage. The end of the vertebral column with its last bone, the *coccyx*, is attached to the hip bones at the sacrum, forming an immovable bony girdle. The two hipbones are constructed of the *iliac, ischium,* and *pubic bones* with its prominent points, the interior iliac spine and the iliac crest in the front, and the posterior iliac process in the back. The ribs affect the joining of the vertebral column in back to the sternum, the thorax's frontal bone. Forming the upper bony cage of the body, the thorax consists of the sternum in front and 12 ribs, 5 regarded as "false" in that they connect not to the sternum but to each other and to the seventh rib in front (eighth, ninth, tenth rib). The eleventh and twelfth ribs, called the floating ribs, connect to the vertebral column only. Attached to the top of the sternum is the *clavicle* which moves across and connects to the spine of the scapula at a junction called the *acromion process*, located at the shoulders.

The line of the shoulders formed by the clavicle takes on a shallow figure-eight curve across the front and back, parallel to the lower border of

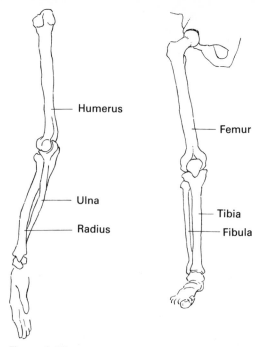

Figure 6-39
(a) Arm bones; (b) Leg bones.

the thorax. Curving the shoulder form will give the upper torso the proper rounded contour and help locate the neck in the center of the yoke. Observe the curving of most bones of the body, as the shape of the overlapping musculature tends to follow the bone curve. The large single bone of the upper arm, called the *humerus*, is attached at the elbow joint to the two crossed lower arm bones of the *ulna* and *radius*. The upper leg bones, the *femur*, connects at the *patella* to the large bone of the lower leg, the *tibia*, and its slender parallel bone, the *fibula* (See Figure 6-39).

The major muscles of the front torso are the *deltoid* and great *pectoral* muscle, which both insert into the upper arm (see Figure 6-40). The deltoid is attached to the shoulder bones of the clavicle, acromion process, and scapula as well as the spine; the pectoral to the clavicle, sternum, and gradually to the fifth rib. Continuing the downward direction of the pectorals is the *serratus magnus* and *external oblique* on both sides of the torso; the serratus attaching to the upper 8 ribs (between scapula and ribs) and the external oblique to the lower 8 ribs and iliac crest of the pelvis.

In contrast to the radiating construction of the thorax and pelvis muscles, the abdominal muscles are vertical, soft, and flat. The two large radiating back muscles, the *trapezius* and the *latissimus dorsi*, originate from the dorsal portion of the vertebrae and attach respectively to the scapula and clavicle and to the humerus bone of the upper arm

Figure 6-38
Vertebrae sections.

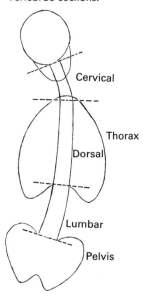

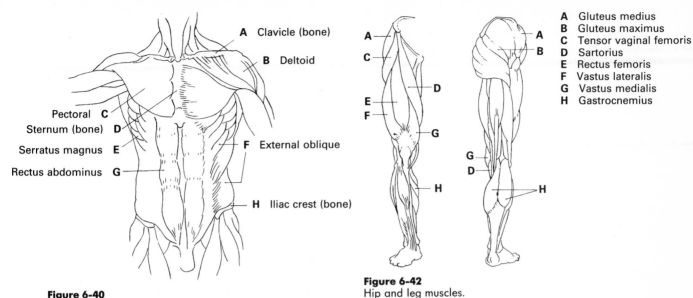

Figure 6-40
Muscles—front torso.

Front torso labels:
A Clavicle (bone)
B Deltoid
Pectoral C
Sternum (bone) D
Serratus magnus E
Rectus abdominus G
F External oblique
H Iliac crest (bone)

Figure 6-42
Hip and leg muscles.

A Gluteus medius
B Gluteus maximus
C Tensor vaginal femoris
D Sartorius
E Rectus femoris
F Vastus lateralis
G Vastus medialis
H Gastrocnemius

(see Figure 6-41). The *erector spinal* muscles in the center of the dorsal region of the back form a six-pointed shape which divides into two parts at the top, an inner vertebrae and an outer, rib-connected part, and, at its lowest point, dips down into the sacroiliac groove.

The main hip muscles consist of the *gluteus medius* and the adjacent *maximus* in the rear (the buttocks), the *tensor vaginae* or *fascia femoris* at the sides (attaching to the iliac crest), and the long sartorius muscles in front (see Figure 6-42). The *sartorius* pulls across the leg from its attachment to the interior superior iliac spine at the hip down to the upper portion of the *tibia*, the inner bone of the lower leg, which the sartorius pulls into a

bent position. The *rectus femoris* stretches under the sartorius, surrounded on the outside by the *vastus lateralis*, and on the inside portion by the *vastus medialis*. The large back muscle of the lower leg, the *gastrocnemius*, is flanked by several long vertical muscles attached to the fibula and tibia above and the foot bones below.

The main arm muscles consist of the *deltoids* in the shoulders, the *biceps* and *triceps* of the upper arm, and the *extensor* and *flexor* muscles in the lower arm (see Figure 6-43). The *sterno-mastoid* muscle of the neck consists of two parts, an inner part attached to the sternum, and the outer part connected to the inner edge of the clavicle. This important muscle, which turns and lifts the head,

Figure 6-41
Muscles—back torso.

A Acromion process
B Deltoid
Trapezius C
D Scapula
Latissimus dorsi E
F Erector spinal
Gluteus medius G
H Sacroiliac groove
Gluteus maximus I

Figure 6-43
Arm muscles.

Occipital (bone) A
Temporal process B
Sterno-mastoid C
Deltoid D
Triceps F
E Biceps
G Extensor
Flexor H

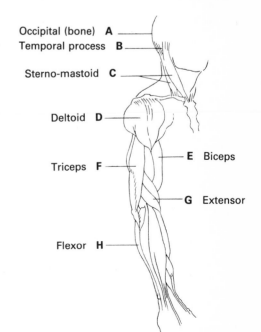

inserts into the skull at the *mastoid* process of the *temporal* bone and the edge of the *occipital* bone.

Planal Organization

In terms of geometric simplification the torso can be divided into two rectilinear blocks, the *thoracic* and the *pelvic*, joined to each other by the small center form of the *abdomen*. The top of the thoracic block can be pyramidal to describe the shoulder, back, and shoulder blades, with the neck attached at the high point of the pyramid. Each separate body form is composed of a front, back, and 2 sides which are joined by curving and radiating muscles. Forms are best understood if treated initially as basic shapes, for example, the foot as a cone and the toes as five cylinders, or the hand as a large rectangle to which are attached five oblong shapes.

To trace the continuity of these muscles, large curves may be found by drawing contours from

Figure 6-44
Contour continuity around body.

front to back so that one contour flows into the other (see Figure 6-44). This establishes a relationship of form to form, both in the rhythmic movement of the large repeats and the intervals between them. The intervals may be seen as rest stops, transitions between large masses which

Figure 6-45 (left)
Life study on armature by Paul Buckner. 1980.
Armature is traditional ½" inside diameter pipe. A reducing elbow will allow the horizontal pipe a ⅜" inside diameter to affect less modeling area at entry into figure. Inside armature here is twisted aluminum wire.
Photo by Paul Buckner.

Figure 6-46 (right)
Side view of figure. Building figure with clay pellets. Figure and photo by Paul Buckner.

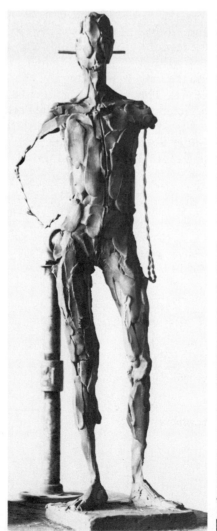

separate and animate each form. Study the angles of these transition planes, and their resulting concavity or convexity for their tonal effect on the entire form. Too acute an angle may cause a strong dark, while an obtuse angle may be too gray. Observing a cross section of planes from above and below will clarify the relationship of one contour to another. These cross-contour relationships are crucial to the sense of rhythmic flow around the work, eliminating abrupt and discordant form juxtapositions.

While building the figure, keep the following points in mind (see also Figures 6-45, 6-46, and 6-47):

1. Treat the whole work as a unit while developing the directions of the forms and the action of the pose. Since the pose of the model will shift in the course of the work, establish the main lines before any particular part moves ahead.
2. Keep forms somewhat beneath the anticipated final size, using the additive process to arrive at the final form. During the entire modeling process, the surface should remain pliant and open to changes and additions.

3. Apply clay in small pellets or pieces left until the very end to "pull together" into a unified surface. Apply pellets with the fingers and press with a large spatula-shaped tool. Avoid smearing and blurring the definition of the planes. The texture of the pellets should be bold at first, but gradually dwindle down to a delicate scale that follows the form and suggests the feeling of volume. The clay should not get too moist nor should its surface be treated with a generalized slick "skin" that eliminates subtle modeling and gives a uniform and inanimate look.

Plasticene or Synthetic Clay

Synthetic clay, known as plasticene or plastilene, is oil based and does not dry out or harden. It is expensive but can be homemade by adding dry powdered clay to melted microcrystalline wax mixed with grease and 30-weight motor oil in proportions of 50% to 60% clay to 50% to 40% vehicle, adding more oil and reheating if the mixture is too stiff. Plasticene is more convenient than earth clay, but less responsive to manipulation and surface texture.

Figure 6-47
Front view. Pulling together form by scraping with wire tools. Figure will be cast into plaster using three-piece plaster mold.
Figure and photo by Paul Buckner.

7

Rigid and Flexible Molds

The casting process is a means of creating a sculpture indirectly, translating the original substance into another, generally more permanent material. It is also a means of reproducing multiples of the original in the same or a different material. Pour or spray a fluid, or press a material, into a predetermined negative form or mold, and the resulting form is called the *cast*. Since the mold is the most essential and complex aspect of the casting procedure, this chapter will confine itself to the materials and methods of moldmaking, specifically those designed for cold casting.

MOLD MATERIALS

Obtaining one form by molding it into another may have had its origins in man's earliest clay vessels. These were made, it is theorized, by packing mud into roughly woven reed baskets which, when used for cooking, fired the mud into permanent vessels. The burned reed survived as a texture imprinted on the outside, a clue to early construction methods. For the ancient artisan, clay was an easily moldable material for multipile

pressings or pourings of small figures, toys, and ritual objects. Bisque molds in one or more pieces have been found in the ruins of the pre-Columbians, ancient Greeks, Romans, and Chinese (see Figure 7-1). In the case of the Greeks, such molds confirmed the existence of works known only through legend or small replicas. Large terra cotta molds found in Olympia in 1955 had been used to hammer out sheets of gold covering for a huge chryselephantine (ivory and gold) statue of Zeus attributed to Phidias during the mid-fifth century B.C. and known to us only through Roman copies on coins and engraved gems.

Plaster molds can be dated from a plaster death mask made during the Old Kingdom (2400 B.C.) of the Egyptian King Tety. Plaster casts of statues and parts of the body were discovered among the ruins of Akhenaton's reign (1370 B.C.). The Greeks, formerly thought to have originated plaster casting, actually began the practice under the naturalistic sculptor Lysistratos during the fourth century B.C. Beginning with the first century, Greek artists used casting to manufacture multiples of Greek sculpture which the Romans used as decorative objects in their palaces and public areas.

The pointing method of reproducing, still in use today, transferred measurements from a plaster model to its permanent form in chiseled stone.

Plaster casts for reproduction purposes were used infrequently during the Middle Ages, but were rediscovered by Italian Renaissance artists, who utilized the gypsum of the Italian countryside to make their molds. Plaster and sometimes wax continued as the primary moldmaking materials until the nineteenth century, when flexible gelatin and glue molds' greater convenience and ease of application made them preferable to the multipiece plaster mold. Gelatin molds were of two types: *agar*, a marine algae refined during World War I for use in surgery, or the tougher and heavier gelatin made by boiling the skins and bones of animals. Glue molds, which are coarser and less elastic than pure gelatin molds, are made primarily of carpenter's glue with additions of gelatin, oils, glycerin, and even molasses for increased elasticity.

The natural *latex* mold was followed rapidly by time-saving synthetic rubbers and plastic molding compounds, including the hot-melt types, *polyvinyl chloride* (PVC), the cold molding *polysulfides* (CMC), the *silicon rubber* compounds (RTV—room temperature vulcanizing), and flexible *polyurethanes*. All operate on basically the same principles, though each has its own particular mixing system and characteristics. Developments in rigid mold materials include fiberglass and polyester resins; polystyrene and urethane foams are often used as direct negatives and treated as waste molds (see below).

Figure 7-1
Pottery molds. Single and two-piece molds from Peru.
Courtesy Department of Library Services, American Museum of Natural History, New York.

MOLD TYPES

A rigid mold made for one-time use is termed a *waste mold*, since the mold is discarded while removing the cast. Plaster is generally favored for this type of mold as it is inexpensive and easy to use. The waste mold is made rapidly and needs few divisions or seams (these leave scars on the castings and must then be patched).

The *rigid piece mold*, in contrast, needs many divisions so that it can be removed intact from the original and preserved for additional reproductions. Since neither the original nor the cast may be damaged, it is important that each piece of the mold be carefully placed in relation to undercuts and adjacent mold sections for easy separation. The mold should fit together by interlocking in a numbered sequence, with one piece often acting as the key that holds the others in place. An outer container or shell of plaster or fiberglass called a *mother mold* is built over the piece mold, often with wires attached to the separate pieces. Also known as a shell mold, this outer mold system prevents the pieces from slipping during casting and serves as a protective housing and support.

For most purposes, rigid plaster piece molds have been supplanted by *flexible mold systems*, allowing for greater ease in moldmaking and casting. The flexible mold, made of a gelatinous or elastomer material like rubber or plastic, is poured or brushed on the original work in one or more sections. A mother mold of two or more pieces usually supports the flexible mold and must be designed for easy pull or draw from the surface.

A *relief mold* is considerably less difficult to make than a three-dimensional mold, particularly if the relief is low and the undercuts not extreme. The mold for a low-relief form may be made as a direct negative, bypassing the positive model. The method is particularly suited to large architectural reliefs and precast concrete or fiberglass panels, using molds of clay, sand, wax, cardboard, wood, polystyrene, or urethane foams. The direct negative relief mold can be modeled or shaped with methods appropriate to the material—pressing, cutting, burning, or lamination with glue. The difficulty is in thinking in reverse, as the forms must be translated *directly* into their negatives. But the method allows you to experiment rapidly with a wide range of forms and textures. After casting, the mold may be salvaged or destroyed, depending on the casting material, the desired number of casts, and the mold material and design. Polyester resin casts should be made in polyurethane, not polystyrene molds, as resin dissolves styrene.

Considerations in Mold Choice

The mold type and material are dictated by the particular problems of the work to be cast, regarding:

1. Number of intended reproductions
2. Type of permanent cast material (metal, cement, resin, etc.)
3. Complexity, size, and materials of the original
4. Fidelity to original size, surface quality, and detail (accuracy)

To make a large edition of many reproductions, the mold should be durable, necessitating more expense and time than a mold intended for a limited edition. Multiple reproductions of complex or delicate works require particularly painstaking molding methods and flexible mold materials. In large works, where the weight of the mold may be a drawback, lightweight fiberglass is a good alternative. Shrinkage of mold materials must be minimized when dimensional accuracy is critical. The need for a perfect surface finish, such as required on polyester resin castings, might suggest sheet glass as a mold. At the other extreme, large rough-surfaced architectural castings in cement may conveniently use polystyrenes, polyurethane foams, wood, or cardboard made as direct negatives that are discarded after casting.

THE PLASTER WASTE MOLD

Availability, minimum cost, and fidelity to detail make plaster the favored material for a waste mold. Simple to use, the material is not noxious to the human system and (more important for piece molds), will store after setting without warping, shrinking, or deteriorating. Plaster's chief disadvantages are lack of elasticity and a short working time after mixing with water.

Plaster is manufactured from the mineral gypsum (from the Greek word *ge* for earth and *epsum* for concoct), which is mined from quarries or underground deposits, the most famous of which is the deposit around the Montmartre area in Paris, first mined in 1770. Plaster consists chemically of calcium, sulphur, oxygen, and water ($CaSO_4 \cdot \frac{1}{2}H_2O$). It is known in various forms as

hydrated calcium sulphate, hydrated sulphate of lime, molding plaster, casting plaster, and dental plaster.

Gypsum is converted into plaster through calcining or heating to 225°–350°F, followed by grinding into a fine powder. The powder has an affinity with water, and when 1 part plaster is mixed with 1 part water, it regains the original amount of water possessed before calcination and returns to gypsum's original crystalline form. The material is homogeneous and behaves predictably, setting to a hard, uniform mass with a low coefficient of expansion. This makes plaster ideal for molding and casting, as it will penetrate intricate areas and set into a dimensionally accurate cast of the original.

Plaster Mixing (see Figure 7-2)

Plaster's compressive strength is affected by the amount of water with which it is mixed. The higher the proportion of water, the further the gypsum crystals are pushed apart and the weaker the material. For molding plaster the usual ratio is 70–80 parts water to 100 parts plaster, the variations depending on the type of plaster (see chapter 8). As its water content increases, the mixture will take longer to set up, and then set overly fast, with the set plaster weaker than the prescribed mix. If the water is reduced too much, the mixture will set quickly and appear homogeneous, but when poured it will sit with water on top and take extra time to set up. The consistency will be uneven— porous on top and hard on the bottom. Mixing plaster is most accurate using weight rather than volume measurements, but for most sculptural purposes, plaster can be mixed as follows (see also Figure 7-3):

1. Weigh or estimate volume of clean water.

2. Add plaster to water (never water to plaster) by sifting it through your fingers and strewing it over

Figure 7-2
Plaster molding tools.

Figure 7-3
Plaster mixing—sifting plaster into water.

the water. Avoid wetting the fingers and dropping the plaster in large lumps.

3. Allow each addition to sink without disturbing the mixture.

4. When the plaster has reached the top, small islands will remain on the surface of the water. After these begin to sink, place your hand flat at the bottom of the container and agitate the mixture back and forth. If plaster must be added to thicken the mixture after agitation has started, sift it carefully to avoid lumps.

5. Small quantities (5 to 25 lbs.) usually are mixed for 2 minutes by hand or with a spatula; larger quantities for 2 to 5 minutes by electric mixer until the slurry has creamed or thickened slightly to the desired consistency—that of sour cream for immediate application, thinner for longer duration of use.

6. Setting is speeded with the use of warm water (130° to 140°F), somewhat more prolonged mixing, or adding alum or salt (up to 1 teaspoonful per quart increases the solubility of the mixing water). Avoid overmixing beyond the smooth stage, which might impair the ultimate strength of the mix.

7. Retardants are cold water, alcohol (added to mixing water), small quantities of citric acid, acetic acid or sugar, and organic matter. Glue or animal hair will also increase the strength of the plaster mixture. (See end of chapter 14 for plaster mixing formulas regarding acceleration and retardation.)

8. Time required for the setting varies with the particular type of gypsum, ranging from 15 to 30 minutes. The cast should not be disturbed during this stage, as movement may interfere with the interlocking of the crystals that produce hardness.

9. Plaster may be stored indefinitely, but under strictly dry conditions, since moisture will make the powder lumpy and prevent it from setting up when mixed. To test plaster, squeeze a small amount tightly in your fist. If an impression remains in the plaster, it is usable; otherwise, it will crumble and fall apart.

10. Never pour setting plaster down a drain. To dispose of plaster, wait until it's completely hard, then crack out of flexible plastic container and discard.

Preparing Clay for the Mold

To make a waste mold the original should preferably be composed of soft, pliant material like moist clay, rather than hard materials, though the stiffer plasticene may also be used as an alternative. If pressure is needed to remove the mold, soft clay will not resist and, in the event of a tight fit because of undercuts, may be easily cut away to release the mold. If kept moist, clay will not absorb water from the moist plaster mold, allowing the two materials to separate easily.

To make a simple two-piece waste mold, divide the clay into two major sections designed to allow the plaster to separate easily from the clay without undercuts locking the mold or hindering separation. Accommodate undercuts either by designing another mold piece or section, or by relocating the mold division (see Figure 7-4).

With a knife or wood tool, lightly draw the mold division line directly on the clay. The mold dividers (or *fences*) may be clay strips 1"–1¼" wide, or strips of tin or brass called *shims* cut into 2" × 3" sections and oiled or greased. Shims are thin enough to let you make two sides of the mold at once; the shims are then extracted when the mold is separated. Working with shims requires some practice as the seams are more difficult to keep neat and flush. Clay walls are easier to handle and result in cleaner seams, but the moldmaking takes longer, as only one side can be molded at a time.

Figure 7-4
Mold divisions.

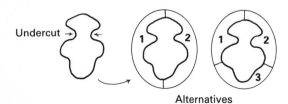

No undercuts

Undercut →

Alternatives

Figure 7-5
(1,2) Application of clay wall; (3) keying wall.

Form clay walls by rolling out slabs and cutting sections to size before placing on the division lines. Press the walls gently to avoid damaging the work's surface, and support them with pellets of clay on the side to be molded last. Slight curving and contouring along the sides, V-shaped cuts, and indentations or projections in several places along the wall will keep the two parts together. Keep the wall moist, as dry clay will crack and fall away from the surface (see Figure 7-5).

To use a third mold division method, lay a waxed thread (similar to dental floss) (see Figure 7-6) on the seam line. The method requires some practice and best involves two people, one holding the thread at the ends, the other spreading the plaster on the seam. The moment the plaster begins to set, pull the thread along the seam from both ends, thus slicing the mold into two parts. Experience is necessary to estimate the consistency of the plaster correctly and produce a clean seam.

Figure 7-6
Thread mold division.

Building and Separating the Mold (Clay Wall Method)

1. Protect the side to be cast last with newspapers or plastic. Have ready U.S. Gypsum #1 molding plaster, plaster tools, flexible plastic bowls for mixing, laundry blue, tincture of green soap or yellow laundry soap, a soft 1"-to-2"-wide brush, a hammer or mallet, a wood chisel and wood wedge, strips of burlap, and heavy wire or soft scrap hollow tubing or pipe.

2. The first coat of plaster consists of a thin ⅛" to ³⁄₁₆" blue coat. Mix a few drops of laundry blue with the water before the plaster is added. This tinting enables you to later distinguish the white plaster mold from the white plaster cast as the chisel approaches the cast surface.

3. Holding the bowl of plaster near the surface of the work and starting near the top of the piece, flick plaster onto the surface in a backhand motion without touching the surface (see Figure 7-7). To guarantee fidelity, apply plaster when still thin so it may settle evenly into undercuts and details. To facilitate this and remove small air bubbles, blow the surface or apply air while the plaster is still fluid.

4. Allow the first coat to set up. Mix a second coat of untinted plaster to the consistency of thick cream. Apply this coat with a spatula to a ½" to ¾" thickness, building it up somewhat thicker along the seams and increasing the thickness in larger molds. Strengthen the second coat with strips of burlap or hemp fiber dipped in plaster. Reinforce larger molds with bands of fiberglass screening material or hardware cloth (wire mesh). Handles for easy manipulation of the mold can be made of metal tubing, rod, or wood lath adhered with burlap strips dipped in plaster (see Figure 7-8). Take care that the burlap does not cover the seam line.

5. As the second coat sets, the clay wall can be peeled away, the seam cleaned, and its location marked with crayon, paint, or grease pencil. Cover the seam's surfaces with a film of soap, oil, Vaseline, or paste wax (thin clay slip applied in several coats may also be used) to keep the two mold sections separate (see Figure 7-9). Keys can be made at this stage by rotating a knife or wood tool into the plaster wall to make

Figure 7-7
Flicking plaster (first layer of mold)

Figure 7-8
One-half plaster mold—handle.

Figure 7-9
(1) Peeling off clay wall; (2) Oiling wall with brush.

rounded indentations oiled well. If metal shims are used instead of clay walls, they are well oiled, and inserted about ¼" deep into the model, angled with the contour to allow for an easy draw off the mold pieces. (Using the shim method, both sides of the mold may be built simultaneously.)

6. The entire process is repeated on the second side, taking care not to cover the seamline. The mold can be opened when setting is complete (30 to 45 minutes) as indicated by the hardness and coolness of the plaster. If a delay is necessary, cover the mold

Figure 7-10
(1) Tapping wood edges; (2) Pulling mold apart;
(3) Laying mold on side to tap seam.

with plastic to retain the moisture in both the mold and the original.

7. Open the mold by tapping wood wedges along the seam lines. The wedge, followed by a blunt chisel, should push apart the two pieces of the mold, gradually pushing out the side which is most shallow and removable. Small amounts of water sponged along the seam softens the clay and aids separation. If the mold is open at the bottom, laying it on its side will help locate lost seams and allow you to dig out the clay to separate the mold (see Figure 7-10). After separation, wash the mold carefully, using a soft brush and soapy water, and assemble to check for proper registration.

The mold of a figure study (off an armature) is generally handled in three parts—one section in front, two in the back. Place clay walls or metal shims around the contours, completely filling any spaces within the figure with the walls or shims. Run the walls across the back hip area of the figure where the armature pipe enters the clay, dividing the mold into three pieces; more, if it is a complex pose (see Figures 7-11–7-18).

Figure 7-12
First coat of thin plaster. Plaster is tinted blue with laundry blueing liquid for splash coat. Medium-thin mixture is splashed on hard-to-reach places first, assisted by a soft brush. Plastilene cushion is added to armature entry pipe. Second coat of cake-frosting consistency added to total thickness of ⅝" with extra strength at shim lines. Figure and photo by Paul Buckner.

Figure 7-14
Mold gently pulled off clay figure. Figure and photo by Paul Buckner.

Figure 7-11
Making a three-piece waste mold of the figure using shim separators. Shims are inserted ⅛ in. deep as nearly as possible on the natural halfway divisions (longitudes) of the figure. Plastilene clamps on edges; keys are "V" folds in several shims. Figure and photo by Paul Buckner.

Figure 7-13
Wooden wedges are placed into shim lines around figure when plaster is set, and progressively tapped into each of the mold pieces. Photo by Paul Buckner.

Figure 7-15
Painting separating solution; inserting support wires in mold. Photo by Paul Buckner.

Figure 7-16 (left)
Mold assembled (keys guarantee registration) and tied together. Seams and back hole are sealed with fresh plaster. For casting, several slush coats of plaster are poured into bottom hole, followed by reinforcement with burlap strips (total thickness approximately ⅝"). Photo by Paul Buckner.

Figure 7-17 (right)
Removing positive plaster cast from negative plaster mold (hacksaw blade scores through mold, snapping off postage-stamp-sized mold pieces). Chisels continue to expose mold. Photo by Paul Buckner.

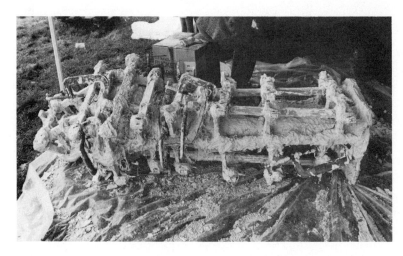

Figure 7-18
A large waste mold assembled for casting, reinforced with tied lath to allow for maximum thinness and strength. Photo by author.

113

THE PLASTER PIECE MOLD

Making a piece mold of five or more sections requires careful analysis of the model and time-consuming care and precision in mold construction. Though flexible molds have replaced them for most purposes, plaster piece molds can still be useful where limited multiples, or wax or clay casts are planned. These materials remove readily from the plaster mold, leaving it free to become a waste mold for more resistant materials like resin.

Rigid models to be used for piece molds require particular surface preparation, depending on the material:

1. Rigid models of plaster or fired clay should first be shellacked and waxed; wood, stone, or bronze are either oiled or waxed (no shellac); unfired clay should be in the leather-hard stage and needs no parting agent; dry but unfired clay can crack and crumble upon exposure to plaster, but will work if sealed with shellac. Mold dividers for hard materials may be either clay or plasticene. Since plasticene has an oil base, it does not stick to greased surfaces, therefore sections should be greased only after the walls are placed on the surface.

2. When complete, each plaster section of the mold should be removed from the model, cleaned, keyed, and refit on the model before making the adjacent section. All sections should be numbered consecutively and removed in reverse order, starting with the last piece made (designated the key piece). Deep undercuts in the model require separate inset pieces.

3. Before building the mother mold, adhere wire loops, smooth the piece mold surface, let dry and apply a coat of shellac and one of wax to the exterior surfaces of the mold pieces. Pull wires from the loops into small holes in the mother mold; twist them tight with small wood sticks tied to the end of each wire (see Figures 7-19, 7-20, and 7-21).

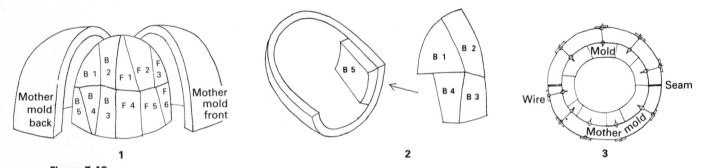

Figure 7-19
Piece mold series—(1) mother mold; (2) inserting pieces in mother mold; (3) wire anchors holding piece mold to mother mold.

Figure 7-20
Plaster pattern in wood form for piece moldmaking. Photo by author.

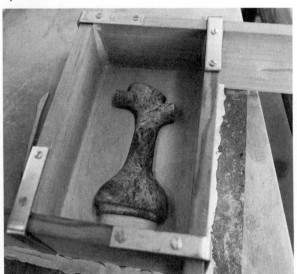

Figure 7-21
Pouring two piece molds in wood frames. Photo by author.

Molds of Reinforced Glass Fiber or Hydrocol—FGR

Lightweight, high-strength molds and shells may be made of fiberglass-reinforced gypsum cement or hydrocol FGR® (U.S. Gypsum trademark), a blend of over 6% glass fibers and gypsum cement. It is mixed as a slurry, adding FGR to water in proportions of 25 lbs. water to 100 lbs. FGR, and can be combined with different forms of fiberglass. The material's working time ranges from 10 minutes to 2 hours, controllable through the addition of nontoxic accelerations or retarders. Setting time is about 1 hour after application, during which time the material gradually expands, resulting in the dimensional accuracy desirable in a mold material. Advantages over fiberglass include economy and safety; FGR costs considerably less than plastic and has no toxic effect.

Wax Piece Molds

On rare occasions, particularly with delicate forms, wax may be used as a negative molding material. For separators, apply talc or grease on the original and over the surface of the wax pieces before making the outer case of plaster. Wax also separates well from a moist plaster model that has been slightly soaped. As an alternative to making the mother mold, reinforce the wax with bandages and wood lath. Wax thickness will vary from ⅛" to ½", depending on the detail and size of the original and the separate sections of the mold. Concrete, plaster of Paris, and resin can be cast in reinforced wax molds.

FLEXIBLE MOLD MATERIALS

These materials fall into three categories: (1) gelatin; (2) natural rubber; and (3) plastic and synthetic rubbers. Plastic flexible compounds are either *thermosetting* or *thermoplastic* which soften when heated and harden when cooled and can be reused much like gelatin. *Polyvinyl chloride* or PVC is a thermoplastic mold material known as a *hot-melt system*. Though the mold material can be remelted and reused many times, it is difficult to handle due to the heat needed for its preparation. Its use is limited to heat-resistant models and casting materials with temperature ranges under 175°F.

Thermosetting mold materials, when heated, solidify and cannot be resoftened into a liquid.

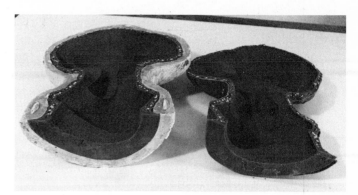

Figure 7-22
Silicon rubber two-piece mold in plaster case. Photo by author.

Into that category fall the other synthetic mold materials referred to as *cold-mold casting compounds—polysulfide, silicon,* and the newest material, *flexible polyurethane* (see Figure 7-22). Easier to handle than PVC since they require no heat, these cold molding compounds are versatile in application to a wide variety of materials, and can be either brushed or poured on the model. In contrast to latex, they cure rapidly at room temperature through use of catalytic agents. At present, silicon is the most expensive at from $5 to $8 a pound, polysulfide approximately one-half that cost, and polyurethane one-quarter to one-third the cost of silicon, making it almost as inexpensive as latex (one-quarter the cost of silicon rubber). Gelatin, at about one-third the cost of latex, remains the most economical flexible mold material.

Gelatin

Making the gelatin mold. This is a method adaptable to RTV, PVC, and CMC pour molds. Although the gelatin mold is less serviceable or convenient to use than latex or synthetic rubbers, it may be the most economical material for limited editions. Gelatin is usually taken off a model of plaster, though it also may be taken from clay, wood, stone, metal, or cement. Several types of gelatin are available, some compounded for surgical purposes. Vegetable gelatin with a base of agar is physically weaker than animal gelatin, but if reinforced may be used for casting plaster, cement, and wax. Additives must be used with agar and water mixtures to add cohesive strength and keep the material from deteriorating. Moulage, a type of agar compound containing additives, was developed for use as a surgical mold material on living flesh. Melting at a higher temperature than

gelatin (210°F as compared to gelatin's 145°F), moulage remains soft until it sets at 100°F, or near human body temperature, and can be remelted and used several times.

Transforming powder, sheet, or flake gelatin to a fluid state is done in two stages, first soaking, then heating. Cover broken-up bits of gelatin with cold water and soak for 12 hours. Heat the softened mass slowly in a double boiler until entirely melted and allow to cool to about 120°F, or until a finger can be put into it comfortably.

If the model is plaster, seal it with shellac thinned with a methylated spirit solution; if wood, stone, or bronze, the model should be oiled or waxed, clay or plasticene covered with dampened paper or thin plastic wrap. Cover the model with an even layer of clay ½" to 1" thick, increasing slightly at the seams (the clay represents the thickness of the gelatin mold). Divide the model into front and back sections by a 1½" wide clay wall keyed with a cut groove or hemisphere of clay placed in strategic spots (see Figure 7-23.)

On the high points of the clay layer, place two to four conical clay plugs about 1" in diameter and height to act as air vents. Place a cylindrical clay pouring funnel, 1½" in diameter and 2" high, on the clay wall. Pour plaster over the clay to the thickness of ¾" to 1". When the plaster is set, remove the clay retaining wall and coat the plaster edge with wax or Vaseline. Treat the second half of the mold like the first, adding only the clay cones for the vents at the high points this time, and covering the clay with a shell of plaster. When set, separate the two sides of the mold, remove the clay layers, and clean the surfaces of the original. Apply shellac and oil over the inner surfaces of the shells. Reassemble the mold and tie it together firmly, taking care to seal the seams with clay or plaster. Pour the liquid gelatin through the funnel (a deep funnel aids in maintaining pressure and proper air escape). When it rises in the mold and begins to run out the vents, plug them with clay. Continue pouring to the top of the funnel, adding more gelatin as it settles.

Another method of making a gelatin mold is to pour each side separately, with a pouring funnel flanked by two vents on either side of the mold. The completed plaster shell can be shaped with a substantial rim or lid to hold a pair of clamps. If the model is on its side, exposing the base, you can make an extra end piece of plaster and hold it on with clamps to prevent the gelatin from running out. After the shell is set, remove both the plaster shell and the clay thickness from one side only; clean and inspect the seam for cracks into which the gelatin might seep. Treat the shell with shellac, oil it and refit on the model, and pour the gelatin. Allow the gelatin to harden overnight before attempting the second half of the shell. Remove the clay thickness of this side, paint the exposed gelatin wall with a hardening agent of alum and water, and treat the shell with shellac and oil. The second side is made as the first; take care to keep the gelatin cool enough to prevent its melting along the seam.

Each firmed section, being flexible, can be pulled carefully away from the model and replaced inside the shell. Dust outer surfaces of the gelatin and the inner surfaces of the plaster shell with talc to remove the oil. Brush the entire gelatin mold with alum and warm water to render it less soluble, and let it dry thoroughly, as alum left in puddles will injure the gelatin surface. In addition, it can be sprayed with a release agent of silicon.

A gelatin mold is best used for plaster, portland cement, or wax positives; the exotherm of plastic resins will blur the gelatin surface. Nor can terra cotta castings be made in gelatin, as the surface is not absorbent enough. Since the heat of crystallizing plaster may mar the gelatin also, remove the plaster positive immediately after its initial setup. Wax for the initial coat should be brushed rather than poured onto the surface to insure that the wax is below 120°F; if poured too hot, the wax might affect the detail of the gelatin. The gelatin mold should be dusted with talc and kept dry in its shell when stored. Before each casting, repaint it with alum and oil.

Natural Rubber

The rubber mold (natural latex) is relatively inexpensive, gives a high degree of detail, and is simple to use. Elastic, strong, and durable, it al-

Figure 7-23
Gelatin moldmaking.

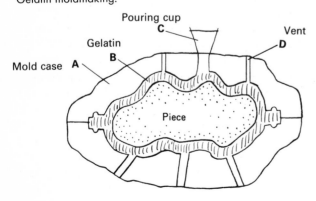

lows for many reproductions in a wide range of materials including plaster, cement, wax and polyester, and epoxy resins. Its chief disadvantage is its lengthy application time due to the many coats required, and the curing time necessary between coats—several days in a large mold. Also, latex shrinks, especially if there is inadequate curing between coats. Humidity affects curing, which is accelerated by warm temperatures.

The rubber can be poured around the work for small pieces and reliefs, or brushed or sprayed on. Seal the model surface with thinned shellac or a spray of acrylic lacquer. Unfired clay should be in a leather-hard condition and will need no parting agent. Handle the poured rubber mold much like the gelatin mold described above, with the rubber poured ¼″ to ½″ thick. To calculate the amount of rubber needed for poured molds of latex and synthetics, form the removed clay into a cube and measure the cubic inches, estimating from the guide of cubic inches per pound provided by the manufacturer.

A brushed rubber mold is constructed much like a plaster piece mold, using separating walls of clay or plasticene to divide the surface, or it can be applied as one piece and slit with a wet razor blade. Apply the first coat of latex carefully, working out air bubbles (spraying is a better method for the first coat, but you must wear a respirator). Build up the layers to a thickness of ⅛″ to ¼″ (about 10–20 coats) and reinforce the last layers with latex-impregnated fillers such as cheesecloth for small molds or burlap or glass cloth for larger ones. Several hours are required between coats, as each must be dry to the touch before the next is applied. Push a toothpick into undercuts to test for drying in deep areas. A few drops of vegetable coloring added to each coat will make the number of coats clearly distinguishable. Large surfaces require heavy molds, with the last coats laden with filler and applied with a spatula. The rubber mold's strength is increased and shrinkage reduced if the final curing is done while the completed rubber is still on the model. To accelerate curing, place small molds in an oven for 40 minutes at 240°F; or remove them from the model and boil them for 40 minutes; enclose larger pieces in a heated atmosphere for 3 to 4 days, the longer the better for large molds.

After curing, the latex surface can be divided into two or more sections by clay walls, and the entire surface waxed or greased with Vaseline. A supporting plaster of fiberglass shell mold is constructed over the latex, reinforced with wood lath, or made more lightweight yet sturdy with sisal

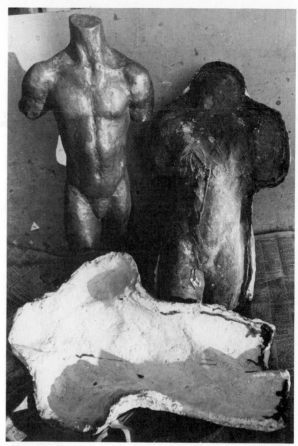

Figure 7-24
Natural latex rubber mold of torso in plaster casing. Photo by author.

fiber dipped in plaster. After removing the shell and the rubber, dust both shell and mold surfaces with talc to prevent sticking and refit the latex into the support mold, where it remains during storage. Brushes used for latex are cleaned with lacquer thinner or mineral spirits, which can also separate uncured sections that are sticking (see Figure 7-24).

Mold-release agents for rubber include Vaseline, waxes, silicone sprays, soaps, and PVA (polyvinyl alcohol), depending on the material to be cast. All-purpose silicone sprays form a rubbery coating that prevents adhesion between materials, but should not be used on resin surfaces that will be painted. For wax and plaster of Paris castings, brush green soap onto the surface of the rubber mold; for portland cement, epoxy, and polyester resin use wax or Vaseline. Water-soluble release agents like PVA are often applied over a thin film of wax, particularly for polyester and epoxy.

Plastic and Synthetic Rubbers

Hot-melt molding compounds. Polyvinyl chloride (PVC), like gelatin, can be used only as a pour mold and must be melted to a fluid condition before

using. The commercial mold material is known by a variety of names, depending on the manufacturer.[1] Developed during the 1920s, polyvinyl (generally known as vinyl), is a flexible form of PVC thermoplastic that is capable of being remelted and used several times. Unlike gelatin it is tough, does not harden with age or shrink a great deal, and is unaffected by the action of water, the acid of alum, or the heat of crystalizing plaster or cement. Though its initial cost exceeds glue or gelatin, it is economical in the long run, being a thermoplastic that can be remelted and used several times.

PVC's disadvantages are its inconvenient preparation, and heat, which excludes casting from originals of wax and some plasticenes. PVC must be melted at temperatures between 225° and 275°F, with a flow point at 250°F. Use pans of stainless steel, vitreous china, enamel, or glass, and supply the heat indirectly through electric coils (like an enamel-lined roasting pan), infrared heat lamps, oven heat, or double boiler. The material should not come in contact with common metal or be overheated, or it will char or decompose. Pour it about 15 minutes after liquefying, when all the small air bubbles have broken.

For some types of PVC, plaster models must be able to withstand high temperatures (like investment plaster) or require special surface treatment recommended by the manufacturer to counteract the high heat's calcining effect. Treat both the models and shells made of molding plasters, which begin to calcify at 150°F. In addition, models for PVC molds can be made of metal, stone, hardwoods, and leather-hard earth clays. These should be sealed with oil or Vaseline or, in the case of clay, covered with thin moistened papers. Plaster, cement, wax, and resin can be cast in PVC molds with no release agent needed.

Polysulfide rubber, discovered in 1929 and manufactured under the name *Thiokol,* is credited as the first commercially made synthetic rubber. Since then, twelve other synthetics have been developed—all organic with the exception of silicon rubber, which was adapted to industrial molding in the 1950s as the first flexible compound to be thermoset by chemical means, requiring no external application of heat. This made it possible for the material to be mixed, applied, and cured in a fraction of the time required for natural latex.

Polysulfide is known as a CMC (cold molding compound) along with more recently developed silicon rubber and polyurethane compounds. It generally comes in a two-part system (a base compound and a single catalyst). A three-part system (a base compound and a double catalyst) affords a wide range of control over setting and working time and remains stable indefinitely. The single catalyst two-part system is less shelf stable (lasting about one year in sealed containers) but produces a stronger and more flexible mold.

Polysulfide molds can be cast over most materials, including resins and vinyls, but not polystyrenes. Dry the model and treat with parting agents such as spray silicon, followed by wax or thin coats of 8 oz. cut orange shellac (8 oz. can orange shellac per gallon of alcohol), let dry, then wax. Acrylic spray in clear form, particularly as a sealer over earth clays, prevents an occasional reaction of the clay to the polysulfide rubber (resulting in a poorly set mold). Avoid lacquer sealers which are affected by the plasticizers in the compound.

Mixing of polysulfides should be precise. Carefully weigh out the base compound A and the curing agent B in separate containers. The curing agent contains a heavy lead compound that tends to settle during storage. Re-disperse it by thorough stirring before weighing. Using dry containers of metal or plastic, mix the A and B together and stir thoroughly, scraping the sides of the can often. Working time with polysulfides is short, from 12 to 20 minutes; the jelling taking place immediately. Allow more than 5 minutes for mixing, using a power mixer for quantities over 1 gallon. If large molds are to be poured, investigate special automatic mixing and degassive equipment. Setting time is slowed by low room temperature and low humidity; conversely, it is speeded at high temperatures. Since the curing agents contain lead peroxide, keep the room well ventilated and wear a respirator-type mask. At 75°F room temperature, using a double catalyst, curing will take approximately 16 hours.

The polysulfide mold can be made by pouring into a shell as described above (see Figures 7-25–7-28). If laminating in the manner of the rubber mold, two different compounds may be used—a thin type for the first coat, followed by a brushable thixotropic type for the heavy final coats of ¼" to ⅜", to which rubber-reinforced burlap straps can be added. Wax or soap the final surface and cover with a shell of plaster of two or more pieces; strengthened by fiber and a wood or metal framework. Before pouring the rubber into the shell mold, treat the inside of the plaster shell with separating agents like shellac and wax. For detailed models, mix a small amount of rubber and apply with a brush as a facing coat just before the pour. Cal-

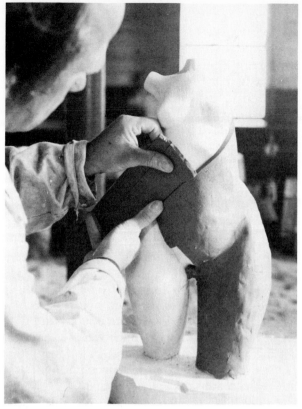

Figure 7-25
Polysulfide moldmaking. Layering ¼" slabs of clay on plaster model. Photo by Paco Mitchell.

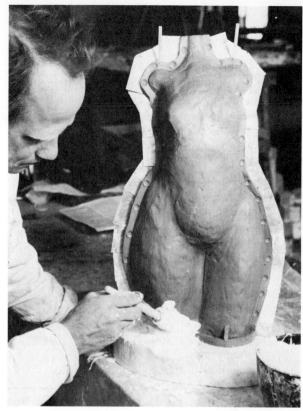

Figure 7-26
Polysulfide moldmaking—reinforcement (key wall) with shims in place. Brush application of first coat of plaster over clay. Base of plaster coated with 50/50 sodium silicate and water mixture for plaster to plaster separation. Photo by Paco Mitchell.

Figure 7-27
Completed plaster mold half replaced after clay has been removed. Space between mold and piece formerly occupied by clay will be replaced with polysulfide rubber. Photo by Paco Mitchell.

Figure 7-28
Polysulfide layer poured in place of clay. One-half piece plaster shell mold removed. Photo by Paco Mitchell. Casting process by Paco Mitchell, Blue Heron Foundry, Port Townsend, Washington.

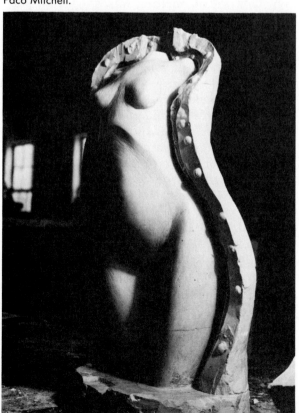

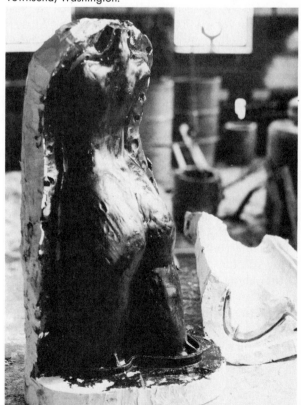

culate the amount of material needed for a pour mold by volume, using the above-mentioned method of pressing the stripped clay into a cube and referring to the manufacturer's table of equivalencies.

Castings from polysulfide molds can be of plaster, cement, wax, polyester and epoxy resins, and polyurethanes. Wax acts as an all-purpose separator, but should be applied in light coats or cut with solvents like kerosene or hot detergent to prevent buildup on the mold surface. For resins with low exotherm (temperatures below 225°F), an effective parting agent is a spray of polyvinyl alcohol followed by a light spray of silicon. Since a wax residue remains on the cast pieces, clean their surfaces after removal from the mold. Store polysulfide molds in a cool place with the original model or a casting inside to minimize distortion and shrinkage. Seal the mold surface with soap or shellac (not lacquer) to avoid shrinkage from the gradual extraction of the plasticizer.

Silicons, developed during World War II, are synthetic rubbers that are highly resistant to temperatures up to 590°F, acids, corrosive salts, moisture, and chemicals. Referred to as Room Temperature Vulcanizing Rubber (RTV), the material produces molds of low shrinkage and high flexibility, insuring easy release of parts and long mold life. Original models can be of any material with a firm surface: castings of cement, plaster, wax, and thermosetting resins. Sealing the model is particularly important where a patch test of the pattern material indicates incompatibility with the cure of RTV, as occasionally occurs with the resins and tars of wood or the sulphur of clays. Sealers include shellac, acrylic lacquer, non-silicon paste wax and/or polyvinyl alcohol spray release. Use thin layers of plastic wrap to seal surfaces of the model before the layer of clay is applied in a pour mold, or apply them to the outside of the rubber layer to facilitate removal from the plaster shell. Though silicon mold's separation qualities are excellent, the manufacturers suggest release agents including Vaseline, paste wax, PVA, and a neutral soap that accelerate the parting of silicon.

RTV is made of a two-component system consisting of a colored catalyst added to the white silica base fluid after weighing. Using paper or disposable containers with 50% greater capacity than volume to be mixed, stir the material together thoroughly for at least 2 minutes until it blends into a single color. Longer agitation accelerates the jelling process. After application by brushing or pouring, leave the material undisturbed until the jelling and curing are complete—approximately 16 hours at a room temperature at 72°F. Setting is slowed at lower temperatures; accelerated if the mold is heated at 100° to 110°F. RTV can be used to repair itself; its adhesive quality allows any number of separate mixes to be placed against previous coats to adhere as one. In pouring large batches, de-air the material by vibrating the model or the table underneath the model.

For patching and making small models, use silicon construction sealant (see Figures 7-29, 7-30, and 7-31). Available in tubes at hardware or construction companies, the sealant is premixed and can be used straight from the tube, particularly for the first thin coats. Thicken subsequent coats by mixing the silicon for about one minute with small amounts of water. Since water accelerates setting, painting must be rapid, best done with a flexible palette knife. Water does not appear to affect the material's tensile strength.

Polyurethanes, versatile plastics introduced commercially in 1954, are available in flexible or rigid foam, solid elastomers, adhesives, sealants, and coatings. The foamed or cellular material is most familiar, but depending on the chemical or additive used, the foams may also be soft and flexible. As elastomers they are tough, resist abrasion, and have a long service life. For sculptors, urethanes answer the need for a tough, long-lasting, inexpensive mold material which has fidelity and is rapid in application. It may be used for production work in low-melting waxes, epoxies, polyesters, urethanes, plastics, and cement. Models should be moisture free and coated with a water-barrier release agent like shellac, acrylic lacquer, or wax, and dried thoroughly before applying the mold material.

The compound comes in two parts, a syrupy base (B) and a dark liquid accelerator (A). If softer molds are desired, a third compound, (C), is weighed and mixed with the base before combining with the accelerator. To mix, first stir base B thoroughly and weigh it into a nonporous container (metal, glass, ceramic, or plastic). Porous containers like paper or wood tend to introduce atmospheric moisture into the compounds, thereby weakening the material. Before weighing and adding the brown liquid part A, redissolve any sediment or solid material present by loosening the lid on the container and warming it to 66°C (150°F), stirring with a metal or glass rod and allowing the liquid to cool before use. A and B both tend to absorb atmospheric moisture and should be used

Figure 7-29
Silicon sealant mold. Application of sealant with plastilene walls and keys in place. Sculpture and photo by Tom Knapp.

Figure 7-30
Paste wax separator applied between two-piece silicon mold. Sculpture and photo by Tom Knapp.

Figure 7-31
Hardened flexible silicon sealant mold removed from clay model. Sculpture by Tom Knapp. Copyright Tom Knapp. Photos by Bruce McElya and Tom Knapp.

as soon as possible after opening. Ten parts A are added to 100 parts B by *weight*. Weighing is critical, since a 5% error of either part can affect the cured rubber's physical properties. A *separate* nonporous mixing container is used and the mix stirred thoroughly. Scrape down the sides often to insure thorough combining of both components. If added, the accelerator (part C) will allow for varying degrees of hardness from shore A 6 to shore A 40, the ultimate hardness without part C. Shore is the term for degrees of rubber hardness as measured by a durometer; a tire measures at 55 shore

A, a heel at 70, a battery box at a hardness of 100. A hardness of 25 shore A produces a strong but flexible mold.

After mixing, the elastomer will remain pourable for 20 minutes, setting up in 24 hours, and taking at least three full days at room temperature to cure. If large amounts are to be poured, vacuum degassing will reduce air bubbles in the mold. Treat polyurethane mold surfaces with parting agents of wax and PVA, particularly when casting plastic resins.[2]

RIGID AND FLEXIBLE MOLDS—SEALERS

Model Material	Mold Materials				
	Plaster	Hot Melt Compounds	Cold Cure Silicon Rubber	Latex	Polyester Resin and Glass Fiber
Plaster	Seal with shellac, then wax or soft soap	Seal with G4 varnish or use water saturated (moist model)	None or slight coat of 5% Vaseline in white spirits over 2 coats of shellac, dried	Thinned shellac, wax or acrylic lacquer	Seal with 2 thin coats of shellac, then wax and PVA or seal with Scopas parting agent.
Fiberglass reinforced gypsum cement	Seal with shellac, then wax, or seal with G4 varnish, then wax	Seal with G4 varnish or use water saturated	As above	As above	Shellac, wax and PVA or G4 varnish, wax, and PVA.
Wood—untreated	Seal with shellac and wax	Seal with G4 varnish or use water saturated	None	Wax or acrylic lacquer	Wax, then PVA
Wood, polished	Seal with shellac, then wax	Seal with G4 varnish or remove polish and use water saturated.	5% Vaseline in white spirit solution	Wax	Wax, then PVA
Concrete or *ciment fondu*	Seal with shellac, then wax.	Use water saturated or seal with G4 varnish	None	Thinned shellac, wax, or acrylic lacquer	Seal with polyurethane varnish, then wax and PVA or seal with G4 varnish, wax, then PVA
Expanded polyurethane and expanded polystyrene	Seal with Vaseline or use untreated and burn plastic out of mold	Unsuitable	None	None	Seal expanded polyurethane with G4 varnish, then wax and PVA. Seal expanded polystyrene with shellac, wax, and PVA
Polyester resin and glass fiber	Use soft soap or Vaseline	None	None	None	Wax, then PVA
Wax	No treatment necessary—melt out of mold	Unsuitable	None	Unsuitable	No treatment necessary
Skin—casts from life figure	Vaseline	Unsuitable	Unsuitable	Unsuitable	Unsuitable
Plasticene	Seal with shellac	Unsuitable	Seal with shellac, then apply 5% Vaseline in white spirit solution	Unsuitable	Seal with G4 varnish, then wax, then PVA.

8

Cold Casting
(Plaster, Concrete, Clay)

Most flexible mold materials described in chapter 7 can be used to cast several types of cold materials, depending on their particular composition. A well-planned plaster waste mold designed for casting plaster, cement, or even lead or aluminum may be used initially for multiple castings in soft clay and wax. Proper sequence is important: Cast the clay first into a porous mold, before it becomes impregnated with wax solution. Wax, in turn, makes a fine separating agent for subsequent casting in plaster or cast stone (see Figure 8-1)

BASIC CASTING IN PLASTER

You should become familiar with plaster as a basic casting material before trying more difficult piece molds and flexible molds. The closed mold (pour or *slush method*) and the open mold *lay-up method* both produce hollow plaster casts. Reinforced hollow casts are both lighter and stronger than solid casts, with much more impact strength and greater saving in materials. Slush castings are more suitable for small, easily managed molds; lay-up castings for large, heavy molds.

Prepare the plaster mold by wetting and assembling to check for accurate registration of parts. Patch any air holes and surface breaks with thin plaster or soft clay before applying the separating agent (tincture of green soap, laundry soap, vegetable or lubricating oil, melted stearic acid, or Vaseline thinned with kerosene). Apply two coats to the mold's interior until inner surfaces are slick to the touch. Avoid lathering the soap, as raised bubbles produce a porous surface on the cast.

Pour (Slush Mold) Casting

1. The mold is soaped, fitted together, and bound with burlap strips dipped in plaster, fortified by ropes or wires if necessary (see Figure 8-2)
2. For pouring, large molds can be placed on the floor or supported in a container that can be moved to vibrate the mold. Mix an estimated quantity of smooth plaster. While still of thin cream consistency, pour it inside the mold along the seam lines, almost filling the entire mold. Vibrate the mold to coat all inside surfaces thoroughly and eliminate air bubbles. Tilt the mold and quickly pour the excess plaster out, repeating the process until the plaster is too thick to pour. Thickened plaster can be used to reinforce

Figure 8-1
Malvina Hoffman, *Bacchanale Frieze*. 1915–24.
Plaster, 26 × 21 in.
Pavlova and Partners. Never cast into a permanent material to date.
Courtesy FAR Gallery, New York.

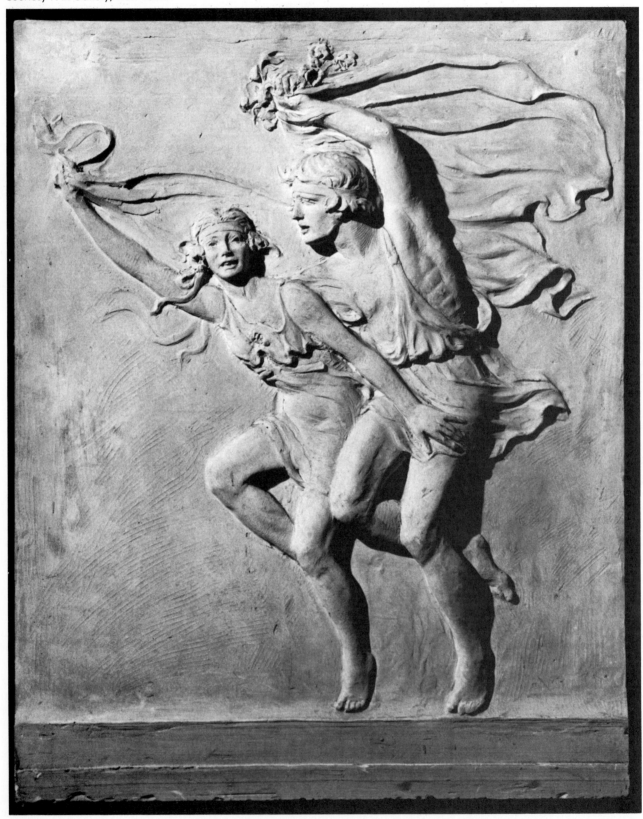

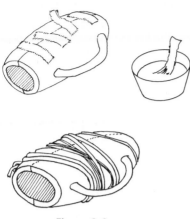

Figure 8-2
Binding the mold.

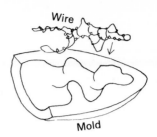

Figure 8-4
Wire armature in mold.

thin or weight-bearing sections near the opening. Use burlap strips dipped in plaster as internal reinforcement, particularly along the seams. Use a stick to push the burlap down through any narrow openings. If necessary, pour additional plaster over the burlap to reach a total thickness of ½″ to ¾″ for smaller works (approximately 3″ or less); 1″ or more for large pieces.

Open mold lay-up works best on large-size molds that cannot be manipulated easily, making them unsuitable for slush casting. When wire reinforcement must be delicately maneuvered and placed inside the mold, use lay-up initially, after which the mold may be slush filled.

1. Assemble the mold sections and check for proper meeting of the seams. Apply a separating agent to the interior surfaces of the wet mold sections and mold walls. Since it does not really matter if a waste mold separates precisely at the seams (the whole shell is chipped away), the wall does not necessarily need a separating agent.

2. Ladle or brush plaster mixed to a creamy consistency (thicker than pouring plaster) on the inner surfaces of the open mold sections to a thickness of ¼″; plaster should bevel down from the seams at a 45° angle to allow for clean fitting of the other mold sections (see Figure 8-3).

3. After the first coat firms up, shape to the work's contours and insert reinforcements (hardware cloth strips and/or rods or wire, shellacked or galvinized). Wires intended as central armatures should rest on small hills of plaster to keep them in the center and away from the surface (see Figure 8-4). Saturated burlap strips can be layered in at this stage, staying clear of seams. Keep the mold wet throughout the casting for the plaster layers to adhere properly.

4. When the plaster is at least ½″ thick, assemble the mold and bind it with ropes, inner tubing strips, or burlap dipped in plaster. If the opening allows, reach in with one hand and apply plaster and a reinforcement of burlap, hemp, or hardware cloth along the inside seams. If the opening is narrow, pour thin plaster in and out of the mold along the seam lines and push seam reinforcement down with a stick.

Chemical action will generate heat in the plaster; when it cools, it has become recrystallized, or set. While setting, the plaster gains physical strength and should not be disturbed for several hours. The mold should never be left to dry out while plaster sets, but should be kept covered in plastic, since it is difficult to separate a dry mold from the cast.

Chipping Off the Mold

1. Tear off reinforcement irons and burlap, which hinder cutting. Begin chipping along the seam near the bottom edge, where the separation is usually most clear and any damage done will be the least visible (see Figure 8-5). Hold a blunted chisel at a slant of 45°

Figure 8-5
Chipping off mold.

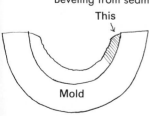

Figure 8-3
Beveling from seam.

This

Not this

Mold

Mold

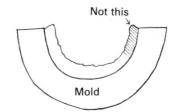

Figure 8-6
Inserting pipe.

and tap it gently with a mallet, cushioning the mold against the blows. The least confusing manner of chipping is to systematically cut one area at a time. Uncovering the blue coat indicates proximity to the positive. Go lightly at that point, or the chisel will make nicks in the cast. Often the blue coat is soft and thin in areas and may be gently peeled off with a knife or fingernail. The newly exposed plaster is very soft and should be protected from damage by resting it on a soft surface free of debris.

2. After removal from the mold, the plaster cast should remain moist until all patching is complete. Fill in chip marks and seam lines with a very thin mix stirred little or not at all—sometimes referred to as killed plaster, which has the advantage of extremely slow setting and adhering better to the cast surface. It tends to match the surface in hardness and color, although at times there is some disparity between the original and the patched area.

3. At this stage, a pipe or bolt can be inserted in the hollow cast (see Figure 8-6). Pour a small amount of plaster into the hollow, insert the pipe before the plaster sets up, and also attach it at the base of the opening with burlap strips dipped in plaster.

4. Before sanding, sealing, and finishing the surface with color, the plaster must be completely dry. Drying should take place soon after patching, with drying temperatures never exceeding 125°F. A dry plaster surface responds to gentle sanding with fine sandpaper and even paper toweling.

Types of Plaster

1. *#1 Industrial Molding Plaster* (soft plaster of Paris) sets in 20–35 minutes, is easily carved, is the best all-around plaster for molding and casting, and least expensive. Mixing ratio: water 70/plaster 100.

2. *#1 Casting Plaster:* Slightly harder and more dense than molding plaster, it has a small amount of hardening additive and develops a hard surface upon drying, making it good for casting, less desirable for waste molding or direct plaster. Art plaster is similar but not as hard or chip resistant. Mixing ratio: water 70/plaster 100.

3. *Hydrocal B-11® Cement*[1] is a gypsum cement with high plasticity and gradual setting action, making it good for building up work; sets in 30 minutes. Mixing ratio: water 44/plaster 100.

4. *Hydrocal A-11®* is used for pattern making in industry because of its hardness and high strength. Smooth, hard surfaced, it stiffens rapidly (20 minutes), with a shorter period of plasticity than B-11 and sets in about 15–20 minutes after mixing. Mixing ratio: water 42/plaster 100. Hydrocals run about 2½ times the cost of molding plaster.

5. *Hydro-stone®*, one of the hardest gypsum cements, is not suitable for carving when set. Heavy consistency, ideal for pouring solid models, greater expansion than Hydrocal A-11 or B-11. Mixing ratio: water 32/plaster 100.

6. *Ultracal 30®*: Harder and stronger than hydrocal. Lowest expansion of all, long period of plasticity, recommended where extreme accuracy and greater surface hardness are required. Gradual set. Available in slower set called Ultracal 60® which sets in 1 hour and is designed for large models. Mixing ratio: water 38/plaster 100:

7. *Keene's Cement,* called an accelerated plaster, is calcined gypsum powder with the moisture evaporated by sustained exposure to high heat. Alum or salt is added as a hardener. When mixed, Keene's cement has a long period of plasticity before setting and hardens with a density similar to white cement. It is slightly higher in cost than molding plaster.

There are also specialized plasters: pottery plasters, designed as a casting and forming plaster; Hydrocal FGR® Gypsum cement, a gypsum reinforced with 6% glass fiber; and Tuf-Art® Plaster FOM, a blend of gypsum cement, polymer, and glass fiber. Both Hydrocal FGR and Tuf-Art Plaster produce lightweight casts more shatterproof than plaster. Tuf-Art plaster works well as a shell mold for flexible molds, allowing a shell 25% thinner than plaster. Hydrocal FGR may sometimes substitute for plastic, costs two-thirds less than most thermosetting plastic, and is nontoxic. Mixing ratio of FGR is water 25/plaster 100. Tuff-Art ratio is water 75/plaster 100.

CASTING IN CONCRETE

Cement mixtures known as *stucco* had been discovered in ancient times. The Greeks applied varying combinations of cement, lime, and sand as an exterior coating over rough stonework. The Romans developed a range of stucco mixtures and a concrete resembling modern masonry. The interior of their structures was covered with mixtures of plaster of Paris or powdered marble. For

exteriors they developed a very durable material of volcanic earth, lime, and broken tuffa, the same material which built the Pantheon and the Baths of Caracalla. After the fall of the Roman Empire, concrete disappeared from general use until 1756, the year hydraulic cement was rediscovered. Portland cement and scientifically proportioned cement mixtures were developed in the 1820s and 30s, and the first patented cement mixture was manufactured in the United States in 1871. Developments since have tried to overcome concrete's tensile weakness and susceptibility to cracks due to moisture and freezing temperatures. *Reinforced concrete* was provided with an interior metal armature. *Prestressed concrete* is compressed concrete under tension using frames or cables. The inherent structural strength of certain geometric shapes such as ellipses, folded slabs, and hyperbolic parabolas was used to span great distances with little material. *Air-entrained concrete*, especially useful for roads and airport runways, is cast with a resinous material that produces air cells that allow the material to expand when freezing. Sculpturally, cement has served primarily in cast stone figurative works and precast panels, and has only occasionally been used monumentally or as a carving material in lieu of stone (for example in the early works of Henry Moore). (See Figures 8-7 and 8-8.) Concrete has also been applied directly over an armature, though this often presents more difficulties than casting. Integrating concrete with extensive color and texture has yet to be fully explored.

Concrete designates a mixture of cement and water with aggregates of sand, gravel, stone, grog, etc. When the aggregate is stone chips which are polished and brought out as decorative accents in the finish, the concrete resembles natural stone and is called *cast stone*.

Cement for concrete consists of 60% lime (calcium oxide), 25% silica, 10% alumina iron oxide, and a small amount of gypsum to help regulate setting or hardening. Lime for cement is derived from limestone (calcium carbonate) and "marl" (clay); clay and blast furnace slag provide silica and alumina, and the iron ore contributes iron oxide. In manufacturing, limestone is reduced to a powder which is then made into a slurry and fired 4 hours in a kiln from 2600°–3000°F. The resulting *clinkers*, or marble-size chunks, are ground into fine powder and packed into 94 lb. sacks equaling 1 cubic foot of cement.

Early strength cement cures rapidly in a few days; *white cement* is for white and light color. *Portland cement* (not a trade name) is a cement

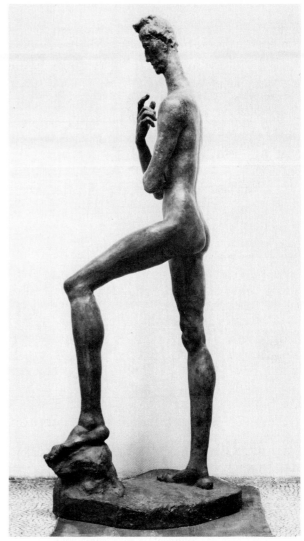

Figure 8-7
Wilhelm Lehmbruck, *Standing Youth*. 1913. Cast stone, H. 7 ft. 8 in. at base, 36 × 26¾ in. Collection Museum of Modern Art, New York. Gift of Abby Aldrich Rockefeller.

of uniform strength and consistency resembling an English limestone called portland stone. *Mortar* is a combination of cement and sand (fine aggregate only). Cement and water mixed without aggregate is called *neat cement*. Its fine consistency allows for registration of surface detail that rough aggregated mixes might otherwise blur.

Aggregates, ranging from fine sand to 2" gravel (maximum size) or stone chips, make up the bulk portion of the concrete mixture. Fine aggregates include stone or brick dust, silica powder, fine sand, and talc; coarse aggregates are crushed marble, crushed fired terra cotta (grog), granite, or gravel. Lighter-weight castings may incorporate mineral granular fillers of perlite and vermiculite (also called zonalite). Crushed marble graded from coarse to

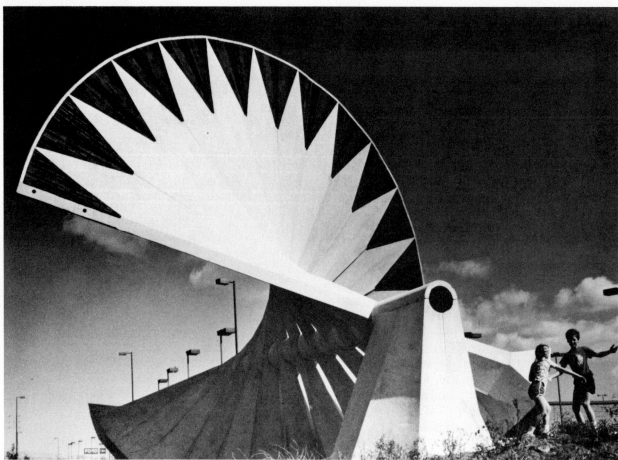

Figure 8-8
Jacques Overhoff, *Torque*. 1979–81.
Auto Plaza Sculpture Project, Richmond, Cal.
H. 40 ft., L. 40 ft. × 60 ft. Precast concrete and mosaic tiles, white concrete.
Twelve precast elements fastened to a central torsion axle supported by triangular
cast-in-place buttresses. Forces of precast cantilevered elements are transferred
through the outside support into a square foundation platform.
T.Y. Lin International, Structural Engineers, San Francisco, Cal.
Photo courtesy Jacques Overhoff.

fine mesh is available in colors from white and cream to pinks, browns, grays, and rich greens. Large aggregate marble chips pressed mosiaclike against the surface of the mold produce an effect called *terrazzo*.

Aggregates must be chemically inert, stable, durable, and not break down the bond with cement (as would, for instance, a ground-up metal like lead). Particles are graded through wire mesh sieves having a certain number of openings to every lineal inch. 50 mesh means 50 sifted particles per lineal inch, finer than 9 mesh (9 particles per inch), and coarser than 100 mesh.

The proportion of cement to aggregate depends on the cast concrete's size and function. In a fine mixture the ratio of aggregate to cement de-creases; a very fine mix consists of equal parts cement to aggregate. As the aggregate increases in size, a greater proportion of fine and middle-grade aggregate is needed to hold the large aggregate in suspension. Conversely, the finer the aggregate, the greater the proportion of cement required. The mixture for a large-scale sculpture might contain one part ⅜″ aggregate, 1 part ⅛″ aggregate, 1 part sand or stone dust, and 1 part cement. Larger particle aggregate, ranging from ⅜″ to gravel or stone aggregate of 1½″, would be mixed in the proportion of 4 to 5 parts aggregate (including ¼″ sand) to 1 part cement.

Concrete can be colored with cement pigments specifically designed to be limeproof, lightfast, uniform, and strong. Available at builder's supply

houses, the colors are added in quantities of ½ lb. color per 94 lb. cement sack for light colors, up to 6 lbs. per 94 lb. sack for intense colors. Earth mineral colors, pure and free of the talc contained in ordinary dry pigments, can be added in amounts up to 10%; yellow and red ochres, burnt siennas, and ambers for reds, yellows, browns, and black-browns, manganese dioxide for black and brown, and chromium oxide for green. Ultramarine blue, carbon black, and zinc white can be added in the same amounts. Make color tests by carefully weighing or measuring, then thoroughly mixing the powdered color into the cement-aggregate mix. Allow the test to dry thoroughly before judging the results. To make the mix uniform, premix the color with a small quantity of dry cement before adding it to the large batch. Always save a small quantity of dry colored cement for later patching.

Mixing Concrete

Shovel together thoroughly *by hand* a measured quantity of dry cement and aggregate in a flat-bottom box or on a clean surface. Make a depression in the center and fill it with just enough water to wet the powder. Stir the powder into the pool of water until it forms a uniform, dense mixture, the consistency of thick cream if pouring into the mold; a thick, stiff paste for lay-up or ramming (see Figure 8-9). For large casts, use a *cement mixer*. Water in predetermined amounts may be added to the dry ingredients, or stir dry ingredients into a premeasured quantity of water. Specified amounts of commercial bonding solutions, available at builder's supply houses, can be mixed with the water and added at this time. Hot water, or calcium chloride, 1 to 2 lbs. per sack, can be added as an accelerator. *Retardants* detain the cement cure, making it possible to brush uncured cement from the surface and expose the aggregate more effectively. Paint retardants directly on the mold surface before casting.

Figure 8-9
Mixing cement—adding water.

Mold Preparation

Plaster molds for concrete castings must withstand considerable pressure from the ramming and tamping of the filling cement and must therefore be thick (1″ or more) and heavily reinforced. The durability of the mold is particularly important for a piece mold which is to be reused several times. Concrete may be cast hollow in a plaster or flexible mold using the lay-up technique or the closed mold method. While making original clay, wax, or plasticine models intended for cement, remember that the material lends itself to broad forms and tends to blur fine lines and relief lower than ¼″. Plan a way of reaching inside the mold to seal the seams, either through a large opening or a separate section to be replaced after the major portion of the mold has been filled (See Figures 8-10–8-15).

The plaster mold can be prepared first with sealers of lacquer or thinned shellac and then oiled, or oil can be applied directly, without a preliminary sealer. If sealer is used, the mold should be dry when it is applied and the sealing coat allowed to dry completely. The mold is then saturated with water to prevent absorption of water from the cement, and greased or oiled with linseed oil, Vaseline, or stearic or engine oil.

Filling the mold

1. If you can reach inside the closed mold, casting can be carried out with the sections assembled. A completely enclosed mold, with no opening to the outside, must be cast while open. Then the pieces are pressed together and bound tightly for close adhesion at the seams.

2. For a rough estimate of the amount of concrete needed for hollow casting, solidly fill the dry mold with unwetted concrete powder. The dry volume plus some extra will be close to the total wet mixture necessary. (Do this before oiling the mold!)

3. For filling, mix cement and aggregate to a dense, stiff consistency, packing and tamping well into the mold to a thickness of ¾–1″. Then press or insert fiberglass, wire mesh, or ³⁄₁₆ rod mild steel reinforcement (not burlap, which disintegrates in cement) into thin extending parts or within all the larger forms. Integrated reinforcement assures a durable cast, with the even thickness that is an important factor in controlling the rate of expansion and cracking. The casting sequence for integrated reinforcement might be as follows: a layer of neat cement for a detailed, dense surface followed by alternate ¼″ to ½″ thick layers of fiberglass and concrete until a total of ¾″ to 1″ is reached.

Figure 8-10
Modeling clay relief to be cast into concrete panels. Students at Clackamas Community College, Oregon City, Oregon. Photo by author.

Figure 8-11
Dividing relief into 2 × 3 ft. sections for plaster mold using steel strips which have been oiled for separation. Photo by author.

Figure 8-12
Filling plaster mold with reinforced concrete. Photo by author.

4. Totally complete each open mold section before going to the next. Bevel the concrete down 45° from the seams for close fitting of the mold pieces. To assemble, fit sections with firmed concrete gently over those with the material still soft. Bind the sections together as they are assembled. Fill curved sections of the mold by pressing concrete in the lower portion first. When this has firmed, tip the mold until the overhang with the hardened filling is on top. Fiberglass reinforcement will help hold the concrete to the curved surfaces.

5. Concrete can be poured into the enclosed mold as a solid mass and vibrated, but it is quite heavy and less reliable than tamping in assuring fidelity to detail. Solid pours work best for reliefs and forms with narrow diameters.

Curing

Cement will set up or harden in a few hours, but not cure (reach maximum strength) for days. Since cement is a hydraulic material, and hardening is most effective under water, cover the cast with wet cloths for three days before removing it from the mold. Patch the green cement immediately after removal, using a cement bonding agent and a reserve of the original casting mixture. Finishing tools include chisels, files, portable air and electric grinders, or drills using various surform drums, sanding drum wheels, and wire brushes. Attach mounting hardware and keep the work damp while curing for at least a week. If the aggregate is to be exposed, sandblast the surface with a small compressor, or transport the work to an industrial foundry where sandblasting is routine for finishing metal castings. Gentle sandblasting is necessary to preserve surface detail. For indoor surface finishes, a wax or coating of clear plastic is sufficient; for outdoors, use a commercial concrete sealer such as *Horntraz*.

PRESS AND SLIP CASTING WITH CLAY

Clay introduced into a mold in liquid or solid form, though traditionally a commercial process, can become a creative approach to sculpture. Contemporary assemblage-type ceramic sculpture often makes selective use of commercial molds or molds from ordinary found objects for bizarre and surrealistic effects. Although primarily a commercial process, press and slip mold casting can be combined with hand-building and experimental decorative techniques.

Figure 8-13
Drilling concrete relief for hanging with steel strips. Photo by author.

Figure 8-14
Completed four-part relief with the same mold used for second and fourth relief. The reliefs, entitled *Oregon City Theme*, were cast, designed, and installed by students at Clackamas Community College under the supervision of sculpture instructor Lorraine Widman. Photo by author.

Figure 8-15
A single side panel of concrete relief project. Design by student Jerry Hermann. Photo by author.

The Press Mold Method

Press clay of normal modeling consistency—plastic but not sticky and containing grog—evenly into a dry plaster mold to about a ¾" thickness. The mold must be bone dry to insure absorption of moisture from the clay. Dust mold surfaces with talc or French chalk, though talc must not stray into the clay body during the pressing operation, or it will prevent the clay from adhering to itself.

1. Using your thumbs, press well-wedged plastic clay into the middle of the mold, working the thumb to spread the clay outward. To avoid separation lines on the surface, new clay should be joined by pressing on top rather than beside the old clay.

2. Work each mold piece separately, beveling the edge of the clay slightly outward to facilitate joining. Wet the edges until sticky and press the pieces of the mold together using rubber inner tubing straps, heavy cords, or burlap strips dipped in plaster.

3. Insert hand or tool to fill the seams with clay and even out the walls. Leave the clay to dry until the leather-hard stage before removal.

Sculpture designed for a press mold should have a relatively simplified surface with no deep undercuts. It is best to design the mold with a way

of reaching inside to fill the seams and even out the wall thickness.

Slip Casting

Slip casting, primarily a commercial method, limits the sculptor since both form and clay quality must be highly controlled (see Figures 8-16–8-20). Liquid clay is poured into a mold without pressure or force of any kind, resulting in rather soft surface detail and relatively porous clay walls. Slip-cast pieces are characteristically fragile and smooth due to the refined clay necessary for the pouring process. Lacking grog, the slip cast tends to shrink and distort easily. Preparation of the clay slip is important, since it must be smooth, free of lumps, and properly deflocculated. Deflocculation promotes homogeneity by keeping heavy particles in suspension so that they don't settle to the bottom. Deflocculant electrolytes will reduce the amount of water or plasticity in the clay, which in turn increases the body's workability and strength and helps reduce shrinkage as the clay dries. Sodium silicate (water glass) and soda ash (sodium carbonate) can be used separately, or together in the proportion of 3 parts sodium silicate to 1 part soda ash. The amount of deflocculant depends on the

Figure 8-16
Plaster piece mold for clay slip casting (commercial mold). Photo by author.

Figure 8-17
Straining clay slip in preparation for casting. Photo by author.

Figure 8-18
Pouring clay slip in and out of dry plastic mold until mold is filled. Photo by author.

Figure 8-19
Breaking apart three-piece plaster mold. Commerical cast filled with clay slip. Photo by author.

Figure 8-20
Cast clay form dried and ready for firing. Photo by author.

clay body, but the recommended amount is of ¼% to ½%, up to a maximum of 1% of the weight of the dry earth clay. Erring in either direction will result in an overly thick slip. Make tests on small quantities, checking for the correct consistency—that of liquid plaster. Excess deflocculant will leave a calcium silicate film inside the mold, which will eventually corrode it completely. Drying the mold between pours will prevent some corrosion, but after twenty or so castings the abrasive effect of the alkalies and clay will wear the mold down.

Slip bodies may be made of any fine process clay powder, though the main components are usually uniform-particle kaolin and ball clays. To make slip, dissolve electrolytes in hot water and add the liquid to the mixing water before sifting in the powdered clay—in the approximate proportion (by volume) of 3 parts clay to 1 part water or (by weight) clay equal to twice the weight of the water. Slip of proper consistency weighs from 52 to 58 oz. per quart, the heavier weight suitable for larger castings. Let the slip mixture stand (oxides may be added at this point for color), stir occasionally, and screen for smoothness. For pouring, first stir and vibrate the slip to remove air bubbles, then pour slowly into the assembled mold, which must be completely dry to absorb the clay's moisture. As the slip is poured, vibrate the mold gently to remove air. As the slip begins adhering to the inside, add additional slip to keep the mold filled to the top. As a variation of the above method, pour slip into the mold, pouring the excess slip out after each layer has coated the surface—until the desired thickness has been reached. Tip the mold to check on the thickness of the sides, which should be a minimum of ¼" to ⅜". After about 10 minutes of pouring and rotating, pour out excess fluid and let the mold drain slowly for about 1 hour in an inverted position. Shrinkage of the clay allows for easy removal from the mold, but be gentle to avoid injuring the fragile cast.

RELEASE AGENTS FOR MOLDS USED FOR COLD CAST MATERIALS

Mold Material	*Release Agents*	*Cast Material*
Plaster	Clay wash Clay film Shellac and oil Shellac and wax Oil Soft soap and oil	Concrete Cast stone
	Soft soap and oil Shellac and wax Oil	Plaster Plastic stone (Hydrocal FGR)
	Wax and PVA	Polyester resin and glass fiber
Polyester resin and glass fiber	Wax and PVA Oil or wax	Polyester resin and glass fiber Concrete, *ciment fondu*
Flexible hot-melt compounds—cold cure silicon rubber latex (limited life when casting in polyester resin)	None necessary	Plaster Plastic stone *Ciment fondu* Concrete Cast stone Polyester resin and glass fiber (limited life to latex mold when casting in polyester resin)

9

Cold Casting
(Plastics)

HISTORY

The development of synthetic plastic actually spans the last 100 years. In the mid-nineteenth century, experiments began in molding natural materials like *gutta-percha*, a juice from the palaquium gutta trees of the Malay Peninsula, and *lac*, the deposit of scale insects on soapberry and acacia trees which is used to make shellac. Cemented asbestos fibers mixed with adhesive was used for molding small objects. Celluloid, invented in 1869, was the first synthetic plastic, followed by viscose rayon, the first man-made fiber (1884), cellophane (1908), and bakelite, the first synthetic resin (1909). During the 1920s and 30s, cellulose acetate, polyvinyl chloride, acrylic, polystyrene, and later, nylon began to be produced commercially. Post–World War I Constructivist sculptors Antoine Pevsner and his brother Naum Gabo combined fabricated plastics in sheets with the materials of wood and metal (see Figure 9-1). Naum Gabo's *Constructivist Manifesto* makes a case for the use of commercial plastics technology to create a new concept of three-dimensional sculpture. Gabo rejected traditional clay, wood, and stone, which gave a con-

crete sense of mass and volume, in favor of translucent plastics combined with reflective metals that evoked more abstract ideas of movement, time, and space.

During World War II, plastics were substituted for scarce traditional materials, resulting in rapid development of polyester, polyethylene, silicons, and epoxy; and in the post–World War II decades, polyurethane and a galaxy of highly specialized plastics were developed, many of which had the impact strength and the thermal and dimensional stability to compete with metals.

CHEMICAL COMPOSITION

The raw materials for plastic are derived from petroleum, coal, limestone, milk, salt, sand, atmospheric nitrogen, wood, and vegetable matter. The large molecules of these natural materials, called *monomers*, join together in chainlike patterns to form polymers. Multiples of these polymer units are *high polymers*; combinations of different monomers linked in a pattern are called *copolymers*. Compounds are built up by uniting basic elements

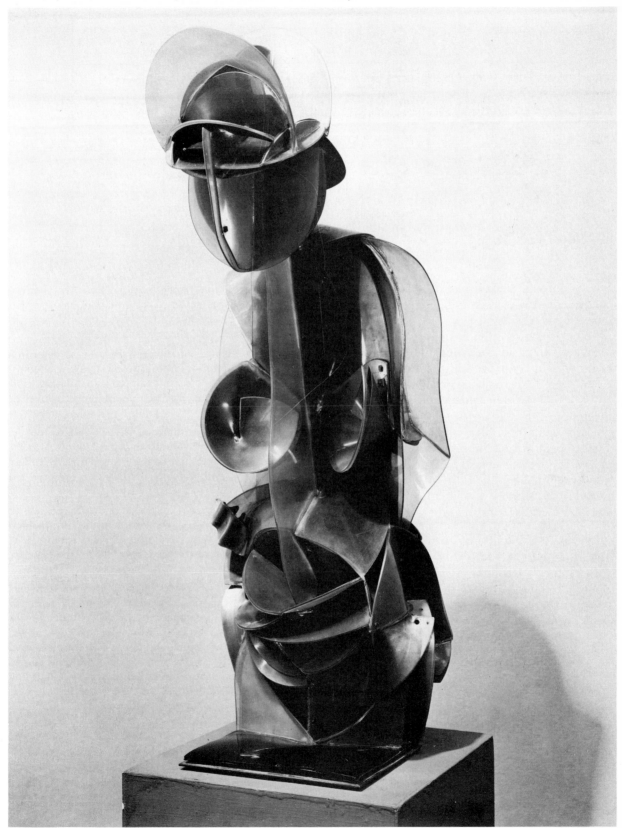

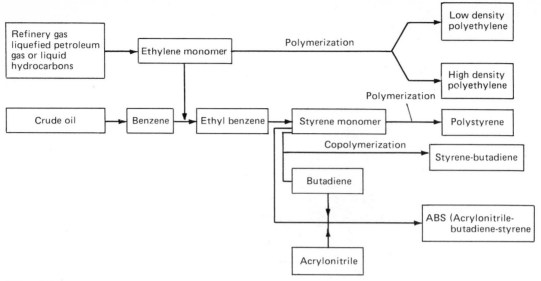

Figure 9-2
Ethylene's role in the manufacture of polyethylene, polystyrene and copolymers.

or by combining elements of other simpler compounds, resulting in a synthesis, or *synthetic* plastic (see Figure 9-2).

Molecule chains differ in their reaction to heat, producing two basic categories: *thermosetting* and *thermoplastic*. Upon heating, the molecules of the thermoplastics slip and become flexible. They become stationary when cooled, but slip again when reheated, resulting in a substance that, like wax, is plastic when hot, firm when cool. When subjected to heat or pressure, the molecules of thermosetting plastics crosslink into a permanent structure. Once heated, these plastics harden irreversibly, similar to the chemical change in a hard-boiled egg (see Figure 9-3).

PLASTIC PROCESSES[1]

Common to all plastics are the basic processes of casting and molding, which incorporate heat and/or pressure (see Figures 9-4–9-14).

Figure 9-3
Thermoplastic and thermosetting plastics.

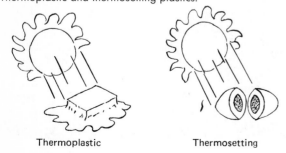

Thermoplastic Thermosetting

1. *Casting*—Using either thermoplastics or thermosetting plastics, softened or liquid material is poured into an open-ended mold and hardens (with or without heat) into the shape of the mold.

2. *Coating*—Plastic in metered amounts is deposited and spread by mechanical means (spraying, electrostatic spraying, brushing, dipping, spatulating, fluidized bed coating, and metallizing) over a sheet or object.

3. *Calendering*—Pressure and heat of rollers convert thermoplastic compounds to plain or textured sheet form. The plastics material is pushed through rollers and, while still warm, coats fabric or material fed into the rollers at the same time.

4. *Vacuum forming*—Thermoplastics are heated to softness and pressed over a mold cavity from which air has been evacuated from below. Atmospheric pressure pulls the softened sheet into the mold, where it cools and hardens.

5. *Hand lay-up*—Consists of molding room temperature curing thermosetting polyester and epoxies with fiberglass reinforcement by spraying, brushing, or spatulating catalyzed mixtures into or onto a mold. Layers are built up, cured, removed from mold, and trimmed. Variations include bag molding, drape molding, vacuum table molding, spray-up, and low compression molding.

6. *Laminating*—A hydraulic press's extreme heat and pressure impregnate layers of wood, cloth, or paper with thermosetting resin. Thermoplastics can be laminated with this method, but the material must be placed between cold platens which are then heated and cooled under pressure.

7. *Molding*—*Injection molding* forces a thermoplastic (occasionally a thermosetting plastic) through a heated revolving cylinder into a cold mold, where it quickly

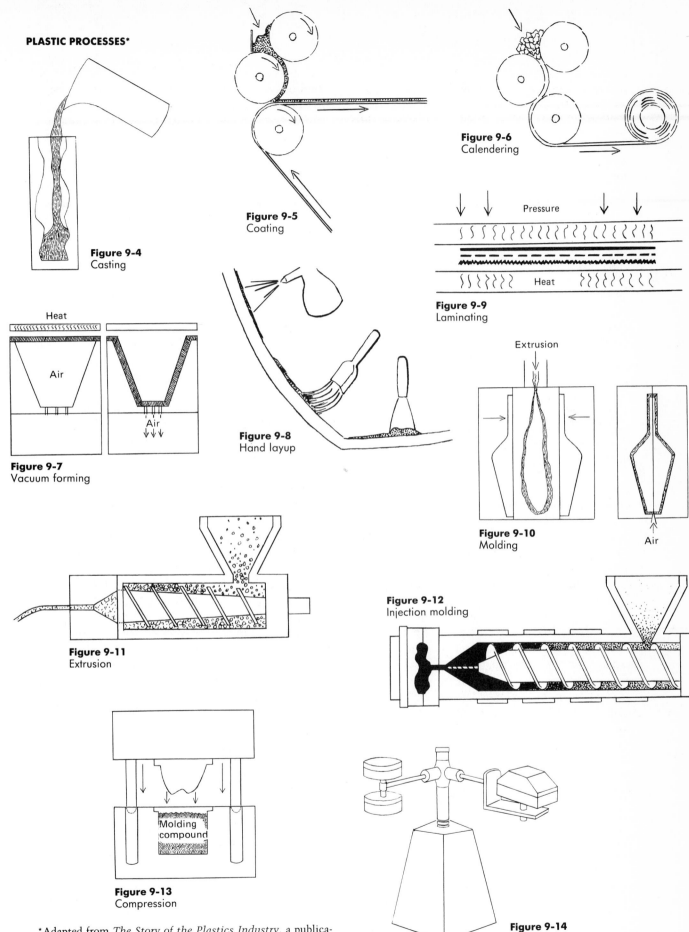

PLASTIC PROCESSES*

Figure 9-4
Casting

Figure 9-5
Coating

Figure 9-6
Calendering

Pressure

Heat

Figure 9-9
Laminating

Heat

Air

Air

Figure 9-7
Vacuum forming

Figure 9-8
Hand layup

Extrusion

Air

Figure 9-10
Molding

Figure 9-12
Injection molding

Figure 9-11
Extrusion

Molding
compound

Figure 9-13
Compression

Figure 9-14
Rotational

*Adapted from *The Story of the Plastics Industry,* a publication of The Society of The Plastics Industry.

cools into shape and is ejected. The method was patented in 1872 to mold cellulose nitrate. *Compression* and *transfer* molding use hot molds and plunger methods to press the material through a nozzle into the mold cavity. It was the earliest (1870) and until injection molding, the most important method of forming thermosetting plastic. *Blow molding* is used for making hollow containers and tubes: Plastic extrudes through a hollow tube into a two-sided cold mold. An air jet blown into the tube expands the plastic to the contours of the mold. In *rotational molding* a multiarmed machine rotates into first a heating, then a cooling chamber, where the thermoplastic hardens into the configuration of the mold. Not oriented, rotationally molded plastic is therefore free of stress points.

8. *Extrusion*—Molten thermoplastic material is forced through a shaped die at the end of a heating chamber consisting of a continuously revolving screw. The action of the screw moves the plastic into the die shape and onto a cooling conveyor belt in an action similar to that of a meat grinder. Wide film or sheeting is split as it comes from the die, then stretched and thinned to desired dimensions. *Coextrusion* incorporates in a single structure several layers of different plastics, offering varying degrees of moisture, resistance, etc.

Foam plastics molding generally uses similar techniques, but blowing agents in the resin decompose under heat to generate the gasses needed to create the cellular structure. Applying steam to expanded polystyrene beads makes them expand and fuse together in the mold (see Figure 9-15). Structural foams are processed using low-pressure casting, high-pressure injection molding in which the mold itself expands, and expansion casting involving the use of closed metal molds filled with expandable pellets and subjected to a heating cycle which expands and fuses the material.

Fabrication Techniques.[2] Machining, cutting, sewing, sealing, grinding, reaming, milling, routing, drilling, tapping, and turning on the lathe are methods of turning cast or molded secondary shapes of plastic into finished products. For soft plastic garments, luggage, and toys, the plastic sheet is cut out and assembled by sewing or by thermal, high frequency, or ultrasonic sealing. Stiff sheets of thermoplastic are formed by bending and joining with hot gas welding, standard paper creasing, and folding machines, or vacuum formed by heating the sheet and forming the softened sheet over a mold. Fabrication of plastics will be covered more completely in chapter 11.

Thermoplastics—Types

Thermoplastics most useful to the artist are the acrylics, polyvinyl chlorides, cellulose acetates, and polystyrenes.

Acrylic in clear or translucent sheets can be cut and glued, or shaped by vacuum forming. As a solid, it can be shaped with abrasive tools. Acrylic in resin, slurry (a thick liquid of acrylic powders added to liquid monomer), or powder form has been cast successfully on a small scale, but is still in the experimental stage for large-scale work. The material's extreme exotherm and shrinkage requires that thicknesses greater than ½″ be poured under pressure in an autoclave. In molds with many undercuts and projections, stress due to shrinkage may be alleviated somewhat if molds are designed to move or break off as the cast shrinks.

Molds for acrylics should be nonporous, or if porous, like plaster, should be fully dry and sealed with wax or silicon. Acrylic resin or slurry is de-aired by vacuum and poured into a mold. The mold is placed inside an autoclave and slowly heated to produce polymerization at a maximum temperature of 250°F—a process taking up to several weeks for large works. To anneal the material, heat is gradually reduced and sustained at low

Figure 9-15
Styrene foam molding

temperatures without pressure. Annealing must be repeated each time the acrylic is machined or polished. Passing a flame quickly over the acrylic surface will help remove abrasion marks. Acrylics are desirable for their optical clarity and high (92%) light transmission, nontoxic quality, and excellent impact strength. Strong and rigid, they have extreme weatherability and are impervious to the action of many chemicals (exceptions are perfume, gasoline, cleaning fluids, and acetone).

Polyvinyl chloride, a member of the vinyl family, includes a flexible PVC, with added plasticizers, which is the material used for flexible molds. As the copolymer *polyvinyl alcohol* (PVA), it is used as a release coating for lay-up of plastics (providing a water soluble film), and may also be cast into a rigid material.

Cellulosics stem from the cellulose nitrate group introduced in the 1900s, but include cellulose acetate, cellulose acetate butyrate film, and cellulose propionate. Manufactured by Eastman Chemical Products[3] under the trade name *Uvex*, most cellulosics soften easily at about 230° to 320°F, and resist moisture, impact, and chemicals. For the vacuum-forming process, cellulosics can be formed at lower temperature and shorter heating time than can acrylic. Specifically, samples 0.125" (3.18 mm.) thick of *Uvex* needed 240° to 280°F; acrylic 320° to 350°F; *Uvex* heated in 95 to 150 seconds; and acrylic 154 to 170 seconds. The forming cycle took 5:50 minutes for cellulosics, and 6:50 for acrylics.

Polystyrenes or styrene can be processed by thermoplastics techniques. The foams have high strength-to-weight ratio, low water absorption, and good chemical resistance. In expanded form, they are most useful as a lightweight armature material for direct plaster and as disposable mold material for casting large architectural reliefs. For a direct negative, cut the foam sheets by sawing rather than melting them (melted styrofoam releases cyanide gas), and/or glue additional shapes of foam onto the sheet; these forms are shaped by carving or grinding with abrasive tools. Separators of wax, oil, or PVA applied to the polystyrene mold prevent the cement from bonding to the surface when the foam mold is removed.

Thermosetting—Types

Thermosetting plastics include the silicons, polyurethane, epoxies, and polyester resins. *Silicons*, with high heat, chemical, and water resistance are used as flexible molds, lubricants, and mold-release agents. *Epoxies* are available as adhesives, protective coatings, sealants, and as resins in combination with fiberglass for reinforced plastics or injection molding. They shrink less and demonstrate greater tensile strength and somewhat more flexibility than polyesters. Epoxies have excellent water, weather, and chemical resistance, but are more expensive than polyesters. They are also less clear than polyester in their transparent form and produce more toxic fumes.

Polyester resins are formulated for such a broad range of purposes that the viscosity, curing, and weathering qualities of each type should be checked with the manufacturer. Flexible polyester resins can produce objects in a wide range of sizes with both molding and lamination processes. With glass fiber reinforcement, they offer a high strength-to-weight ratio, chemical resistance, and are adaptable to coloration and variations in transparency. *Polyurethanes* consist of foams and solids, with each group containing a rigid and flexible type. Solid, flexible urethane is used for moldmaking. Foamed polyurethane for casting is a rigid, high-density material not to be confused with the more open, cellular styrofoams. Also available as coatings, adhesives, and sealants, the urethanes are generally considered thermosets, though a few are thermoplastic in nature.

Casting Polyurethane Foam[4]

Minute details can be reproduced in polyurethane foam from a properly prepared mold or pattern. Mold materials are preferably latex, flexible urethane, or flexible silicone, and must be dry, since urethane is extremely sensitive to moisture. All but silicone rubber mold surfaces should be treated with recommended release agents like wax or silicone. Silicone molds may not need a release agent, but should have heat of about 200°F applied before casting to avoid bubbles in the plastic caused by moisture from the rubber. Preheating the mold will hasten a cure in castings with sections under ¼", as due to lack of heat buildup, thin sections cure slowly.

Polyurethane foams are prepared by two reacting liquid components—polyols (B) and isocyanates (A)—weighed and blended together in equal parts. The mix is stirred for 1 minute maximum, scraping down the sides often, and poured, sprayed, or injected into a mold before 2 minutes has elapsed. The cast's demolding time is 15–20 minutes, with maximum hardness reached within 24 hours (shore D hardness of 70) (see Figures 9-16 and 9-17).

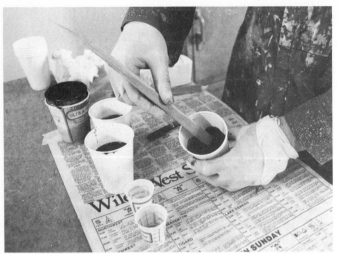

Figure 9-16
Mixing polyurethane foam, rigid type. Photo by author.

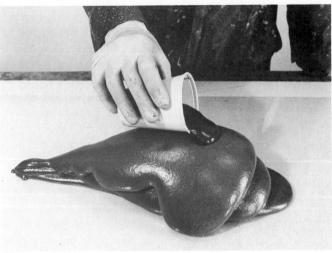

Figure 9-17
Pouring rigid polyurethane foam; instant expansion of foam. Photo by author.

Cured urethane changes to a tan opaque solid and will darken slightly when exposed to sunlight. If it is to be painted, test the adhesion of the particular paint since it may be affected by the internal lubrication of the urethane. Rigid urethane can be drilled, sanded, and machined with woodworking tools, can vary in density from 1 to 50 lbs. per cubic foot, and can be developed with more or less porous skin surfaces. New reaction or liquid injection molding techniques inject isocynate and polyol directly into the mold where the reaction takes place, producing nonporous, solid surface skins known as integral skin foams.

In unopened containers, components will keep at least three months at room temperature, but are susceptible to atmospheric moisture. Sedimentation can be dispersed by slight mixing or heating to 170°F, then mix and allow to cool to room temperature. The material sets so rapidly there is no time for cleaning tools, so use disposable containers of paper, metal, or polyethylene. Acetone and MEK (*methyl ethyl ketone*) will soften cured urethane, but cellosolve acetate is a less flammable solvent. When casting resins for any length of time, provide adequate ventilation and avoid prolonged skin contact.

Casting Polyester Resin

Some flexibility is possible, but most polyester is a rigid formulation controlled by the amount of styrene monomer (up to 30%) which has been combined, in the manufacture of the resin, with the viscous polyester molecules. Resins are formulated differently, depending on whether the purpose is for lamination or casting thick layers or masses. Agents for setting up the resins are catalysts for the promoted type and promoters for the nonpromoted types. Most resins are now available in the prepromoted form. The newer water-extended resins increase volume by 50%, with shrinkage occurring after curing when the water evaporates.

The catalytic agent, usually the organic peroxide *methyl ethyl ketone peroxide*, triggers crosslinking of the polyester molecules. The amount of catalyst varies, depending on the thickness of the cast, the temperature at the time of casting, and mold material. For a thickness of about ¾" poured in 60° to 70°F temperatures, the amount would be 2 to 3 drops of catalyst per ounce, dropping down to ½ drop per fluid ounce at 85°F temperatures. A thickness of 1" to 2" generates more exotherm, causing a reduction in catalyst to 1 to 2 drops per ounce, decreasing the possibility of cracks.

Comparing the amount of catalyst in a 6" cube to that of an 8" cube, given the same temperature, the 6" might use 2 drops per ounce or 256 drops per gallon, while the 8" cube would drop down to 180 drops per gallon or 1½ drops per ounce. A good rule is to use a minimum amount of catalyst and allow several days for a mass of resin to cure. A heating lamp (150 watt light) helps accelerate cure. Though catalyst and resin proportions can be measured in drop form, utmost accuracy is obtained with a gram scale.

Polyester resin can be made opaque with fillers or opaque pigments, or maintain transparency with transparent dyes. Fillers like perlite and vermiculite affect opacity and decrease the density of the resin. To receive fillers of fine grade, resins should be thinner than laminating resins. To hold coarse-grade filler particles in suspension, resins should be thickened with fine fillers after the catalyst has been measured and mixed with the resin. Types of fillers are calcium carbonate (chalk or whiting), magnesium silicate (talc), and calcined clay, all of which produce a marblelike appearance. Clay is a retardant in thin application, while calcium carbonate accelerates setting for thin coats. In thick application, fillers tend to act as accelerators. Other fillers are sawdust and wood flour (both of which control shrinkage and add impact resistance), carbon black, a colorant and a retardant, metallic powders, and Cab-O-Sil®, a highly refined aerated silica that does not affect the transparency of the resin. Metallic powder fillers premixed with resin and producing a metallic appearance have been marketed as a prepared cold casting "bronze." Reinforcement with fiberglass mat or cloth will help control resin's high degree of shrinkage, running sometimes to 2½%.

Molds for polyester or epoxy should be dry and treated with a release agent of wax or polyvinyl alcohol (PVA). Silicone spray is less effective than PVA and will have an adverse effect on polyester surfaces intended for painting. Waxes tend to cloud the first layer of resin, while PVA puts a film on the mold surface that tends to protect the resin color. Flexible molds, or molds of simple sheet form such as metal or glass, smooth sided and easily disassembled, are preferable. Sheet molds make it easier to obtain highly refined, finished surfaces. As a mold material, negatives of wax can lead to spontaneous exercises in resin casting. The wax can be carved directly and melts slightly from exothermic heat when the resin is poured in, but resets immediately. The wax coating left on the resin surface makes the cast easily removable.

Solid Pour Resin Casting

The glass mold used in this method has several advantages: nonporosity, smooth surface, and transparency to permit checking of levels of pour and the setup. Its low insulating qualities allow for rapid water cooling to dissipate the heat if curing takes place too rapidly. The glass sheets are disassembled easily after casting, but restrict the work to simple, smooth-surfaced forms (see Figures 9-18–9-22)

1. Arrange glass sheets to accommodate the resin; cover with mold release wax or PVA, and hold in place with soft clay that will "give" as the resin sets and moves the glass. The design of a mold for a straight-sided form must compensate for the shrinkage that occurs as each successive layer is poured and set. For pouring a 1" thick slab, set the glass parallel at 1" at the base, but spread it (depending on the number of layers poured) at the top to a slight V. Each layer contracts upon setting, pulling the glass walls in to a parallel position.

2. Introduce color with transparent dyes or powdered pigments *before* the catalyst is added to the resin. A master batch may be colored and kept uncatalyzed until ready for the pour. The thickness of the work determines the amount of dye, since dark color distributed through a thick piece will lighten in tone. Differently colored sections may be poured within the mold by masking off areas with tape or clay. After casting, the masked areas are removed and resin substituted as a bonding agent.

3. Add catalyst averaging 2 to 3 drops per fluid ounce for a ¾" thickness in 60° to 70°F temperature, dropping to 1 to 2 drops for a thickness of 1" to 2". Stir the catalyst back and forth in circles for 30 to 40 strokes and slowly pour the resin into the mold, gently breaking air bubbles with a metal probe. Higher catalyst concentrations will shorten gel time, but should be added by gentle stirring, not whipping, into the resin. Shortened gel time may cause more retention of the air originally stirred into the mixture, as it has less time to escape.

4. A 1" thick by 1" high poured layer will take several hours to set up and become jelly firm. Subsequent layers can be poured when the surface of the previous layer becomes tacky. To absorb exothermic heat generated by the resin, apply cool cloths to the surface, or set the mold in water. As the resin contracts, it sticks to the glass and superficial cracks may occur. In a transparent piece, these can be ground out rather than covered with resin: An opaque work may be patched by covering with additional resin. When a fingernail scratches rather than presses into the surface, the resin has set. The mold may be removed by gently tapping at the edges of the glass.

5. To join resin sections, either use resin as glue and adhere several resin-coated sides of the cast sections together and/or encase sections by pouring a resin coating over all the cured and polished sections. A thickening agent like Cab-O-Sil® added to the resin makes a thick paste for bonding. A thin layer will be colorless, but should be tested for congruity with the piece. To fill seams, push resin and, when appropriate, fiberglass reinforcement, into seams defined by tape on both sides to prevent the resin from

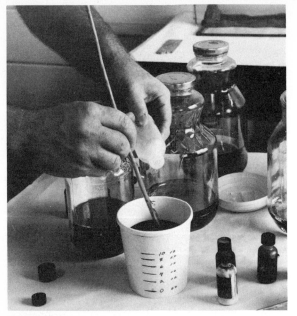

Figure 9-18
Mixing polyester resin—adding catalyst.
Process by Steve Soihl. Photo by author.

Figure 9-19
Polyester resin setting up in sheet glass mold.
Process by Steve Soihl. Photo by author.

Figure 9-20
Separating glass sheet from polyester cast slab. Process by
Steve Soihl. Photo by author.

Figure 9-21
Sanding polyester slab. Process by Steve Soihl.
Photo by author.

Figure 9-22
Cast tinted polyester resin with
fiberglass base by Steve Soihl.
Photo by Diane Kornberg.

straying onto the surrounding surface. After setting, remove the tape and smooth the seam by filing and sanding.

6. Finishing is done only after curing—a matter of several days, depending on temperature. A heater, 150-watt bulb, or 200°F oven will accelerate the cure. Finish surfaces using files and coarse (150 grit) sanding papers on drum, disc, or belt sanders. Following this, hand sand in the opposite direction with wet/dry carborundum papers ranging from 220 to 400 and 600 grit. Polish with a felt disc in a portable buffer and by hand using commercial plastic polishes like aluminum oxide, pumice, and rouge and plastic polishes. Extrafine auto shop polishing compound and car waxes can be applied and buffed by hand.

Resin Lay-up Using Fiberglass (see Figure 9-23)

1. Plaster molds should be sealed with thinned shellac or lacquer before applying wax. Apply wax and PVA release agents in alternating layers to the inside surfaces of a plaster or flexible mold. Release agents should dry completely.

2. The surface of the mold, warmed to 70°F, is painted with a gel coat—a mixture of polyester or epoxy resin with or without a filler of talc, Cab-O-Sil®, calcium carbonate (chalk or whiting), metallic powder, perlite, etc., with or without color. Apply a total of 3 coats, making a 45° angle away from the seam line for close fitting of the mold pieces.

3. Fiberglass cloth of coarse or fine grades (depending on the size and detail of the piece) are pressed into the resin's still tacky surface. Brush or pour another layer of resin over the fiberglass for complete saturation, to a total thickness of ⅟₁₆″ to ½″, depending

Figure 9-24
Frank Gallo, *The Swimmer.*
Polyester resin. H. 65 in., W. 16 in., D. 41¼ in.
Collection of Whitney Museum of American Art, New York.
Gift of the Friends of the Whitney Museum of American Art.

on size. Use a minimum of 3 layers of glass in every part of the sculpture, alternating cloth and layers of mat. A sequence might be gel coat, a layer of glass tissue (in pieces of 3–4 square inches at a time), 1 or 2 layers of 1½ ounce matting, a layer of 2½ ounce matting, and if a large work, woven roving (strands) ending with 6- to 10-oz. cloth. Press out air bubbles between layers by tamping or using rollers. All edges are thickened for adherence of the mold pieces when assembled.

4. Assemble mold sections and, while seams are tacky, press the mold together tightly with strips of inner tubes or burlap dipped in plaster. Add fiberglass reinforcement of the seams if there is access to the inside of the mold. The cast should be released from the mold soon after polymerization of the resin, which softens the wax separating agents, easing removal. Fill seams and voids in the cast before curing. After curing, finish surfaces by sanding, buffing, and polishing.

Figure 9-23
Layering polyester resin into silicon rubber mold housed in plaster mother mold. Photo by author.

Thermoforming Plastic

The method consists of molding softened thermoplastic sheets by pneumatic (air pressure) or *mechanical* means (tools, plugs, solid molds, etc.). These techniques are described as vacuum forming, pressure forming, plug-assist forming, etc.

Early methods of thermoforming involved the use of a forming press after the sheet was oven heated. Recent developments combining heating and forming use continuous rolls of sheet plastic which feed from the extruder to the thermoforming press. Cold-forming techniques reduce the heat applied to the plastic and use higher pressures on stamping presses.

To produce a vacuum-formed sheet, a plastic sheet ¹⁄₁₆″ to ⁵⁄₁₆″ thick (1.52 to 6.35 mm.), and either clear, translucently or transparently colored, is clamped on a frame of wood, aluminum, or black iron (see Figures 9-25, 9-26, and 9-27). It is held with toggle clamps, C-clamps, spring-loaded clamps, clamping pliers, nails, or staples. The frame facilitates handling of the hot sheet, permits deep draws, and prevents webbing or bridging near the corners. The frame-attached sheet is then sandwiched between hot-air ovens or radiant electric or gas heaters, about 12″ from the top heater and 20″ from the bottom, with heaters extending 6″ beyond the sheet on all sides. Heater density should be between 6 and 18 watts per square inch of heater area. A single heater may be used for thin gauges of ⅛″ or less located above the sheet, but it should be situated over or near the molding machine, so the sheet may be lowered quickly before it cools. Thicker sheets between ⅛″ and ³⁄₁₆″ (3.8 mm. and 4.7 mm.) are heated with bottom and top heaters at a uniform sheet distance of 8″ (20 cm.) to avoid overheating the top surface before the lower surface. Place the sheet in position and heat for 4 minutes between 300° and 400°F. Turn the heaters

Figure 9-25
Vacuum machine for forming sheet plastic (cellulose acetate butyrate sheet). Photo by John Casey.

Figure 9-26
Vacuum-cast sheet cellulose acetate—Kodak Uvex. Casting by John Casey. Photo by John Casey.

Figure 9-27
John Casey, *Englewood.* 1978. Spray-painted, vacuum-cast cellulose acetate butyrate sheet (Kodak Uvex), 46 × 37 in. Photo by John Casey.

off for one minute with the sheet still in position, allowing time for heat to be conducted to the lower surface of the sheet. If the sheet is still stiff, turn the heat on for one minute and off for another minute before forming.

After heating, lower the plastic over a mold far enough to provide a seal between the sheet and the mold. The space between is evacuated, and atmospheric pressure forces the sheet into the mold. No part of the sheet should be stretched more than 3 times its original area, or a drawdown ratio no greater than 3 to 1 including both the depth of the draw and the angle of the sides. The process must permit air removal between the sheet and the mold capable of evacuating the reservoir to a vacuum of 22″ of mercury (210 mm absolute pressure) in less than 3 to 4 minutes. A single pump and reservoir may operate several vacuum-forming machines. A vacuum line connecting the reservoir and forming table should be 1½″ to 2″ (38 to 51 mm.) in diameter, controlled by a gate or ball valve which should, for certain operations, be capable of regulating evacuation rates. Gauges indicate when pressure is low enough for operation.

Vacuum forming using a positive mold, called *drape forming*, involves draping a heated sheet over the mold, pulling it down across the edges of the mold base, and applying the vacuum to draw the sheet against the mold. Used when a deep draw is required but sharp detail is not critical, drape forming prestretches the sheet and minimizes uneven drawdown and thin spots. It also keeps the sheet's top surface from touching the mold, thereby retaining the gloss.

In the *negative mold* operation, only the portion of the sheet directly over the cavity opening is stretched. The *plug assist* involves a negative mold and plug approximately the shape of the cavity, but slightly smaller (see Figure 9-28). After the sheet is blown upward with compressed air, the plug is lowered into the blown sheet, stretching its center down into the cavity. Vacuum is applied around the edges of the cavity after the plug has sealed the sheet around the edges. Plug assist and drape methods both prestretch the entire plastic sheet and minimize uneven drawdown.

The *free-forming* method is done by first heating and then lowering the sheet against the vacuum box. The sheet is drawn down through a cutout with vacuum pressure to a predetermined depth, usually most easily controlled with a lightweight ruled stick resting against the upper surface of the plastic. To observe the depth of draw, a small win-

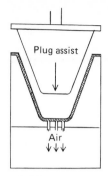

Figure 9-28
Plug assist vacuum forming—thermoforming plastic sheet.

dow is built into the vacuum box, or an electric eye can be set to indicate when a particular depth is reached (this may also be a control to stop further air evacuation). Even heat should be applied to avoid hot spots, which stretch some parts more than others, causing asymmetry. Even application of vacuum to the entire sheet area is necessary for symmetrical stretching. The best position for the vacuum opening in the box is below the cutout's geometric center.

Pressure forming operates similarly, except that atmospheric pressure forces the hot plastic sheet into contact with the mold. Compressed air is released into the pressure box, and forces the sheet against an either positive or negative mold. The holes required for vacuum forming function as vents rather than air entries, allowing air between the sheet and the mold to escape as the sheet descends. Free forming by compression rather than vacuum causes the sheet to blow upward into a bubble, and hold in that form by a reduction of pressure. Air for pressure-forming operations can be supplied by a compressor like those used in service stations. A reservoir of compressed air is necessary, as well as an air system capable of applying pressure at a controlled rate. A pressure gauge and pressure reduction valve are necessary too, since pressures vary in different operations. Also install a diffuser at the air compression port to prevent localized cooling from a blast of cold air striking the hot sheet.

Mechanical forming can be done with pneumatic, hydraulic, mechanical, or hand force. Either a positive plug is forced into the heated sheet (a method for forming domes), or a cavity and matching plug form the heated sheet between them. The chief problem in mechanical forming is that the separate location of the heat and molds allows the sheet to cool too rapidly before forming.

COMMON FAULTS OF CASTING IN
POLYESTER RESIN AND GLASS FIBER

Fault	Possible Causes	Suggested Remedies
Tacky surface	Gel undercured	Check catalyst addition
	Insufficient catalyst	Check mixing
	Working conditions too damp	Avoid cold, damp conditions
Blistering	Air trapped between gel coat and lay-up (laminations)	Apply generous layer of resin over gel coat so that, in laying-up, air is forced through the glass material
	Contamination with water or solvent	Insure complete removal of cleaning solvents or water from brushes and rollers
Fiber pattern	Gel coat too thin	Insure even and adequate gel coat
Glass fiber shows through resin	Gel coat undercured	Avoid applications under cold, damp conditions Allow adequate time for hardening a gel coat before commencing lay-up
	Premature extraction of cast from mold	Insure adequate cure of cast before extraction
Pinholing	Air bubbles trapped in gel coat	Avoid beating air into gel coat when adding catalyst or color paste Lay gel coat with light, even strokes and avoid stippling action
	Dust particles on mold surface	Remove all traces of dust before laying gel coat
Flaking gel coat	Faulty adhesion between gel coat and layers of chopped strand mat	Avoid leaving gel-coated mold for longer than 12 hours before applying layers of chopped mat
Distorted or discolored areas	Excessive exotherm	Adjust accelerator/catalyst system Reduce thickness laid up at one time—use lighter chopped strand mat (CSM) and more layers
Delamination	Insufficient resin	Insure even and adequate resin application
	Poor wetting-out of glass mat with resin	

10

Casting of Metals

BRONZE—THE PRIMARY SCULPTURAL METAL

The sophisticated and complex art of alloying and casting bronze was first practiced by the Babylonian, Chinese, and Indian civilizations about 3000 B.C. Knowledge of the techniques of casting, first copper, then bronze, had travelled throughout China, Mesopotamia, Egypt, and the Aegean before 1000 B.C. The bronze artifacts of these cultures (predominantly vessels, ornaments, and weapons), revealing a high level of skill, were made with both sand-mold and lost-wax methods and were cast solid. There is evidence that the techniques of hollow casting were first discovered by the Egyptians, but the Greeks developed the craft of large-scale hollow sculpture using cores. It is speculated that these bronzes were originally fabricated by hammering sheets of metal against wood and securing them with rivets. Later, the wood originals were used as positives for a two-piece sand mold cored with casting clay. By the mid-fifth century B.C., Myron and Polycleitus were producing life-size and monumental figures predominantly in bronze. They were succeeded in the

fourth century B.C. by the masters Praxiteles, Skopus, and Lysippos. Only a handful of their large works have survived and knowledge of their existence has been derived primarily through historical accounts and Roman copies. The earliest Greek hollow bronze figure yet found, the Apollo Kouros from Piraeus cast in 530 B.C., stands 6 feet 3 inches. The largest hollow bronze original yet recovered is a 6 foot 10 inch statue of Zeus or Poseidon dated at 460 B.C.

During the sixth century B.C., the Etruscans of central Italy (Etrusca or Tuscany) excelled in casting bronze vessels, utensils, and granulated gold jewelry. In the Orient, ceremonial bronze vessels were cast during the Shang dynasty (sixteenth to eleventh century B.C.); later, iron weapons and tools were cast from stone molds during the Chou dynasty (fifth century B.C.). Recent evidence suggests the Nok culture of Africa was familiar with iron from as early as the second century B.C.; the Noks are believed to have produced Africa's earliest metalwork, as well as amazingly naturalistic terra cotta heads.

Bronze casting flourished under the Romans (see Figure 10-1), particularly in the area of private and

Figure 10-1
Standing Figure of Youth. Imperial Roman, early 1st cent. A.D.
Bronze, H. 23¾ in., pedestal 6½ in.
Collection Portland Art Museum, Portland, Ore. Gift of Mr. C. Ruxton Love, Jr.

official portraiture. Classical influence first appeared in India during the early years of the Roman Empire, expressing itself in the Buddha image, which later changed and took on a more distinctive Indian style. During the later years of the Roman Empire, when the Gupta dynasty ruled Hindustan, bronze casting flowered into a highly refined art. Ancient Indian religious manuscripts refer to lost-wax casting—a detailed description of the process is preserved in the *Manasara*,[1] a textbook on image making, which includes formulas for various amalgams of as many as eight metals—gold, silver, iron, tin, lead, mercury, copper, and zinc, each of which symbolized a special value in the relationship of the image to cosmic forces.

After the fall of Rome in the fourth century A.D., the early Christians rejected classical ideals, and the casting of bronze was reserved almost exclusively for liturgical art and metalsmithing to serve the needs of feudal lords. Not until A.D. 1166 was bronze casting revived on a large scale by the Saxon school of Germany. After A.D. 1200 ornamental bronze work, chiefly liturgical, spread from Germany to northern Italy, France, England, and Flanders. During the thirteenth and fourteenth centuries there was a proliferation of bronze tomb effigies, particularly in England. During this period Portuguese explorers brought knowledge of bronze casting to Africa, where it was adopted as a native art form by the Ife tribe. In the thirteenth and fourteenth centuries, the Ife and in the sixteenth century, the Benin tribes (of Ede, later Benin City in Nigeria) produced portraits of extraordinary sensitivity and naturalism. (See chapter 6, Figure 6-5).

In Italy, bronze casting experienced the greatest revival since classical times. The early Renaissance silversmith Ghiberti cast the magnificent doors of the baptistry in Florence (1435). His student Donatello was the fifteenth-century sculptor most responsible for the return of the independent figure, in classical terms, to Western art. A fine goldsmith and sculptor, Cellini provided an instructive account of lost-wax casting. His great sixteenth-century contemporary, Michelangelo, who preferred a medium from which forms could be extracted, executed only one bronze: that of Julius II on the facade of St. Peronio in Bologna. The Baroque and the later Rococo movements as expressed by Bologna and Bernini gave preeminence to carving in their large-scale work. The Neoclassical style led by Canova, Houdon, Hildebrand, and Thorvaldsen also favored stone over bronze. International in scope, this preference dominated Italian, German, French, and American sculpture during the eighteenth and early nineteenth centuries. Though stone was still the preferred sculptural medium in early nineteenth-century Europe, bronze was also becoming a favored material of the more realistic French style that influenced later nineteenth-century European art. Adapted by Antoine-Auguste Préault, François Rude, the animal sculptor Antoine-Louis Barye, and Auguste Rodin, bronze again predominated in architectural and commemorative sculpture.

Because of its complexity, casting has always been expensive, particularly for young artists. Modern fabrication and welding provide less expensive means of obtaining large works in metal. The small school foundry has given rise to do-it-yourself casting and wide experimentation in metal technology (see Figure 10-2). Industrial foundries are still an option; if the sculptor adapts his methods to one of the many sand-casting techniques, costs can be considerably reduced.

Bronze is an alloy composed of from 80% to 85% copper and 2% to 20% tin (up to 25%) with slight percentages of phosphorus, lead, and zinc. The traditional bronze alloy formula of the past was 85% copper, 5% each of tin, zinc, and lead. Designated *nonferrous* as it generally contains no iron, bronze is softer than iron but excels in tensile strength. Brass, often called "commercial bronze," has a predominance of zinc (2% to 17%) over tin (less than 6%), with varying small amounts of lead, nickel, iron, aluminum, and manganese. The resulting alloys are designated accordingly: yellow brass, tin brass, silicon brass, red brass, leaded red brass, etc.

Bronzes are alloyed variously as *tin bronze, leaded, nickel, aluminum, silicon,* and *beryllium bronze.* Tin lowers the melting point and allows greater flow, enabling more intricate castings. It also acts as a deoxidizer and increases strength and hardness; thus the higher the percentage of tin, the harder the bronze. Zinc has the same effect as tin, though to a lesser degree, making brass softer and more malleable than bronze, with a somewhat more porous surface. Lead increases ductility and tensile strength and makes the alloy cheaper, easier to cut and later to lubricate (when the material is used for bearings). Nickel and silicon add strength and corrosion resistance; phosphorus increases hardness. Nickel bronze with 10%–15% nickel, 45%–65% copper, and 20%–40% zinc (also called *German silver* or *nickel silver*) is entirely white and corrosion resistant, making it especially suitable for fountains. A related

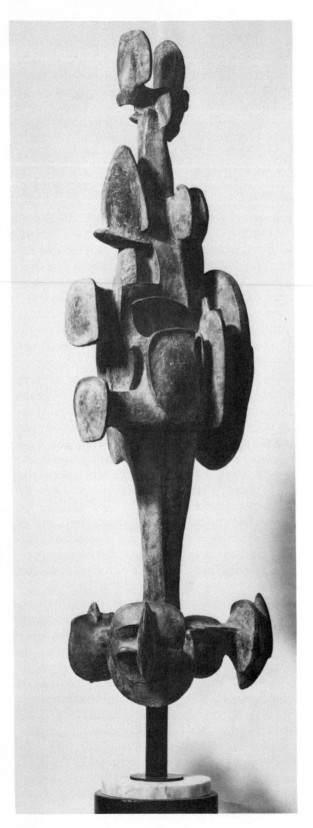

Figure 10-2
James Lee Hansen, *Guardian*. 1965.
Silicon bronze, H. 6 ft. Clark College, Vancouver Campus.
Cast in Herculoy silicon bronze formula—90.74 copper 4.42
silicon, 4.55 zinc, with minute proportions of tin, lead, and
manganese.

alloy, *Muntz metal*, consists of 60% copper and 40% zinc. Silicon bronzes contain not more than 98% copper, from 1% to 3% silicon, and small percentages of aluminum and manganese, and are exceptionally strong and suitable for intricate castings. The tradenames *Everdur* and *Herculoy* are used for silicon bronze, the preferred bronze for small foundries because of its ease of melt and limited need for fluxing. Aluminum bronze contains 5% to 15% aluminum, up to 10% iron, less than 0.5% silicon, with or without manganese or nickel; phosphur bronze is composed of 98% copper, 2% tin, some phosphorus, and lead. Aluminum bronzes containing 10% or more of aluminum may be hardened by heat treatment—followed by the same type of quenching and drawing methods used for steel.

THE LOST-WAX METHOD (CIRE PERDUE)

In the traditional process, a wax positive is first surrounded by a refractory material (referred to as *investment*) and then fired. The void created by the melted wax is subsequently filled by molten metal.

The Wax Model

In the past, sculptors made their own wax formulas primarily from natural materials such as beeswax, cocoa butter, lanolin, rosins, pitch, tallow (suet), and paraffin—an inexpensive petroleum wax was added to later formulas for firmness and a nonsticky consistency. The waxes produced ranged from soft, delicate types that could be modeled with the heat of the fingers to the stiffer types, more suitable for pouring into molds.

The wax most widely used today is the refined #2305 microcrystalline (small crystalline-structured) petroleum wax. Varying degrees of hardness can be obtained by mixing the microcrystalline with 30-weight heavy oil or petroleum jelly for a softer consistency, or with paraffin for a firmer consistency. Adding 1 part paraffin to 2 parts microcrystalline gives a firm but malleable wax, stretches the mixture, cuts the cost, and lowers the melting point, important when working with gelatin molds. For a very hard wax with shrinkage less than 3%, particularly useful in large projects, mix 35% microcrystalline with 65% Certan wax. Minuscule amounts of colorants can be added, such as English vermilion, red or green stearates, or

mercury colors which burn out without residue. Many companies now sell bulk ready-to-use colored sculpture wax.

Melt the wax in an electric fry pan or roaster with thermostatic controls so it heats only to the melting point and no higher (145°–185°F). When melting the wax for gelatin molds, exact control is necessary where wax should remain as cool as possible (under 145°F) to prevent damage to the gelatin. Higher temperatures of about 190°F should be used when casting into wet plaster molds. Wax sheets can be made by pouring molten wax into a wet plaster slab indented to the desired thickness (³⁄₁₆" to ¼" is most versatile). If precise thickness is not important, any moistened surface, such as heavy wet paper, will act as a separator.

Wax can be used as sheet or in bulk form in a semimolten state. Manipulation of the sheets is easier if they are kept soft and flexible under an infrared bulb hung over a table (see Figure 10-3). Tools for wax are simple metal spatulas and knives warmed over an electric hot plate, Bunsen burner, or alcohol lamp. A unique wax model can be made, or a mold can be taken off any existing form and used to cast the wax.

The methods are the following:

1. A traditional method described by Cellini and Vasari is the modeling of wax over a refractory

Figure 10-4
Wax over investment core.

core. A model is made in fireclay the size of the intended sculpture. This core is fired, shrinking in diameter, then covered with a layer of wax approximating the original size (see Figure 10-4). Refractory materials (*investment*) suitable for cores include dental plaster and plasters combined with banding sand, perlite, and silica flours, the same formulas as those designed for outside investments. The wax should be of even thickness, remaining under ½" thick.

2. Model over a temporary core of urethane foam or styrofoam. The core may be dissolved with acetone or lacquer thinner before or after investment. Foam is relatively easy to cut, and this method is very useful for large works that must be cast in sections.

3. Modeling in solid wax, cut and join rods or strips of wax together or let them serve as an armature for wax in sheet, strip, or pellet form. Wax may be applied on armatures of copper or steel rod which will remain permanent after casting. Solid wax is limited to delicate and linear pieces keeping within ½" maximum in diameter. A casting thickness of 1" to 1¼" is possible if ½" length chill pins of bronze or similar alloy are inserted into the center of the wax and the bronze is poured slowly into the mold. Both measures are necessary to distribute the heat, allow even cooling of molten bronze in the cast, and to avoid excessive shrinkage and consequent fracturing when a large amount of overheated metal fills the mold.

4. Hollow modeling with wax sheets allows volumetric forms to be modeled inside and outside simultaneously, like a vessel. Control of the form is often maximized, as in hand building terra cotta. The core may be poured separately or at the same time as the outer investment.

5. Wax can be poured or brushed into a mold. A plaster, gelatin, rubber, or synthetic rubber mold allows for multiple waxes to be cast (see Figure

Figure 10-3
Working directly in wax sheet using hot plate to warm tools and spotlight or infrared lamp to keep wax pliable. Photo by author.

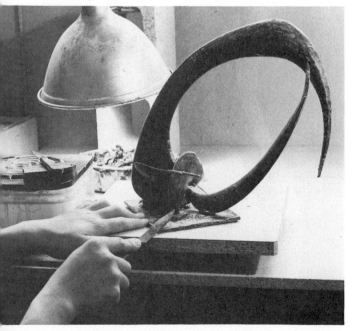

Figure 10-5
Wax poured in silicon rubber molds encased in plaster mother molds. Photo courtesy of Tom Knapp.

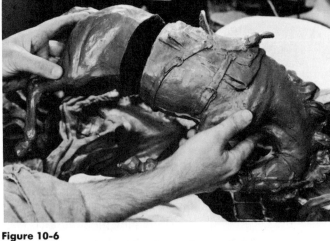

Figure 10-6
Cast wax horse, to be cast into bronze in two sections. Photo courtesy of Tom Knapp.

10-5 and Figure 10-6). A plaster mold, being inflexible, should be designed with enough pieces to allow for easy freeing of the wax without damaging the fragile surface. The mold must be wet when it receives the warm wax, to provide the means of separation. Warm wax, heated to melting, is brushed or poured into the mold to a thickness of ³⁄₁₆″ to ⁵⁄₈″. If brushed, a pouring must follow to fill the seams. The wax may be removed immediately. Gelatin and rubber molds should have a surface treatment before the wax is introduced, of ½ part tincture of green soap (mixed with) ½ part zeracol.

6. A reversal of the process described in #1: A solid wax model with sprues and vents is coated with a 2″ coat of investment and is allowed to set. Steam out the wax in a 180°F oven (drain and salvage the wax). The inside of the shell is then coated with a layer of wax, a core is poured, and the shell drilled with holes into which core pins are inserted.

Preparing for Investing—Sprue System

A system of wax "feeder" rods of varying lengths and diameters called sprues must be attached to the wax pattern before the investment material is applied. The system consists of main vertical sprues; from them smaller horizontal feeders or runners distribute the molten metal on different levels over the entire piece. The system may be made independently of the model by casting wax into two-piece plaster molds made around a wooden dowel, cut to size and adhered by melting the ends with a hot knife. Design the vertical sprues keep-

ing in mind the distances of metal flow and the thickness of the area being fed. Keep the sprues as short as possible to prevent the metal from hardening before it reaches the model. Because metal tends to cool and solidify as it travels, the diameter of the sprue (generally ¼″ to ½″) must be proportionately larger as its length increases, and should be from 2 to 5 times as thick as the area it is filling (a ³⁄₈″ wall requires a sprue at least ¾″ wide). The point where a sprue, also called runner, attaches to the model is called the gate. Since this is the metal's point of entry into the model, each gate should be fashioned to form a smooth, nonturbulent transition. It is also important to locate the gates at high points for easier removal after casting.

The main sprues converge to a single pyramidal or cone-shaped funnel, also of wax, as wide as the composites of the diameters of the runners to guarantee they fill when pouring. The sprues direct the metal poured into the funnel to the lowest point in the model; from there it rises by means of secondary feeder sprues. These smaller sprues point upward, forcing the metal to descend before it rises and gradually fill from the bottom upward (see Figure 10-7). Pouring to the bottom first is called a *bottom gating system*. The simpler *top pour method* feeds metal directly into the top and will work where forms are continuous.

Vents called risers allow the escape of air or gas that might cause turbulance in the casting. These thin (⅛″) rods of wax are generally placed (with the model in a pouring position) on an extremity; they lead upward to the outside and for stability are temporarily attached to the outside of the pouring funnel until the mold is made. The core

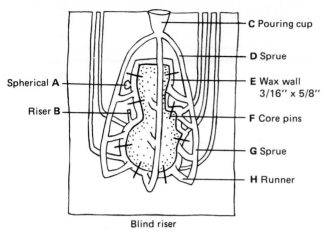

Figure 10-7
Sprue system.

Labels in diagram:
- C Pouring cup
- D Sprue
- E Wax wall 3/16″ × 5/8″
- F Core pins
- G Sprue
- H Runner
- Spherical A
- Riser B
- Blind riser

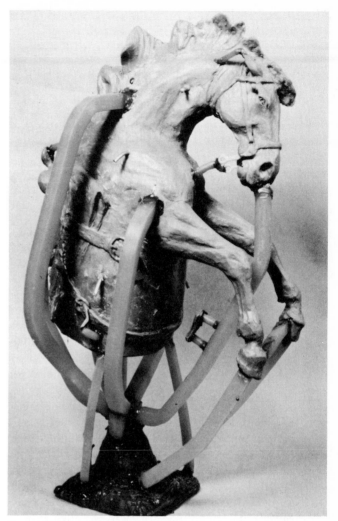

Figure 10-8
Bottom sprueing of wax horse. Sprues should not be too close as this causes flashings, or too far, as this wastes material and fuel and cools the metal. Core pins shown. Photo courtesy of Tom Knapp. Copyright Tom Knapp. Photos by Bruce McElya and Tom Knapp.

is also vented, either by a wax rod or by a temporary steel rod. When the core is set up, the steel rod is withdrawn, leaving a vent space. Another way to vent the core is by a wax-filled copper tube drilled with holes for the wax to melt out, leaving the tube as a hollow vent. Solid casting or heavy areas of hollow casting often require an additional metal flow, accomplished by a ball-shaped reservoir of metal attached as a blind riser. The ball lets additional metal flow into an area which has not filled due to shrinkage or quick chilling. If the wax is to be reclaimed and not allowed to vaporize, or if the mold is too large to turn upside down, a metal drain tube is attached to the base of the piece opposite the pouring funnel. After the wax runs out, the tube is plugged and continues to burn out traces of wax.

After completing the sprue system, but before the core and core pins are added, the wax is weighed to estimate the necessary bronze. The weight of the wax model including the sprue system is multiplied by 10. Steel pins about 2″ in length (or nails) are passed through the wax, projecting inside to hold the core to the outer investment when the wax burns out (see Figure 10-8). The core of investment material may be poured at this time, when the outside is invested, or before the sprue system is added, or even while the wax is still held in its piece or flexible mold—in which case the weight of the wax is a known factor (as in the case of an edition of several castings from the same sculpture).

Investing the Wax (Plaster, Silica)

Investment is the highly refractory yet porous material that will encase the model. The investment must be able to withstand the high temperatures of burnout and molten metal, and take the pressures of the pour without disintegrating. Its composition must also be porous enough to let gases escape, yet refined enough to faithfully reproduce the original.

Traditional investment materials have consisted of a strong binderlike molding plaster mixed with a porous, refractory substance like silica, fireclay, sand, and luto, or fired reprocessed investment. Calcined earth clays or grog may be added in quantities up to 50% of the total volume. Perlite or mica may also be added, the latter to reduce weight particularly in large molds. Commercially prepared investments are available from dental and jewelry supply houses. U.S. Gypsum's permeable plaster Hydroperm® B-32 introduces air

spaces in the mold material as it is mixed. Three formulas for investment are as follows:

1. 1 part 20-mesh grog (80 mesh for facing coat)
 1 part banding sand (80-mesh sharp)
 1 part plaster
2. 1½ parts silica
 1 part banding sand (80-mesh sharp sand)
 1 part plaster
3. 1 part silica flour
 1 part banding sand
 1½ parts perlite
 1½ parts plaster

To insure reproduction of fine detail, apply a ⅜″ facing coat of 1 part silica sand and 1 part plaster before using one of the above formulas. Mix 5 parts investment to 2 parts water, much like mixing plaster. Sift premixed dry ingredients into the water and stir with the fingers constantly to keep the heavy compounds in solution, taking care not to entrap air. Vibrating the mixing container will assist the removal of air bubbles. Investment is ready for pouring when the surface resists fingermarks. Thicker consistency is necessary when it is to be dipped or brushed, as in a facing coat.

Before the pour, prepare the wax by painting a surface tension reducer or debubblizer on the surface. Use a prepared commercial product or a mixture of ½ zerocol (shellac thinner) and ½ tincture of green soap. A mold container or flask must be formed around the model to contain the poured investment, often made of 14 to 16 gauge 1″-mesh poultry netting steel mesh covered on the outside with roofing paper (see Figure 10-9). The pattern is either suspended or set on a base of investment at least 3″ thick. The investment should be poured all at once, in a steady continuous stream to avoid bubbles (see Figure 10-10). If more than one pour is necessary, roughen or score the surface of the partial fill. Allow to set about a half hour if using standard set plaster investment formula, and remove outside tar paper, leaving the steel mesh or chicken wire encasing the mold. If the mold is to sit for some time after hardening, either keep it in plastic or, if left to dry, spray it with water prior to burnout. A totally dry mold insulates the interior and absorbs wax too readily.

Piece-Mold Investment Method

Using investment material to make a piece mold for multiple wax castings is suitable for a simple form requiring few pieces. Sprues and vents are attached to the model, which is then treated with

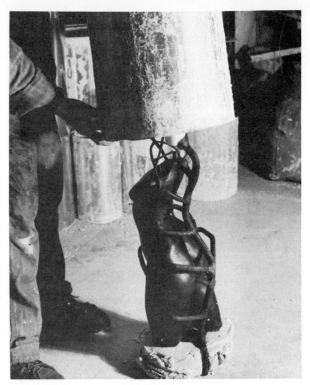

Figure 10-9
Flask of sheet aluminum placed over wax torso with side sprue. Main sprue need not follow contour of piece. Depending on the size of the work there should be a minimum of 1″ or 2″ between the outermost point of wax and the flask. Casting at the Blue Heron Foundry, Port Townsend, Washington.
Photo by Paco Mitchell.

Figure 10-10
Filling flask with investment material. Initially a small amount of investment is poured into the bottom of the flask to seal it. When the seal has set, the flask can be carefully filled. Blue Heron Foundry, Port Townsend, Washington.
Photo by Paco Mitchell.

a separating agent of wax, Vaseline, soap, etc. Apply the investment material in lieu of plaster, remove from the model when hard, and then line it with a layer of wax. After casting the number of waxes desired, reassemble the mold, incorporating the sprue and vent system, wrap it with wire to hold it together, then pour an additional wax to fill the seams. Drill holes through the investment and wax for the core pins that hold the core to the shell. Then soak the mold in water to insure better binding to the investment, place it in a container and pour investment under and around the mold and inside to become a core, taking care not to cover the pouring cup and vents with investment.

Burnout melts the wax without leaving residual matter in the mold, and drives out all moisture so that the mold can receive the molten bronze. The burnout kiln may be gas fired, with fire bricks stacked around the molds for each firing and then dismantled, or a ceramic kiln designed with an opening for the melted wax. For draining the wax, either place the mold upside down in the kiln or provide a drain in the mold which is plugged with fired clay, plaster, or an iron rod before pouring.

The investment mold is placed in a cold kiln able to sustain temperatures of 1100°F and heated rapidly, with temperatures rising 100° to 150°F per hour. During the initial stage of melt out and burnout, the 200°–400°F temperature is reached and maintained for 6 to 12 hours, until a temperature of 1000° to 1300°F is attained (8 hours to 3 days, depending on the mold). Lower temperatures take more time than rapid temperature increases, but less shrinkage occurs. Burnout is complete when no flame or smoke appears in the mold and the pouring funnel is surrounded by discoloration

and appears as a dull red. Turn off the kiln and leave the investment mold to cool slowly to 250°F or cooler. Black carbon on the mold indicates insufficient burnout. Premature removal would shock the mold and cause cracking.

To avoid losing the wax, the mold can be steamed before baking (see Figure 10-11). Place the mold drain-side down over a large drum filled with several inches of water, making sure the mold does not touch the water. Then heat the drum, creating enough steam to melt out the wax, which can be retrieved from the water. Steaming-out is appropriate for investment but not for ceramic-shell mold methods where the steam's pressure would cause the mold to crack.

Ceramic Slurry Investment

A recent development (since the 1940s), ceramic slurry has updated the ancient technique of plaster-silica investment casting for modern industrial use. The wax model is dipped into a refractory slurry and, while still wet, covered with a grainy material referred to as stucco. The result is a mold as strong as fired clay, yet thin and light. Whereas solid investment castings of over 20 lbs. of metal are awkward and hard to handle, 100 lbs. of metal may be handled easily with ceramic slurry. With this technique, the final size is limited, not by the size of the mold, but by commercial abilities to make accurate patterns on a large scale. In large works, pieces can be cut into sections for casting and later welded together.

The resistance to thermal shock allows for higher firing temperature and, consequently, a shorter burnout cycle than investment (½ to 4 hours, depending on size). The porosity and strength of ceramic slurry requires a less complex spruing and venting system than plaster investment, and affords greater fidelity to surface detail. Ceramic shell molds may cost half as much as investment molds for the same size casting. Initial cost of equipment and material are outweighed by the time and wax saved.

The material for the slurry and stucco application is an aqueous colloidal silica derived by removing the sodium from sodium silicate. The resulting silicic acid is marketed in five different grades denoting particle size, pH level, and concentration of silica by weight. A single drop of this colorless, water-soluble liquid contains millions of tiny silica particles. It makes an excellent binder for a refractory of fused silica, alumina, and other silicates such as clay, mullite, talc, and mica.

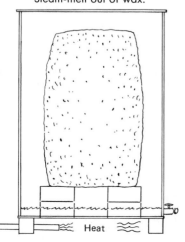

Figure 10-11
Steam-melt out of wax.

Heat

1. Attach sprues to the wax using the top pour method. The strength and porosity of the ceramic shell lets heavy metal flow through a more simplified sprue system than that used for investment casting. Except for complex shapes, a single large sprue will often be adequate, and venting (with a few exceptions) unnecessary. Gates and runners should be hollow and of a softer wax to allow for fast runoff. Insert core pins, paint the wax with a cleaning and wetting solution of alcohol or a combination of ½ isopropyl alcohol and ½ trichloroethylene, and let dry.

2. The primary slurry mix is P-1 (200 mesh) or 300 to 400 mesh added to the colloidal silica (binder) in proportions of 2½ parts silica flour to 1 part binder. Keep slurry from settling by constant mixing with the propellers of a heavy-duty drill press. Use stoneware, stainless steel, or noncorrosive, nonflexing containers. Stir the mixture slowly to reduce evaporation and air bubbles, and let sit for 5 hours before using. After thorough mixing, add a small amount of wetting agent. Check viscosity with a Zahn Viscosimeter, a cup with a calibrated hole that measures the seconds required for the cup to empty. A thick, heavy, creamy mixture is desirable for fine surfaces. Slurry kept for a prolonged period should be covered to prevent surface evaporation. Before using, adjust the mixture by thinning with a slurry of colloidal silica or thicken with silica powder.

3. Brush on slurry or immerse the wax pattern in the slurry solution. Then dip it into a dry stucco of 200-mesh fine silica sand. Slurry should stop running but remain wet enough for the sand to stick to the surface. To avoid touching the wax when dipping, devise a handling system (a metal plate attached with a series of nuts and bolts) which will later separate from the sculpture. Before dipping into stucco, prewetting with colloidal silica binder permits the second coat to stick to the first without rolling off. Before stuccoing, break air bubbles by blowing. Stucco silica should be very dry when applied.

4. Subsequent coatings repeat the above sequence, except that later coats consist of a coarser grade of silica flour (50–100 mesh). About 4 to 8 coats are applied in all; 2 primary and 2 to 6 outer coats, the time between coats varying from 20 minutes to 4 to 5 hours. If the shell sits overnight, you can apply a liquid binder of colloidal silica before dipping. Stronger shells result from thorough drying between coats, a lengthy drying time (4 to 5 days total), and good air circulation. Dipping in a wetting solution will displace most air before the next coat is applied. The last coat consists of a sealer of slurry without the stucco, which might otherwise come loose in the dewaxing. Total mold thickness ranges from a minimum of ⅜" to ½" for a 12" piece. Unsupported extensions can be reinforced with fiberglass or stainless steel wire placed between outer layers of the mold. Core material can be a special rapid-casting silica-refracto mix to which is added catalyst combined with chopped fiberglass and alcohol.

5. Dewax ceramic shell molds rapidly to prevent slow expansion of the wax from cracking the thin ceramic shell. A "shock heat" treatment causes the outer film of wax to melt and form a liquid cushion that absorbs the pressure caused by expansion of the wax inside. First place the dry shell upside down into a hot furnace heated to between 1200° and 1600°F., for a flash firing of 3 minutes. Thermal shock will not crack the shell even if temperatures go as high as 2000°F. The furnace should have an open bottom allowing the wax to drop out, preventing excessive carbon from forming in the furnace atmosphere.

6. The wax can be saved for incorporating in homemade plasticene, but because of its carbon content should not be used for another lost wax. To save it, melt with a gas burner or oxyacetylene torch, by heating the base of the mold, or by placing infrared radiation lamps so that they penetrate the shell and melt the wax closest to the surface, or by thrusting a heated iron rod into the mold. For ceramic shell molds, vapor removal of wax does not incur the expansion problems of furnace dewaxing. About 1" of dewaxing solvent (such as trichloroethylene) is heated in the bottom of a metal drum placed over a burner with the mold positioned upside down on a rack above the solvent. Since vapors are toxic, avoid this process where ventilation is insufficient.

Foam models created for plaster or ceramic shell can be dissolved with acetone or lacquer thinner poured over the foam (polystyrene dissolves most easily).

After the 3-minute wax melt, continue firing at about 1300°F–1700°F until all residue is visibly burned off, about 15 to 30 minutes, or until smoke and soot are no longer evident from the mold opening and pouring funnel. A piece with a solid core will take longer than a coreless piece.

7. Inspect the cooled mold for cracks and leaks by filling it with water. Since the water will flush out debris, hold a mesh screen over the opening to check on whether pieces of shell have fallen out. A moldable patch material made of slurry can be applied, with the crack showing up as a hairline on the metal surface. Blow air into the cavity to get rid of foreign matter left in the shell (see Figures 10-12, 10-13, and 10-14).

8. After inspecting the molds, return them to the furnace for a rapid (15 to 20 minutes) preheat at a high enough temperature (1000°–1600°F or, in less time 2000°–3000°F) to burn out all carbons and calcine the silica, leaving a white shell. Black shells are produced in a reducing atmosphere with insufficient oxygen. Bronze poured into a cold shell will often fill the thin sections inadequately, so the mold must be kept within 500°F of the temperature of the heated bronze. Since the shell's temperature drops 600°F in two minutes, the pour must be made very rapidly

Figure 10-12
Grinding of hardened ceramic slurry mold. Ceramic slurry process by Tom Knapp. Photo by Tom Knapp. Copyright Tom Knapp. Photos by Bruce McElya and Tom Knapp.

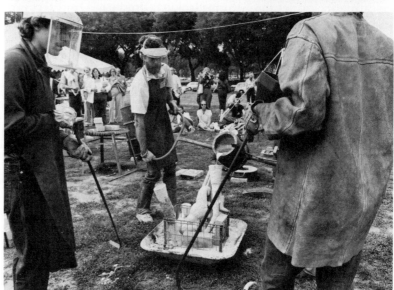

Figure 10-13
Pouring bronze into fired ceramic slurry molds—1980. International Sculpture Conference in Washington, D.C. Photo by author.

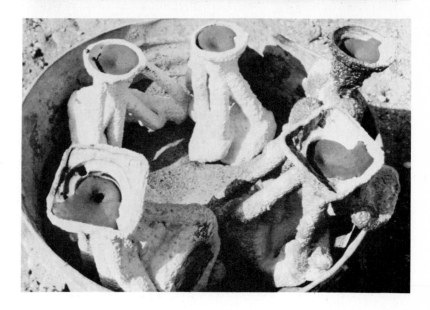

Figure 10-14
Ceramic slurry molds with poured bronze. Photo by author.

once the shell is removed from the kiln. Aluminum castings need a cooler shell (about 600°F) for metal cast at pouring temperatures of 1300°F. Prolonged heat treatment of molds at 1500°F and higher causes fused silica to recrystallize and weaken the shell.

9. While reheating the mold, preheat the crucible to insure that all moisture has evaporated and it will take the shock when placed in the furnace. For pouring, suspend the shell with metal rods over dry sand or resin bond sand. Do not ram them into wet sand, as that will reduce permeability.

SAND CASTING

Metal cast by the sand mold process may be the method of choice for several reasons: (1) an industrial foundry is generally more available than an art foundry; (2) the cost is often less than with investment casting; and (3) forms lacking complex surfaces and deep undercuts are more successfully cast in sand than in investment. Broad simple surfaces take refinement and polish more readily, as the porosity of sand produces an evenly textured surface.

A model of any firm material is placed on a bed of sand in an iron molding box which, when upper and lower parts of the box are assembled, com-pletely contains the model. Ram sand and tamp it down around the model, dust model and sand with a parting agent such as French chalk or silica. Make a piece mold of blocks of interlocking sand, trimmed to fit and tapered to eliminate undercuts. Stack a second box on the first and ram sand against the model and sections of piece mold. After the two boxes are complete, invert the mold and discard the temporary first half, revealing the second side of the model. This is treated like the first half by dusting and making a piece mold from it. Then separate the two sides and carefully remove the piece mold from the model, insert into a mold case, and attach with long pins. Remove the model and put it aside. When the mold is separated, introduce a gating and venting system by cutting channels into the sand and at the seam edges of the two cases. Cut the sprue gates large enough to exert pressure during the feeding of the metal into the mold. Locate the riser off the gating system, if possible, to receive the last (and therefore the hottest) metal, guaranteeing adequate feeding—which is indicated when the metal in the riser remains liquid during the pour until the cast has solidified. (See Figure 10-15.)

After placing all the pieces in the sand case, make a core by casting soft sand into the negative

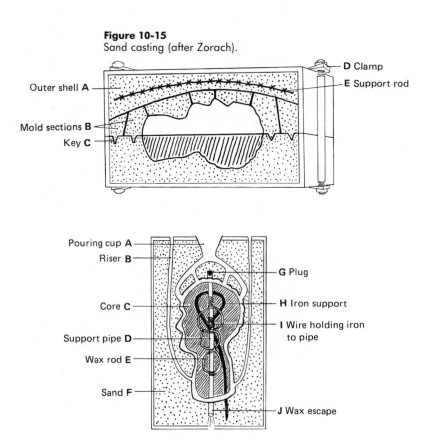

Figure 10-15
Sand casting (after Zorach).

Outer shell **A**
Mold sections **B**
Key **C**
D Clamp
E Support rod

Pouring cup **A**
Riser **B**
Core **C**
Support pipe **D**
Wax rod **E**
Sand **F**
G Plug
H Iron support
I Wire holding iron to pipe
J Wax escape

sand mold, thereby reproducing the original positive model or pattern. Then pare down the surface of this core pattern, the amount cut away representing the thickness of the metal. Hold the core in place by iron rods resting on the flask, and make core vents for gases to escape. With the core in position, clamp the flasks and seal the seams. The sand mold is then dried and hardened by heating about 12 hours before receiving the molten metal. Cores can also be made by taking a plaster mold off the model, packing the negative mold with sand mixed with boiled linseed oil, and baking the core and mold at 450°F to harden the core. After separating the hardened core from the mold, a layer of this core is filed away, about 3/16" to 1/8" depending on the size of the work.

The sand mold process utilizes natural sand containing a clay binder as well as synthetic sands with special binders added. Add the binders to the dried and cleaned sand when the mold is prepared. Premixed molding sands produce stronger molds and are generally preferred over green sand (silica sand with 10%–20% bentonite clay).

Sand particles range in size from 0.1 to 1 mm. in diameter, and the shape of grain from round to angular. Small grains give finer finishes than large grains, but as fineness increases, mold permeability decreases. The porosity of the mold is also a result of the moisture content of the sand, the amount of earth clay or loam in the sand mass, and the degree to which the sand is packed or rammed in. The sand must be packed firmly enough to resist the pressure of molten metal, but remain porous enough to vent the gases produced in the pour. Consistency of sand will vary with the particular metal (for instance, fine-grain processing for aluminum, coarse for iron). Round sand particles have greater mold permeability; angular particles produce stronger molds with less permeability. Sand molds fall into three classifications:

1. *Green sand* using binders of clay such as kaolinite, fireclay, or bentonite. Green sands have less than 20% clay binder mixed with up to 5% water—enough to make the sand manageable while green, yet strong enough to withstand the metal's pressure and weight. Bentonite increases green strength and permeability, while fireclay increases hot strength, holding sand particles together as hot metal contracts.

2. Baked dry sand molds containing clay or oil binders which must bake up to 12 hours at 450°.

3. No-bake sand molds use a resin binder to which a catalyst is added. The no-bake process is the simplest for sculpture, producing high-strength molds without a great deal of equipment. No-bake types include:

A. *Cement*–1 part portland cement is mixed with 10 parts sand. The moisture content should be low, 4% to 8%. Cover the mold and keep damp for 24 hours for setting and curing, then uncover and let dry before pouring. The dry cement and sand may be reconstituted for use in baking of fresh cement and sand molds.

B. *Resin bonded*—Using a mixer, a small proportion of resin (2 lbs. to 100 lbs. of 80- to 100-mesh sand) is mixed into the sand. The catalyst is then added as 20% of the weight of resin or oil (30 oz. of oil require 6 oz. of catalyst) to solidify the sand-resin mixture. To avoid a combustible reaction, never mix the resin and catalyst alone, but always with sand. Additional refractory materials like iron oxide may be used in proportions 1–½% by weight. Working time is 40 minutes; curing time 2 hours. Resin-bonded sand can also be hardened without catalyst using heat (200° to 500°F).

C. *Sodium Silicate*—A liquid inorganic, 3% to 5% sodium silicate resin is mixed into clayfree silica sand. Chemicals mixed directly into the silicate-sand mix cause hardening in 30 to 70 minutes. Very cold low-pressure carbon dioxide gas can be passed through the mold with the use of a probe or metal tube and applied for 20 seconds, hardening the sodium silicate resin in the sand immediately. For small molds, transmit gas by flexible cups held against mold walls; in larger molds, insert hoses or tubes. (See Figures 10-16–10-18.)

Variations of Sand Mold Casting

Variations that allow direct use of the positive pattern are as follows:

Lost foam: a low-density foam is assembled with glue and wire and shaped by sawing, filing, or heated wire. Wax can be used to coat the foam for a smoother casting, and a sprueing and gating system attached by gluing a tube to the mold (the tube also serving as a vent). The foam form is placed in a wood flask into which a fine-grained no-bake silica sand is packed, the sand having been bonded with oil and mixed with a waterless catalyst. Pour the metal rapidly while still hot to complete the foam melt out. Remove the metal from the mold immediately to prevent the heat from baking the sand and adhering to the metal. For hollow castings in foam, core sand is modeled and held together with core adhesive. Foam sheets ¼" thick can then be bent and formed over the sand, and the surface treated with wax and a refractory wash before investing.

Lost wax in sand: Spray a wax pattern with a graphite refractory mold wash and pack with a no-bake silica sand hardened either with CO_2 or resin

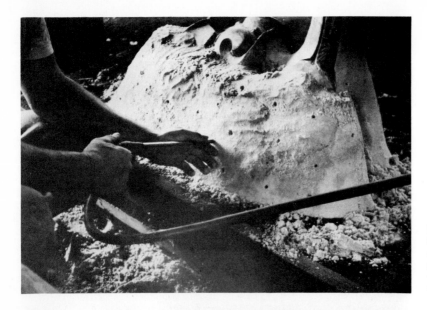

Figure 10-16
Sand molding process. Carbon dioxide injection into sodium silicate bonded sand. Master moldmaker Roy Seibel of Oregon Brass Foundry working on sculpture by Edward Brownlee. Photo by author.

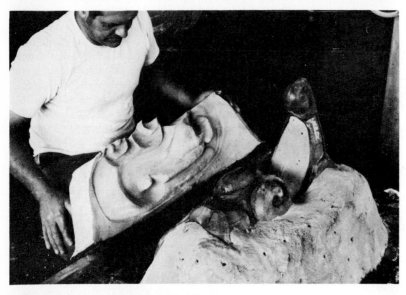

Figure 10-17
Removing hardened sand mold pieces. Carbon dioxide injection process. Photo by author.

Figure 10-18
Assembling pieces of sand mold for aluminum pour. Carbon dioxide injection process. Photo by author.

sand with a catalyst agent. After burnout, the stucco will keep the impression of the wax and prevent interaction between poured metal and sand. The pattern is sprued using a system somewhat larger than investment casting. Wax designed for bronze should have a wall thickness of ³⁄₁₆″ to ¼″. Burnout takes about 12 hours in a moderate (350°F) kiln or oven with the coated pattern placed upside down to drain. After baking, pack the hardened mold in a flask or frame, and pour the metal—bronze, iron, or aluminum. This type of mold is suitable for any combustible material, so wood or fabric patterns may also be used.

Cored pieces can also be made with the above method. Pack a premixed core paste of 50 parts sharp sand to 1 part boiled linseed oil into the hollow wax, and support with pipes held in grooves cut into the mold. When the wax melts out, the main axis pipe, hollow and filled with wax, acts as a core vent. Another recipe for small cores uses 10 parts beach sand and 1 part flour, mixed with molasses water and dried with heat. For large cores, combine 8 parts fine sand, 2 parts loamy sand, and 1½ parts flour, mixed with clay water and dried slowly.

Relative thickness of sand sections to size of casting are as follows:

1 to 10 lbs.	=	1/2″ section
10 to 50 lbs.	=	2″ sand thickness
50 to 100 lbs.	=	3″ sand thickness
1000 lbs.	=	6″ sand thickness

CASTING IN LEAD, ALUMINUM, AND IRON

Lead, aluminum, and iron are often more convenient and economical than bronze. Because of their relatively low melting points, aluminum and lead may be poured, with special precautions, directly into plaster piece molds without using sand or investment molds. Iron casting can use the same investment formulas as bronze or be designed to take advantage of industrial sand-casting techniques—in which case relatively inexpensive casting can be carried out in an industrial foundry.

Lead offers outstanding resistance to corrosion and a soft, workable surface after casting. Melt lead by gas burner or acetylene torch in a cast-iron or steel pot. Melting at 625°F, lead can be cast directly into piece molds of dental plaster, simple plaster, or refractory plaster (plaster with brick dust, silica sand, or pumice) which has been thoroughly dried and heated. For porosity, plaster molds should have a high water, low plaster ratio. Several methods may be used for the mold. A piece mold can be formed over a material such as clay and poured solid, or cored with the same material as the mold. The hollow mold may also be filled with wax and treated as a lost wax by steaming out the wax prior to drying the mold. A foam original may be dissolved with acetone or lacquer thinner. Wax may also be vaporized with a solvent of trichloroethylene, but since the vapors are toxic, it is preferable to steam the wax out by placing it in a cylinder over a pan of water heated to about 200°F. The melted wax floats in the water and can be recovered for reuse. Cores can be held with wire pins (nails to the outside mold). A wide-pouring sprue and vents can be cut directly into the plaster mold, or attached to the wax or foam originals. Completely rid the mold of moisture by baking to 500°F for 12 hours.

Aluminum can be cast as a lost-wax investment, sand cast or, for solid small works up to 15 lbs., cast into dried and heated plaster piece molds without further investment. To free the mold completely of moisture, dry it for 3 days, then bake from 400° to 500°F for 10 to 20 hours. The warm mold (secured with strips of rubber inner tubing) is temporarily covered at the mold entry with paper to keep mold free of debris, and buried in sand that is level with the top of the mold. Heat aluminum in a crucible until molten and pour at a temperature of 1100° to 1200°F. Cool the casting overnight before removing. Take precautions that no moisture enters the mold and avoid overheating the aluminum, which will result in porosity and pinholing. Investments for aluminum casting are:

1. Molding plaster mixed with equal parts pumice.
2. By weight, 10 parts molding plaster, 2 parts sawdust, 56 parts sand, the total mixed with 32 parts water.

Molds of plaster alone can be used if mixed for maximum porosity, with a high water to plaster ratio of, roughly, 130 parts water to 100 parts plaster.

THE CLAY MOLD PROCESS

This process is derived from a traditional Japanese method for iron casting as practiced by sculptor Jim Rodgers. It utilizes inexpensive and abundant materials, may be used for any metal, and offers

the following advantages: (1) it allows casting in iron, not possible with plaster type investment; (2) it is less of a health hazard than investment casting; (3) it makes possible thin and intricate casts; and (4) it utilizes inexpensive organic material obtainable from your own backyard. The chief drawback of the method is that it is slow and tedious.

The materials consist of (1) clay (any garden variety); (2) sand from river (or beach, if washed free of salt); and (3) rich garden loam or humus.

Preparation of mold material: (1) Mix equal parts of clay, sand, and loam together with water to form a sticky paste; dry on boards or bats in the sun; fire in kiln to first red heat, approximately cone 018 to 015; (2) Crush resulting bisque cakes and put through a series of graduated sieves: 1. ¼" to ⅛"; 2. ⅛" to ¹⁄₁₆(16 mesh); 3. ¹⁄₁₆" to ¹⁄₄₀" (40 mesh); and 4. ¹⁄₄₀" to ¹⁄₈₀" (80 mesh). Separate these into piles according to mesh and from each grade make a slip the consistency of whole milk. To the slip add paper fiber (about 5% by volume) which has been broken down and sieved through a 16-mesh screen.

The core: The above may be used as a core material by (1) fashioning it as a positive around an armature and firing it, after which wax may be modeled directly over it; (2) ramming the core into the hollow wax; or (3) cutting open the wax, molding the core, and rejoining the wax.

The mold: Beginning with the finest grade of slip (sieved material mixed with paper), pat over the wax to a thickness of ⅛" to ¼", leaving no bubbles or lap lines. Proceed with successive layers of grades starting with a thin layer of fine grade and getting progressively coarser, as follows: 40-mesh grade (¼" thick), 16 mesh (¼" thick), ⅛" (½" thick), ¼" (½" to 2" thick)—totaling 1¾" to 3" in thickness. After 40 mesh add a generous amount of porous material such as chopped straw, grass clippings, crumbled dry leaves, hair clippings from barbershops, etc. Add a generous quantity of reinforcement wire, re-bar, etc., to the outside layer.

Burnout and pour: Burnout to a dull red heat approximately 015 (temperature 1418°F), allowing enough soak time for core to reach red heat. Pour while mold is hot, or when your hand can be held above sprue cup without discomfort. A cold mold pour has been tried without apparent ill effect. Break out is as usual. Material can be sieved and reused. Iron melts at 2100° to 2200°F, more readily in a cupola-type furnace, a refractory cylindrical box in which the metal comes in direct contact with heat without the use of a refractory crucible.

MELTING AND POURING BRONZE

Bronze's melting temperature ranges from 1300° to 1900°F. Average casting temperatures are about 1950° to 2250°F with thin casting at the hotter temperature of 2300°F. Melt the bronze in a refractory crucible made of clay, graphite, or silicon carbide—a more expensive but stronger material. Crucibles are sized from 6 to 800, indicating their capacity in aluminum pounds (to obtain capacity in bronze, multiply by 3). The crucible is fragile and must be handled with care. Since water causes an explosive condition, keep the crucible quite dry. Initially anneal a new crucible by placing it in a furnace, warming it to 500°F, and gradually cooling it in place. Ingots should be composed of primarily new metals of a known alloy, with some supplemental scrap of the same alloy. For melting, prewarm them and place them carefully (not dropping them) into the crucible, with the higher melting alloy added before those with lower melting points—for example, copper before tin or zinc.

Melt in a slightly oxidizing atmosphere and as rapidly as possible to minimize absorption of gas, with the maximum temperature about 100°F over necessary pouring temperature. A large melt, thin sections, or a cold mold may require a temperature 200°F above pouring temperature. The difference between heating and pour temperatures allows for cooling between removal of the crucible and pouring. A drastic reduction of zinc and tin (as a consequence of overheating and subsequently holding

Figure 10-19
Pouring bronze excess into pans after filling silica molds. Photo by author.

over of the hot bronze before pouring) may result in a sluggish flow of metal, and porosity and coarseness in the bronze cast. Accurate control of the pour temperature is essential and should be monitored with a pyrometer. You can counter the inevitable internal shrinkage caused by too rapid a cooling of the mold by placing extra metal risers next to heavy sections of the model. Investment molds should be housed in dry sand or loam; sand molds are placed in wood or metal flasks.

Fluxing protects the molten metal from impurities and improves pouring qualities. Agents consist of the zinc in the alloy and a small amount of phosphorous (4–6 oz. per 100 lbs.) added as phoscopper shot. Glass (broken bottles, silicon, and boron) is also used as a fluxing agent. Stir the flux into the melt with a metal rod after the temperature has been taken and the bronze has just been skimmed, immediately before pouring. During the initial melt, a protective cover of oxides and flux forms on the surface which should remain unbroken until additional flux is added. Slag and flux are skimmed prior to the pour, and held back by the skimming bar during the pour. Pouring should be in a steady stream, in sufficient quantities to maintain a reservoir in the pouring cup (see Figure 10-19).

Mold material fractures easily and may be broken away with hammers after the mold is fully cooled (several hours). Carefully remove invest-

Figure 10-20
Power cutting and sanding tools—from left to right: die grinder (21,500 rpm), heavy-duty disc sander (4000 rpm), and angle head disc grinder (10,000 rpm). Photo by author.

Figure 10-21
Grinding cast bronze to prepare for mounting.
Photo by author.

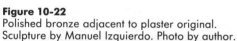

Figure 10-22
Polished bronze adjacent to plaster original.
Sculpture by Manuel Izquierdo. Photo by author.

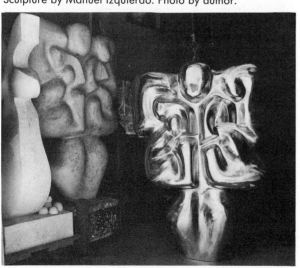

Figure 10-23
Manuel Izquierdo, *The Shepherd*. 1980.
Cast bronze. Patina applied. Installed at Pacific University Library, Forest Grove, Oregon. Photo by author.

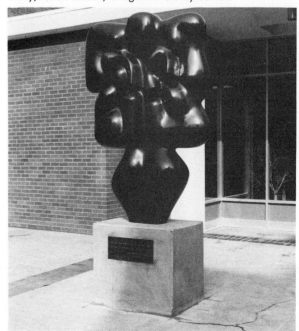

ment near the surface with files, brushes, chisels, or a fine-controlled sand blasting. Cut sprues and vents with heavy metal shears, cut-off wheels on electric grinders or drills, or hacksaws. Remove core pins of steel along with core material and fill the holes either with threaded plugs of metal using a tap and die set, or by welding. For finishing use small steel chasing tools and grinders with abrasive wheels and discs, followed by polishing wheels and buffs. Brush patinas or surface-finishing acids on surfaces first warmed by a torch to produce a range of metal coloration from blacks to browns, yellow-greens and blue-greens (see Figures 10-20–10-23).

Defects of Casting

Flashings are caused by a break in the mold due to poor choice of mold materials, mold design, or reinforcement. Lack of mold permeability or venting is responsible for *blowholes*, caused by trapped gases. *Cold seams* or joints, appearing as hairlines on the casting surface, occur when cooled metal meets warm metal and does not bond properly. Correct this by control of mold and metal temperatures and the addition of gates and sprues. *Porosity* is produced by gases introduced during melting, or pouring, or from moisture in the mold. Cooling too rapidly after pouring may result in *warping* or *distortion*, particularly if there is an irregular thickness in the wall or mass of metal.

Melting Furnaces

Melting furnaces used primarily for nonferrous metals are gas-fired crucibles consisting of a refractory-lined steel 50-gallon drum container, a lid, a burner, and an air supply (see Figure 10-24).

Refractory bricks or castable stucco can be pressed and held in place in the lid and steel drum, or linings and a lid may be purchased precast. For burners, a 1½" steel pipe attached to a motor and fan for the air supply should feed from a ½" steel gas pipe. The burner pipe enters the furnace at an angle so the wall acts as a baffle for the flame. Lighting may be manual. First lift the lid, light a rag wetted with charcoal lighter fluid, and drop it in front of the burner; then turn on the gas. Using a match or stick to light the *pilot light* will turn the burner on as the pilot is lit, making the rag unnecessary. During lighting, close air at intake or keep at low until a yellow flame appears in the furnace. Then add air on low, increasing slowly with the gas flow. Preheating the crucible and furnace on low is necessary to avoid thermoshock, before intensifying to a slight bluish or oxidizing flame. After the metal reaches the required temperature, turn off the gas, then air, and lift the crucible out of the furnace with lifting tongs and into a pouring shank sitting on a bed of dry sand. The crucible sits on a refractory block in the center of the shank opening, while the surface of the metal is skimmed of slag and flux. Raise the shank and withdraw the lifting tongs. Pour in a steady stream.

In the cupola furnace, frequently used for cast iron and large castings in bronze, the metal is not insulated by a crucible but is melted directly in the furnace chamber using coke as fuel, limestone as a fluxing agent. After the coke fire is built up, a charge of metal is placed on the fire and allowed to melt to the bottom, where it is discharged from a tap hole (see Figure 10-25). Unburned coke and ashes are cleaned from the bottom through a drop door. The complex electric furnaces used in steel foundries process metals with the most efficiency and least contamination but are not applicable to the casting of sculpture.

Metal Surface Treatment

A process developed in the early nineteenth century, whereby nonmetallic or metallic forms are coated with thin, uniform films of metal, *electroplating* passes electric currents through a salt solution containing anodes of the metal to be deposited. The metal is dissolved from the anodes and deposited via the current on the cathodes—or objects to be plated (see Figure 10-26). Preparation of the model includes complete cleaning, polishing, and buffing. If porous, it must be dried thoroughly and waterproofed with wax, shellac,

Figure 10-24
Melting furnace for nonferrous metals.

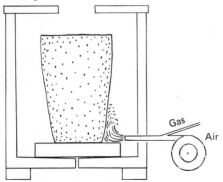

Gas

Air

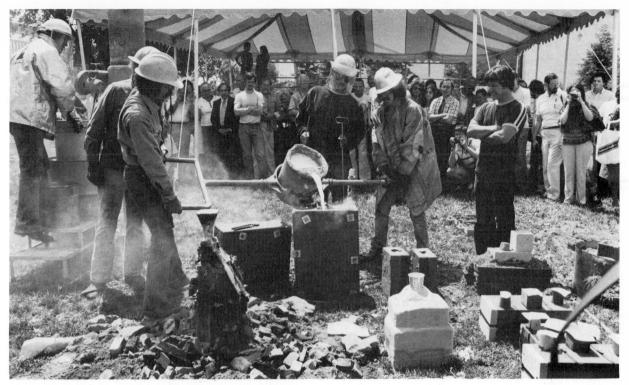

Figure 10-25
Iron pour in sand molds. Pouring supervised by Julius Schmidt at 1980 International Sculpture Conference. Photo by author.

or lacquer. Dust bronze, copper, or graphite powder (plumbago) on the surface, or pigment the lacquer or varnish with graphite, copper, or silver powder. Pour plating solutions into a glass tank using 2 to 3 quarts for small objects. Add sulphuric or cyanide acid in proportion of ½ to 1½ oz. of acid to 1 quart of tank water (always add acid to water, never water to acid). Suspend the object to be coated with wire of the same metal as the coating. Attach a sheet of the coating metal to a positive wire leading from the storage battery. Attach a negative wire to the object, which is suspended in the plating solution by a metal cradle of the coating metal. Current must be DC (direct current), supplied by a ¼ h.p. electric motor powering 1 or 2 generators. Voltage will vary from 1½ to 5 volts and will take 75 minutes to 1½ hours, depending on the thickness of the plate desired. Too low a current will cause an uneven plating and will slow the operation. Chrome coatings require several undercoats of nickel, copper, or cadmium. Seek industrial advice for plating large sculptures, which can be designed to suit the available facilities, usually at reasonable cost.

Brush plating, a variation and improvement on electroplating, allows local application of plating material without immersion. Large sculptures can be plated without cumbersome tanks, and complex surfaces can be covered that might take un-

evenly in the plating bath. A power pack, anodes, a plating tool or a brush, and accessories allow the conductive plating to reach a wide range of shapes and sizes.

In *chemical plating* without electrolysis, metallic sulfates, chlorides, oxides, and nitrates are combined with other chemicals to form plating solutions. Commercial plating solutions can be

Figure 10-26
Electroplating

D.C. power source

Positive

Negative

Anode plating material

Work piece

Plating solution

165

purchased to form deposits of copper, gold, silver, tin, lead, nickel, etc., on aluminum, zinc, copper alloys, iron, and steel.

Hot metal spray, a relatively new, but rather expensive and specialized method, utilizes oxyacetylene to melt wire as it is fed through the spray gun and subsequently blown over the surface with an air compressor. Aluminum, zinc, and cadmium surfaces are most effective on steel intended for exterior placement; copper, silver, brass, and nickel eventually react to the steel. Use these latter metals on nonmetallic surfaces such as plastic, wood, hard plasters or ceramics, and even cloth. Bonding the metal to these surfaces requires initial cleaning and roughening of the surface. Precede applications of copper and bronze with coats of low-melting alloys such as aluminum, zinc, lead, or tin.

Nonmetal Depositing

Phosphate and *chromate solutions* act as rust-inhibiting coatings on metals like zinc, aluminum, and steel. Brush, spray, or dip the coatings on the surface. Phosphates neutralize rust where it exists and condition the surface for priming and painting. Apply chromates similarly for copper, silver, magnesium, zinc, and cadmium.

Anodizing

A surface of aluminum and magnesium serves as the anode when submerged in a solution of chromic or sulfuric acid and subjected to an electric current. The surface forms a porous film of oxidation which can absorb colorations. When sealed, the surface has a durable, hard, noncorrosive finish. Aluminum alloys vary in their ability to accept anodizing, so check the original alloys and those added during the fabrication process.

Oxidation

Surface chemical treatment has traditionally been the primary means of accelerating a metal's color change. The desired effect is often similar to those which come about naturally with age and exposure to the elements. Spray or brush oxidizing salts onto a warmed metal surface for an immediate patina or surface change which, in the case of outdoor works, will be carried further by sun, wind, and rain. Mix oxides yourself or purchase premixed commercial formulas with color possibilities ranging from blacks and browns to green and blue-greens.

There are two methods for applying patination treatment. Either heat the surface with a blow torch held in your left hand while your right hand holds the brush and applies acids to the heating bronze, or apply acids on cold metal surfaces— the preferable method for large works that will acquire a patina outdoors. Do not overheat bronze or it will sweat tin to the surface, preventing chemical action. Between applications of acid, wash it with cold water to prevent acid buildup. Always add acid slowly to water, never water to acid.

OXIDE FORMULAS FOR BRONZE

Browns	Potassium sulphide or ammonium sulphide 2 to 4 oz. Water 1 quart Dissolve acid in water and heat or apply to heated surface. Sulfurated potash—bean-size piece in ½ cup water. Dissolve and brush on.
Blacks	Copper carbonate 2 oz. Ammonium carbonate 4 oz. Sodium carbonate 1 oz. Water 1 gallon 2 base solutions stored in separate containers: 1. 1 oz. water 1 oz. nitrate of copper 2. 1 oz. water 1 oz. nitrate of silver Mix the two solutions: Water 3–6 parts Copper nitrate solution 2 parts Silver nitrate solution 1 part Apply to metal. Heat to dry and brush off. Immerse 5 minutes in liver of sulphur (sulfurated potash) in solution of 2 oz. of liver of sulphur to 1 gallon of water. Dry without rinsing. Lacquer or wax.
Red-brown	Heat small pieces of bronze to straw color and drop into vinegar. Bottle the mixture and leave it to dissolve. Paint it on heated metal.
Light blue-green	Ammonium chloride 10½ grams Copper acetate 5 grams Water 1 quart Warm water to dissolve. Spray on and let dry.
Antique (dark green)	Copper sulphate 6 oz. Ammonium chloride 2 oz. Water 2 quarts or Copper nitrate 2–4 oz. Water 1 quart Wash with coat of above and let dry. Apply a coat of ammonium sulphide where darker spots are desired. Let dry and set with wax.
Turquoise	Potassium sulphide 15 grams Ammonium chloride 200 grams Water 5 oz.

Copper or Brass

Sage green	Apply copper nitrate and water 1:4 as a hot solution.
Olive green	Iron perchloride and water 1:2 as a hot solution
Black	Copper nitrate and water 1:3 solution

Aluminum

Black	Caustic compounds such as Draino or lye will darken aluminum. Brush on thin coat of olive oil and heat slowly over an alcohol flame. Polish with wool or leather. Zinc chloride 1 lb. Copper sulphate 1.5 oz. Water 2 quarts Apply hot solution.
To decolorize	Wash with mixture of 30 parts borax, 1,000 parts water, and ½ teaspoon ammonia.
Aluminum, lead, pewter	Rub with dilute solution of muriatic acid (hydrochloric acid) followed by an application of linseed oil rubbed in with fine steel wool.

APPROXIMATE WAX TO METAL RATIOS BY WEIGHT

Wax		*Metal*
1 lb. wax	____	9 lbs. iron
1 lb. wax	____	10 lbs. bronze
1 lb. wax	____	30 lbs. aluminum

APPROXIMATE WEIGHTS OF MATERIALS IN POUNDS PER CUBIC FOOT

Aluminum bronze	475
Aluminum, cast	160
Babbitt metal	454
Bronze	534
Cast iron (mean)	450
Charcoal (lump)	18
Clay	120–135
Coal	60–80
Concrete (set cement)	140
Copper, cast	548
Fireclay	90
Gold, cast pure	1200
Gold, 22-carat	1090
Lead	710
Limestone	158–168
Mercury	847
Nickel, cast	516
Nickel-Silver	516
Oak (wood)	45
Phosphor bronze, cast	536
Pine (wood)	30
Sand (dry, unrammed molding)	75–85
Sand (silica)	85–95
Silver, cast pure	656
Steel (mean)	490
Tin, pure	453
Wrought iron	480
Zinc, cast	428

INVESTMENTS FOR NONFERROUS METALS

1. Nonferrous investment #1 (U.S. Gypsum)

2. #1 Molding plaster, white 1 part
 Luto 1 part
 Water as required

3. #1 Molding plaster 2 parts
 Silica flour (flint) 2 parts
 Luto 3 parts
 Water as required

4. Investment for aluminum only

 1. #1 Molding plaster 5 parts by weight
 Sawdust 1 part by weight
 Sand 28 parts by weight
 Water 16 parts by weight

 Allow to cure overnight, then heat at 190°F for 2– 4 hours, then heat to 575°F for 1–2 hours.

 2. #1 Molding plaster 1 part
 Pumice 1 part
 Water as required

5. Investment for lead casting
 #1 Molding plaster 6 parts by weight
 Chalk 3 parts by weight
 Crushed grog 3 parts by weight
 Marble dust 3 parts by weight

CORE SAND FORMULAS

1. Core sand for small cores

 Beach sand 10 parts
 Flour 1 part

 Mix with molasses water, dry with heat.

2. Core sand for large cores

 Sharp fire sand 8 parts
 Strong loamy sand 2 parts
 Flour 1.5 parts

 Mix with clay water; dry with gentle heat.

3. Core sand for small, complex type

 #1 Beach sand 15 parts
 Fire sand 15 parts
 Rosin 2 parts
 Flour 1 part

 Mix with molasses water and dry with heat—too much water will make it the sand stick—too little will make it crumble.

 Core sand for small, complex type

 #2 Beach sand 15 parts
 Molding sand 5 parts
 Flour 2 parts
 Core oil 1 part

 Mix with molasses water, dry with heat.

PLATING FORMULAS

Amperes required to plate 1 square foot area

Nickel	4 amperes
Brass	6–8 amperes
Bronze	6–8 amperes
Copper	6–8 amperes
Silver	2 amperes
Gold	1.5 amperes
Zinc	10 amperes

Current must be D/C (direct current) and can be supplied by one or two automobile generators in parallel driven by a ¼ h.p. electric motor.

PLATING SOLUTIONS

Silver

Silver cyanide	4 parts by weight
Potassium cyanide	10 parts by weight
Water (distilled)	70 parts by weight

Use pure silver at the positive terminal.

Brass

Copper sulphate	1 part by weight
Zinc Sulphate	10 parts by weight
Potassium cyanide	16 parts by weight
Water (distilled)	1024 parts by weight

Use brass at the positive terminal.

Copper

Copper acetate	20 parts by weight
Sodium carbonate	17 parts by weight
Potassium cyanide	20 parts by weight
Sodium sulphite	25 parts by weight
Water (distilled)	1024 parts by weight

Use pure copper at the positive terminal.

Nickel

Nickel sulphate	10 parts by weight
Sodium citrate	9 parts by weight
Water (distilled)	288 parts by weight

Use pure nickel at the positive terminal.

To Electroplate Plaster with Copper

Coat the plaster with shellac, spar varnish, or wax. Apply a coating of plumbago (powdered graphite); polish. Prepare a solution as follows:

Add ½ oz. of hydrochloric acid to each quart of water. Suspend a bag containing ½ lb. of copper sulphate in the solution until it is saturated with copper sulphate.

Suspend a copper plate at the positive terminal, hanging clear in the solution. Immerse the treated plaster or object to be plated in the solution, and connect it to the negative terminal. Use low voltage (1–16 volts) and 6–8 amperes per square foot of surface to be plated.

11

Direct Fabrication of Metal and Plastic

HISTORY

From the time metal ore was first extracted from rock, over 5000 years ago, all great ancient cultures actively pursued metal casting and fabricating—initially with nonferrous copper and bronze and precious gold and silver; later (about 1000 B.C.), with iron and to a small degree, steel. Valued for its practical application in times of war, metal technology was furthered by a series of major developments such as the Catalon forge in A.D. 700, in which wheel-powered air was blasted under the fire; the blast furnace in 1340; and wrought iron in the 1700s. The Bessemer process in 1832, in which air was blown through molten iron to remove impurities, resulted in the replacement of iron with steel in bridge construction, skyscrapers, railroads, and machinery. New means of forming and joining steel led to the welding processes used today.

Welding has its antecedents in the traditional methods of riveting, soldering, and forging. *Riveting* is a mechanical way of joining sheets of metal by inserting pegs made of the same metal and hammering the pegs or rivets level with the surface. *Soldering* joins nonferrous metals with metal of a lower melting temperature, using heat applied locally by heated irons or in a kiln or forge. *Forging* first preheats a metal in a blacksmith's fire; while soft and pliable it is shaped by hammering on an anvil and/or bending and twisting, before it is allowed to harden. This method is adaptable for small pieces, as large works cannot fit in a forge.

Fusion welding, invented in the early 1900s, produced a joint as strong, or stronger, than the metals being joined—an efficient, dependable, and economical means of joining metals. In 1895 the French chemist Le Chatelier demonstrated that the combustion of acetylene with oxygen produced a flame far hotter than any known at the time. From this combustion both hydrogen and carbon monoxide are produced; in the outer envelope of the flame, these two gases unite with oxygen from the surrounding air to form water vapor and carbon dioxide.

In the 1890s a commercial process was developed to extract acetylene from calcium carbide by heating limestone and coke in an electric furnace and mixing the resulting calcium carbide with water. About the same time, a machine was de-

veloped which produced liquid oxygen. In 1901, blowpipes were manufactured that permitted control of the oxyacetylene flame, and welding was used commercially by 1903.

The oxygen-acetylene process made possible the fabrication of large metal works in a remarkably short time. Twentieth-century sculptors adopted welding as a method of the machine age. Julio González, the son of a Spanish ironsmith, was one of the earliest artists to use fabricated and welded metal as his major material. Working from the late 1920s to the early 1940s, along with his friend Pablo Picasso, he may be credited with being the first to incorporate industrial discards in his sculpture. He was also instrumental in impressing other sculptors of this period with welding's potential. The examples of Picasso and González motivated

the next generation of artists, which included the Russian-born Constructivists Naum Gabo and Antoine Pevsner. During the 1920s the pair (who were also brothers) produced highly original works in metals and plastics which eventually led to the acceptance of new industrial materials and processes in the arts.

Partly as a result of the Constructivist influence (Gabo and Pevsner settled and did their mature work in America), twentieth-century American artists became prolific and experimental in welded metal (see Figures 11-1, 11-2, and 11-3). David Smith, Richard Stankiewicz, Theodore Roszak, Seymour Lipton, Ibram Lassaw, Herbert Ferber, and Harry Bertoia each expanded metal's expressive potential, giving it linear delicacy, humor, fantasy, even spirituality. During the 1960s,

Figure 11-1
Manuel Izquierdo, *Dreamer.* 1981.
Welded sheet bronze over steel strap frame, H. 14 ft., L. 12 ft., D. 7½ ft. Pettygrove Square, Portland, Oregon. Commissioned by the Metropolitan Arts Commission, Portland, Ore. Photo by Al Monner.

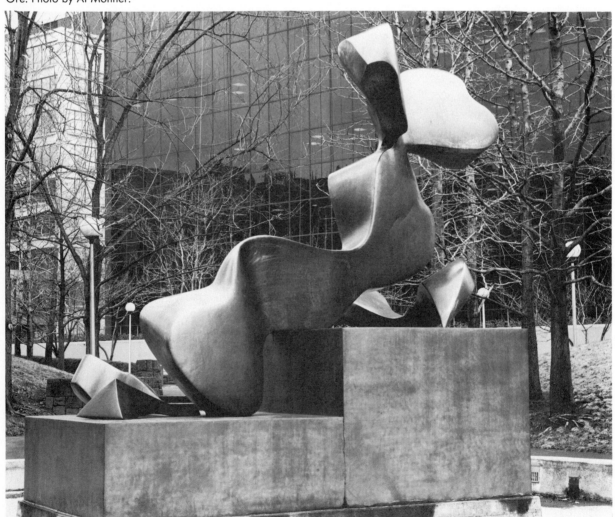

sculptors adapted industrial techniques and arc welding to produce architectural sculpture of monumental proportions designed for the environment. The outdoor location of the works required protective surface treatment such as plastic-based paint and noncorroding metals like stainless steel and aluminum. The preference for fabrication over the more expensive casting process has led to the establishment of specialty fabrication studios such as Lippincott's in New Haven, Connecticut.

OXYACETYLENE WELDING EQUIPMENT

One acetylene unit or tank and one oxygen unit, or tank of compressed air, may be leased or rented from a welding supply house. When these two gases are mixed, a flame of over 5000°F is created, allowing metals of considerable thickness to melt and readily join with little loss of strength. When acetylene gas is used alone, it produces a flame of 2500°F, suitable for brazing, hard soldering, and melting nonferrous metals. Two pressure regulator gauges for each tank—one indicating pressure in the cylinder and the other the working pressure established at the blowpipe—may be leased or purchased. Mechanical details vary slightly among different manufacturers, but operating principles are the same for all welding and cutting regulators. The one-stage type of regulator is designed for a manifold system of welding stations where pressure is regulated at a central station. In the two-stage type, designed for single operations, the gas moves into a pressured chamber where a predetermined pressure is maintained, usually 200 lbs. per square inch for the oxygen chamber and 50 lbs. per square inch for the acetylene. From the pressurized chamber it moves to a reducing chamber with a screw adjustment controlling pressure at the final outlet. Should the flow of gas out of the outlet be stopped, regulators deflect the diaphragm in the low-pressure chamber and close the valve, preventing gas from entering the high-pressure chamber. Oxygen regulators are designed to indicate the full cylinder pressure of 2200 lbs. per square inch, though some are calibrated to 220 cubic ft. or just 2000 lbs. per square inch, with pressures above that estimated.

Other components of the oxygen-acetylene outfit include the following (see Figure 11-4):

1. **Nonporous double hoses**, green for oxygen, red for acetylene, using right-hand connectors for oxygen, left-hand threads for acetylene.

Figure 11-2
Jason Seley, *Primavera.* 1964.
Chrome-plated steel, H. 80 in., W. 35 in., D. 35¾ in.
Collection Whitney Museum of American Art, New York. Gift of the Friends of the Whitney Museum of American Art.

2. **Blowpipe or torch.** Blowpipe types are classified according to acetylene pressure, with injector types designed to use acetylene at very low pressure (1 lb. per square inch), and balanced or equal pressure types operating with both oxygen and acetylene at medium pressure of 1 to 15 lbs. per square inch. The equal pressure types are most often chosen for sculpture because of their versatility. Interchangeable tips of various sizes come with the blowpipes, the tip-size selection coordinated with the thickness of the

Figure 11-3
Jan Zach, *Can-Can.* 1957.
Polished stainless steel kinetic sculpture. H. 50 ft., D. 25 ft. Installed in the rotunda of the
Meier and Frank Co., Valley River Center, Eugene, Oregon.
Photo by George Farquhar.

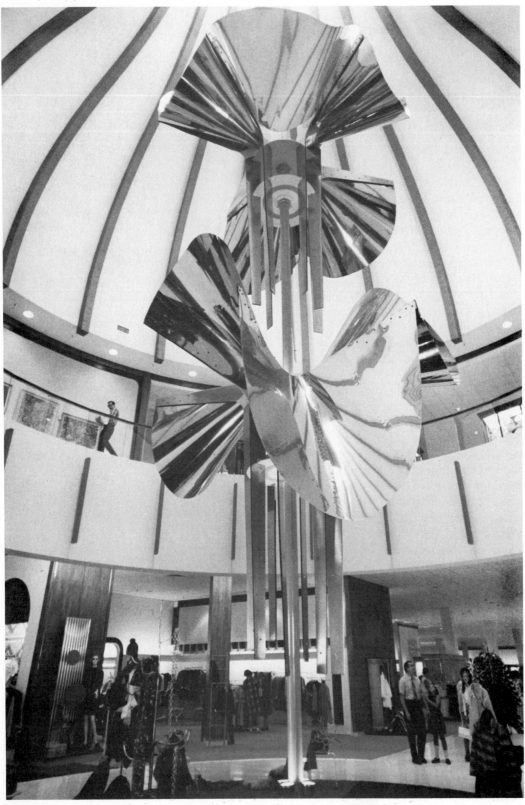

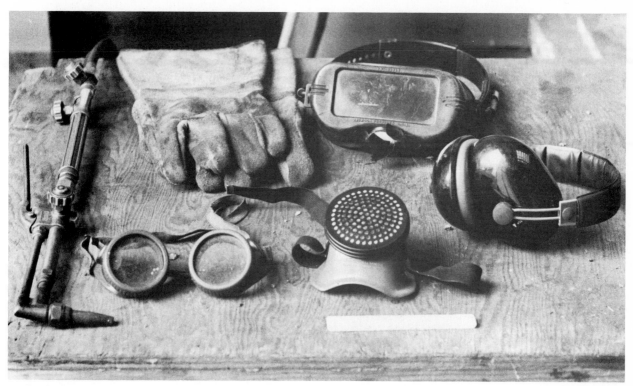

Figure 11-4
Welding equipment—cutting torch, protective goggles, ear muffs, gloves, and mask for fumes.

metal and the chosen working pressure. The higher the pressure, the larger the tip. (Manufacturers of equipment will have these settings.)

3. ***Cutting attachment.*** A cutting tip that allows changing conveniently from welding to cutting can be fitted to the blowpipe by a hand-tightened connector nut. The cutting tip is designed with small holes surrounding a large central opening. The flame from the holes preheats the metal, which is cut by the jet of oxygen produced from the central opening.

4. It is imperative to protect the eyes and body with ***goggles*** of colored optical glass, heavy ***gloves***, and appropriate ***shop aprons***.

5. A ***friction lighter*** is preferable to the dangerous practice of using hand-held matches. Other equipment would include metal clamps of different sizes, forging hammers and anvils, metal-cutting shears (electric and manual), pliers, bolt cutters, wire brushes, etc.

Operating the Equipment

Secure the tanks well so they will not tip over. Standing out of the way of any possible released oxygen or acetylene, remove the caps, turn the valve of each tank one quarter turn to blow out any possible dust around the valve, and then close the valve. Screw the regulators to the tanks with an open-ended wrench, the oxygen using a right-hand thread, acetylene left-hand thread. Connect the hoses, the green hose to the oxygen regulator, the red to the acetylene. Attach the other ends to the valves on the torch. Take care not to use force, which will mar the connections. Oil or grease must not touch the oxygen fittings, as this is a very combustible area. After connecting the regulators, turn the pressure adjusting screw counterclockwise (to the left) to loosen before opening the cylinder valve on the acetylene. This will avoid possible damage to the regulators and gauges. To mix the gases, follow the procedure outlined below (see Figure 11-5):

1. Turn on the oxygen tank valve by turning the hand wheel at the top counterclockwise all the way.

2. Turn the acetylene tank valve counterclockwise ¼ to ½ turn. Both gauges will indicate tank contents.

3. Make pressure adjustment for hoses by turning in regulator pins clockwise. Pressures for oxygen average 7 to 10 lbs., for acetylene 5 to 7 lbs. Larger works require large tips and higher pressures. Acetylene pressure never exceeds 15 lbs. per square inch. In

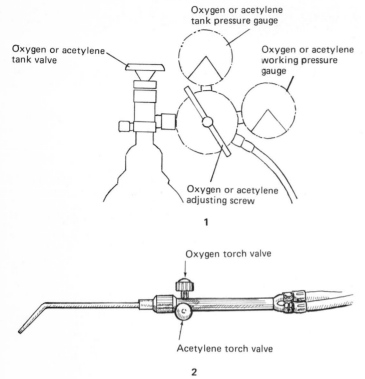

Figure 11-5
Turning oxyacetylene tanks on and off: (1) Oxyacetylene pressure regulator; (2) Oxyacetylene torch.

To turn on tanks:
1. Turn on tank valves counterclockwise:
 1½ turns for oxygen
 ¼–½ turns for acetylene
2. Turn in pressure gauge indicating pressure in cylinder: oxygen generally 7-10 lbs for medium size work acetylene generally 5-7 lbs for medium size work, not exceeding 15 lbs.
3. Turn on torch valves. Turn acetylene valve counterclockwise ⅛ to ¼ turn.
4. Light torch with friction lighter and adjust to slight flame.
5. Turn oxygen torch valve counterclockwise ¼ turn and adjust torch to neutral flame.

To turn off tanks:
1. Turn off acetylene torch body (turn clockwise)
2. Turn off oxygen torch body (turn clockwise)
3. Turn off acetylene cylinder valve.
4. Turn off oxygen cylinder valve.
5. Bleed system by opening and closing acetylene torch valve; repeat for oxygen.
6. Turn out acetylene and oxygen adjusting screws of tanks until loose.

cutting, oxygen pressures range from 30 to 60 lbs. while acetylene pressures remain below 8 lbs.

4. While keeping an average working pressure, test for leaks with the blowpipe valves closed. Using nothing but Ivory soap and water, test these points for leakage: (A) Oxygen cylinder valve stem. (B) Acetylene cylinder valve stem. (C) Oxygen regulator inlet connection and cylinder valve. (D) Acetylene regulator inlet connections and cylinder valve. (E) All hose connections. (F) Blowpipe oxygen and acetylene valves. To test for leakage of blowpipe valves and tip connections, immerse the tip in water and watch for bubbles. If damage is noticed, first tighten hose connections using new nipples and nuts. Dirt lodged in the connection between regulator and cylinder can also cause leakage. To clean, first close one cylinder valve and clean both the inside of the cylinder-valve seat and the regulator inlet-nipple seat. Tag leaking cylinders and return them to the supplier with the serial number on the tag.

Turn the torch on by igniting the acetylene first, then adding the oxygen. With the acetylene torch body valve turned counterclockwise ¼ turn, ignite the blowtorch tip with the friction lighter. Adjust the acetylene until the flame stops smoking, then open the oxygen torch body valve slowly and adjust for a neutral flame with a sharp-edged pale blue inner cone. Excess oxygen produces an oxidizing flame, with a short blue inner cone; excess acetylene produces a carburizing flame with a long feather or envelope on the outside of the inner core (see Figure 11-6).

Close the torches by turning off first the acetylene torch body valve, then the oxygen valve. If the day's work is completed, turn off the acetylene cylinder valve, then the oxygen (clockwise). Bleed the hoses by turning on the acetylene torch body valve until all the acetylene is released and the pressure goes down to zero; repeat for oxygen. Turn

Figure 11-6
Types of welding flames.

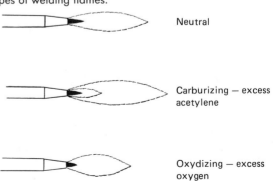

Neutral

Carburizing — excess acetylene

Oxydizing — excess oxygen

out the adjusting screws on the oxygen and acetylene regulators (counterclockwise) until loose.

STEPS IN WELDING AND CUTTING

The edges of two metals melt simultaneously, causing them to flow together and solidify as one. In addition, a filler rod is usually necessary to help seal the joints (see Figure 11-7). Hold the torch at a 30° angle, with the hottest part of the flame held just off the steel. The angle allows for the premelting of the metal, which forms a molten puddle in the shape of an O or U as the torch rotates. Hold the filler rod at the same angle, slanted away from the torch, keeping the tip of the filler rod at the molten center of the puddle. Synchronize the movement so the rod melts into the puddle fully. If the puddle becomes too hot through slow movement, the metal may burn through; if too fast, it will not fuse with the surface. The forehand method—with the rod fed before the flame, working from right to left—is the more frequently used. The backhand method, where the torch tip precedes the rod as the torch works from left to right, is the preferred, faster method for thicker materials (see Figures 11-8 and 11-9). Good welding requires clean tips (use the proper size tip to avoid over or underheating metal), and the proper torch speed.

The *cutting* attachment, which easily screws

Figure 11-7 Types of Metal Joints
1. V-grooved butt joint
2. simple butt joint
3. simple Tee joint welded on both sides
4. simple corner weld—one side
5. lap joint—welded from both sides
6. butt joint V-grooved and welded on both sides.

on and replaces the welding torch, is valuable for cutting thicker pieces of nonferrous metals (see Figure 11-10). Cutting requires higher oxygen pressure, 20 to 30 lbs., than acetylene pressures, which may be as low as 3 to 5 lbs. To light the cutting torch, first open the oxygen valve on the torch body, then turn the acetylene ⅛ while lighting the torch with the friction lighter (see Figure 11-11). Increase both the acetylene and the oxygen

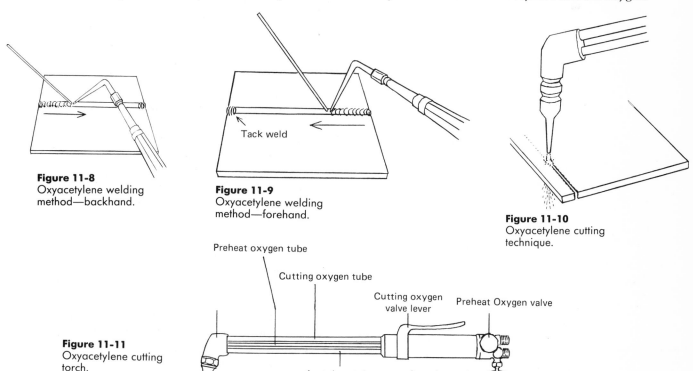

Figure 11-8
Oxyacetylene welding method—backhand.

Tack weld

Figure 11-9
Oxyacetylene welding method—forehand.

Figure 11-10
Oxyacetylene cutting technique.

Preheat oxygen tube

Cutting oxygen tube

Cutting oxygen valve lever

Preheat Oxygen valve

Figure 11-11
Oxyacetylene cutting torch.

Tip

Acetylene tube

Acetylene valve

until a neutral flame is reached. Heat the metal with the flame until bright red, then depress the lever slowly and move the torch in the direction of the cut. Speed is crucial, as too fast a speed will result in an incomplete cut, too slow will melt and fuse the metal after cutting. The torch accomplishes rapid oxidation with a jet stream of oxygen (a speeded-up version of what occurs when metal rusts) with the oxidized metal running off as "slag" or waste. More expensive than flame cutting, *powder cutting* cleanly separates thick sections of nonferrous metals like copper, brass, nickel aluminum, as well as ceramic and cement. First a stream of metallic powder is blown into the cutting zone, thereby fluxing the metal oxides in the cut and lowering the melting temperature before cutting.

During welding and cutting, the torch will sometimes emit a loud pop or backfire. The cause may be dirt on the tip, touching the work directly with the tip, or too low acetylene pressure. *Flashback*, the flashing of the flame back into the mixing chamber, is caused by an overheated tip and extinguished by shutting off the oxygen. If it occurs too frequently, the torch should be repaired.

BRAZING

Brazing differs from welding in that the base metals are not melted and fused, but rather heated to a temperature above 800°F and then bonded to a nonferrous filler metal (usually in rod form) which melts at a lower temperature than the base metals (see Figure 11-12). Fluxes prevent oxides from forming on the brazed joints and interfering with proper bonding. Brazing requires less heat than oxyacetylene welding and can be used to join two dissimilar metals for surface textural effect and color, and as a protective surface for ferrous metals. For joining by brazing:

1. Clean metal thoroughly.
2. Using a reducing flame (slight excess acetylene), heat the area to a dull red.
3. Apply flux by dipping the heated rod into the powdered flux. For large areas, apply flux-coated rods.
4. When the heated flux becomes transparent and fluid, touch the filler rod to the metal. The base metal should be hot enough to melt the alloy without the flame directly on the rod. Keep the torch near but not on the rod, or it will easily overheat. For textural surfaces using bronze rod, direct the torch to the tip of the fluxed rod, which then melts and puddles into one preheated metal surface. Heating more surface will spread the bronze further. Bronze rod is gener-

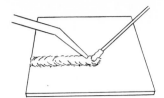

Figure 11-12
Brazing procedure.

ally used for brazing since it creates a strong joint; it works well on steel, brass, copper, and cast iron but not aluminum. Unless the metals are rather thick, temperatures needed for brazing generally do not exceed 2500°F; an air-acetylene unit, therefore, may replace oxyacetylene for brazing and hard soldering. Hard soldering techniques require mastery in the use of silver solder, which melts at lower temperatures of approximately 1500°F. Torches using acetylene, propane, or gas, or a combination of air and natural gas are adequate for hard soldering temperatures. Precise methods for silver soldering are described in books on jewelry techniques.

WELDING ALUMINUM

Welding aluminum with oxyacetylene resembles brazing: Flux must be applied both to the rod or filler material and the surfaces to be joined. Aluminum flux is very corrosive, requiring protection during use and washing of the joint after welding. Preheat the metal, particularly if thick, but since it overheats easily, support it with a backup plate to prevent it from slumping. Filler rod can be bare or flux coated on pieces of the parent metal, but should match the parent alloy. Check it for compatibility to gas welding, as some alloys work better than others. Use the correct size filler rod to prevent chilling the puddle. As with brazing, direct a reducing flame to the fluxed joint at the same time the filler metal is applied, allowing the filler and base metal to fuse.

WELDING BRONZE
(see Figures 11-13–11-20)

Thermal conductivity requires preheating. Though the metal flows freely, the oxides which form in the weld area make a flux desirable. A slightly oxidizing flame will prevent holes in the weld and keep the weld puddle from boiling. Shrinkage stress is great during welding and may be relieved somewhat by working from the center to the opposite ends (tacking the center and ends before welding). Copper silicon alloys like *Everdur* weld more eas-

Figure 11-13
Plaster model, one-half scale, for bronze sheet sculpture by
Manuel Izquierdo. Paper patterns are taken from the model
and enlarged on a grid to twice the size. Photo by author.

Figure 11-14
Cutting ⅛″ thick Muntz sheet bronze using power nibbler.
Bronze comes in 4′ × 8′ or 4′ × 12′ modular sheets.
4,000 lbs. of bronze, approximately 200-300 sheets, were cut
and oxyacetylene welded. Photo by author.

Figure 11-15
Shaping metal by pounding on leather sandbag (repoussé
process). Photo by author.

Figure 11-16
Shaping (repoussé) cold metal on steel stake.
Photo by author.

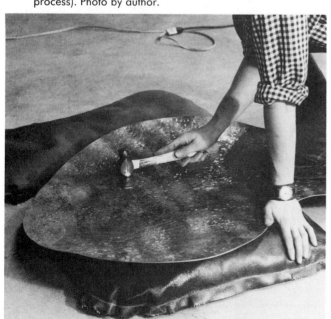

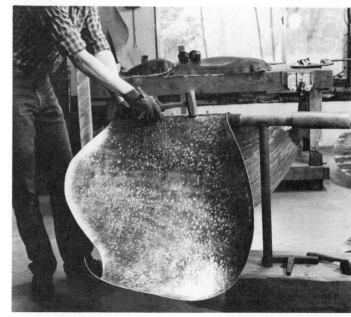

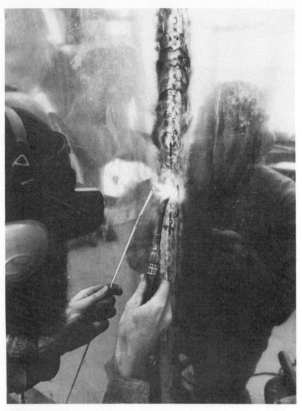

Figure 11-17
Oxyacetylene welding flat sheet bronze using flux-coated bronze rod. Seam is then ground after cooling. Photo by author.

Figure 11-18
Oxyacetylene welding sheet bronze curved sections of *The Dreamer* by Manuel Izquierdo. Flux-coated bronze rod is used. Photo by author.

Figure 11-19
Assembling fabricated sheet bronze showing interior steel strap support system. Construction was done in four sections, two major body pieces and two smaller pieces, these bolted to the base. Photo by author.

Figure 11-20
Installation of *The Dreamer* by Manuel Izquierdo. 1981. Pettygrove Square, Portland, Oregon. A work which sets a precedent in the use of fabricated sheet bronze applied on a monumental scale. The traditional methods of casting proved impossible within the allowed budget. Due to size and the cantilevered design, approval of the design by a structural engineer was required by the city. The hollow interior was filled with styrofoam to make the piece more resilent to denting and to deaden the sound. No patina was applied, as the chemicals accelerate a breakdown of the surface. In time the surface will darken naturally. Photo by author.

ily than other bronze alloys, as thermal conductivity is not as great. Filler rods should be compatible with the parent metals. Copper, brass, and bronze may be braze welded with phos-copper rods containing 90% copper that require no flux. *Copper* can be welded if it is pure, oxygen-free or deoxidized, as opposed to the electrolytic or oxygen-containing types. To test for weldability, puddle a small amount with a torch. If a clear and shiny ball forms, the metal is weldable; a ball that boils and gives off fumes indicates impurities and should not be welded. You can eliminate use of the welding rod and fuse-weld pieces while molten, or weld them with phos-copper rod, using no flux. If color is not a problem, use bronze rod. Due to its high heat conduction, heavy-gauge copper must be preheated in a kiln or with a torch.

WELDING STAINLESS STEEL

Oxyacetylene may be used on stainless steel of 18 gauge or less; inert-gas shielded arc welding for heavier gauges. Use a smaller tip than for mild steel of the same thickness, as stainless steel re-

tains heat longer. A neutral flame is necessary, since excess of oxygen may oxidize the steel's chromium (stainless steel contains 18% chromium), thereby reducing its corrosion resistance. You will need a cromaloy flux to protect all heated surfaces from oxidation, and rods of high chromium content to fill in the oxidation losses (see Figure 11-21).

ARC WELDING

The term covers metal arc welding, Argon or Helium arc welding, or TIG for *"tungsten inert gas"* and MIG for *"metallic inert-gas welding."* The arc-welded joint is made by heat produced by the electricity of an arc passed through a welding rod called an electrode and across to the metal surfaces. TIG and MIG are gas-shielded welding processes which confine the inert gas of argon or helium to welded areas, preventing atmospheric contamination.

Arc welding produces almost twice the heat of oxyacetylene in a short time, allowing heavy pieces of metal to be rapidly welded with little distor-

Figure 11-21
Lee Kelly, Model for proposed fountain in Portland, Oregon. 1979. Stainless steel, H. 27 in. Photo by Ancil Nance, Portland, Oregon.

tion. TIG and MIG are preferred means for welding nonferrous metals like copper, brass, stainless steel, nickel, aluminum, and magnesium, since in these methods the gases pushing away air from the weld form a shield preventing rapid buildup of oxides which weaken the joint. Eliminating the need for flux and protecting the weld area from oxides make for a fast and efficient welding system and strong, clean joints.

Arc-Welding Equipment

Arc-welding equipment includes a machine, power supply, cables, ground clamp and well-insulated electrode holder, a helmet designed to protect the eyes against harmful ultraviolet and infrared rays, leather gloves, and heavy apron. Since the light of the arc is dangerous to the naked eye within 50', a booth or a screen of fire-resistant material should enclose the welding area to protect others. Preferred is a 180 amp, 230 volt combination AC/DC welder, direct current rather than AC for a greater choice of electrodes and more steady current.

For operation, plug the machine into a wall socket, plug the cables into a jack-plug socket for the polarity, and select the amperage. Polarity designates the flow of the current: direct current—straight polarity, direct current—reverse polarity, or alternating current—depending on the metal's type and thickness and the type of weld. In straight polarity, electrons flow deep into the work from the electrode (good for thicker metal), while in reverse polarity electrons flow from the work through the electrode, making a wide weld that more actively consumes the electrode itself. Amperages, depending on rod size and thickness of metal, can be equated roughly with the torch-tip size in gas welding. (Too high a current setting increases the electrode's rate of melt and excess heat in the base metal, revealed by wide beads and spattered metal. A narrow bead that sits on the surface rather than integrating with it and lack of a molten pool indicates too low a current.) Finally, fasten the ground clamp to the work piece. Place the rod in the electrode holder at right angles to the holder and in position a few inches from the work. Then turn on the power holding the rod a few inches from the metal, and lower the helmet before the arc is started (see Figure 11-22).

1. Start the arc with a tapping or scratching motion and withdraw to a distance equal to the diameter of the rod. Pull the rod back quickly or it will stick and become red hot (in which case, twist, bend, or disengage it from the holder).

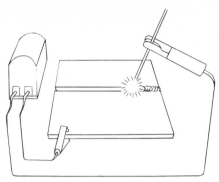

Figure 11-22
Arc welding process.

2. Hold the electrode in a near vertical position and move it in the direction of the weld, from left to right, while rotating it in a semicircular or side-to-side motion to prevent too rapid a movement and too long an arc.

3. Another determinant of heat, along with amperage, is the length of the arc between the rod and the metal. Too long an arc causes spattering, hissing, and insufficient fusion; with too short an arc, the electrode frequently sticks to the parent metal and filler builds up on the surface.

4. The current flows (the arc is struck) when the electrode is linked to the metal. The flux on the electrode melts and becomes a gaseous shield protecting the weld by keeping it free of an oxidizing atmosphere. The electrode is consumed up to the last inch or two before it is replaced.

Electrodes are selected to match the particular alloy, thickness of the metal, and type of weld. Flux coatings on rods also vary for specialized welding problems. For welding some nonferrous metals like silicon bronze, a nonconsumable carbon electrode starts a carbon arc that melts the metal, followed by a consumable rod for filler as with oxyacetylene welding. In penetrating thicker materials, a V grooving of joints or beveling at a 30° angle is desirable, using several passes to fill the trench made by the V.

TIG (TUNGSTEN INERT GAS) WELDING

TIG welding is also called tungsten arc welding, Heliarc, and Heliweld, for the helium gas used to shield the tungsten electrode as it welds (see Figure 11-23). Argon gas has more weight than helium, requires less volume, diffuses more easily, and is used more frequently, hence is more readily available from suppliers.

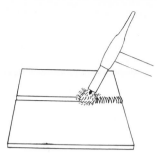

Figure 11-23
TIG welding.

The TIG-welding machine is designed with a range of welding currents, current controls, and control of shielding gas. The electrode is not consumed but is used to start the current, the weld then made by fusion of the metal itself, or with a filler rod. Precontrolled settings for each metal can be adjusted for the rate of gas flow; amperage; current setting (direct current reverse, straight polarity, or AC); electrode size; welding rod; weld speed; and the size of the gas cup. Equipment includes a torch with a porcelain or water-cooled cup; a tungsten electrode, and a combination cable designed to carry electricity; inert gas and water; an argon or helium steel tank and pressure regulator (one tank and line-pressure gauge); and a flow

meter and circulatory water pump—required if the torch is cooled by circulating water.

For welding, start the current by simply touching the work with the electrode and withdrawing it to ⅛" above the metal. Hold the electrode at an 85° angle. Make the puddle at the beginning of the weld, and insert the filler rod held at a 10° angle into it, the torch forming a rippling pattern by its movement.

TIG welding excels with nonferrous metals like aluminum, copper, brass, nickel, magnesium, and stainless steel. The protective wall of gas around the arc prevents the formation of oxides, a problem characteristic of nonferrous metals, and allows for a clean, strong weld.

MIG (METALLIC INERT GAS) WELDING

MIG welding is similar to TIG but uses a consumable wire electrode forming a molten metal pool as it is deposited into the joint (see Figure 11-24). The electrode is in the form of a continuous wire in the same alloy as the metal (bronze, steel, aluminum, or stainless steel), fed from a spool mounted on the machine through the torch

Figure 11-24
Welding stainless steel using a MIG (Metallic Inert Gas) welder. Studio of Lee Kelly. Photo by author.

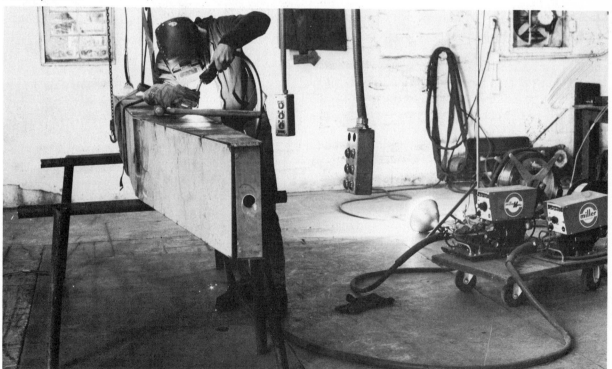

at preset speeds. Direct current is used generally with reverse polarity. There is no need to stop and replace electrodes, and the heat penetrates deep into metal, allowing for efficient welding of small joints. Once the angle and travel speed are controlled the technique is simple, with the absence of slag or flux producing clean welds and eliminating cleanup of finished welds.

ARC CUTTING

Arc cutting with the electric welder produces a rough cut, but is effective in cutting heavy ferrous and nonferrous metals. For most metals, special cutting rods are necessary. Move the rod like a saw blade, up and down through the metal. Amperage increases with the size of the rod, generally ranging from 250 to 500 amps. Air arc-cutting torches blow the slag out of the cut or key, making cleaner cuts. The TIG and MIG processes can also be adapted for cleaner cutting.

SHAPING METALS—REPOUSSÉ

Repoussé, from the French verb *pousser*, to push, is a term for hammering metal into relief form. This shaping—in effect stretching—can be done from either side, with the metal over or inside supports like steel anvils, stakes or mandrils, wood forms, sandbags or pitch bowls, or a combination of these. Large pieces of nonferrous metals can be suspended so that both sides are accessible for hammering. Repoussé may be used initially to shape separate sections of a large work which will be welded or brazed together. A support armature often must be welded or brazed to the interior or, in a relief, to the back of the piece. (Refer to Figures 11-13–11-20.)

Ferrous metals can be used, but most conducive to repoussé are the nonferrous copper, brass, or bronze in 16 to 24 gauge, and sheet lead in thicknesses ranging from $\frac{1}{16}''$ (4 lb.) for small work, $\frac{1}{8}''$ (8 lb.) to $\frac{3}{16}''$ (12 lb.), or $\frac{3}{8}''$ (24 lb.) for larger work (see Figure 11-25). Wrought iron, aluminum, nickel, and nickel and copper alloys such as Muntz Metal (60% copper and 40% zinc) also respond to repoussé. Lead does not work-harden and remains ductile even after numerous blows, but the above metals become brittle and tend to crack after numerous blows of the hammer. To allow for extensive stretching, work-hardened metal is heated or annealed to a dull cherry red, and allowed to cool slowly before further hammering. Heating can be done on a forge or with the heat of an air-gas, air-propane, acetylene, mapp, or oxyacetylene torch depending on the metal's thickness and size. The process is called *cold forging*, since the metal is beaten while cooled.

HOT FORGING

Hot forging is necessary for ferrous metals, as they must be worked when heated for maximum malleability and least impairment. Medieval armorers forged hot chunks of ferrous metal into

Figure 11-25
Fred Littman, *Mother and Child.* 1959.
¼ in. hammered lead, H. 6 ft. Facade of the library of the University of Portland, Portland, Oregon.
Photo courtesy of Fred Littman.
Lead will not work harden but remains ductile throughout repousse process without annealing.

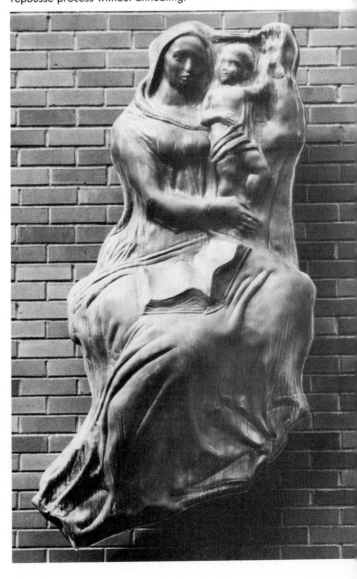

intricate and graceful sheets that followed the body contours. Heat the metal rapidly in a forge or by torch to a bright red for bending or bright yellow for hammering. Then hold it with tongs over an anvil and beat with a heavy ball peen hammer. The metal becomes dull red in the process. As the metal cools, reheating is required for further shaping.

TOOLS FOR METAL FABRICATION

Cutting tools range from jewelry saws for fine work to hand hacksaws, keyhole saws, and metal shears of various weights (see Figure 11-26). Select a proper blade for the density and thickness of the metal (thicker and softer metals require few teeth per inch, thinner and harder metals need more). The approximate number of teeth per inch range from 14 for over ½″ blades, 18 for ¼″, 24 for ¼″ to ⅛″, and 32 per inch for ¹⁄₁₈″ or less.

Power tools include power hacksaws, band saws, jigsaws and power shears, and the nibbler for sheet cutting. Portable shears have a maximum capacity of 14-gauge mild steel sheet, thicker for softer metals. The shear makes long cuts, but first drill out a hole for any cut made away from the edge. Power hacksaws operate accurately but slowly, cutting rods, bars, tubes, and flat sections. The saw must be anchored to the floor because of its weight, but remains steady and can be left unattended during long operations when it is necessary to make repeat cuts. Jigsaw blades reciprocate at high speed and work well for cutting small radius curves and cutting into the centers of large sheets. The choice of blade is important (fine blades for thin material, wider for thick metal). A variable-speed jigsaw should be considered. Vibration caused by the high-speed action of a variable-speed jigsaw

can keep it from cutting effectively, so clamping or fastening the work is necessary. Protect your ears when using all power tools because the action is very noisy.

The metal band saw has a looped blade which passes above and below a cutting table at various speeds, controlled by a gear and pulley system. Blades for different metals vary in tooth-set design, pattern, and width. The choice of blade depends on the metal's hardness, thickness, and the type of cut desired. Use the widest possible blade for any job.

Other variables include speed of blade and rate of feed, the latter indicating the amount of pressure on the metal as it is fed into the saw. Excess pressure will pull the metal irregularly, creating possible hazards. Wear goggles and unplug the saw while changing blades.

Shaping and finishing tools include bending brakes, rollers and punch presses for cold-forming sheets, bars, or strips of metal into bends, angles, and folds. A wide range of complex shapes can be hot or cold forged using steel-forming stakes and flat anvils. Scrap metal such as chrome bumpers can be machined into any desirable shape. The top of wood stumps or heavy blocks can be carved into forming surfaces. Pitch blocks and sandbags covered in canvas or leather also make effective forming surfaces. Metalsmithing hammers range from round-ended ball peen to flat-ended metal chasing hammers and mallets of leather and rubber (see Figure 11-27).

A wide range of tools are available for the small shaping operations of cutting, twisting, and fitting. *Abrasive* tools include hand files and rifflers in a variety of sizes and shapes—round, flat, and angular (see Figure 11-28). Large and small rotary files are designed for use with electric drills, drill presses, and the flexible shaft.

For riveting, screwing, or fastening metal, use screwdrivers, pliers, wrenches, riveting hammers, thread-cutting tools with tap, thread-cutting dies,

Figure 11-26
Handsaw types.

Figure 11-27
Metal forming stakes.

Figure 11-28
Metal hammers and files.

drill bits, nuts, bolts, and fasteners such as studs. Expansion-type molly and toggle fasteners are used with machine and lag screws (for concrete walls).

Grinding, sanding, polishing and *buffing* make up the sequence of the abrasive process. Each step uses progressively finer and softer abrasives, with grits which range from 4 to 800 (fine). Abrasives and sanders come as wheels (grinding and cutting), sheets, belts, and discs. Finishing materials include wheels, pads, and buffs of flannel, muslin, leather, wire, felt, and wool (see Figure 11-29). Grinding wheels of various shapes can be mounted on stationary or portable grinders. Portable electric drills, air or electric grinders, or grinders mounted on flexible shafts are more versatile and functional for the sculptor. Grinding abrasives are aluminum oxide and silicon carbide with grits between 12 and 600.

Sanding abrasives are flint, emery, aluminum oxide, and silicon carbide bonded to cloth or paper as sheets, drums, discs, or belts. Grain size is printed on the back side of the paper, running from 16 to 600 for garnet, aluminum oxide, and silicon car-

Figure 11-29
Buffing wheel shapes.

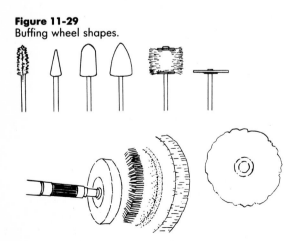

bide, or extra coarse, medium fine, and extra fine for flint and emery.

Hard-surface materials like stone, ceramic, glass, and enamel require abrasives of silicon carbide. Steel, aluminum, copper, bronze, wood, and plastic can be finished with aluminum oxide using grits from 20 (rough) to 240 (fine) for metal, 300 for wood, and 600 for plastic.

Complete dry sanding with grits from 80 to 120 are followed by wet sanding with progressively finer coats from 120 to 600, after which the surface is hand or machine buffed with compounds like tripoli, rouge, pumice, rottenstone, white silica, and unfused aluminum oxide. Mount buffing wheels on sanding machines, drill presses, electric drills, or flexible shaft machines. For satin finishes, wire brushes from coarse to fine are available in a wide variety of shapes and metals. When buffing nonferrous metals or stainless steel, avoid a residue of rust on the surface by using brass or copper brushes, not steel.

HARDENING AND TEMPERING TOOLS

To reshape and temper stone carving and chasing chisels, the tools must be reforged as follows (see Figures 11-30 and 11-31):

1. Anneal the tool by bringing it to a bright, but not brilliant, red heat—not white hot. Hammer on the anvil so the metal flows under hammer blows. If the metal is hammered after the red heat dies down, the molecules will crystallize. After shaping, allow the tool to cool slowly. Now soft, it can be filed and sharpened, grinding at a 20° to 30° angle for small chisels, 30°–60° for larger chisels.

2. Bring the chisel to a cherry red slowly, just to about 2″ from the tip, as there is no need to anneal the whole tool this time.

3. Quench the red-hot tip ¾″ deep in a pan of water to which is added a handful of salt. Holding the tool vertically, move it rapidly around in a circular motion below the water surface to make it glass hard at the tip, with some elasticity in the remainder of the tool to keep it from breaking under the hammer. Immerse the tool just long enough for the visible glow to disappear. Withdrawing it too soon could result in the heat running too fast, causing brittleness in the metal. Waiting too long will dissipate the reserve heat and prevent the full color spectrum from showing up, making it necessary to start again.

4. Polish by rubbing the tool in sand or on an emery cloth tacked to a piece of wood. The scale is rubbed off by this process, revealing the color as it travels toward the point. The color sequence, as it appears

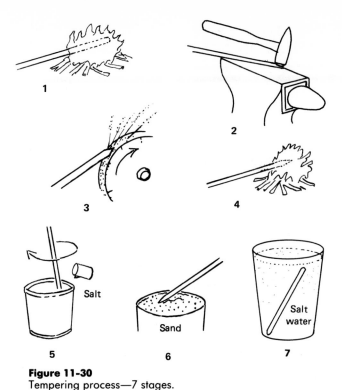

Figure 11-30
Tempering process—7 stages.

Figure 11-31
The tempering process.

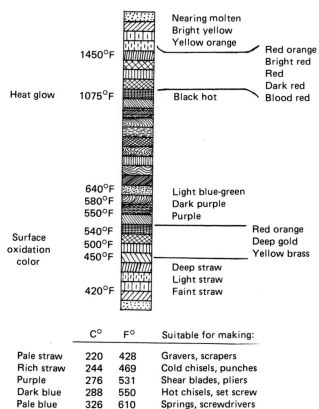

HEAT/COLOR SCALE FOR STEEL

		Nearing molten		
		Bright yellow		
		Yellow orange		
1450°F			Red orange	
			Bright red	
			Red	
			Dark red	
Heat glow	1075°F	Black hot	Blood red	
640°F		Light blue-green		
580°F		Dark purple		
550°F		Purple		
540°F			Red orange	
Surface oxidation color	500°F		Deep gold	
450°F			Yellow brass	
		Deep straw		
		Light straw		
420°F		Faint straw		

	C°	F°	Suitable for making:
Pale straw	220	428	Gravers, scrapers
Rich straw	244	469	Cold chisels, punches
Purple	276	531	Shear blades, pliers
Dark blue	288	550	Hot chisels, set screw
Pale blue	326	610	Springs, screwdrivers

consistently the same in high-carbon steel, is faint straw at first, followed by straw, bronze, peacock, purple, and finally blue. The color for stone carving tools is silver to light straw at tip for granite; bluish purple with copper to bronze at the tip for marble; and purple at the tip for limestone carving.

5. As the desired color reaches the cutting edge, arrest the process by first dipping to a depth of ½", then gradually entering the whole tool in salt water. The reserve heat in the tool will prevent it from brittle hardening. When polishing, should the color run slowly to a stop at the necessary color, cool slowly rather than quench. Slow cooling causes less tension and is particularly desirable for delicate tools. The quenching requirements for steel vary. Some harden best with oil, others with water only. Water, being faster quenching than oil, may sometimes cause cracks in the steel.

PLASTIC FABRICATION

History

The sculptural possibilities of plastics fabrication were first explored by the Constructivists Naum Gabo and his brother Antoine Pevsner in the 1920s. From the first discovery of acrylics in 1934, this form of plastic, composed mainly of methyl methacrylate, has been favored for sculptural fabrication. Also known as Plexiglas, Lucite, crystalite and in Europe, perspex or altuglas, acrylic is a thermoplastic plastic of great strength and clarity (see Figure 11-32).

Advantages

Lightest of the plastics (one-third to one-half as heavy as aluminum), it has high tensile strength (it bends like wood); impact strength (10–17 times harder than other thermoplastics); and resistance to contaminating oil, grease, and alkalies. It burns slowly, is impermeable to moisture, and its highly adhesive surface accepts paints and dyes. Acrylics' optical properties are superior to most plastics and even to glass, with less image distortion due to an ideal diffusion of light rays. Clear acrylics can transmit 92% of absorbed light, becoming transparent or highly reflective from the inside. Light, therefore, forms an important aesthetic component of the material. It has limitations in that it is susceptible to scratches and dust and is dissolvable by solvents and thinners like turpentine, benzene, acetones, and ketones, and tends to yellow slightly in the sun. Two types of acrylic sheet

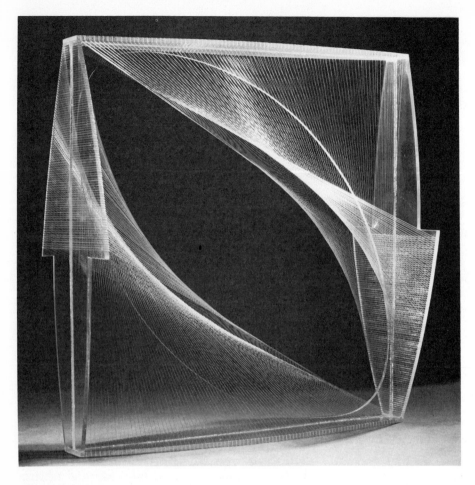

Figure 11-32
Naum Gabo, *Linear Construc-tion No. 1. Variation.* c. 1942-43. Plastic and nylon strings, 17⅞ × 7 in.
Evan H. Roberts Memorial Sculpture Collection, Portland Art Museum, Portland, Oregon.

are available: *unshrunk*, which shrinks 2% when formed, and *shrunk*, which remains stable when formed.

CUTTING AND SHAPING PLASTICS

This process is done with hand cutting tools such as handsaws, keyhole saws, hacksaws, coping, fret, or jewelry saws. For large quantities or heavy pieces of plastic, use power cutting tools like jigsaws, band saws, and circular saws. Cut plastic cautiously, since the material scratches easily and may chip and craze. Keeping the plastic covered with its protective paper will prevent scratching. Hold sheet material steady while cutting by clamping it to a table; hold rods and tubes in a vise. For cutting operations, use slotted tables that allow for clamping of the work.

Handsaws need 10 to 12 teeth per inch, somewhat more (15 to 20) for hacksaws and coping saws. The jigsaw, essential for interior small radius curves, should have a narrow cutting blade with a skip tooth structure (18 to 24 teeth per

inch). The band saw also requires metal cutting blades: 3 to 4 teeth per inch for materials over 1″ thick; 6 to 10 teeth per inch for materials under 1″ thick (2 to 3 teeth should be in contact with the surface as a general rule; blades with more teeth per inch are needed for thin materials). A good average is a ⅜″ blade for straight cuts, down to ¼″ for complex cuts. The bandsaw speed varies: the thicker the material, the slower the speed; the blade for 4″ material runs at 2300 rpm.

Circular saw blades should be at least 8″ in diameter, and hollow ground to prevent binding and aid in cooling. The saw teeth should be of uniform height and shape, with the blade higher above the table than the thickness of the sheet. For thin materials the number of teeth per inch is 6 to 8, for thicker (½″ and over) 3 to 4 teeth per inch. Tungsten carbide or diamond-tipped teeth are more wear resistant and retain sharpness longer than steel, and cut faster and cleaner. If the saw is not in constant use, try substituting an alloy steel blade with a 0° or 10° rake. Feed pressure while cutting should be slow but steady, as too fast a rate of speed can cause friction and gumming of the blade through heat. A coolant such as a bar of soap or

wax on the blade prevents the cut from reknitting and keeps the blade free of plastic particles. Solvents for cleaning blades are acetone, alcohol, and mineral spirits.

Plastics are also shaped and cut with drill presses, portable electric hand drills, or flexible shafts with metal twist bits which have been modified to a 60° angle for a scraping rather than cutting action. Speeds range from 700 rpm for heavy drills to over 5000 rpm for light drills. While drilling, the bit should be removed and coolants applied consisting of water with 10% soluble oil added. Plastic shapes can be turned on a wood lathe (average size about 10″), or routers or shapers provided with carbide-tipped cutters, with the spindle speed of routers preferably 23,000 rpm.

Abrading cuts, shapes, and finishes plastic surfaces. Mount high-speed resinoid cutting and grinding wheels, the type used for cutting sprues on metal, on portable grinders or stationary cutting equipment. The wheels are reinforced with fiber and come in diameters from 7″ to 14″ for electric grinders and thicknesses of ⅛″ to ⅜″ with grits from 16 for coarse to 120 for finer cutting (grit sizes run 12 for coarse to 600 for finest). Grinding wheels may be mounted on stationary grinders and drills, portable air and electric grinders, and flexible shaft machines, with wheels mounted either horizontally or at a 90° angle to the machine. Wheels should have guard covers, and protective masks should be worn. Air grinders are considerably lighter and safer than electric grinders and will, like the flexible shaft machine, allow for speed control.

Sanding abrasives for plastics can be attached to portable electric drills or orbital and belt sanders or stationary belt, disc, or vertical sanders. Use coarse grit 50 to 150 grit paper to start, but take care not to overheat the material. Follow with wet and dry sanding with 180 to 600 grit silicon carbide paper, always removing previous sanding marks. Fine paper of 400 to 600 grit may be used by machine, or by hand in hard-to-reach places. Remove mild scratches by polysand, a cushioned abrasive.

Buffing, a stage beyond polishing, achieves a highly lustrous finish using abrasives from 220 to 600, and fine abrasive compounds of aluminum, silicon carbide, tripoli, or chromium oxide mixed with wax or water soluble emulsions.

Firm buffs of felt are for *polishing*. For *buffing*, a loosely stitched buff of muslin, flannel, or wool produces fine mirror finishes on plastic and soft metal. Attach buffing wheels to electric drill presses, lathes, and sanding equipment.

ANNEALING

Plexiglas should be annealed after stress work, including polishing, is complete in order to reduce all risk of crazing (a network of fine surface cracks). Before annealing, clean the plastic with mild detergent. Place the work in an oven preheated to 170°F and leave for 16 to 24 hours, depending on the size and thickness of the Plexiglas (leave a 16″ × 16″ × 4″ piece for 16 hours; a 1½″ thick piece anneals for 12 hours at 175° to 185°F). Forced air circulation makes a professional oven preferable to a home oven, which may be used, however, if the temperature can be kept steady at 170°F. Anneal both before and after cementing or bonding plastic (see Figures 11-33, 11-34, and 11-35).

BONDING PLASTICS

The simplest method of bonding plastics is by application of adhesives. The most adaptable is a two-part epoxy system—a viscous solution of MMA monomer polymer, plus a catalyst. Epoxy produces a clear, hard cushion between parts and is unaffected by solvents, moisture, and heat which can accelerate curing (setup may be retarded in low temperatures; infrared heat lamps help in curing). Thorough coverage of dry, clean surfaces, free of oil, is required for successful bonding. Epoxy cements do not dry upon aging but remain elastic and compensate for differences in thermal expansion. Protect areas adjacent to joints being bonded from the etching action of cement by using a cellophane fiber tape or masking with gelatin hide glue, glycerine water, or rubber cement.

Solvent cementing causes molecules to intermingle by penetrating and softening the surfaces, allowing them to join together. Place the parts to be joined in position. Deposit solvent with a brush or hypodermic syringe to both sides of the joint. The solvent flows into the seam by capillary action; keep it from moving into unwanted areas by solvent-resistant tape. Capillary cementing is fast, but varies in strength or permanence. Humidity may affect the solvents ethylene dichloride or methylene chloride. Strong solvents like acetone or chloroform may cloud or whiten the surface, particularly in high humidity conditions.

Another way of solvent cementing is to dip or soak the edges by holding the plastic in a glass or stainless steel tray filled with ⅛″ of solvent. When the edge is softened (from 1 to 15 minutes depending upon thickness), it is lifted and pressed lightly into place. Too much pressure will squeeze

Figure 11-33
Cutting acrylic block with bandsaw. Elaine Aptekar. Bandsaw uses a metal cutting blade. For 4" Plexiglas the blade should run aobut 2300 rpm. Blades are skiptooth 6-10 teeth per inch, ¼" to ½" wide. The thicker the material the slower the speed necessary. Acrylic's trade name is Plexiglas, made by Rohm and Haas Co.
Photo courtesy Elaine Aptekar.

Figure 11-34
Elaine Aptekar. Annealing Plexiglas following use of router, drill, and sanding and buffing agents. Annealing reduces all risk of crazing, which is a fine network of scratches on and below the surface. Annealing 16-24 hours at 170°F, cooling from 10-12 hours. Photo courtesy Elaine Aptekar.

out part of the cement. Slow the setting-up action by adding acrylic chips to the solvent. For butted joints, apply softening solvents to edges with brushes until the surfaces appear wet. The joining of plastic is similar to wood; consider stresses and clamp the pieces in place while the bonding agent is curing.

Heat sealing and welding are used industrially for bonding thermoplastics. Both require specialized equipment and technical expertise. As with metal, welding utilizes a gas or electric torch to apply heat locally. Filler rods of plastic may be pressed and melted into the softened joint. Heat sealing uses electric and ultrasonic waves to create vibrations and friction at the bonding surface. Metal powders (induction heat sealing) produce electrical charges that heat and bond the plastic. In thermal sealing, a more direct method of bonding, the plastic surfaces are pressed against a heated die until the materials melt and bond.

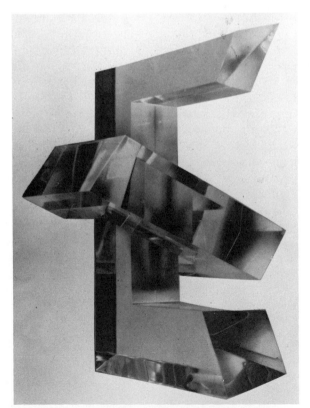

Figure 11-35
Elaine Aptekar, *L'inconnu I.*
Plexiglas.
Photo by David Politzer.

WELDING CHART*

Metal Thickness (inches)	Welding Tip No.	Oxygen Pressure (psi)	Acetylene Pressure (psi)
¹⁄₃₂ (22 ga.) and under	0		
¹⁄₁₆ (16 ga.)	1		
³⁄₃₂ (13 ga.)	2	5	5
⅛ (11 ga.)	3		
³⁄₁₆	4	4	
¼	5		
⅜	7	7	7
½	7	7	7
¾	9	9	9

*Generalized—variations according to manufacturer

CUTTING CHART

Metal Thickness	Cutting Tip No.	Oxygen Pressure (psi)	Acetylene Pressure (psi)
¼	0	30	5
⅜	1	30	5
½	1	40	5
¾	2	40	6
1	2	50	6
2	4	50	7
4	5	60	8

HARDNESS OF METAL (BRINELL HARDNESS)

The relative hardness of metals is often expressed by their Brinell hardness number as measured in a Brinell testing machine. Brinell hardness may be determined in a general way by filing the surface of the metal with a new, machinist's hand file.

Brinell Hardness	Ease with Which Steel Surface Can Be Filed
100	File bites into surface very easily/metal is very soft.
200	File readily removes metal with slightly more pressure. Metal is still quite soft.
300	At 300 Brinell, the metal exhibits its first real resistance to the file.
400	File removes metal with difficulty. Metal is quite hard.
500	File just barely removes metal. Metal is only slightly softer than file.
600	File slides over surface without removing metal. File teeth are dulled.

TEMPERATURE DATA

Melting Points of Metals and Alloys of Practical Importance

Metal	Degrees F	Degrees C	Color Scale
Pure iron	2800	1550	white
Wrought iron	2900	1600	white
Stainless steel (12% Chromium)	2800	1550	white
Nickel alloys	2450–2950	1350–1650	white
Mild steel	2725	1500	white
Cobalt	2700	1475	white
Nickel	2640	1450	white
Chromium—nickel steels and irons	2150–2780	1175–1540	white
Silicon	2575	1425	white
Hard steel	2560	1400	white
Monel	2470	1350	white
Manganese	2300	1250	white
Copper	1980	1100	light yellow
Gold	1940	1075	lemon yellow
Red brass	1860	1020	lemon yellow
Brasses	1560–1900	850–1050	orange
Everdur	1850	1025	lemon
Silver	1750	950	salmon
Yellow brass	1700	930	salmon
Tobin bronze	1640	900	bright red
Manganese bronze	1580	875	cherry or dull red
Bronzes	1300–1900		lemon—dull or cherry red
Aluminum	1225	675	medium cherry
Magnesium	1200	650	medium cherry
Aluminum alloys	1240–860	675–460	medium cherry—faint red
Magnesium alloys	1200–660	650–350	medium cherry—faint red
Antimony	1150	625	dark cherry—faint red
Tin alloys	1150–370	625–190	dark cherry—faint red
Zinc	790	425	faint red
Lead	625	340	faint red
Babbit	480	250	faint red
Tin	450	240	faint red
Lead alloys	640–140	340–50	faint red

FERROUS METALS

Metal	Melting Point	Surface Appearance	Recommended Welding Method	Heat Source Flame	Recommended Rod	Flux
Steel	2700° F	Dark gray	Fusion	Oxyacetylene neutral flame	Steel or iron	None
Steel (thin sheets)			Solder	Soldering—automatic iron	50% lead or silver	Borax (paste)
Steel (thin sheets)			Braze	Air or oxyacetylene Slightly oxidizing	Bronze rod Oxweld Cupro (phosphor bronze)	Brazo None
Stainless steel	2550° F	Bright gray	Fusion	Oxyacetylene neutral	Stainless steel	Cromaloy
Wrought iron	2880° F	Bright gray	Fusion	Oxyacetylene neutral	High-test steel	None
Cast iron	2100° F	Dark gray— sand mold textured surface	Fusion Braze	Oxyacetylene neutral Oxyacetylene oxidizing	Cast iron Bronze	Ferro Brazo

NONFERROUS METALS

Metal	Melting Point	Surface Appearance	Recommended Welding Method	Heat Source Flame	Recommended Rod	Flux
Aluminum	1200° F	White—bright gray	Fusion	Oxyacetylene: slightly carburizing	Aluminum	Ox-weld aluminum
			Braze	Oxyacetylene: slightly oxidizing	Aluminum	Eutectic 190
Brass	1700° F	Red—yellow smooth	Fusion	Oxyacetylene: oxidizing	Bronze	Brazo
			Braze	Oxyacetylene: slightly oxidizing	Bronze	Brazo
Bronze	1600° F	Red—yellow smooth	Fusion	Oxyacetylene: neutral	Bronze	Brazo
			Braze	Oxyacetylene: slightly oxidizing	Bronze	Brazo
Copper	2000° F	Reddish brown to green	Fusion	Oxyacetylene: neutral	Copper	None
			Braze	Oxyacetylene: slightly oxidizing	Phos-copper	None
Lead	600° F	White to gray Velvety and smooth	Fusion Fusion	Soldering automatic iron, air or oxyacetylene	Lead	None
Monel metal (alloy of nickel and copper, and small % of other elements)	2450° F	Light—dark gray	Fusion	Oxyacetylene: slightly carburizing	Monel	Monel

WELDING RODS

Name of Rod	Purposes	Diameters (in.)	No. Rods per Pound (approx.)
Steel rod (high test)	Weld strengths up to 65,000 lb. per sq. in. High carbon content increases resistance to corrosion, shock, and vibration. Slightly more viscous than low carbon rod. Self-fluxing, producing clean weld metal.	1/16	31
		3/32	14
		1/8	8
		5/32	5
		3/16	3½
		1/4	2
		5/16	1⅓
		3/8	1
Drawn iron rod	High ductility (malleability) and free running due to its pure iron content. Tensile strength of welds is about 45,000 lb. per sq. in. Useful for welding materials of 1/4" and under.	1/16	31
		3/32	14
		1/8	8
		3/16	3½
		1/4	2
Cast-iron rod	Fine-grained metal as strong as the casting and with easy machining qualities. Ferro flux is required with the fusion welding of cast iron.	1/8 × 18	28
		3/16 × 24	9
		1/4 × 24	5
		5/16 × 24	3½
		3/8 × 24	2⅓
		1/2 × 24	1¼
Nodular cast-iron rod	Designed for the repair and fabrication of nodular and ductile castings, high strength gray iron and pearlitic malleable iron castings. Requires less machining and produces better physical characteristics with less cracking than ordinary cast-iron rods.	1/4 × 24	5
		3/8 × 24	2⅓
Stainless steel rod (18-8) Columbium-Bearing	Developed for welding 18% chromium, 8% nickel stainless steels, with sufficient amounts of alloying elements to give excellent welds. Welds other chromium steels having chromium content equal to or less than the rod metal.	1/16	31
		3/32	14
		1/8	8
		3/16	3½
		1/4	2
CMS steel rod	Useful for high strength and high speed welding. Tensile strength is between 75,000 and 90,000 lb. per sq. in.	1/16	31
		3/32	14
		1/8	8
		5/32	5
		3/16	3½
		1/4	2

Rods for Braze Welding and Welding Nonferrous Metals

Name of Rod	Purposes	Diameters (in.)	No. Rods per Pound (approx.)
Drawn aluminum rod	Used primarily for welding pure aluminum sheet and plate, and aluminum alloys 3S and 2S. Ductility and hardness of weld is approximately the same as that of the pure annealed aluminum.	1/16	90
		3/32	40
		1/8	23
		5/32	15
		3/16	10
		1/4	6
Drawn aluminum rod	This rod has a lower melting point than that of pure aluminum. Ductility of the weld is less than annealed aluminum. Weld metal is less resistant to corrosion than pure aluminum.	1/16	91
		3/32	40
		1/8	23
		5/32	15
		3/16	10
		1/4	6
Bronze rod	This rod has Brinell hardness of approximately 100 and unexcelled machinability. It is recommended for braze welding where high strength, resistance to wear, and ductility are required. It melts rapidly, flows freely, tins easily, and solidifies quickly. The weld metal is free from porosity and inclusions and possesses low-fuming properties.	1/16	29
		3/32	13
		1/8	7
		5/32	5
		3/16	3
		1/4	2
		3/8	1

Rods for Braze Welding and Welding Nonferrous Metals (cont.)

Flux-coated bronze rod	Properties the same as the rods above.	3/32	13
		1/4	2
		5/32	5
		3/16	3
		1/8	7
Bronze rod	Recommended for fusion welding of Everdur plate and castings. Ductility of welds is approximately 40% to 60% as measured by the free bend test and tensile strength is about 52,000 lb. per sq. in. The rod is made of virgin metal for uniformity of welds. Corrosion resistance is equal to that of the base metal.	1/16	29
		3/32	13
		1/8	7
		3/16	3
		1/4	2
Cupro rod	A free-flowing phosphor bronze rod which solidifies quickly, producing practically no slag and requiring no flux. It is used for fabricating such items as metal furniture, bonding rail ends and for joining steel parts where a high-melting point bronze is desired. Welds produced will be ductile but can be hardened by mechanical working.	1/8	7
		3/16	3

FLUX TYPES AND PURPOSES

Brazo flux	Bronze, welding steel, cast iron, and malleable iron, and for fusion welding brass, bronze, copper, and copper alloys. The main purpose for using flux when braze welding these metals is to remove the oxide scale so that the bronze will adhere to the base metal.
Ferro flux	Fusion welding cast iron and steel castings. Flux must be used to remove the heavy coating of silicon dioxide which forms on the surface of the molten metal when welding cast iron. Use of proper flux will also help to clear the weld of inclusions which lead to the formation of blowholes.
Aluminum flux	Welding cast or wrought aluminum and aluminum alloys. Proper flux removes the aluminum oxide which forms rapidly on the molten weld metal. Flux should be mixed with an equal volume of water in a nonferrous container to form a thin paste. The paste is then painted on the welding rod or the rod may be dipped into it.
Cast-iron brazing flux	Bronze-welding cast iron, malleable iron, and steel. Flux must be used in braze welding to obtain good bonding. Brass spelter contained in the flux assists in the tinning of the base metal.
Cromaloy flux	Welding all high-chromium alloys such as stainless steels. Should be mixed with water to the consistency of a thin paste in a nonmetallic container, and painted on both sides of the base metal and on the welding rod.

PITCH FOR REPOUSSÉ FORMULAS

Burgundy pitch	8 parts by weight
Tallow, mustard oil, or linseed oil	1 part by weight
Pumice, plaster, or brick dust	Add to desired density

12

Carving in Stone

HISTORY

For centuries, stone remained the primary sculptural medium. During the Neolithic (Stone Age) period, essential stone implements were shaped initially by flaking, pounding, and chipping. Rubbing with an abrasive such as sand took the shaping process a step further. The development of copper, bronze, and iron tools allowed stone carving to progress. Most of the same basic metal tools invented by the earliest civilizations were eventually adopted by all Iron Age cultures, and have been used to this day.

Historically, carving proliferated where the raw marble and hard stone and/or stone abrasives could be mined or were available through trade. The Egyptians practiced with enormous skill in working intractable as well as medium and soft stones. Stone was carved at the quarry and later transported to permanent sites. Schools of sculpture developed at the stone's source. Carvers of hard basalt and diorite originated in the Eastern desert, limestone carvers out of Memphis and Middle Egypt, and the quartzite and Nubian sandstone carvers in upper Egypt.

Egyptian wall paintings depict stone being broken out of the quarry by pounding with granite hammers, and being split, much as in today's method, by driving in wood wedges and swelling them with water (see Figure 12-1). A squared grid was drawn on the cuboid block, which was then reduced by granite-trimming hammers. The composition was contained within an imaginary cube, by working the stone layer by layer on all four sides and maintaining the axis parallel to the sides. Transitional planes and curves were introduced gradually with background supports left for stability. Hard stones were struck repeatedly, rubbed with stone implements, and cut with metal saws and drills to which quartz abrasives were adhered. Limestones and other soft stones were cut with metal chisels and adzes. Because copper could be coldsmithed or hardened by pounding, copper tools were preferred to bronze tools until iron came into use about 600 B.C. For cutting hard stones, abrasives like corundum (an impure form of emery, a rare and very hard mineral) were mounted on bush hammers and the cutting edges of drills. Examples of the unique tubular drill used by ancient sculptors have not survived but the cored holes it pro-

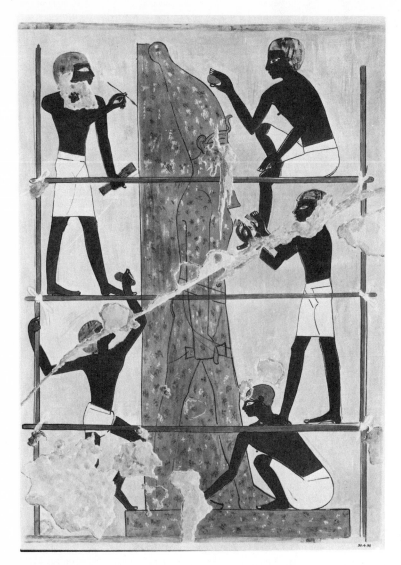

Figure 12-1
Egyptian wall painting. XVIII Dynasty.
Sculptors at work on a statue. Painted copy
in tempera. From the tomb of Rekh-mi-Re,
Governor of the Town and Visier of
Upper Egypt.
Metropolitan Museum of Art, New York.

duced have been found in the Aegean civilization of Mycenae.

In Egyptian figures, the face was carved in more detail than the body and embellished with glass or stone eyes (see Figure 12-2). All stone surfaces were eventually painted, the harder stones of granite, quartzite, basalt, and diorite less elaborately than the softer limestones, alabasters, and sandstones. Later, the harder stones were often left completely unpainted to expose unusual texture or pattern, such as red and black veining. Occasionally, varieties of small semiprecious stones were assembled for a larger sculpture.

Contemporaneous with the Egyptian New Kingdom, the Mesopotamian civilizations of Babylonia and Assyria carved the natively abundant soft stones of alabaster and steatite. They generally favored commemorative reliefs, though some monumental carving in the round was practiced by the Assyrians in limestone, as in the Gates of

Assurnasirpal (885 B.C.). Earlier, the Babylonians to the south had executed a series of twelve commemorative sculptures in hard black diorite portraying the ruler Gudea of Lagash (2450 B.C.). Little hard stone is native to Mesopotamia; therefore, it is conjectured that granite and diorite were imported from the Sinai and traded along with copper tools for carving.

The pre-Columbian civilizations of the Americas all achieved some carving skills, though the Mayans (A.D. 200–800) practiced the most impressive stone sculpture. The Mayan maize god, the Chacmool altars carved with sacred reliefs, and unique axe-shaped heads and yokes were carved in limestone and the more intractable diorite and trachyte (crystalline volcanic ash). Carving tools were made of flint and obsidian, as no hard metal implements were introduced into pre-Columbia until the Spanish invasion.

India abounded in temples carved from living

rock completely covered with images of Hindu gods. The classically influenced Buddha image spread from northwestern India (Gandhara) in the second century A.D. to the Orient. The earliest Chinese Buddhas are represented in stone reliefs of the grotto sanctuary of Lung Men (fifth century A.D.) appearing as a freestanding figure during the T'ang Dynasty (A.D. 618–907), the first monumental (in one case over 89 feet high) image in China. Cambodia produced the stone reliefs at Angkor Vat (twelfth century A.D.) as well as freestanding Buddhist figures.

Greek knowledge of stone carving techniques is thought to have derived both from Egypt and the early civilizations of Crete (Minoan) and Mycenae (Greek mainland) between 3000 and 1100 B.C. The Cretan Snake Goddess of soft steatite, the earliest sculpture found in this region, is thought to have been imported to Crete from Sumeria. After carving with a knife, the stone was coated with a layer of stucco and painted. Harder stones, like the marble and alabaster lion heads at Knossos and the Lion Gate at Mycenae, were

Figure 12-3
Seated man with a harp. Cycladic statuette.
Marble, H. 11½ in.
Metropolitan Museum of Art, New York. Rogers Fund, 1947.

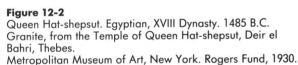

Figure 12-2
Queen Hat-shepsut. Egyptian, XVIII Dynasty. 1485 B.C. Granite, from the Temple of Queen Hat-shepsut, Deir el Bahri, Thebes.
Metropolitan Museum of Art, New York. Rogers Fund, 1930.

cut primarily with tubular drills, abrasive stones, and saws of toothless metal or wire in conjunction with emery powders and water, or oil. The saws were designed either like knives with a handle at one end, or with handles at each end for two men to operate. Another type may have been a blade fitted into a wooden spine.

Cycladic marble sculptures, eyeless and mouthless idols with wedge-shaped ovoidal heads that date from 2600 B.C., were found in large numbers on the Cyclades Islands (see Figure 12-3). Since emery mines are located on the island of Naxos which also contains the majority of these works, scholars have concluded that abrasive rubbing with tools of shaped emery was the primary method used to carve the hard Naxian marble.

Working stone against stone continued through early Greek sculpture of the seventh century B.C. and lasted as late as the fifth century B.C., when vast demand for sculpture created a need for speedy output. With the introduction of varied metal tools like the claw and flat chisel, Greek sculpture placed a new emphasis on the male athletic figure. Con-

Figure 12-4
Youth of the "Apollo type." Athenian Greek.
615-600 B.C. Marble.
Metropolitan Museum of Art, New York.
Fletcher Fund, 1932.

lasting edge. The flat chisel, along with abrasives, clarified the surfaces, emphasizing edges and defining such forms as hair and eyelids. The precise effects of the flat chisel initiated the burin-cut surfaces of the newly popular bronzes; the parallel grooves of hair in the heads of the stone Olympian carvings resemble the hair in such bronzes as the *Delphian Charioteer.* Flat chisels were primarily used for cutting the low reliefs decorating the numerous tombstones of the fifth and fourth century B.C. and were henceforth to become the principal finishing tools in stone carving.

Claw chisels, adopted in the sixth century B.C., defined forms further by scraping across the contours—a step immediately preceding abrading or refining with the flat chisel. Except for the classic Greeks and Michelangelo, the claw chisel remained secondary to both the punch (point) and flat chisel.

The bow drill, also introduced in the sixth century B.C., was later improved into a running drill, useful for carving complex and narrow grooves of drapery and waves of hair and eyelids (see Figure 12-5). Drill holes placed close together allowed for quick and easy removal of the stone between the holes with a punch. Use of the flat chisel and drill continued throughout the Roman, early Christian, and Gothic periods. The most elaborate drill effects were achieved in late Renaissance, Mannerist, and Baroque works.

Greek sculpture was often composed of separate pieces joined with marble tenons and mortises, metal dowels, or cement of molten lead or lime. Parts such as heads and arms were carved separately and fitted with bronze dowels into sockets prepared for them. Accessories such as jewelry, locks of lead or bronze hair, scepters and helmets were added; eyes of ivory, stone, or glass were inset.[2]

Incomplete Greek sculptures showed fixed holes bored into the top, bottom, and center of the fig-

Figure 12-5
Bow drill.

centrating on solid and rounded form, the male nude took precedence over the kourai (or draped female figure), which is thought to have evolved its linear and vertical contours by abrasion, rather than chiseling.

In carving early Greek figures, the bronze punch was directed at right angles to the piece, since otherwise the softer metal was unable to grip the stone and make an impact (see Figure 12-4). Stunning the stone to a depth of ¾", as in Egyptian methods, the punch loosened small pieces layer by layer around the work. Scholars Carl Bluemel and Stanley Casson[1] conclude that early Greek sculpture gained its volumetric character and uniquely luminous surface through this particular carving approach, although the method made the stone susceptible to decomposition.

With the introduction of tempered iron, the flat and tooth chisel were now able to hold a more

ure. It is speculated that depth measurements were taken from a plumb line stretched from the holes in a small projecting block on the hairline to matching holes at the feet.[3] The more complex system of dropping a plumb line from a frame was developed during the Roman period, when carving was less spontaneous and more of an exact copying process.

The local Piraeus limestone was the material used for the pediment figures of the early temple of the Acropolis. Soft and lightweight, therefore easy to carve, its naturally unattractive surface was enriched with paint. Marbles included the hard crystalline Naxian from the island of Naxos, the finer-grained transparent Parian, and the Pentelic, close-grained, white marble from Mt. Pentelikon, quarried from the fifth century. A blue-gray (containing iron) marble came from Mt. Hymettos, but generally the Greeks preferred white or light stones to the multicolored stones popular in Egypt and Rome. Italy's dense white Carrara and Lava marbles were utilized to some degree by the Etruscans, but were not mined until Roman times.

Color was almost always added; the punch claw, and abrasive procedure of the Greeks (followed similarly by the Romanesque and Gothic) helped hold the thick paint to the final surface. Though only traces remain on the works themselves, portrayals of Greek sculpture in Roman frescos and mosaics show that the application of surface color was a common practice. In archaic Greek sculpture, women's flesh was rendered a whitish tone, men's flesh brown, with features and garments painted in blues, reds, and yellows. Over the color, an expert in the process applied a unique protective coat of wax and oil. Works were mounted on stone (limestone) bases and fastened with metal dowels secured with molten lead. Occasionally a dedication or signature appeared on the base, but work was generally unsigned.[4] Stone and wood surfaces were painted up until the Renaissance, when wood continued to be polychromed but stone was left uncolored.

Monumental scale carving was in decline during the Byzantine period, replaced by small ivory carvings and the ornamented sarcophagii in which the Romans, like their Etruscan forebears, specialized. It reappeared after 600 years of dormancy in western Europe as the Romanesque and Gothic styles of the eleventh to fifteenth centuries. Innumerable stone carvings of draped saints and heroes adorned church facades in France (Chartres, Amiens, Reims); Germany (Bamberg, Naumberg, Strausberg); and England (Lincoln, Westminster

Abbey). The making of the sculpture, like the building of the churches themselves, involved scores of people working on the site under the artist-stonemason's direction. Illustrations of the time show the stone being carved while lying on the mason's bench, not upright or on the building. Although handsome, the present-day monochromatic effect is somber compared to the original painted sculptures; the gilding, silvering, and patterned drapery made, no doubt, a magnificent sight to behold (see Figure 12-6). Dating from this period (A.D. 1236) is the stone equestrian sculpture *The Bamberg Rider*, located in Bamberg Cathedral. Exceptional in the quality of its modeling, it is the first life-size equestrian statue after the fall of Rome, and is composed of not one, but seven stones.

Figure 12-6
Virgin from the Cathedral of Strasbourg. French, Rhenish. 1247-1252.
Sandstone, gilded and polychromes, H. (with base) 58½ in.
Identified as coming from cathedral choir screen.
Metropolitan Museum of Art, Cloisters Collection, 1947.

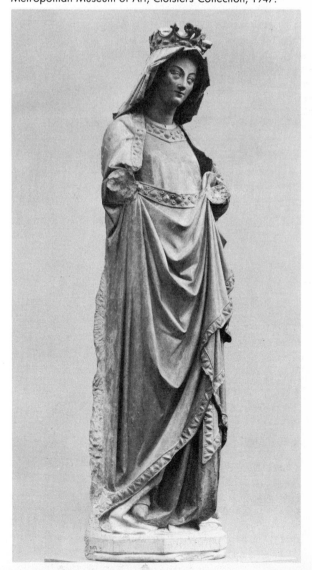

The revived classicism of Nicola Pisano (The Baptistry of Pisa in 1260) injected a new realism into the Gothic style, carried further in Donatello's fifteenth-century carvings. Though earlier works such as the *St. George* were still somewhat Gothic in spirit, the bold naturalism of Donatello's later interpretations (*Niccolo d'Uzzano, Zuccone*) inspired Michelangelo's great heroic figures.

Michelangelo (1475–1564) brought a renewed classical interpretation to stone. Early in his career he carved the magnificent 14-foot *David* (1501–4) out of a piece of marble discarded 30 years before. The drill work in the hair, and the edges and surfaces which appear to have been completed with flat chisels, utilized traditional methods. In Michelangelo's later work he at-

Figure 12-7
Michelangelo, *Atlas* (Prisoner). 16th cent.
Marble.
Accademia, Florence. Bildarchiv Foto Marburg,
W. Germany.

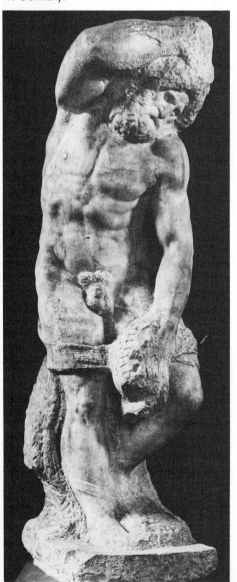

tacked the stone with a pointed punch exclusively from the front and sides of the block, as in a deep relief, working with an "expressionistic" speed and vigor possibly unparalleled in sculpture. To locate the main masses and establish the major rhythms, he gradually chiseled the stone away "in the same manner that one would lift a wax figure out of a pail of water, evenly and in a horizontal position."[5] Forms were further identified with a lighter punch and claw chisels (1" and ½") which moved across and with the surface contours in a cross-hatching motion. Layers were gradually unveiled; starting from the outside of the block, he pushed the background further and further back, leaving a maximum amount of original stone between the forms to allow for adjustment in the final stages. The dynamic effect produced was of imprisoned forms struggling for release from the block (see Figure 12-7). The twisting, contrapposto postures of Michelangelo were to influence the following generation of sculptors, the *Mannerists*. The most accomplished sculptor among them, Giovanni da Bologna (1529–1608) was considered the last great sculptor of the Italian Renaissance and the first representative of the Baroque.

In the century and a half after Michelangelo, stone surface effects were brought to their ultimate potential by Bernini (1598–1680) in such complex and theatrical works as the marble altarpiece *The Ecstatic Vision of St. Teresa* for S. Maria Della Vittoria in Rome. Bernini's virtuosity with marble is also evident in his classically inspired figure groups such as *Apollo and Daphne*, and his vivid, animated portrayals of kings and church leaders.

The eighteenth-century Neoclassicists Houdon (1741–1828) and Canova (1757–1822) eschewed elaborate surface effects and returned to restraint in composition, form, and themes of more traditional classicism (see Figure 12-8). Though leading to rigid and empty classic imitations (exemplified by Hiram Powers' portrait of George Washington as a Roman Senator), the Neoclassical style brought to stone a renewed sensitivity and delicacy of interpretation.

A return to a romantic vigor in design and spirit appeared in the carving of the nineteenth-century French sculptor François Rude (1784–1855), whose *La Marseillaise* appears on the facade of the Arc de Triomphe in Paris. Following the romantic tradition of the late nineteenth century, Auguste Rodin (1840–1917)—a modeler exclusively, his modeling translated by use of the pointing machine into carvings by assistants—gave impetus to the abandoned practice of direct carving (see

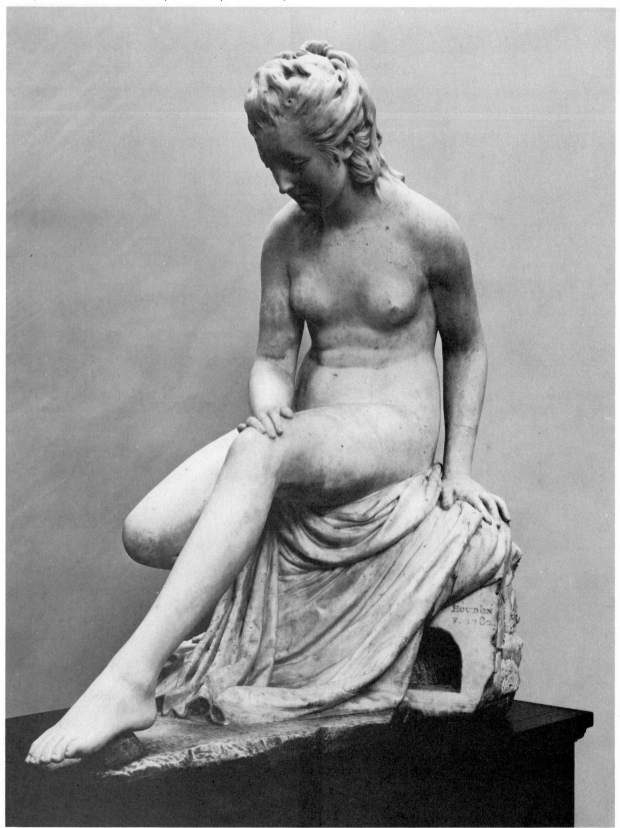

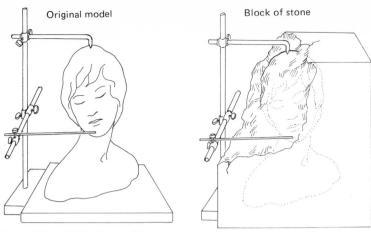

Figure 12-9 Pointing machine
The pointing machine is a traditional mechanical copying device. A sculpture can be duplicated in the same or larger scale (in correct proportions) by setting a machine with adjustable arms, marking given points on the original model. A stone block (generally) is set similarly, with the arms of the machine fixed gradually deeper as the stone is punched away to the predetermined points.

Figure 12-9). Said to have been influenced by Michelangelo's incomplete compositions, Rodin broke with classic conventions in favor of romantic fragmentation, contrasting elegant, partially emerged finished forms with unfinished stone.

In the twentieth century direct carving in stone was initiated by the English figure sculptor Eric Gill in 1909 and taken up by avant-garde sculptors Brancusi, Gaudier-Brzeska, Modigliani, Lipchitz, Arp, and John Flannagan, among others (see Figures 12-10 and 12-11). The great stone carvers of the mid-twentieth century have been the English carvers Henry Moore and Barbara Hepworth, the French Aristide Maillol, the Austrian Fritz Wotruba, the Italian Andrea Cascella and Americans William Zorach, José de Creeft, Isamu Noguchi, and Ivan Mestrovic. Gutson Borglum's Mount Rushmore is a modern-day resurrection of the great monuments of history. On the contemporary scene, younger carvers like Dimitri Hadzi and Walter Dusenberry keep the carving tradition alive (see Figures 12-12, 12-13, and 12-14).

Figure 12-10
William Zorach, *The Future Generation*. 1942-47.
Botticini marble, H. 40 in., W. 19 in., D. 14¼ in.
Collection Whitney Museum of American Art, New York.
Purchase (and exchange).

Figure 12-11
Charles Wells, *Figure in Rosato Di Verona*. c. 1972.
Marble, H. 34 in., W. 16 in.
Photo courtesy of FAR Gallery, New York.

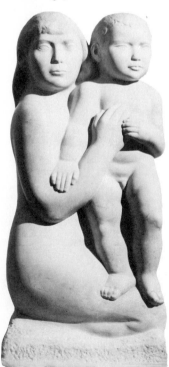

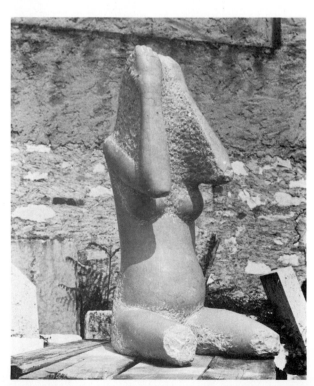

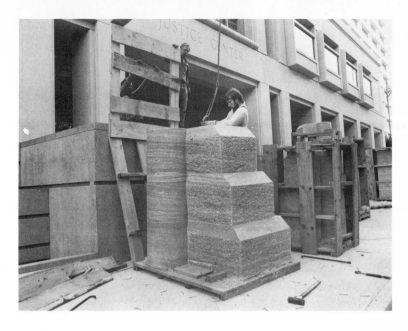

Figure 12-12
Walter Dusenbery, *The Portland Columns.*
1983.
Yellow travertine, carved in sections and cemented together. H. 17 ft., weight 13 tons.
Carved in Italy over a two-year period for Justice Center, Portland, Oregon.
Installation photo of hoisting sections in place.
Commissioned through 1% for Public Art project administered by the Metropolitan Arts Commission and Oregon Department of Transportation, funded by the Federal Highway Department, Multnomah County and the City of Portland, Oregon. Photo by author.

Figure 12-13
Walter Dusenbery, *The Portland Columns.*
Installation showing cemented column sections wrapped in moist fabric and plastic, awaiting additional sections. Photo by author.

Figure 12-14
Walter Dusenbery, *The Portland Columns.*
Completed installation of work flanking entry of Justice Center, Portland, Oregon, 1983.

ORIGINS AND FORMATIONS OF STONE

The fundamental composition of all stone is silica (silicon), alumina (aluminum), calcium (lime), and magnesium (magnesium oxide), found in combination with carbon dioxide.

The earth's hard material has three major origins.

Igneous rock is extremely hard, formed by the solidification of molten masses as they approach the cool surface of the earth. Slow cooling forms coarser-grained stone, the faster cooling forms the finer grained. Granites possess 1/1,000 the porosity of limestone and sandstone (1%–10% porosity). Examples of igneous rock are diorite, basalt, gabbro (black granite), obsidian, and granites.

Sedimentary rock, more porous than igneous, is formed from erosion on the earth's surface. These rocks are stratified and reconsolidated with new rocks from deposits laid in river beds by rushing water. This stratification can often be seen in the sedimentary rock limestone, chemically a calcium carbonate. Sandstone is another type of sedimentary rock, more porous than limestone.

Metamorphic varieties are igneous and sedimentary types that have been chemically changed and recrystallized by heat and pressure. Crystalline stones like marble were transformed from granular limestone in this way. Other metamorphic types include quartzite, schist, slate, soapstone (steatites), serpentines, and alabasters.

TYPES OF CARVABLE STONES

Granite, a hard igneous stone, derives its name from the Latin *granum*, meaning seed, because of its granular texture, or the Italian word *granito* (grain). Any dense, crystalline, unstratified rock of igneous origin is considered a granite. Composed of felspar, silica, and quartz, it is ten times as strong (and resistant to carving) as limestone (the silica and felspar are harder than steel). Granite pulverizes, not flakes, when carved, and granite dust contains silicates, requiring adequate ventilation. Varieties of basalt and diorite can be carved with granite tools, but obsidian fractures easily and must be shaped with abrasives. Granite porphyry is a coarse-grained stone with large feldspar chunks scattered through the mass of ordinary rock. Lava rock like Oregon Rainbow is a volcanic ash that carves easily. Spongy when first quarried, it hardens in time. Italians keep the stone soft by storing it in earth pits. Granite is plentiful and is available in grays, whites, pinks, reds, and black in many eastern and western states. Barre, Vermont is a leading producer; Scotland, Ireland, Sweden, Finland, and France (Brittany) also have abundant supplies.

Sandstones are sedimentary rocks composed of silica grains in a matrix of calcium carbonate and/or iron oxide and having about the same weathering resistance as limestones. Grindstones, dense sandstones containing 98% silica, are more enduring than granite as grains are welded by heat and pressure. Pure siliceous sandstones welded together by quartz crystals are difficult and dangerous to carve because of the silicosis danger. Most varieties are porous and contain a quantity of water when freshly quarried, making them easier to carve when fresh or when wet. Wetting also cuts down on grittiness. Freestone sandstone has no stratified structure. If stratified, the stone must rest on its bedding plane, with its stratification horizontal, not vertical, to insure that no water gets between layers and splits the stone. Sandstone is found in abundance in France, England, Canada and the United States, with Ohio the leading producer of the well-known Berea type. Sandstones are available in colors from yellows and reds to greens and blacks. Many, such as brownstone, receive their name from their color.

Limestone, another type of sedimentary rock composed of the mineral calcite (calcium carbonate, $(Ca\ CO_3)$) and/or magnesium carbonate, is generally white unless stained by iron oxide. Dolomites, composed of skeletal remains of shellfish and marine life, contain double carbonate of lime and magnesium. They are less durable than granite and are related to marble chemically and in hardness and working properties, responding well to steel tools. Limestone is used for most of the world's sculpture and the majority of the world's stone buildings. Though generally softer, and therefore easier to carve, limestone comes in varying densities, from extremely hard types used for lithography to softer varieties such as Texas cream, so soft it can be nicked with the finger and worked by rasping. Limestone from Utah, Ohio, and Kentucky also are carvable in the soft to medium-hard range. A type that will take a particularly good polish is Indiana limestone. Imported limestones used frequently are English portland limestone, English Bath stone, and Caen stone, a soft cream-colored French limestone. Travertine, a cross between limestone and marble, has been quarried near Rome for over 2000 years. It is soft and workable when freshly quarried but hardens and becomes durable upon exposure. Wonderstone is a

dark gray, slatelike sedimentary stone imported from Africa. Hard slate, used sculpturally by the Egyptians, is worked with woodcarving tools, files, rasps, and abrasive stones (not chisels, as it is fragile and tends to fracture easily). It is brought to a luster with melted beeswax applied to the surface and buffed.

Marbles fall into a category considered by the trade as separate and distinct from that called "stone." Metamorphic limestone in origin, marbles form the most important group for the sculptor, due to their qualities of workability, beautiful surfaces, and varied colorations. Marbles and limestones are chemically similar, both containing calcite and dolomite, but marble has no bed or stratifications and the structure of its carbonates is crystalline rather than granular—a quality allowing for a high polish. Colors range from white to black, either uniformly or in veins or streaks of mineral impurities such as iron oxides, manganese oxides, pyrites, or aluminum silicates (clay). Generally, tools for marble must be harder than for sedimentary stones, and the stone is chipped or flaked away rather than cut. The alabasters, technically members of the marble family, come in a hard carbonate of lime type called onyx marble, and a softer type composed of hydrous sulphate of lime, the latter calcined for plaster of Paris. Alabasters have a crystalline, translucent composition which is fragile, easy to carve, and polishes well; agate and gabbro rosso are rare types of alabaster. Soapstones, a form of talc, are soft and grayish in color, with a distinctively greasy feel and a high magnesium silicate content. (Their asbestos content makes it hazardous to use). *Steatite*, a related stone of the talc family, can be cut easily with knives and fine chisels, takes a good polish resembling marbles, and comes in a variety of colors from whites to yellows, greens and grays (see Figure 12-15). Serpentines are green and elaborately veined stones classed with the marbles, but may be igneous in origin. They are often unsound due to pockets of soft steatite within the harder serpentines.

Production of domestic marbles is foremost throughout the mountain regions of the Appalachian belt (which experienced metamorphic conditions). The eastern states of Alabama, Georgia, and Tennessee (largest producer) produce marble ranging from fine to coarse grained, with colorings from white to gray, pink, and tan. Vermont, Maryland, Pennsylvania, and Colorado also quarry marbles of varied densities and colors. Imported marbles originating from Greece are the white Parian and Pentelic, or the green-veined cipollino; Italian

Figure 12-15
Paul Buckner, *Siren.* c. 1979.
Steatite, H. 11 in.
Collection Olympic College Library, Bremerton, Washington.
Photo appeared in *National Sculpture Review* Magazine.

marble is the dense, white Carrara; Belgium marble is veined and black, while France produces a great variety of both colored and white marbles.

Selecting Stone

Marbles, soapstones, wonderstones, alabasters, and onyx are priced by the pound from stone dealers. Quarry stones may be ordered custom cut. Softness of stone may be tested by scratching with a point, hitting a corner with a chisel, or rasping across the stone. If the stone powders or flakes, it is carvable. Exposed to weathering, white marble will sometimes produce a sugary or powdery texture that causes it to disintegrate when chiseled; for that reason, it is safer to obtain a freshly quarried stone. Flaws in stone are cracks, soft streaks, veins, rust streaks, and stratification, which occasionally may be worked around, as Michelangelo did with the marble from which the *David* was carved. To test the soundness of a stone: (1) tap the stone lightly with a steel hammer. If sound rings clear, the stone is sound; if a dull thud, the stone is "dead"; (2) wet the stone with water. A deep-grained dark streak going all around or through the piece indicates a crack. Soft areas may be caused by fossils or imbedded pebbles (see Figure 12-16).

Transporting Stone

When no pulley systems are available, transport stones over two feet high and wide by placing on 2″ × 4″ boards or on a tire to distribute weight

Figure 12-16
Small carving stones in rough—marble, alabaster, steatite. Studio of Eleanor Margolin. Photo by author.

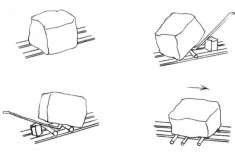

Figure 12-17
Transporting stone.

(see Figure 12-17). To turn stone, lever one side up, placing a pebble or small strip of wood in the exact center to act as a swivel. Raise stones by levering up alternate sides, padding the edges with a piece of wood to prevent chipping on the edge when height is reached. Roll a large block over three or four lengths of steel pipe, moving each pipe to the front as it comes free at the back. Cradle a large stone on a stretcher, to be carried by two or four persons. Completed stones should be crated carefully for transport, with padded crosspieces secured to the framework to prevent the stone from shifting, and cushioned with styrofoam blocks, packing paper, excelsior, old blankets, etc. When handling marble, wear gloves to prevent the stone from absorbing oil and grease from hands.

Carving Stands

Stonecutting stands should be below elbow height, about 2' square by 2'–2½' high, and sturdily constructed (see Figure 12-18). Cushion small stones in sand held in with boards at the top, and pad with old rugs, burlap sacks, foam rubber or canvas sandbags, or frame in the base with wood securely

Figure 12-18
Stone carving stand.

screwed to a baseboard or adhering one stone to a larger one with plaster of Paris, wetting the stones before applying the plaster. Secure reliefs on easels by plastering the stone to a heavy wood support. A 50-gallon steel drum filled with sand or a stump cut flat on top and bottom will work well as a stand.

TOOLS AND METHODS

Stone carving methods involve chipping, scraping, fracturing, flaking, crushing, or pulverizing (see Figure 12-19). *Chipping* breaks away small pieces; *fracturing*, large chunks; *flaking*, thin layers; *scraping* is done by rubbing with sharp teeth; *pulverizing* requires hitting the stone repeatedly, with force.

The tempered steel tools used for carving all stones are basically similar in shape. Though harder than limestone or marble, hardened steel is not as hard as the crystalline composition of granite. To compensate for steel's relative softness, granite tools are more robust than marble tools (forged from a thicker steel bar) and more obtuse (less acute) in the cutting angle. Consequently, though

Figure 12-19
Stone carving methods—chipping, scraping, flaking, fracturing, crushing.

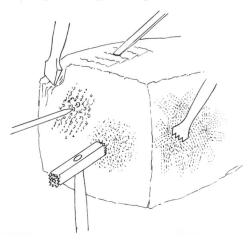

granite tools may be used on hard marbles, marble tools are too light and sharp edged for granite. Granite hammers are heavier in the head and have longer handles than marble hammers, for swinging a more powerful blow with a minimum of fatigue. The chisels for granite are more truncated and less tapered than those for marble, looking more like cold chisels. Rather than a bevel, the cutting edges of heavy granite chisels (pitchers) are sometimes at right angles to the body, enabling them to split off or powder away the hard granite when driven by a hammer. A recently dis-

covered metal, tungsten, is harder than granite. Tungsten carbide has replaced steel tips on granite drills and chisels. A knowledge of tempering is necessary if granite is carved; temper for marble and limestone will last as long as the sharpened tool.

Basic Tools (see Figures 12-20–12-25)

Pitcher or *Hand-set*—A wide blunt-ended chisel used for initial roughing out, and clearing larger volumes of stone.

Figure 12-21
Stone carving rasps and files.

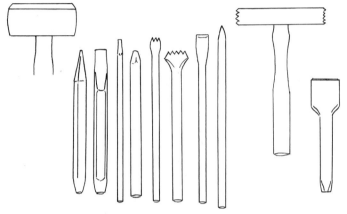

Figure 12-20
Basic stone carving tools—chisels and hammers.

Figure 12-23
Stone carving chisels: points, flat, and claw (tooth) chisels. Photo by author.

Figure 12-22
Stone hammers—dummy, pick, and bush hammer. Photo by author.

Figure 12-24
Stone files and file cleaner. Photo by author.

Figure 12-25
Stone rasps in a variety of shapes. Photo by author.

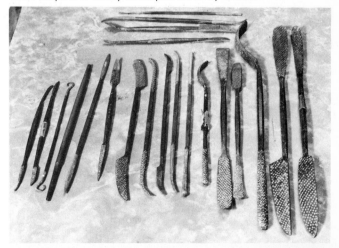

Points (punch or pointed chisel)—1 light, 1 heavy, for roughing out after pitcher.

Claws (tooth chisels)—3–4 wide and narrow, for clarifying the forms after the points.

Straight (flat) *Chisels*—1″ to ¼″ wide. For definition of forms after point or claw.

Bull-nose chisel—rounded-end chisel for concave forms.

Bolster—wide chisel for large flat surfaces.

Hammer—1–4 lb. Soft iron gives a dull blow and is preferred to steel hammer which bounces off chisel.

Dummy—smaller hammer of a metal alloy for lighter work.

Mallet—wood (best is beech) for use with mushroom-headed tools and for soft stones. Dummy and mallet are interchangeable in use.

Boucharde (Bush hammer)—A hammer with a toothed face for bruising stone surface.

Rasps—coarse, file type tools for abrading limestone and marble, not sandstones or granites (teeth would wear down) (see Figure 12-21).

Riffler—shaped rasps in various sizes for working in odd-shaped areas.

Abrasive stones—natural and synthetic grindstones used for sharpening claws and chisels and polishing stones along with emery cloths and sandpaper. Fine abrasives are chunks of solid pumice, scotch and black hone, and snakestone. Carborundum, silicon carbide, and aluminum oxide are used for shaping and smoothing harder stone, starting with coarse grits and working up to finer, applied wet or dry.

Protective goggles or shield—for flying chips.

Mask—respirator-type mask for granite, particularly, but should be used when abrading any stone.

Exhaust system—advisable for long-term carving.

Supplementary Tools

Pick (trimming hammer)—fractures off large chunks of stone.

Tungsten-tipped chisels—for use on granite and hard stones.

Drill—hand driven or electric. For making holes for driving in plugs in splitting stone. Also used with grinding and polishing attachments. Star drills are long metal rods with fluted ends, used primarily for drilling holes for mounting purposes.

Gouges—woodcarving type, for soft stones only.

Calipers—measuring device, for assessing proportions.

Tee squares, measuring tape.

Pulley—for lifting and turning large blocks of stone.

Crowbar.

Power Tools

Industrial tools with vibratory action are driven with compressed air or electricity using flexible shafts (see Figure 12-26). Bits may be points, claws, or chisels. Hammer-driven tools should be held firmly but not clutched too tightly, as the tool needs room to move. The constant vibration may cause prolonged use of pneumatic tools to affect circulation in the hands. Thermal tools are a new process for rapidly spalling off layers of stone through surface expansion. The high-velocity flame is fueled with mixtures of oxygen and any vaporized fuel.

Sharpening and Shaping Tools

Keep tools sharp and clean, maintaining edges and repairing nicks by regrinding cutting edges. A 5″ wheel of aluminum oxide, silicon carbide, or carborundum mounted on a bench grinder or a flat stone may be used to grind edges. Place chisels on the wheel with the flat of the blade pointed against rotation and beveled at a 30° angle. Dip in water regularly. Blue or black spots appearing on the chisel edges indicate loss of temper and the need for more frequent cooling with water. Hollow-ground edges are the concave curves of the bevel resulting from grinding on the curved edge of the wheel. Since stone carving chisels should not be hollow ground, grind flat chisels on the *side* of the grinding wheel.

For sharpening chisels without nicks it is unnecessary to grind. Simply rub edges back and forth on an oilstone, lubricating the stone with oil to increase cutting action and prevent clogging with

Figure 12-26
Power tools for stone sanding and polishing. Electric sander and buffer (on drills) and small grinder on flexible shaft. Photo by author.

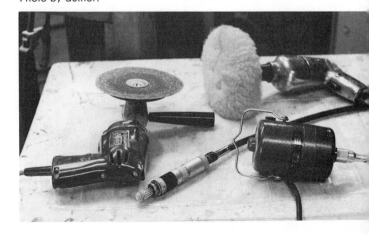

Figure 12-27
Sharpening chisels.

Figure 12-28
Splitting stone.

metal particles. Sharpen the bevel by moving the chisel in a figure-eight pattern against the stone until a fine wire edge develops. Hone on a fine stone in a figure-eight pattern, turning from beveled to nonbeveled side. Sharpen toothed tool edges with a knife file (see Figure 12-27).

Stone tools may be shaped from 8″ length square steel rods cut with a hacksaw. The striking end is heated until glowing, then hammered on an anvil to a rough point. After cooling, grind chisel to a smooth point on grindstone and temper.

Tempering Tools

After several resharpenings, the points become blunted and the blade thickens, requiring reshaping and retempering. Heat the steel tool to a soft, flowing condition so it can be hammered to an exact shape. After hammering, tempering is necessary to soften the hard steel, making it less brittle and breakable when hit against hard stone. The degree of temper varies with the hardness of the stone, with temper limited to the cutting end. Should the hitting end be tempered too soft, the impact of the steel hammer causes the hammer to bounce off the tool. The impact of the hammer on a chisel end with too soft a temper will cause a mushrooming of the end. The steps in tempering are described in chapter 11.

CARVING PROCEDURES

Splitting Stone (Cutting Out a Block)

Two methods are used for splitting off a block from a larger stone (see Figure 12-28).

1. Mark the block and groove it with points—on 3 sides if heavy, 4 sides if light enough to be lifted. Wedge with a steel bar directly under line of separation so block is slightly suspended. Continue working around the groove until stone separates.

2. Drill a series of narrow holes 3″ to 4″ apart and 4″ to 6″ in depth, depending on block size. Insert small steel wedges (also called plugs) into holes reinforced with iron shims (to keep hole from enlarging). Tap carefully to insure breakage along the line. After 10 to 20 minutes, the stone will split.

Leveling Surface

Standing a rough block on end, cut two small level areas with point and claw at each end of a block. Lay small wood blocks of equal thickness on the level areas and place a straight edge on these. Repeat the process on the other end of the block, lining up the undersides of the straight edges by eye. Join the four level corners by cutting the stone between them on the edges. Checking with the straightedge, work off remaining stone in center (see Figure 12-29).

Roughing Out

Rid the block of its squareness and superfluous stone by chipping off corners with a pitcher, called "bull setting." Hold the pitcher at a steep angle and give a hard blow with the striking hammer

Figure 12-29
Leveling stone.

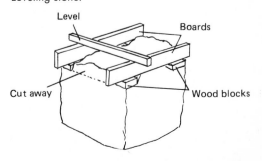

Level

Boards

Cut away

Wood blocks

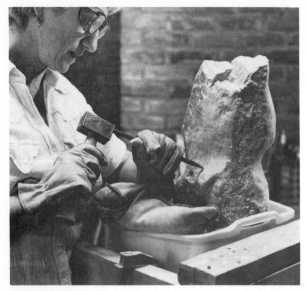

Figure 12-30
Roughing out stone with point (punch). Eleanor Margolin.
Photo by author.

(see Figure 12-30). The large pieces can be broken off and the approximate shape reached before the punch is used.

The heavy punch is held at a 40°–60° angle for limestone, marble or sandstone, a steeper (more vertical) angle for granite, to prevent the punch from skidding off the surface of the hard stone. Holding a 2-lb. hammer near the head, tap the punch rhythmically with a relaxed movement, working at a downhill slope. Strike more than one blow without repositioning, systematically cut-

ting grooves and furrows. On softer stones a bush hammer will perform the same function as a punch. Glove the tool hand to avoid injury from miscalculated blows of the hammer. Work from outside edges on projections which will yield easily, taking off even layers of stone (see Figure 12-31).

Developing Forms

Use fine-pointed chisels to develop forms gradually, keeping simplified planes and visualizing the image as it emerges from the stone. Maintain a rough surface, at times alternating the pointed chisel with the bush hammer. Further develop the forms with a fine-toothed chisel (claws) keeping delicate parts anchored to the larger mass (particularly in marble) by cutting on a bevel. The claw removes stone more evenly than the point, producing a furrowed but level surface (see Figure 12-32). Drills with tungsten carbide tips may be used for piercing or difficult places. Penetrations should be kept as half-round concave forms until the surrounding forms are complete; if opened up too soon, the hole tends to widen and the surrounding areas to weaken.

Finishing

The claw chisel begins the refinement of the forms on marble and softer tones, leaving a fine striated surface which may or may not be followed by a flat chisel. Claws should be sharp and used at a

Figure 12-31
Bush hammering stone. Eleanor Margolin. 1980. Stone rests on sandbag in basin anchored to heavy sculpture stand. Photo by author.

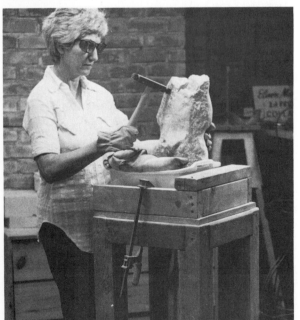

Figure 12-32
Claw chisel on limestone. Kay Macnab. 1979. Photo by author.

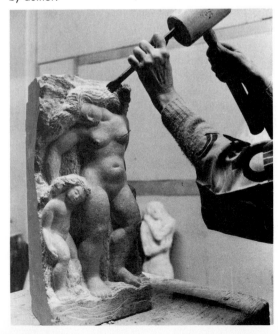

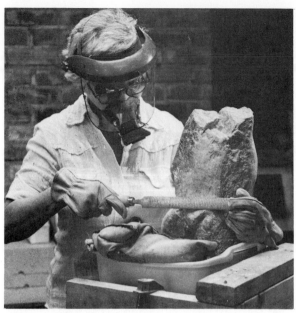

Figure 12-33
Abrasive filing on surface. Protective face gear and ventilator mask are worn against dust and chips. Photo by author.

low angle to avoid pitting the surface. Bull-nose chisels with rounded ends form hollows. Flat chisels held at a low angle may be pushed, without a mallet, over the surface, leaving smooth but faceted surfaces (as in Gothic and Romanesque carving). Abrasives vary with stone—rasps and rifflers for marble, slips of coarse to fine carborundum for granite. For soft stones, surform files and files on flexible shaft machines may be used. Final abrasives include pumice, garnet papers, emery cloth, wet/dry papers used wet for a finish, and fine hones, such as scotch and black which may be glued to wood for hard-to-reach places. The stone should be washed between rubbings of abrasives (see Figure 12-33).

The final rubbing or *polishing* is done with putty powders (tin oxide) and felt, except for granite which uses fine carborundum (see Figures 12-34–12-39).

To mount, drill a hole for a rod or rods with a power drill or a star drill, revolving the drill between thumb and fingers while striking the rod repeatedly with a hammer.

Maintaining

Stone may be repaired with cements specifically designed for stone and marble, such as *Akemi*, a two-part mixture of glue and hardener. The cement is mixed with stone dust to fill cracks, with a 30-minute wait for hardening.

Marbles resist weather well, though freezing conditions may cause contraction and expansion. Flaking results from wind and dust erosion, color changes from soot or smoke. Sun or intense heat may change marble to lime. Limestones and sandstones should develop a tough crust and be gradually introduced to weathering by placing outdoors in the summer. Apply silicon as a preservative to the surfaces of the more porous stones.

After handling and exposure, marble will eventually need cleaning. Scrub gently with a soft brush and a mild cleaner like Bon Ami, Dutch Cleanser, or a mild soap, though the latter may leave a shiny film and must be rinsed thoroughly. Lemon juice or sodium citrate combined with fine pumice will remove some stains from stone. A chemical such as ammonium fluoride will give excellent results cleaning lichens and stains from marble, sandstone, or limestone. Brush a thick paste (made with the chemical and 4 parts powdered talc) on the moistened surface and leave on for 20 minutes. Remove it by brushing under water with a brass wire brush and rinse thoroughly.

Cement Carving

Concrete blocks for carving in lieu of stone may be cast in molds of cardboard, wood and plastics—preferably in the approximate shape desired for the finished work (Fig. 12-34). Mix aggregate with cement in a proportion of 3 or 4 parts to 1 part cement, pour into a mold, and allow to set up for 12 hours or overnight. You can also add cement color in proportions recommended by manufacturer. Blocks can be carved when newly set and still moist using abrasive tools, or when cured and dry (and much harder) with stone carving tools. The type of aggregate is dependent on the hardness or density of cement desired and the size of the work. Aggregates include sand, perlite, vermiculite, stone chips, gravel, and mixtures of sand and gravel.

Figure 12-34
Pouring cement blocks.

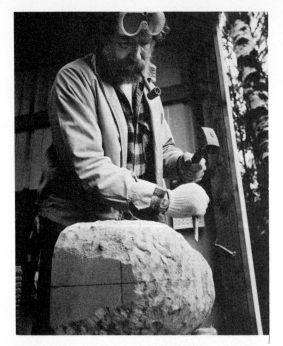
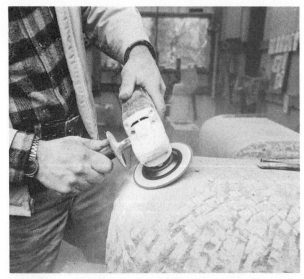

Figure 12-35 (*upper left*)
Section of mall piece for Downtown Mall, Portland Oregon.
Don Wilson, 1980. Roughing out marble with flat chisel.
Photo by Roberta Kelly.

Figure 12-36 (*upper right*)
Disk sanding marble. Photo by Roberta Kelly.

Figure 12-37 (*center left*)
Hoisting section of mall piece. Photo by Roberta Kelly.

Figure 12-38 (*center right*)
Buffing section of mall piece. Photo by Roberta Kelly.

Figure 12-39 (*lower left*)
Final polishing of mall piece. Photo by Roberta Kelly.

Figure 12-40 (*lower right*)
Don Wilson, mall piece, Downtown Tri-Met Mall, Portland,
Oregon. 1980.
Marble.
Commissioned by Metropolitan Arts Commission.

CARVABLE STONES— TYPES AND QUALITIES

Carvable stones are categorized under hardness. Sources for information on stone may be obtained from U.S. Geological Survey Department, Washington, D.C., and Marble Institute of America, Washington, D.C. Stone companies are listed in the Thomas Registry.

Soft

Alabaster—Varies from translucent white to pale yellows, browns.

Soapstones—Green-gray, soft, greasy, can be polished. High asbestos content makes it hazardous to carve.

Steatites—Less greasy than soapstone to the touch, green, yellows.

Beer—Off-white limestone which is soft but takes good detail.

Bathstone—Easily worked, includes a number of oolitic limestones. Does not take fine detail, as it is coarse in texture. Ranges from cream to yellows and pale browns.

Caen—Cream-colored French limestone, fine textured.

African wonderstone—Imported from Africa, gray sedimentary. Carves well with an even texture.

Medium-Soft Stones

Includes many limestones (oolitic and others) and some sandstones.

Portland—popular cream oolitic limestone which weathers white. Can be shelly or shellfree.

Indiana—American, medium hard, fine grained, cuts easily. Gray to buff in color.

Ohio—American, widely used sandstone. Fine to medium grained, varies in color from blue to gray to buff.

Travertines—Porous, pinks, buffs and whites which resemble marble. Cannot be highly polished.

Hard Stones

Includes some hard sandstones. There are 295 types of marble.

Marble

Carrara—White, fine grained, translucent. Best grade is Italian Statuary White. Used by Romans and Michelangelo. Colors vary from snow to creamy to bluish white.

Sicilian—Hard, coarse, and blue-white.

Belgium—Hard, veined black, popularly used.

Vermont—Fine grained, but not too durable outdoors. Reds, greens, blues, creams, and mottled white. White is highly regarded.

Tennessee—Compact and harder than any other American marble, so is durable outdoors. Difficult to carve and polish. Colors are gray, light to dark pinks, fine and coarse dark red.

Georgia—Whites, grays, pinks, with crystalline texture. Takes high polish.

California—Produces a *White Columbia* marble similar to Carrara.

Alabama—One of the finest white marbles in the United States, hard and durable.

Granites–Numerous types—black, red, gray, all hard. Maine granites are medium white and gray to dark gray.

Other stones (Occasionally employed for sculpture but mostly for jewelry). Mineral rocks—Jade, lapis lazuli, lepidolite (lithea stone), malachite, quartz (several colors), which include agates, amethysts, jasper, carnelian, flint, and chalcadony.

13

Woodcarving and Fabrication

HISTORY

Few early wood sculptures have survived deterioration. Preservation of Egyptian carved woods of acacia and sycamore can be attributed to the dry, stagnant atmosphere of the tombs in which they were buried, as well as their surface treatment with gesso. The fortuitous placement of Japanese and northern European wood sculptures in temples and churches preserved examples of these two great woodcarving traditions. Most of the Greeks' wood sculpture had been destroyed or had deteriorated by the early centuries of this era. Earlier Aegean tree carvings, considered sacred and divinely endowed, are thought to be the origin of the columnar form adapted later for the archaic female cult figures of stone known as Kourai. In his second century A.D. journal *Travels in Greece*, Pausanias described in detail large numbers of sacred wood sculptures, mentioning especially two Olympian athlete statues of wood. He referred to hundreds of statues, made of such woods as oak, apple, pear, olive, cypress, cedar, lotus, juniper, and ebony, and some dressed in real drapery. Carved wood was used as the form for sand casting of

bronze and for the core of such major works as the 40-foot-high *Athena Parthenos*, whose face and arms were of ivory and the drapery covering the wood of hammered gold.

Polynesia, Indonesia, and Africa have produced dramatically expressive works in wood, primarily complex figure groups and ornately carved and painted masks. Though the identity of specific sculptors is not always known, there are distinct styles or "schools" attributable to particular sculptors whose skills had made them famous in their local area. Characterized by great power and force of form, the sculptures were intended primarily for use in religious ceremonies in which the intensity of the imagery served to enhance their magical effect. Late nineteenth century artists like Gauguin, and early twentieth-century Cubist and Expressionist sculptors emulated primitive carvings, and were among the first to recognize their legitimacy as an art form.

China and Japan made highly refined woodcarvings for the temples of the sixth, seventh, and eighth centuries A.D. Official Japanese missions to China brought Chinese styles to Japan, the Japanese stylistically following the Chinese by a cen-

tury and a half. Early Japanese woodcarvings of the *Asuka* and the *Hukuho* periods (derived from the *Wei* dynasty of China) were composed of hard cypress wood covered with gold leaf and color. Before the lost-wax method replaced sand casting, the wood forms also served as a mold for casting bronze. During the Japanese Hukuho period, sculpture assumed the larger size and realistic treatment characteristic of the earlier *T'ang* period in China. The dry lacquer technique, originally invented during the T'ang Dynasty (the lacquer plant originated in China), was adopted by the Japanese at this time. The technique took two forms—a hollow and a wood-core type. The hollow type used clay for the rough shape, repeatedly covered it with flax soaked in liquid lacquer, then removed it from inside the shell. Surface details were then modeled with a mixture of lacquer, sawdust, and fine clay. In the second method, blocks of soft wood were first carved, then assembled and used as the core for cementing layers of flax with lacquer.

During the Japanese *Heian* period (the eighth to the twelfth century AD.), wood was favored for its economy, in contrast to the labor-intensive techniques of bronze, clay, and dry lacquer processes used in the previous *Nara* period (see Figure 13-1). The dominant spiritual tendency of the time emphasized the sacredness of material considered to possess divine origins, such as the large, older trees from which the wood sculptures were carved. Certain Buddhist sects observed sanctifying rituals that included purifying the wood to be carved, as well as the sculptor and his tools. Japanese hinoki (cypress wood) was favored for its hardness and elasticity. Camphor trees were later used for their large size.

The carving technique called *ichiboku* developed at this time and utilized a single block for the main portions of the figure with smaller blocks forming the projecting portions added to the body. Sharp chisel work characteristic of "single-block" Buddhist statues of the *Jogan* period (early Heian—A.D. 794 to 897) produced a style of drapery called "the rolling waves," characterized by rolling high convexes and low, sharp ridges entwining the body in swirling parallel curves. Honored as the father of Japanese sculpture, the eleventh century sculptor Jocho later softened the sharp edges into a shallow, soft carving. He invented the *Yosegi* or assembled block method by which separate blocks for the head, trunk, and limbs were carved by different artisans and assembled later by a master sculptor. The new process led to mass production, the formation of woodcarving guilds,

and the eventual loss of individuality through adulteration of style.

Starting from the ninth century A.D., Europe experienced a revival of woodcarving, primarily in the forested north. One of the few works in the round carved during the early Romanesque period, the *Gero* crucifix (A.D. 975–1000) of the Cologne Cathedral is the earliest known surviving image of Christ on the cross. In early French portrayals of the Virgin and Child (generally carved of wood, though occasionally beaten out of metal), the Virgin was presenting rather than holding the Christ child. Her posture was rigidly symmetrical and frontal and, though free standing, compositionally bound to the block and wall. The carvings were often covered with gold leaf, usually hammered by a specialist other than the carver (see Figure 13-2).

From France, the subject of Virgin and Child travelled east to Bohemia and Czechoslavakia, north to Scandinavia, and south to Spain and Italy, becoming the primary subject of the International Gothic style flourishing between the thirteenth and sixteenth century A.D. The madonnas were an exception to much of the iconography of the time, most of which dealt with the passion and death of Christ—the Entombment, the Crucifixion, and the Flagellation. Intricately carved in wood, late Gothic compositions featured angular, complex renditions of drapery, which came to be known as the "broken style." Though religious in theme, much of the work was sensual and materialistic, delighting in complexity and mannerism (see Figure 13-3). The predominant carvings were of over-life-size, in-the-round figures in oak, limewood, and walnut, portrait heads in boxwood, and minutely carved relief sculpture such as the stallwork of Amiens (1508–1518) portraying Biblical figures. Inspiration for this outburst of wood sculpture may have been the wood engravings designed by Dürer, among others, for the new process of printing multiple copies of books. During the late Gothic period (end of the fifteenth and early sixteenth century) particular individuals with distinctive styles began to emerge from the anonymity of the artisan guilds. Among the great northern sculptors, many of whom carved in stone as well as wood, were Veit Stoss (1438–1533), Claus Sluter (1380–1405), Conrad Neit (1438–1531), Peter Vischer (1460–1529) and Tilman Riemenschneider (1468–1531), all famed for their magnificent church altarpieces.

Tomb effigies were sculpted in Gothic England of fine quality oak. After carving, the work was hollowed from behind to thin the wood and thereby

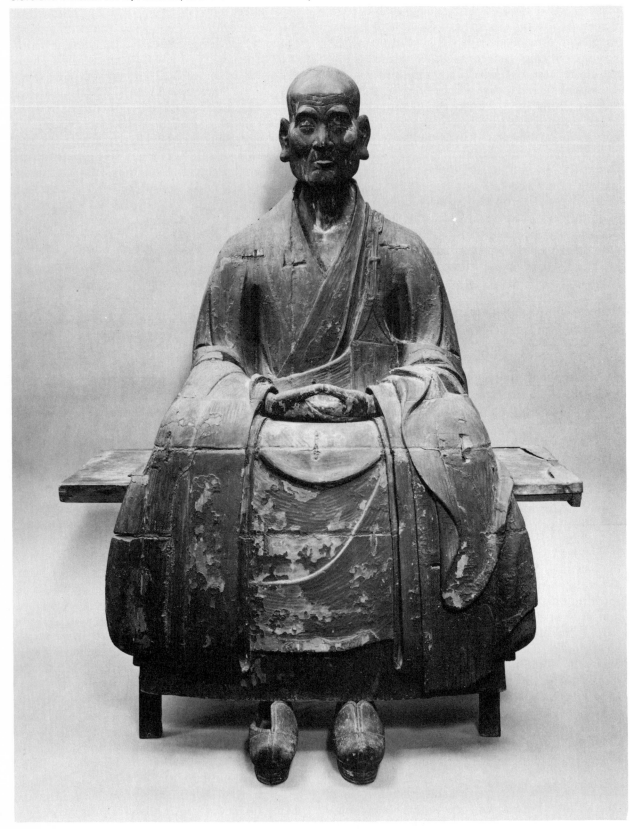

reduce the possibilities of checking or splitting due to external temperature changes (the thinner the cross section, the more even the effects of humidity). The finished wood surface was coated with gesso, a creamy paste of lead, plaster, and the glue from boiled parchment cuttings which filled up the grain and acted as a preservative. The painted and gilded image, with adornments of glass and semiprecious stones, was then mounted on a slab. It is conjectured that the wood images were originally carried in the funeral procession and later used as the molds from which the permanent bronze effigies were cast; the bronzes exhibit the crisply defined surfaces of a carving rather than the soft contours of an original in clay or wax.

During the Italian Renaissance, the great master Jacopo della Quercia (1367–1438), whose very name means woodcarver, introduced a new lyric

Figure 13-3
Tilman Riemenschneider, *Three Saints*—St. Erasmus (on right), St. Christopher bearing Christ child on his shoulders (on left); behind them, in center, Eustace.
Lindenwood, H. 21 in., W. 13 in.
Metropolitan Museum of Art, Cloisters Collection. Purchase, 1961.

Figure 13-2
Virgin and Child, French, Auvergne. 12th cent. Polychromed oak, H. 31 in., W. 12¾ in.
Metropolitan Museum of Art, Gift of J. Pierpont Morgan, 1916.

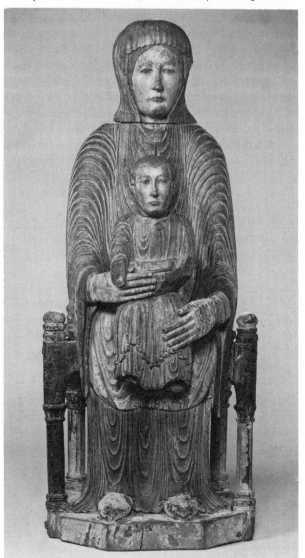

and simplified style. A carver of limewood prophets, madonnas, and portraits, the magnificent life-size oak *Madonna and Child* in the Louvre departs from Gothic stylization in the expressive power of its gesture and the volume emphasized in his figures. Della Quercia's elegance and clarity, contrasting to the complexity and angularity of the northern Gothic style, is thought to have provided the inspiration for Michelangelo's stone sibyls. Michelangelo is purported to have carved a life-sized wooden Christ for the church of San Spirito, but it has not survived.

Mannerism began to dominate French and Italian sculpture and led to the use of materials other than wood. Seventeenth-century Spanish wood-carving adapted the violent gestures and intricate drapery of the northern style, reflecting the in-

tensely devout character of Spanish Catholicism. The foremost practitioner of the Spanish Baroque, as this style was called, was Alonso Berruguete (1489–1561), a carver of ornate polychromed wood and stucco altarpieces that became the prototypes for the future national style.

The Baroque taste of Spain was shared in Bavaria, Silesia, and Austria. Churches, castles, and palaces were adorned with polychromed wood, stucco, and plaster altarpieces that developed into particularly extravagant and theatrical displays. In late seventeenth-century England, wood was adopted for interior decoration (much of it designed and carved under the supervision of the prolific English master carver, Grinling Gibbons), and the crafting of fine furniture under the now legendary names *Chippendale, Sheraton, Hepplewhite,* and *Duncan Phyfe.* Throughout the early nineteenth century, wood was primarily associated with the decorative traditions of artisans, while serious works of sculpture were created in stone and bronze.

The Cubists in the twentieth century reintroduced wood as a sculptural medium, combining it with paper, metal, and cardboard in mixed media assemblages. Wood was also used actively in such Dadaist *ready mades* as the bicycle wheel attached to a stool by Marcel Duchamp (1913) and in the Constructivist-influenced colored assemblages of Arp and Archipenko. Brancusi's rougher woodcarvings combined elements of primitive African and native Romanian folk carving, related to the late nineteenth century primitive woodcuts of Gauguin, the earliest of the moderns to show non-Western influences. Primitive American folk art inspired the elegantly simplified wood figures of Elie Nadelman (1882–1946) (see Figure 13-4). Stylization ranging from the African to the Renaissance and Gothic influenced the prominent carvers of the twentieth century, such as the German Ernst Barlach, the English Henry Moore and Barbara Hepworth, and the Americans Chaim Gross, William Zorach, and Leonard Baskin.

Heirs of Surrealism and Dada, contemporary assemblage sculptors Louise Nevelson, Marisol, and Joseph Cornell juxtaposed found materials, primarily of wood. Cubist-oriented Gabriel Kohn and George Sugarman laminated wood into architectural structures that reflected the hard-edged, classically Constructivist ideas of the 1960s. Like the early relief forms of Arp, much of the work was painted, the effects ranging from pictorial (as in the Marisol) to Nevelson's somber monochromatic tones and Sugarman's playful colorations.

In the 1960s and 70s *primary Structuralists* and *Minimalists* created large-scale environmental wood works for both temporary and permanent installation, and at times, as models for later execution in metal. Gaining impetus from the large-scale environmental work of the American metal sculptor David Smith, structuralists such as Mark di Suvero fabricated room-size assemblages of construction discards—heavy, splintered wood beams and planks that exhibited Constructivist influences as well as the gestural effects associated with abstract Expressionist painting (see Figure 13-5). Wood sculpture of the 1980s is characterized by experimentation and elegance of surface treatment. The eclectic attitudes of the times have encouraged diversity and personal metaphor.

Figure 13-4
Elie Nadelman, *Seated Woman.* c. 1918-19.
Cherry wood and wrought iron. Figure 32½ × 10½ in.; chair 25 × 12½ in.
The Evan H. Roberts Memorial Sculpture Collection.
Collection, Portland Art Museum, Portland, Ore.

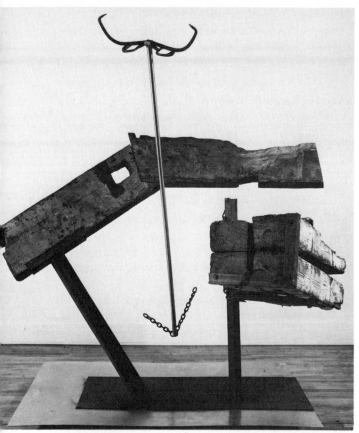

Figure 13-5
Mark di Suvero, *New York Dawn (for Lorca)*. 1965.
Iron, steel, and wood. H. 78 in., W. 74 in., D. 50 in.
Collection Whitney Museum of American Art, New York.
Gift of the Howard and Jean Lipman Foundation, Inc.
A combination pioneered in the Nadelman piece, the juxta-
position here of metal and wood is a rugged assemblage of
the industrial age.

Figure 13-6
Longitudinal structure of tree (gives
wood its tensile strength).

THE MATERIAL

Intrinsically beautiful and versatile, its longitu-
dinal and fibrous nature (derived from the struc-
ture of the tree) allows wood to support its own
weight (see Figure 13-6). Its tensile strength, plus
the ease of cutting and assembling, make wood
an ideal material for fabrication and construction.
A tree's age can be determined by counting its
rings, each representing a year of growth. A light-
ish ring reveals the quick growth of spring; the
ring darkens as growth slows in summer. Wide
rings indicate a series of good growing years; nar-
row shows poor growth. Harder woods are slower
in growth. Sap passes up through the outer fibers
to branches, the outer rings clogging with gummy

material which become part of the tree support
system. The outer rings are called sapwood, the
inner, darker, harder rings called the heartwood.

In color, wood ranges from off-white to reds and
blacks. Exposure to air often darkens or yellows
the surface. The softwoods are the most striped;
wide bands are lighter, narrow bands dark red or
brown. Rather than striped, the grain in hard-
woods is textural. Woods classified as soft (like
pitch pine and yew) may not actually be soft. In
either hard or soft woods, open grain may be hard
but not as tough as close grain, which cuts with
more difficulty but affords fine detail.

WOOD SELECTION
AND SEASONING

Three categories of wood are available: logs, new
kiln-dried wood, and weathered wood. Logs and
driftwood may be collected and dried, while wood
from lumberyards is kiln dried and precut, though
boards may be laminated.

Wood from the same tree differs depending on
whether branches are cut from down low or higher
up. Vertical cracks develop, particularly in logs
which have been air dried for months or years.
Knots or burls may show up where branch for-
mations have been swallowed by the block. Avoid
knots and burls by choosing select rather than
common grade. The grain observed in the board

Figure 13-7
End grain.

length is called the *face grain*; the grain showing the growth rings in a circular pattern is the *end grain* (see Figure 13-7). Eight hundred varieties of wood exist; *the softwoods*; (pines, firs, hemlocks, holly, cedar, spruce, redwood, and cypress) have needlelike, narrow, resinous leaves. Except for pine, which cuts clean, softwoods tend to splinter, are less durable, and do not take as high a polish as *hardwoods*, the broad-leafed trees of oak, walnut, mahogany, cherry, ebony, maple, hickory, basswood, beech, gumwood, poplar, and willow.

Large and simple-lined carvings are best done in wood with an open grain, such as butternut, chestnut, Philippine mahogany, mahogany, or cedar. Small carvings are best done in close-grained woods such as boxwood, ebony, or lime (also called linden or basswood) which cut like cheese, free of splits. First carvings should be in a softwood or medium hardwood such as hemlock, cedar, white pine, redwood, aspen, basswood, holly, soft maple, cottonwood, spruce, cypress, or poplar. *Redwood* or *sequoia* is aromatic, compact, soft, light in weight and easily worked, with a cherry to red-brown color to the heartwood. Cypress is soft and durable but doesn't take a good finish. Cedar comes in several types; red carves easily but is brittle and soft, though durable; yellow is harder. Hemlock is a light softwood with strong markings, like Douglas fir. Douglas fir is splintery and hard to work, as is western larch, southern yellow pine, and yew. There are forty varieties of pine in the United States, some soft, others medium hard, with colors varying from white to red-brown. Soft pine is easily worked but not strong; yellow pine cuts cleanly; pitch pine is the densest of the pines with attractive markings; sugar pine is of uniform consistency, good for carving and available in large pieces. Holly is a close-grained, compact, and medium-hard, light wood which carves easily.

Medium-to-Hard Woods (Domestic)

Easy-to-carve hardwoods: red alder, aspen, basswood, soft maple, willow, and yellow poplar.

Basswood—compact, easy to carve, close grained.

Maples—come in both soft and hard varieties, close grained, compact texture.

Yellow poplar—soft, fragile, bruises easily.

Medium- to hard-to-carve hardwoods:

Apple—firm, close grained, reddish.

Ash—wide, clearly marked grain, tough, pale.

Beech—tough, hard, even. Pink with silvery specks, occasionally a twisted grain.

Birch—good wood for students, close grained, attractive.

Cherry—good for detail. Even, straight grain makes it good for carving. Reddish color similar to mahogany.

Dogwood—available in small diameter logs (3"–4"). Hard, straight grain.

Elm—carves well but very hard, wide grain; attractive.

Gumwoods—southern red gum a good carving variety. Others tend to warp, shrink, and check in seasoning.

Hickory—similar to ash but darker. Very strong. White to brown.

Madrone—beautiful light pink to intense red. From Pacific Coast.

Maple—several varieties of hardwood types, including bird's-eye, an ornamentally grained type.

Myrtlewood—mountain laurel, hard, heavy, strong, takes good polish, good for carving. Minimum danger of warping, swelling, shrinking, mold, and decay. Hard to obtain commercially.

Walnut—close grained, hard to carve. Beautiful grain and texture. Available in specialty woods only.

Imported and Exotic Hardwoods

Amaranth or *Purpleheart*—rich, violet colored, tropical hardwood. Available in planks 1" to 6" in thickness.

Cocabola—reddish color tropical wood, imported from South America. Hard and dense. May cause an allergy. Small pieces are good. Larger pieces sometimes internally decaying.

Ebony—very hard, expensive. Black or dark brown.

Lignum vitae—very hard, heavy, dense fine-grained wood. Yellow sapwood almost as hard as purple-brown heart. From Cuba, Puerto Rico, Bahamas, Nicaragua.

Lemonwood—also known as degame. Cuba is major source.

Mahogany—strong, inexpensive hardwood, with resistance to atmospheric changes (less warping, swelling, or shrinking). Carves well but is splintery. Fine grained and capable of highly polished surface. Warm

red-brown color. Trees grow between 6' and 10' in diameter and 150' in height. Cuban type is densely grained, hardest, and heaviest. African is soft with large pores and pink when cut, changing to pale brown. Carves well. Philippine type is not true mahogany but is soft and carves well, loses color on prolonged exposure to light. Larger pores and coarser appearance than other types coming from Africa, Spain, South America, West Indies, and Mexico.

Rosewood—red to black striped hardwood. Even textured but not easy to carve. Used for furniture. Expensive. Honduras rosewood is a light-colored, even-textured, smoother type.

Teak—strong, hard, and durable, with a component which repels insects. Carves well. Most prevalent in India. Available in logs, blocks, and planks.

Figure 13-8
Plain quarter sawing showing face and quarter cut.

Wood should be felled during the winter rest season when sap is not flowing. The logs should be stripped of bark and exposed ends painted to prevent sap from drying too quickly, causing the wood to split. Store wood on its side, keeping it out of direct sun and heat. As a rule of thumb, allow one year of seasoning for each inch of thickness. Water acts as a good seasoning agent; the wood found on beaches and rivers is well aged and suitable for carving after slow drying. Check wood for (1) soundness (no splits); (2) burls—malformation of the structure during growth; and (3) grain—some carvings with, across, or along the grain; along the grain is the easiest to work.

To test wood for soundness, hit it with a mallet, taking care not to bruise it. It should ring out audibly. Wood with a dull, soggy thud has a high moisture content and structural flaws. If wood shows signs of cracking, treat it to continual soakings of warm linseed oil. Since changes of temperature and humidity cause constant expansion and contraction, keeping a steady medium to cool temperature will help to minimize cracking.

Selecting Board Lumber for Fabrication

The manner of cutting board lumber affects the appearance of the grain. *Plain* sawing cuts straight through the log; *quarter* sawing cuts parallel to the radius, producing a straight grain with lines parallel with the length. Quarter-sawed lumber tends to shrink and warp less than plain-sawed lumber and takes paint more easily (see Figure 13-8).

Forms of Lumber

Boards are cut 1" or less in thickness, 4" in width; *lumber* 2" to 5" in thickness; *timbers* 5" thick. *Sheets* are of plywood or pressed wood, such as Masonite or particleboard. Lumber cut from the log is initially labeled "rough cut" until it is sur-faced (planed smooth) on one or more sides, designated "dressed lumber" (losing ¼" to ½" from its original dimension). Usual dimensions before planing are 1" × 2", 1" × 4", 1" × 6", 1" × 10", 1" × 12" or 2" × 2", 2" × 3", 2" × 4", 2" × 6", 2" × 8", 2" × 10", 2" × 12", up to 16' in length. *Moldings* and tongue-and-groove lumber are categorized as *worked* lumber, having received additional milling.

Classifications of lumber range from *yard* (common lumber) to the better class of *factory* and *shop* grade, used for manufacturing wood products. Grading of yard lumber is based on uniformity of surface which is free of knots and other decay, from number 1 (best) to 5 in the common lumber category. *Select lumber*, the next grade up, has 4 categories from A to D, A and B being the least defective.

Factory and shop lumber is graded for quality wood products and so must be clearly labeled on the end or surface of the board as to grade, kind, or condition. Lumber is purchased in board feet computed in inches by multiplying thickness by width and length in inches and dividing by 144, length in feet is measured by thickness times width in inches multiplied by the number of feet and divided by 12. Lumber widths are in increments of 2'—from 2' to 20'. Strips of molding are purchased by the lineal foot, boards and sheets by the square foot.

Plywood sheets can be conveniently fabricated into large-scale hollow sculptures and are often used for preliminary models of sheet metal sculpture. To make plywood, veneer sheets are glued at alternating angles to a thickness of 3 to 7 sheets or ply, from ⅞" to ³⁄₁₆" thick. Sheet dimensions range from 4' × 8', 12', or 16' in length. Exterior and interior grades are manufactured, from N (best) to D (poor) with grades A, B, and C usable as exposable face for natural finish, staining, or paint-

ing; grades C and D are backing layers. Wood used in the veneer is also graded from 1 (best) to 4 (poorest). Within the exterior and interior grades are a wide range of types and surface treatments, from textural differences (rough, sawed, brushed, striated) to surfaces coated with plastics or fused with a fiber. Marine plywood is a good weather-resistant and paintable exterior plywood for sculpture. Quality is marked on the panel and the edge designating type (exterior or interior); wood type (species group number); grade (quality); and mill numbers.

Masonite and particleboard are composed of wood chips pressed into boards under high pressure. For Masonite, chips are expanded into fibers by steam and pressed into sheets with heated hydraulic presses; particleboard consists of resin-impregnated wood chips. Masonite can be obtained in tempered and untempered 4' × 8' sheets, from ⅛" to 5⁄16" in thickness. Sheets of particleboard come in 4' × 8', 4' × 10', and 4' × 12' sheets, in thicknesses from ¼" to ⅛".

CARVING AND FABRICATION TECHNIQUES

Basically, sculpture is either carved from a single naturally grown or laminated piece of wood or assembled from previously carved sections and sometimes *found* pieces (parts formed for some other purpose, such as molding). Cutting is accomplished by machine and/or hand and the results are glued, nailed, bolted, screwed, or doweled to one another. Variations consist of adding other materials (plastics, metals, fiber, paper) and working with both sheet and beam construction using plywood, timbers, and planks. More specifically, variations may be listed as follows:

1. Carving from a single piece of wood.
2. Carving from assembled pieces which extend original wood dimensions; adding materials such as string, dowels, wires, etc.
3. Fabricating wood structures of either natural growth or laminated wood by cutting, shaping, and then forming pieces. Experimental lamination and band-saw cutting techniques can produce subtle and intricately shaped pieces which may appear to be molded rather than constructed (see Figure 13-9).
4. Assembling already shaped or "found" pieces in wood and other materials, such as plaster and metal, for "mixed media" work.
5. Fabrication of sheet wood or board for primarily large-scale hollow wood forms.

Figure 13-9
Molded appearance produced by lamination.

WOODCARVING EQUIPMENT AND TOOLS

Bench

2"–3" thick top with a trough at back to hold tools. Use two widths of 10" or wider timber, soft or hard wood. Bench should hold carpenter's vise and end vise, screwed on one end of bench (see Figure 13-10).

Gluing Clamps

Types: Corner clamp, C-clamps, spring clamp, pipe (bar) gluing clamp, gluing clamp (see Figure 13-11). Clamps hold stock while gluing—*C-clamps* for a few inches in thickness, *bar clamps* for wide distances, *glue clamps* for moderately wide distances. *Corner or miter clamps* hold square mitered corners for nailing or gluing; *spring clamps* for holding flat-sheet material.

Woodcarving Tools

A basic set of tools consists of special hardwood (hickory, beech, or lignum vitae) mallets; one or two flat chisels; two or three shallow curved chisels or gouges from ½" to 1" wide; files or rasps; and stone slips for sharpening and honing the tools.

Figure 13-10
Wood workbench.

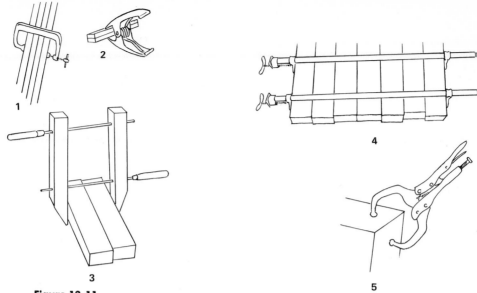

Figure 13-11
Clamps: (1) C-clamp; (2) spring clamp; (3) wood-gluing clamp; (4) bar clamp; (5) corner clamp.

If the work is large, blocking out can be done with an adze, an axelike tool with a curved, gougelike blade end, used historically by the Northwest Indians for large carvings. The gouges have wood handles and, unlike carpenter's chisels, are extremely sharp, with tapering blades. The half-rounded shape of the blade helps penetrate into the wood in any direction, preventing splintering of long pieces along the grain. The rolling form of the mallet also has a function in the forcefulness of its blows, its short handles allowing for maximum push down and through the wood. Chisels are used without the mallet for light finishing surface cuts. Rasps follow to level off edges and high points left by the gouges.

Types of Chisels (see Figure 13-12)

The number indicates depth of gouge, not width. Straight chisels and gouges are parallel. If the chisel is ¾″ (19 mm. or more), it becomes a fishtail, with sides widening toward the blade.

Flat chisels
{
#1—¾″ (19mm.) straight-edge chisel, sharpened on *both* sides (unlike a carpenter's chisel).
#2—¼″ (7mm.) similar to #1, beveled cutting edge.
}

Curved chisels
{
#3–#9—½″ to ⅝″ gouges which form an arc. #3 is shallow, almost flat; #9 a semicircle. #7 or #8 used for a hole or hollow, #5 or #4 for convex shape. The shallow curve of #3 and #4 (like a flat chisel) avoids digging into the surface of curved surfaces.
}

#10 and #11 are U-shaped gouges, #11 being deeper than #10. #10 are called *fluters*, #11 are *veiners*.

#39–#41 are V tools, called *parting* tools, designed for intricate relief techniques. But #21 to #32 start flat and get deeper as number increases.

Store chisels in rack, wood tray, or felt roll with pockets. Alternate position of blades and handles.

Mallet—Lignum vitae, beech, hickory.

Traditionally cylindrical. Same type goes back to ancient Egypt and medieval times. No specific striking face. Made from the branch of a round tree trunk. The heavier the wood mallet, the smaller the size it might be.

Figure 13-12
Chisels, flat, V shaped and curved, mallet, and sharpening stones.

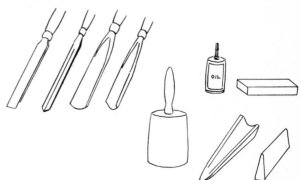

Figure 13-13
Wood files, rasps.

Slipstones—One 2″ × 8″–10″ × 6″ long.

Two kinds: *Artificial*—coarse, medium, and fine—one each, or combined in one stone (combination). *Natural*, consisting of hard Arkansas stone which cuts metal slowly to a fine edge; smaller and more expensive than artificial stone. Slips are shaped to fit inside of gouges. One half round with one concave surface or V-shaped. Stones need 3-in-1 oil, the stone oiled, brushed, and wiped clean with a solvent such as turpentine. Specialized shapes are made for sharpening particular tools, such as drill bits. Slips can be shaped with grinders and/or emery and wet/dry papers.

Leather Strap for Honing

Abrading Tools—files and rasps (see Figure 13-13)

1. *Rasp*—oval-toothed file with coarse to fine teeth. Tears the wood, so preferably for soft rather than hardwood.

2. *Files*—for smoothing after rasping (see Figure 13-14).

3. *Surform*—supersedes dreadnought and rasp (see Figure 13-15). Consists of a pierced curved or flat blade fit into an appropriate frame. The rat-tail version is a long, narrow cylinder. Working like a vegetable grater, it combines the action of file and plane, leaving flattened ridges rather than smooth wood. The speed and ease of use makes it possible to remove too much wood at one time.

4. *Riffler*—a small, shaped rasp consisting of a short, metal rod with abrasive ends, shaped to fit corners and hollows.

5. *Scraper*—a rectangle of tensile steel with burred edge. It is held with both hands at 60° to edge of wood and dragged over surface. When blunted, edge is resharpened by dragging it along hard steel.

6. *Abrasive papers*—garnet lasts longer than sandpaper and has slower cutting action for final phases than aluminum oxide. For wood finishing, open-coat abrasives in which only 30%–50% of the surface is

coated with abrasive grains is preferred to abrasives with closed coat (complete coverage), more appropriate for hard materials in a wet or dry process. Identification of coated abrasives is on back, labeling paper weight, cloth, type of bonding, and grain size, which runs from 16 to 600 (for garnet, aluminum oxide, and silicon carbide) and simply coarse, fine, medium, extra coarse, and extra fine for flint and emery. Starting grain size depends on material, but usually runs from rough (30–60), to medium (80–120), with fine (120–150) and extrafine (160–300) used for finishing.

Basic Carpentry Tools—Saw, drill, hammer, screwdrivers.

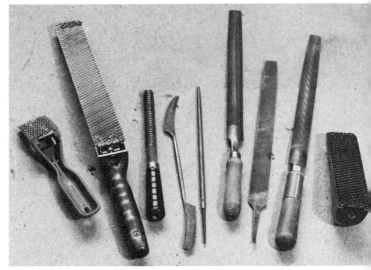

Figure 13-14
Wood rasps and files. Photo by author.

Figure 13-15
Shaping with surform rasp. Photo by author.

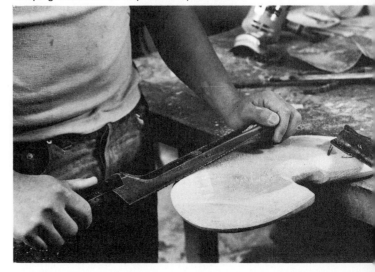

Power Tools

Power tools include lightweight power jigsaw, grinder, portable sander, narrow belt sander, right angle sander, and drum sanders. Disc and narrow belt sanders are used for sanding contours, while orbital and belt sanders are designed for flat surfaces and are less desirable for carving in the round. The right-angle version of the disc sander, either as air operated or mounted on an electric drill, is particularly useful. Disc sizes are 6", 7", and 9", either rigid or flexible mount with flexible rubber mount preferred. Rigid discs come with sandpaper already cemented. Electric sanders are rated in amps from 2.5 to 12 amps, with 5–8 the most useful for general studio work. Drum sanders are circular sanding belts mounted on rubber drums which attach to flexible shaft machines, electric or air-powered motors. Sanding "flap wheels," consisting of sandpaper inserted into drums with slotted discs, are useful for contours. When using power tools, wear a protective mask and when necessary, ear muffles and respirator (against dust and fumes) (see Figure 13-16).

Bench Grinder and Buffing Wheel—For tool sharpening and light grinding of tools, restoring nicked and damaged edges to the proper cutting edge and angle (for woodcarving the smaller model would serve). Powered by ⅓ to 1 h.p. with motor speeds of 1725 or 3450 rpm. Will accommodate a wheel on either side of motor from 6", 7", or 10", usually a coarse grinding wheel of 36 grit and a 60-grit wheel for fine grinding and sharpening. The spindle may be designed to accommodate a polishing buff, useful for smaller wood pieces. A buffing wheel mounted on a portable sander or drill is of greater use for large wood carvings.

Wood burner, *soldering iron*, *heated calrod* for wood burning pattern, signature.

Gouges and *rasps* may be driven by air or electricity on drills or flexible shafts for larger works.

Figure 13-16
Mask, muffles, respirator. Photo by author.

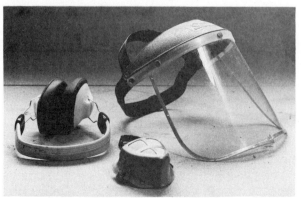

CARE OF TOOLS

Carving tool handles are either octagonal or round with brass ferrules already drilled to take the gouge. Handles should be long enough to hold firmly without danger of striking the hand with the mallet. A shorter, polished handle is suitable for small tools which operate with the index finger touching the top of the gouge, the butt held in the palm and pushed without need of a mallet. To insert handle, place gouge in vise tang uppermost (upside down). Place handle over tang and tap lightly with a mallet—twist, tap, twist—rather than knocking the handle directly on the gouge, as this will cause splitting (see Figure 13-17).

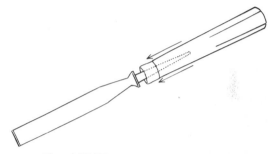

Figure 13-17
Inserting handle of chisel.

Sharpening of the gouges is required constantly to maintain an edge as sharp as a razor blade. The gouge must be sharpened initially, as it has been cast, not wrought (as are stone tools), making the tool roughly ground. To sharpen a gouge, hold it in the right hand and with the left hand pressing down on the steel part, gently push it along the stone surface with the angle of the bevel at 15° from horizontal. Grind blade evenly, using a rocking motion as the blade is pushed forward from bottom left to top right and reverse in a figure-eight motion. The object is to obtain a bevel on the back which is long and tapered, not short and steep like a carpenter's chisel. Press where the blade is heavy, lighter where thin, avoiding a wavy edge. The inside of the gouge is sharpened with slipstones of equal or next smaller radius, concave on one side, round on the other. Lubricating the blade with thin oil, hold the tool in the left hand against the bench while making a series of downward rubbing movements with the slipstone against the inside edge. Alternate between inside and outside of gouge, checking the edge by allowing light to strike it (over thick part, parts will show as a

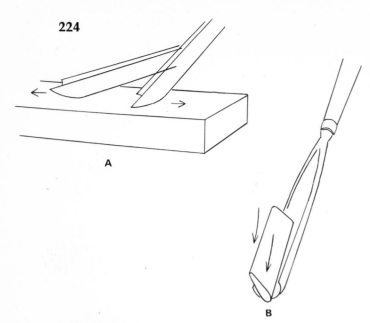

Figure 13-18
Sharpening gouge—(a) outside edge; (b) inside edge.

stone, followed by inserting and rocking the round edge of the slipstone back and forth flat against the inside curve. Test the sharpness of the chisel by pushing the nonbeveled side against the thumbnail, which, if sharp enough, should slightly nick the nail.

A chipped or broken edge must be ground down on a coarse oilstone or electric carborundum wheel. Constantly dip the tool in water to prevent overheating, which causes the steel to lose its temper and become soft and useless. Try the edges by cutting across the grain of soft pine wood, as softwood is more difficult to cut cleanly than hardwood, unless the blade is extremely sharp.

CARVING PROCEDURE
(see Figures 13-19–13-26)

1. Draw profiles of forms on a cylinder or block of wood, for beginners all sides of the block, for experienced carvers one view at a time, a procedure which tends to encourage overall blockiness of the work rather than the desired cylindrical forms. After pieces are cut away across one view of the block or cylinder, redraw image from another (90°) angle.

2. Remove major masses by cutting with large gouges. Holding the gouge at a 45° angle, strike it with a mallet, driving it in the direction of the wood grain, decreasing the angle as the gouge enters the wood. If directed against the grain, the gouge may get jammed between the fibers and split off a piece of wood or break a piece off its cutting edge. Leave a jammed gouge where it is and cut away the wood around it with another

silver line). Or, with chisel held firmly in right hand, slide the left thumb lightly along edge. Blade should nick the skin slightly as it moves along edge (see Figure 13-18).

Remove fine wire edge or burr developed by sharpening by honing on a leather strap attached to a block of wood and smeared with emery powder mixed with oil. The chisel is drawn toward you and rocked from left to right. For curved gouges, bend a piece of strap to fit the curve and draw toward you several times. Fine honing for flat chisels is also accomplished on a fine stone, rotating in a figure-eight pattern or oval pattern on both the beveled and nonbeveled side. For curved gouges, hone the inside of curved gouges by rocking the beveled edge on the concave side of a slip-

Figure 13-19
Drawing and cutting away silhouette
(one side at a time).

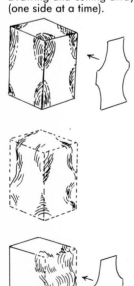

Figure 13-20
Removing major and minor masses
with large and small gouges.

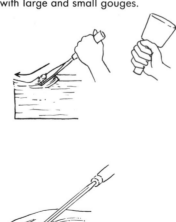

2

Figure 13-21
Flat chisel leveling surface.

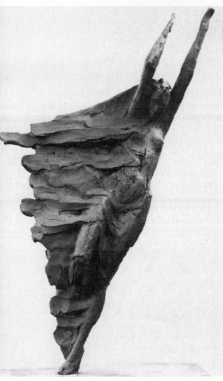

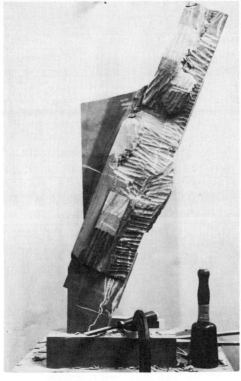

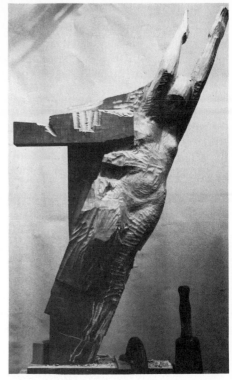

Figure 13-22
Paul Buckner, plastilene sketch for
wood sculpture. 1978.
H. 17¼ in., to be enlarged twice
the size.
Photo by Paul Buckner.

Figure 13-23
Roughing out sculpture after planing and gluing
cherry wood boards. Dowels whittled out of
parent material strengthen edge joints. Almost
all rough carving is done cross grain to main-
tain control. Photo by Paul Buckner.

Figure 13-24
Carving proceeding with additional pieces
added as needed. Photo by Paul Buckner.

Figure 13-25
Paul Buckner, *Arabesque.* 1975.
Walnut, H. 26 in.
Photo by Paul Buckner.

Figure 13-26
Paul Buckner, *Risen Christ.* 1978.
Cherry, H. 68 in.
St. Paul Catholic Church, Silverton, Oregon.
Photo by Paul Buckner.

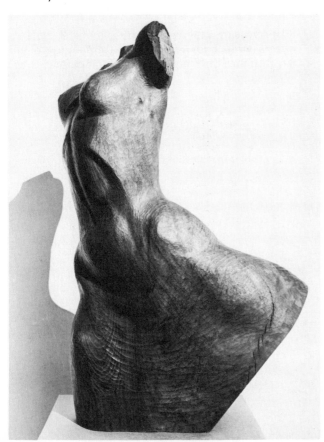

gouge until it can be removed without damage.

3. Aim to avoid squareness and develop roundness by developing planes at 45°. Start a hollow by gradually deepening form, waiting until the work is far along to penetrate wood completely and introduce extreme undercuts at the end, as positions change and material may be needed later.

4. Define *edges* and separations of the forms, with a *fluter* (narrow U-shaped tool) for details and relief forms. The angle at which the outline is cut will determine the quality of light hitting the edge of the form, with the slightest differences sufficient to affect the modeling.

5. Ridges made by deeper gouges are flattened by shallow gouges using either a lighter-weight mallet or pushing and tapping with the palm of the hand. Flat chisels further level the surface, which may either retain the tiny chiseled planes or facets or be abraded with rasps, rifflers, surform, or small pieces of glass. For speed, rotary rasps may be powered by electricity, or air, as attachments on portable drills and grinders or as a flexible shaft. Abrading tools, especially in the case of the softer woods, might be used for almost the entire carving process.

6. Reliefs must be of wood thick enough for carving, kiln dried, and free of warpage. Reinforce back with wooden bars set into grooves rather than glued or screwed into place to allow for expansion and contraction.

7. Surfaces left entirely rough will eventually attract dirt and be difficult to maintain. Tool marks and uneven surface can be retained, but should be preserved by burnishing for durability and brightness. Burnish with a section of glass or an agate to press down the fibers of the wood and polish the surface. Rough edges can be cleaned with #00 sandpaper or garnet paper wound around a cork and rubbed *with*, not against, the grain. To avoid scratches, blow dust rather than wipe off surface. Save sanding for the final finish, as grit from the sandpaper becomes embedded in the wood and dulls the metal tool. Other rubbing materials are #2/0 steel wool and #2/0 pumice powder.

8. Mend and patch splits due to temperature and humidity with wedges of similar wood, keeping the grain going in the same direction as the piece. Paint wedges with glue and tap into place. Wedge should stand above crack and the surplus wood worked off when the glue has set. Mix sawdust from sandpapering wood with glue or polyester resin for filler. Glues should be PVA white glues, which are superior to old scotch glues. Coat both surfaces of wedge and sculpture and clamp until set.

9. Three possible finishes are (1) preserving natural tone with oils and waxes, (2) staining, or (3) painting. Stain penetrates pores and should be water based, which gives a clearer finish than oil. For stain mix 1 oz. color powder to 1 quart boiled water. Powders are of raw umber, burnt umber, vermilion, zinc white, black, French ochre, and Vandyke brown. The process will raise the grain unless the wood is wet first. Improvised stain can be made from vinegar poured over nails and left for 8 hours. The resulting antique gray is suitable for pine and light woods.

Oil-based stains will not take on paste filler, which first needs a wash of shellac. Shellac only dry wood, as it is not waterproof and contact with moisture will produce a whitened, cloudy surface. Use orange shellac on dark woods, white on lighter woods. Other sealers are epoxy transparent resin or polyurethane clear varnish applied in thin coats. Glossiness of coating is cut by rubbing in carnuba wax. If paint is to be applied as a finish coat, first seal raw wood with paint sealer or shellac. Outdoor sculpture should be treated with clear wood preservative.

WOOD FABRICATION TOOLS (HAND AND POWER)

Hand Tools

Saws—Crosscut, keyhole, coping (see Figure 13-27)

1. Cut across the grain with a crosscut saw, 8 teeth or points per inch for a rough cut, 10½ or more points per inch for a finer cut, 5½ points per inch for cutting along grain.

Figure 13-27
Wood saws: (1) handsaw; (2) keyhole; (3) large handsaw; (4) coping saw.

Figure 13-28
Cutting inside hole with keyhole saw.

2. To cut, start with short repeated strokes, graduating into long, even strokes. Cut along outside of line, spreading the wood with a wedge if saw binds.

3. Inside holes are started by drilling, then cut with a keyhole saw (see Figure 13-28).

4. Coping saws are used for complex and delicate cuts. The saw is held with the teeth pointing down toward the handle, the material clamped to a table or held in a vise.

Clamps (see Figure 13-29)

1. Bar (pipe)—clamps distances of several feet.
2. C-clamp—clamps a few inches in thickness.
3. Corner (miter)—for holding square corners.
4. Spring—for flat sheets while gluing to frame.

Hammers

1. Claw—5–20 oz., for driving, setting, or pulling nails. The 20-oz. hammer is used for heavy construction,

Figure 13-29
Clamping wood with pipe clamps. Photo by author.

12–16 oz. for average work. Head should be of slightly concave, polished steel, and used only for wood.

2. Tack—for hammering small nails and brads.
3. Rubber mallet—for straightening, leveling, exerting pressure.

Screwdriver

1. Flat-tipped, large-handled—in several sizes.
2. Phillips—for round-headed screws.
3. Offset
4. Stubby } for places inaccessible to flat-tipped type.
5. Ratchet offset

(Electric and pneumatic available for speed.)

Hand Plane

1. Bench plane (8″–9″ long) for smoothing or beveling surfaces and edges.
2. Jointer—22″
3. Fore plane—18″ } for rough removal of wood.
4. Jack plane—14″ all-purpose and finishing.
5. Special-purpose planes for cutting tongue and grooves, rabbets, and other shapes.
6. Normal angle for most planes is 45°.
 Depth of cut is controlled by adjusting nut. Blade can be adjusted for tilting or moving with a lever. Depth also controlled by hardness of wood.
7. Wood is planed in direction of grain to avoid tearing. End grain is planed by moving at slight angle from main direction. Hone blade on oilstone. To sharpen, grind nicked blade on bench grinder before honing.

Chisels

1. ¼″ to 2″ wide with 3″ to 6″ blade lengths.
2. Flat chisel for paring dovetails and lap joints.
3. Special purpose chisels are the *mortise* (for making the mortise-and-tenon joint), the *firmer* chisel for all-purpose work, the *butt* (short blade), *offset* (close to surface work), and the *paring chisel* for finishing.
4. Cut with bevel down, hitting head of chisel with mallet, tapping with palm of hand, or pushing with a slight rocking motion.

Squares

T-bevel square used for other than 90° (set desired angle on protractor).

Gauges

Sliding, adjustable combination square. Marks off specific width along edge of board.

Levels

To check vertical and flat horizontal surfaces for accuracy. Air bubble is centered between two lines in glass indicator.

Rasps and Files (see Figures 13-30 and 13-31)

1. Replaces plane in difficult places. Surform and open mesh have removable blades, come in varieties of shapes and degrees of coarseness; in drum form for the electric drill. Self-cleaning with rapid cutting action.
2. File cut on a forward stroke, with pressure released on a back stroke.

 File cards, keep files clean. Metal and wood files should be separate.

Wood Bits

For fitting of a bit brace, hand drill, and electric drill.

1. Hand-drill bits are twist drills and countersinks.
2. For bit brace, use twist auger bits for large holes, twist drills, and countersinks.
3. Twist drill bits, plug cutters, countersinks, hole-cutting saws, and wood screw bits are used with electric drills (countersinks countersink holes to a predetermined depth; wood-screw bits drill both pilot hole and countersink).

Miter Box

1. Metal parts are better than wood. Attachments are designed for the hand planing of beveled edges.
2. For hand cutting at 45°, adjusts from 0° to 45°, right or left, and for depth of cut. Also squares ends of wood pieces.

Figure 13-30
Rotary power rasp on drill head. Photo by author.

Figure 13-31
Shaping with electric rotary rasp. Photo by author.

Nail Sets

1. Finishing nails may be concealed by driving below the wood surface, later filling the holes with wood putty.
2. Place point of nail set on nail left protruding $\frac{1}{16}''$ above surface, strike head of set with hammer to drive down nail. Nail sets come in $\frac{1}{32}''$ to $\frac{5}{32}''$ diameters.

Power Tools

Portable Power Tools

1. Drills, planes, routers, saws (saber, jig, circle). Operate all electric tools using goggles and 3-point plugs for grounding. Remove plug when changing cutters.
2. *Drills*—$\frac{1}{4}''$, $\frac{3}{8}''$, $\frac{1}{2}''$, $\frac{3}{4}''$ up to $1\frac{1}{4}''$ (industrial). Classified according to drill-bit sizes chuck will accommodate. $\frac{3}{8}''$ is most popular while $\frac{1}{2}''$ is for heavy work. Motor size is rated by amperage—amperage from 2.4 and 115 volts for $\frac{1}{4}''$ drill to 11 amps, 115 volts for $\frac{3}{4}''$ drill (see Figure 13-32).
3. Rpm are revolutions per minute. The larger the bit the lower the rpm, as $\frac{1}{4}'' = 750$ to 3,300 rpm while $\frac{3}{4}''$ has a speed range of 200–300 rpm. Variable-speed drills are also available.
4. Attachments for electric drills are sanders, countersinks, twist drills, bits, hole-cutting saws, wood-screw bits (for pilot hole and countersink combined).

Power Plane

Planal surface is adjustable for varied planing angles. Planes are 16″ to 24″ long and 2″ to 2½″ wide. Motor capacity is ¾ to 1 h.p., speed 18,000 to 23,000 rpm.

Portable Routers

1. Used for gouging and relief carving, routers are pushed over secured surfaces by both hands, the adjustable guide and shape of cutters determining configuration of cut (depth and width). Along with a variety of molding cuts there are grinding, power plane, trim saw, and other attachments. Blades must be kept sharp.

2. Size of router is based on horsepower or amperage as well as diameter of cutter shaft. Light work uses ¼ h.p., studio work ¾ to 1 h.p., heavy duty 1¼ h.p. Speeds range from 18,000 to 27,000 rpm.

Saber Saw

1. Operates like a jigsaw with reciprocal action.

2. Average blade 3″–4″ but larger saber saws have 12″ length blades. Cuts primarily 2″–4″ material, though 12″ blade may cut wood up to 10″ thick. Wood cutting blades average 6–10 teeth per inch, fewer teeth for rough cut. Cutting guides for mitering, ripping, and cross cutting can be mounted on saw. Saw can tilt at 45°. Variable speeds available and more useful. Amperage from 2.5 to 3 amp (5 amps on general saw).

3. Operate saw by downward pressure, maintained until saw has stopped. For inside cuts, drill a starting hole first.

Figure 13-32
Electric drilling using drill stand. Photo by author.

Circular Saw (portable)

1. Classified by blade size and motor. Blades from 6″ to 10″, amperage from 7 to 14 amps, the latter for heavy-duty work.

2. Blades for cutting metal and plastic available. Saw-blade sizes determine depth of cut, a 10″ saw making 4″ deep cuts. Angle of cut can be changed by tilting the surface. Saw is equipped with a rip gauge or guide.

3. In cutting, blade should extend ¼″ beyond wood material and pushed ahead while holding handle and front knob.

Stationary Power Tools

The band saw, table saw, radial arm, scroll saw, shaper, lathe, drill press, and planer are rated according to blade size, cutting capacity, and horsepower of motor. Over 1 h.p. speed, 220 volts, and single- or three-phase motor for maximum power and efficiency. Overload switch prevents overheating and burnout of motor.

Band Saw (see Figures 13-33–13-34)

1. Consists of a continuous steel blade mounted on two wheels. The revolving blade is particularly useful for cutting curves.

2. Blade *speed* is 3000 surface feet per minute. Adjustment for cutting blade, supporting back of blade during working pressure.

3. *Sizes* of blades are based on the size of the wheels, between 12″ to 40″. The cutting capacity ranges from 14″ for small shop (cuts wood up to 6″ thick) to 20″ for a studio saw size (cuts up to 13″ thick). Adjustment tension varies with blade size; guidelines must clear the blade and be adjusted so saw teeth project in front of guide pins. Blade support at the back holds blade in position, with working pressure applied at the front.

4. Widths of blades range from ⅛″ to ¾″, ½″ being an all-purpose size. Blades come as standard and skip tooth. An alternate set with 1 tooth right, 1 left is common for wood cutting, a blade with a raker set, a straight tooth between alternating left and right teeth is used for coarse cuts. Fine cutting and scroll blades are standard blades with wavy (alternating at graduating degrees) or alternate sets and 6 teeth to 1″.

5. To cut, raise upper guides to clear material and feed with moderate to light pressure. Excess pressure results in dull blades. Table saw adjusts for cutting angle. Complex cuts are made with several short cuts. Jigs are used for cutting special shapes.

Table Saw

1. Consists of a circular blade rotating through a slot on a level table. The table saw is classified by blade

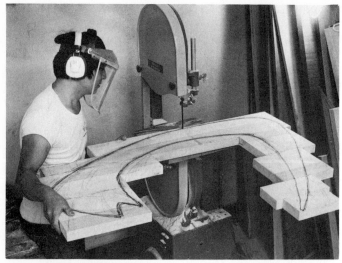

Figure 13-33
Cutting wood with band saw after horizontal lamination.
Photo by author.

size ranging from 8″ to 16″. A 10″ blade is the most useful, with a 2 to 3 h.p. motor and an operating speed of 3,450 rpm, with a 2″ to 3″ depth of cut. Heavier 14″ saws require 7½ h.p. motors, and will make over 2″ deep cuts.

2. Blades are cross cut, rip, and combination for ripping and crosscutting. Combination carbide-tipped saw blades will remain sharp longer and will cut plastic as well as wood.

Figure 13-34
Kanetake Ikada, *Sculpture*. 1979.
Laminated, shaped, and doweled pine.
Photo by Al Monner.

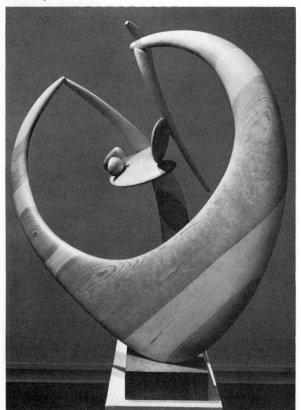

3. Molding heads attached can be used with special blades for cutting molding shapes. For lengthwise ripping and cutting, guide the wood by a rip fence to maintain proper width. Rip fences slide along front and rear guide, the front guide calibrated in inches for width of cut. As a precaution, ride hands on the fence to avoid getting close to blade. Use push sticks to guide strips narrower than 3″. For crosscutting and complex angle cuts, use miter gauge as a guide.

Radial Arm Saw

1. As opposed to the band and circular table saw, the radial arm saw moves and the material to be cut is stationary. The saw is mounted on a track above the work, making the cutting process more observable than circular saw cutting, particularly for crosscutting of boards.

2. For ripping with the grain, push the board through the saw from the back side of the blade, making it easier to control the rate of speed and safer for the hands, which could be pulled into the blade if fed from the front.

3. Overarm can be raised and tilted to adjust for crosscutting at 45°, 90°, and angles between.

4. Like table saws, radial saws are rated by blade sizes which are up to 20″, larger for industrial purposes, with motor speeds of 3,450 rpm. Average usage requires a 10″–12″ saw with a 1 h.p. motor for the 10″, a 3 h.p. for a 12″. Blades are basically similar to those for the table saws.

5. Attachments for drilling (drill-chuck), routing, molding, sanding, and shaping.

Scroll Saw (Jigsaw)

1. Operates like a band saw but with a reciprocating blade (blade moves up and down) rather than a continuous blade. Blades are inserted into both ends (jeweller's) or in the lower mount only (saber). Blades are mounted with teeth pointing downward, since cutting is on the downstroke. Capable of making shorter radius cuts and more intricate patterns than a band saw.

2. For inside cuts blades can first be inserted into a predrilled hole, and then attached to mount of machine.

3. Cutting capacity is maximum 2″ thick. Bevel cuts can be made by tilting the table. Valuable speed control gives ranges of 600 to 1700 cutting strokes per minute. Small motors of ¼ to ⅓ h.p. are standard.

Jointer

1. Rotary cutting heads turn at 4,000 rpm, planing edges of boards as they move across table surface.

2. Tables range from 4″ to 16″ in width, the midsize of 8″ (1 h.p. motor) used for wood shops.

3. Wood is pushed slowly over the cutting heads with grain of wood in direction of rotation of cutters. Left hand leads while right hand feeds, with both hands clear of table surface.

Planer

1. Planers, expensive for the individual, are available through commercial mill shops.
2. Two types: One type planes surfaces one side at a time; the other type planes both at once. Sizes range from accommodating wood 4″ thick to 8″ thick (large), the size of the motor starting at 2–3 h.p. and increasing.
3. Boards are cut with grain. The machine is set for depth of cut (1/16″ or less) and rate of speed.

Shaper

1. Three basic cutters with knives are mounted on a vertical spindle which is raised and lowered on a table.
2. Cutters produce special moldings by cutting grooves, rabbets, and joinings. Sanding drum attachments permit sanding of edges and insides of contours.
3. Spindle speed is 10,000 rpm, with a 3,450 rpm 1 to 2 h.p. motor. Wood is pushed past the cutters, aided by sliding jigs, miter gauges, and hold-down clamps.

Drill Press

1. Standard drill press is 14″ to 15″ (distance between drill chuck and back support is measured by the radius of a 14″ circle), single spindle, powered by a 1/2 or 3/4 h.p. motor, with speeds of 300 to 5,000 rpm. Variable speed allows for both metal and wood.
2. Drills, countersinks, circle cuts and cuts, plugs, and mortises. Also sands, routs, and shapes with solid cutter attachment. Clamping of the work is a safety precaution in case wood is pulled.

Lathe

1. Turns wood and spins metal with rounded shapes. Attachments for buffing, grinding, sanding, and drilling also may be used.
2. Average size is 11″ to 12″ (maximum diameter of material it can turn) with a 1/2 to 3/4 h.p. motor, with speeds between 300 to 3,600 rpm. Speeds for roughing out cylinder range from 600 to 1,000 rpm, for shaping between 1,200 and 1,600, and further to 2,400 for finishing.
3. To turn, place wood between spur center on headstock spindle and cup center on tailstock spindle. After firmly seating the spur center by striking with a wood mallet, place spur center and wood to be turned in the lathe, locking it in place.
4. Wood-turning tools are held against the spinning work

either horizontally for scraping, or slightly dropped for a cutting action. A long grip on the handle (grasping toward the rear) gives maximum leverage and control during the roughing out. The gouge is held with the concave surface pointing up, the curve resting on tool rest. For forms too large for fitting on the spindle, position an outside spindle on the lathe.

SHAPING AND JOINING WOOD

Shaping is primarily by machine (subtractive) and bending by steaming. To steam, wood is placed in metal tanks, covered but not sealed to avoid steam pressure buildup. Wood should rest on supports to avoid touching water. Steam one hour per inch of thickness.

After steaming, wood becomes pliable, ready to be clamped in place or in a jig to desired shape. For ease in bending wood, make relief cuts with radial arm to about 3/4 of wood thickness. Close cuts are required for sharp, even bends and uniform spacing. For lamination, clamp thin strips of wood bent to shape or held in place in a jig until glue has set.

Wood Joints

Exposed joints must be invisible, yet retain strength. Types of joints are:

1. *End-to-end* joints are simple, but to avoid separation of parts mitering with reinforcement can be used; splined (insertion of piece), mitered, dovetailed, box jointed.
2. *Edge-to-edge* joining of several boards to form wider boards are tongue and groove and splining (see Figure 13-35). Edge-to-edge corner joints may be mitered at 45° angle.
3. Methods of joining *end to surfaces other than ends* are half lap, dovetail lap, mortise tenon, and dado (see Figure 13-36).
4. *Surface-to-surface* end joints are the end-lap joint, treated as a mitered, splined, or a mortise and tenon (see Figures 13-37–13-44).

Fasteners for Joinings

1. *Dowels.* For doweling, drill holes into the two pieces to be joined. Insert glue-covered dowels into one side, driving in the dowels with a wooden mallet. Dowels should be driven below the surface and, when exposed, plugs inserted to hide them.
2. *Nails.* Finishing nails can be hammered to a fraction above surface and the driving below the surface completed with a nail set. Surface holes can be filled with

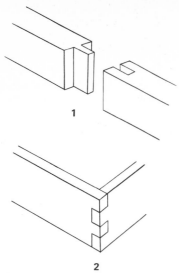

Figure 13-35
Wood joint types—(1) tongue and groove; (2) glue joint.

Figure 13-36
Wood joint types—(1) lap; (2) doweled.

Figure 13-37
Sawing circular pieces using band saw. Photo by author.

Figure 13-38
Gluing wood with white carpenter's glue. Photo by Diane Kornberg.

Figure 13-39
Clamping wood with C-clamp. Photo by Diane Kornberg.

Figure 13-40
Chiseling wood with wood gouge. Photo by author.

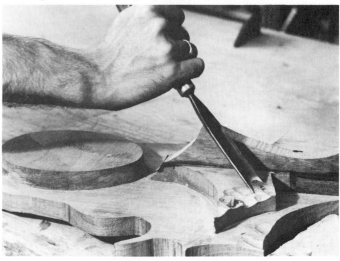

Figure 13-41
Assembling chiseled fabricated wood parts. Fitting, gluing, doweling. Photo by author.

Figure 13-42
William Moore, *Insect.* 1979. Kwila (guinea teak).
Photo by author.

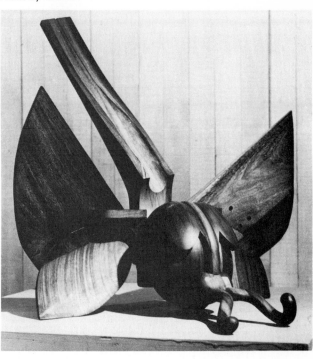

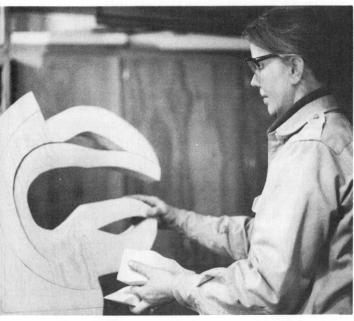

Figure 13-43
Joanne Peekema. Assembling fabricated wood sculpture.
Pine and oak, fabricated and carved wood.
Inserting sections cut with band saw. Sections are then glued in place. 1979.

Figure 13-44
Joanne Peekema, *Seed Clamp.* 1979.
Pine and oak, fabricated and carved wood. Stained finish.
H. 39 in., W. 24 in., D. 10 in.

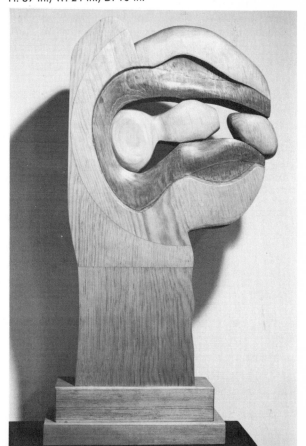

Figure 13-45
Joinings: (1) doweling; (2) toe nailing.

Figure 13-46
Types of nails.

commercial wood putty, epoxy paste, or a polyester resin thickened with Cab-O-Sil® (aerated silica) or wood flour. Joining ends to surfaces requires toe-nailing, angling nails toward each other. Drilling of a preliminary hole before nailing will prevent splitting of splintery wood (see Figure 13-45).

Types of nails are the common nail with a flat head; box nails with a flat head and thin shank; finishing nails with a small head and diamond point (called a brad when of small dimension); and casing nails, similar to finishing nails but with a larger head. For large work, ring-lock and grip-type nails assure more permanent joints. Specialized nails are designed for concrete, masonry, roofing, and decorative purposes, the latter with unusual heads (see Figure 13-46).

Nail sizes are in inch lengths from 1 to 6 (the larger), the diameters increasing with length.

3. *Screws.* Screws are often preferable to nailing as a more permanent fastening. A hole is made first with a drill and if countersunk, a countersink or count-

erbore is used, with fillers or wood plugs to cover the heads.

Screws are classified according to length and diameter from 0 to 24, the diameter increasing with the length. Head styles are oval, round, and flat, with standard or Phillips-type slots (see Figure 13-47).

4. *Bolts.* Holes the diameter of the bolt are drilled or countersunk, the bolt then inserted with a washer between the bolt and the wood to tighten. Types of bolts are lag bolts, with a flat head and a shank like a screw; machine bolts for wood and metal; and carriage bolts with a round head and a square neck for wood to wood (see Figure 13-48). The square neck anchors the bolt in the drilled hole while the nut is tightened on the bolt.

5. *Adhesives.* Adhesives range from white carpenter's glue for bonding well-fitting joints which need not be waterproof to contact cements for large surface-to-surface areas. Waterproof glues are epoxy and resorcinol formaldehyde which are available in powder form to control amount mixed at one time. Epoxy putties and pastes can be used as fillers for cracks.

Figure 13-47
(a) Fastening—counterboring screw holes; (b) Wood screw types: (1) flat; (2) round; (3) oval binding; (4) oval; (5) oval fillister.

Figure 13-48 Bolting wood:
(1) machine bolt (wood to wood, metal to wood), tightened with nut and washer
(2) carriage bolt (wood to wood)

14

Direct Viscous Materials: Plaster, Cement, Plastics, and Paper

HISTORY

Modeling through the direct application of plaster, cement, plastics, and paper-mache slurries on a framework is often a preferable alternative to casting these materials in a mold. The direct buildup method necessitates tensile strength and thin-walled construction, using materials which are not self-supporting (in their viscous form) but require strong reinforcement. Properly reinforced, the completed work is usually durable enough to be considered permanent. It may be the final version or serve as a pattern from which molds for future castings may be made. Building directly has definite advantages over pressing or pouring the material into molds made from an original in another material. It allows a freedom from the limitations of the moldmaking and casting process, enabling greater spontaneity and speed in execution and complexity of design and form. It is usually less expensive than casting if a single work is to be produced. (See Figure 14-1.)

Traditionally, direct application of lime mortars and whiting-glue mixtures have been long-employed methods of builders and architectural artisans known as plasterers. The general terms *stucco* and *stucco-duro* designate the varying mixtures of lime and sand often combined with fibrous binding material such as goat or cattle hair and hardeners of powdered marble or volcanic stone. The use of carbonate of lime (calcium carbonate) derived from powdering limestone is thought to have preceded the discovery of gypsum, a sulphate of lime (plaster of Paris).

For several centuries the ancient formula for stucco-duro was replaced by gray stucco until rediscovered by Giovanni da Undine (1487–1564). The formula he devised consisted of five pounds of powdered travertine with two pounds of slaked lime in water colored white with white lead mixed with flour of sifted lime. Three coats of stucco were usually applied, these of rough sand and broken marble, graduated to three more coats, primarily of marble dust. When dry, all coats were polished with marble dust and chalk, uniting the particles into a dense, solid mass. Strong, durable, and brilliant in whiteness, the surface did not become dirty or lose applied color when washed.

Ancient stucco-duro was described in a two-thousand-year-old treatise by Vitruvius as con-

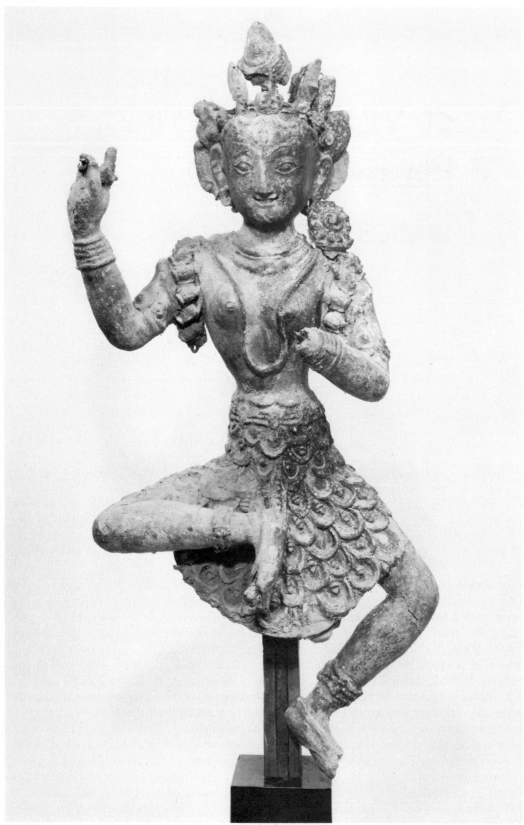

sisting of lime slaked, or cooked, in water for a long time, beaten with heavy sticks, and chopped up and mixed with sharp sand and white marble dust, the latter allowing it to receive a high polish. Pliny, the first century A.D. Roman author, mentions retarding the setting of plaster with fig juice, whites of eggs, and blood. Wax and pitch were also mentioned as blending into stucco and mortar.

Ancient stucco weathered better than marble, with a consistency so fine it rivaled gem engraving in delicacy; ancient jewelers were said to prefer it to wax for model making. Vitruvius describes its surfaces as so smooth it was used for mirrors. A description of excavations at the Aegean city of Knossos (1800 B.C.) by Dr. Evans of the Royal Academy, mentions a stucco-formed bull's head and human figure and remnants of a ceiling ornamented with repeat spirals modeled in relief and colored.[1] Even earlier (3500 B.C.), Mesopotamians preserved unbaked mud brick walls with stucco adorned with frescoes and decorative modeling. In Egypt the interiors of pyramids (Memphis is an example) were lined with stucco coatings to conceal seams in the stone wall in preparation for surface painting. The Greeks continued the custom, covering the mud bricks of their rough and porous building stones with a stucco which was then highly polished and ornamented with frescoes. The fact that the Greek writer Pausanias (A.D. 174) refers to stucco in his travelogue of Greece suggests that the material must have been in general use; traces still endure in Dorian monuments of Sicily at Paestum.

Romans obtained material from quarries at Ponte Leucano, first using brown colored volcanic tufa, then harder volcanic stone with the ancient names *Lapis Albanus* and *Lapis Gabinus*, later *Lapis Tiburtinus* (from Tiber, now Tivoli). Use of travertine by the Romans is evident in the remnants of Pompeii, where stucco formed a low-relief wall; also at Herculaneum.

Later, Byzantine Greeks imbedded mosaic in plaster-putty mixtures similar to stucco, incorporating the material in the enrichment of their churches, specifically in cornices and decorative window frames. Carolingians lacked the Greek skills at polishing and Greek building methods but utilized stucco engraving and ornamental relief in interior and exterior decoration.

During the five centuries of Moorish domination of Spain, stucco was a favored material for decorating elaborate mosques and palaces, such as the Alhambra. After centuries of obscurity in Europe, the art of stucco was revived in sixteenth- and seventeenth-century Elizabethan England. It was employed for decorating prosperous Tudor castles and homes of the upper and newly burgeoning middle class. Much of this internal decoration was of plaster or unseasoned lime—that is, lime which was not slaked or toughened like the lime prepared for the exterior stuccoing of the modest houses and cottages of the time. In the grand homes, ceilings were decorated lavishly with motifs of fruits, flowers, acorns, zodiac and heraldic signs, organized into swags, sprays, swigs, panels, and friezes. Ireland in the eighteenth century favored cherubs which were modeled free hand with the thumb. Ceiling ribs forming main patterns were cast in plaster of Paris or run in situ with reverse templates. Initially modeled by hand, motifs were later stamped like butter molds, and still later, cast in plaster of Paris. Molds and models were taken house to house by plasterers, who followed the mason, joiner, and smith. The procedure was to model the original in plaster or clay, make a mold from it, remove the model, and soap and varnish the mold. The semiliquid plaster was then cast into it and the mold immediately applied to the ceiling and held by scaffolding until set, where the mold was removed. Decorative stucco detail continued to be lavished on the interiors of wealthy homes until its decline in the twentieth century. Along with the knowledgeable artisans, such surface enrichment disappeared completely in the mid-twentieth-century contemporary interior. A reappreciation of this extinct craft has occurred, however, resulting in preservation and restoration rather than destruction of historic architectural relics.

Historically, several variations of stucco-duro have been developed by craftsmen and sculptors. *Tesso-duro* consisted of a combination of whiting (calcium carbonate), fish glue, rosin, and oil.[2] *Gesso duro*, described by Vasari as invented by the sixteenth-century sculptor, Jacopo della Quercia, was adapted for use by later sculptors; the nineteenth-century English sculptor G.F. Watts modeled his equestrian statue *Physical Energy* in gesso-duro. The process of building in gesso-duro began with a wood armature covered over with a mixture of hay, hemp-tow fiber and clay, cement, glue, and wood shearings. Drapery was formed by wetting real cloth, covering it with gesso-duro, and arranging it around the figure in folds. Since the material did not harden for some length of time, it could conveniently be added to and carved away when necessary.

Pure gesso, made of parchment size and whiting, or rosin, glue, linseed oil, and whiting, is generally modeled while hot onto wood surfaces to

form decoration in low relief, such as ornate museum-type picture frames. The hardened gesso may be cut carefully and sanded with fine emery paper. Gessoing was widely practiced as a finish treatment for wood, protecting the wood from deterioration and acting as the primer coat for the decorative painting and gilding which was often applied to wood sculpture.

ARMATURES FOR DIRECT APPLICATION (PLASTER AND CEMENT)

Armatures for these slurries must be built to accurate proportions and designed to withstand the weight of the material as well as the pressure of handling and transporting the work—at the same time, keeping the structure as light as possible. It should be keyed to retain the viscous material while it sets. Steel rods welded to a steel base are ideal initial supports, superior to the support systems of wood lath nailed to wood bases (used prior to the introduction of welding) (see Figure 14-2). Hardware cloth or screening is suitable for plaster; expanded metal lath is preferable for cement. These are cut and formed over the supporting rods and tied with wire. For bulk without weight, styrofoam or crushed newspaper can be adhered to the metal armature and covered with wire mesh for reinforcement (see Figures 14-3–14-6). Polystyrene or polyurethane foam blocks are versatile in that they can be shaped easily by sawing and rasping, but should be bulky enough to withstand the weight of cement or plaster.

The direct application of concrete, if adequately reinforced, increases the design possibilities and potential complexity of the medium over more limiting casting methods. One conspicuous example of the durability obtainable with this direct approach is the 100-foot-tall Watts Tower of Los Angeles—hand constructed of cement by Simon

Figure 14-2
Welding steel armature for giraffe. Sandra Haefker. Photo by author.

Figure 14-3
Armature of styrofoam over welded rod. Photo by author.

Figure 14-4
Hardware cloth armature with plaster applied. Photo by author.

Figure 14-5
Fitting expandable lath to armature. Photo by author.

Figure 14-6
Attaching expandable metal with pliers. Photo by author.

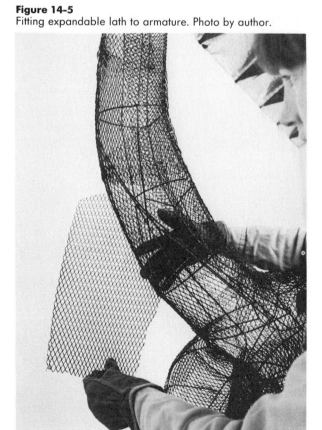

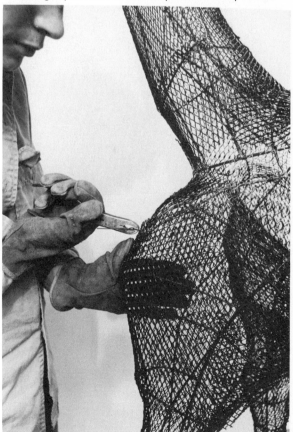

Rodia. The steel armature uses no bolts, rivets, or welded joints; its supporting strength is derived from reinforced concrete. In addition, heights, complex curves, and shell-like thinness are now also possible in direct cement techniques.

DIRECT PLASTER

The armature is shellacked and covered first with strips of wet burlap or cheesecloth soaked in plaster. Plaster is mixed to a smooth, thick, creamy consistency and applied in thin layers (see Figures 14-7 and 14-8). (For mixing directions see Rigid and Flexible Molds, chapter 7). Roughen each layer and keep moist for better adhesion of the added plaster. Glue size or vinegar retard the setting; hot water for mixing the plaster will accelerate it. As modeling proceeds, cut and carve with chisels, rasps, and rifflers to help define the form. When dry, refine the surface with files and sandpapers (see Figures 14-9 and 14-10).

DIRECT CEMENT
(see Figures 14-11–14-19)

The term concrete, like the term stucco, is generic; it refers to any hard insoluble mix of cement powder and aggregate. There are two basic types of hydraulic cements: *portland*, calcium aluminum silicate, and the darker, somewhat more expensive aluminous cements. High alumina cement, known as *ciment fondu*, is more expensive than portland cement, but may be preferred for its speed of cure and final compressive strength. Compared to the 10-hour setting time of portland cement, alumina cement sets in 3 hours, hardens in 7 hours (1–3 days for portland), and cures in 24 hours (7–21 days for portland). Although it will continue to develop strength under moisture, in 24 hours high alumina cement will achieve a compressive strength 10 times that of rapid hardening portland cement (5600 lbs. per square inch versus 500 lbs. for rapid hardening portland cement), 3 times greater after 3 days, and almost twice as great after

Figure 14-7
Plaster applied to figure armature.
Michael Chase. Photo by author.

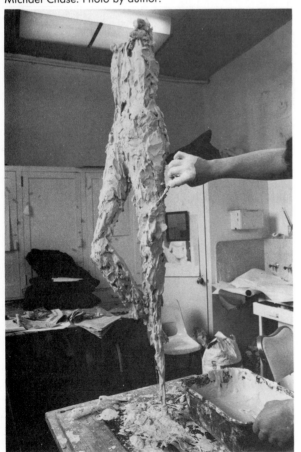

Figure 14-8
Completed direct plaster figure. Michael Chase.

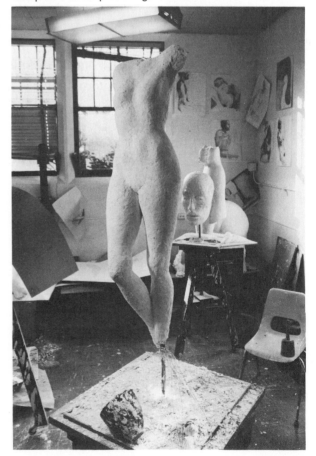

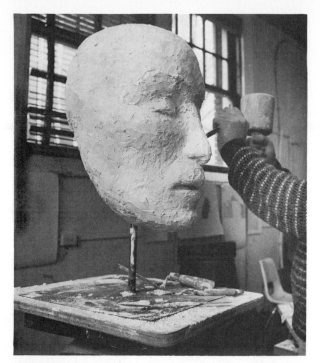

Figure 14-9
Chiseling plaster head. Michael Chase. Photo by author.

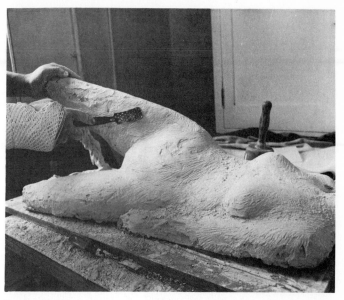

Figure 14-10
Rasping direct plaster torso. Michael Chase.

1 month of curing. Unless "ready mix" is used, concrete is mixed from sacks of cement powder and aggregate. If sand is the lone aggregate, the mixture is designated *mortar* rather than concrete, which requires a larger aggregate in addition to sand. Water is simply added to the cement-aggregate mixture, making a thick paste which solidifies into a hard, dense mass. Neither combinations of cement and water or cement, water, and sand alone have sufficient compressive strength to be structurally useful; their chief function is wall surfacing or binder between bricks. For surfacing large-scale forms such as swimming pools, a 4-part sand to 1-part cement mixture called *gunite* is sprayed as a slurry into wire mesh and reinforcing rod.

Hydrated lime, from 5% to 10% of the cement weight, can be added to increase plasticity and flexibility of the mixture. Recently developed acrylic latex polymers also improve the adhesive qualities of the material, allowing gradual buildup of forms by bonding fresh to hardened cement. The foundation coat for small works may consist of 3 parts cement to 1 part lime putty by volume. An alternate formula for foundation and buildup consists of, by volume:

1 part coarse (20 grade) sand

1 part fine (70 grade) sand

1 part cement

⅕ part or 20% hydrated lime

Concrete color (less than 10%) powdered earth colors, commercial cement colorants

A coarser mixture for foundation might consist of 1 part cement, 2 parts sand and 1 or 2 parts aggregate with particles ranging from ⅛" to ¼". Aggregates are fine gravel, marble dust, brick dust, marble chips or, for lightweight mixtures, vermiculite or perlite; the ratios of cement to aggregate in direct application are basically the same as those of cast concrete. Very large aggregate should be avoided for direct buildup, as their weight makes mixtures with them difficult to apply to slanted surfaces. Generally, coarser layers serve as the foundation, the layers getting finer as the work proceeds.

To make concrete, mix the dry ingredients together completely before adding water. Water is added to the mixture gradually by first forming a well in the center of the mix, then folding the powder into the water until it makes a thick slurry the consistency of oatmeal. A minimum amount of water should be used to reach this stage of plasticity. Excess water will not be incorporated but evaporates and weakens the mixture; the less water, the stiffer and stronger the mixture. At the other extreme, adding too little water will prevent proper hydration and weaken the cement. An approximate ratio is 100 pounds portland cement to a minimum of 25 pounds, a maximum of 50 pounds of water.

Shrinkage and cracking will be minimized with the addition of an acrylic latex polymer such as Acryl-60®, produced by Standard Drywall Products. The polymer emulsion is already suspended in water and can be substituted for water in any mixture. Used full strength it is especially effec-

241

tive as a bonding agent for slurries near the surface and the binding of new to old material, thereby allowing for gradual buildup of the forms. Latex should not be used with air-entrained cement. Latex stiffening will occur in hot weather, avoidable by cooling in the refrigerator or floating ice in it: an adhesive substance, it will cling to mixing buckets, tools, and clothing, making cleanup difficult.

Fiber cement mixtures give the added advantage of reinforcement and texturally interesting surfaces. Preparation is similar: bundles of steel or bronze wool, grades 00–000, are pulled apart and wetted with a thin mixture of cement and water. This is followed with enough cement to form a thick mulch which can be kneaded like modeling clay. Matted fibers must be constantly separated during the kneading process. Bronze wool

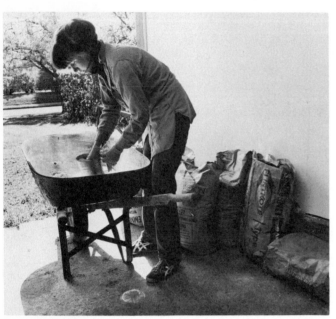

Figure 14-11
Mixing cement for giraffe. Sandra Haefker.

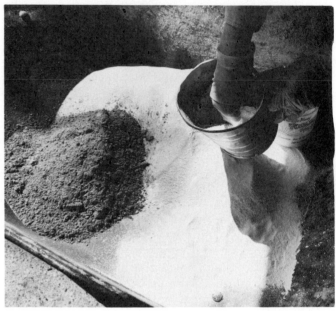

Figure 14-12
Mixing cement—adding lime to cement. Photo by author.

Figure 14-13
Mixing cement—adding latex. Photo by author.

Figure 14-14
Mixing cement with water. Photo by author.

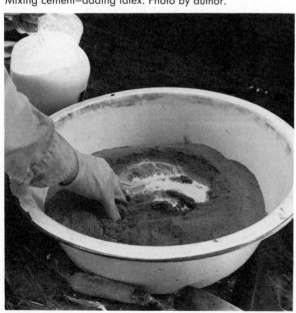

Figure 14-15
Applying cement to expandable metal lath—first stages. Photo by author.

Figure 14-16
Applying cement to armature with a trowel. Photo by author.

Figure 14-17
Applying cement to armature—advanced stage. Photo by author.

Figure 14-18
Example of the penetration of cement through expandable lath. Photo by author.

Figure 14-19
Wetting down cement over armature with wet cloths. Photo by author.

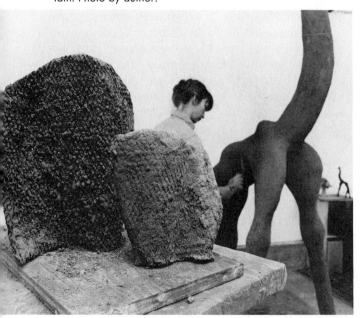

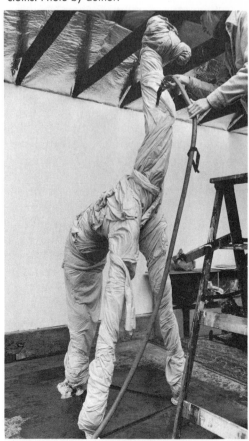

243

with white cement is a nice variation, producing a delicate blue tinge on the surface as a reaction to the alkalinity of the cement.

Concrete mixtures are applied with a spatula or trowel and scored or left rough to hold additional layers. Fiber cements can be applied in small bits like pellets of clay to develop a textured surface. Maximum thickness per application is ½", each layer then left to harden 8 to 10 hours before adding the next layers or rasping the surface. Except for large work a total thickness of 1" is sufficient. A hydrocal material, cement cures to full strength only as it absorbs water, the curing taking from 3 to 4 weeks. If more rapid curing is necessary a high early-strength variety is desirable to use. The sculpture should never be allowed to dry out during the working process. Wrap with wet cloths and cover with plastics between sessions and for 2 weeks after completion. In a hot, dry climate it may be necessary to saturate the work with water while working.

Abrasives for cement include bendable tungsten carbide rod saws, rat-tail files, riffler and surform files, and electric grinding attachments. Hard cement may require the use of stone chisels, but cements with fiber or aggregates such as perlite or zonalite are usually soft enough to cut with knives. File or chisel marks are removed with light grinding and abrasive, wet/dry papers, starting with 220 paper for the roughest marks and continuing with 320 paper and/or burnishing with the flat side of a knife blade to develop a gloss. As the work hardens, surfaces to remain rough may be wire brushed to expose aggregates. If contrasting colored cements have been applied in surface layers, rasping through one color will reveal the contrasting color beneath. Surface patterns can be formed by filling grooves with contrasting colored cements, letting them harden for a day or two and filing away the ridges. On large works it may be expedient to sandblast the surface using gentle abrasion.

Surfaces should be saturated for 2 to 4 weeks, at which time they can be wet rubbed with 400 paper to a final finish. After a minimum drying time of 2 weeks, concrete may be waxed or sealed with commercial cement sealers. If cement is to be left out-of-doors it can be sealed with commercial floor sealer or 3 coats of boiled linseed oil mixed with turpentine in a 3-to-1 proportion (by volume). Waterproofing, to a degree, can be accomplished by saturating the pores of the cement with solutions of copper and iron sulfate and other metallic colors, which, when oxidized, give a metallic look to the surface.

Because it is highly alkaline, care should be exercised in mixing cement powder. Avoid irritation of eyes, nose, throat, and bronchial passages by proper ventilation (mixing is best done out-of-doors), and wearing of a face shield and rubber gloves. As with plaster, cement should never be washed down the drain.

Magnesium oxychloride cements are made from calcining magnesite or magnesium carbonate. The resulting calcined magnesium is then combined with dry additives such as sand, sawdust, fibers, and marble chips, 60% to 85% by weight.

Magnesium oxychloride cements are less weather resistant as well as structurally weaker than cements of calcium aluminum silicate (portland) or high alumina content. Their usefulness in the building industry lay in the bonding abilities of the material with wood; the material was used primarily for making composition floors before the advent of plastics. Sculpturally, it has been employed for casting, direct building, and as the bedding material for mosaics. Though it is not completely waterproof, magnesite cements show resistance to the deteriorating effects of water if given waterproofing treatment.

Mixing is accomplished by moistening the dry material with a magnesium chloride solution in the proportions of 1 quart of gauging or wetting solution to each 5 lbs. of dry mix. Mix for 10 minutes to a stiff consistency for troweling, somewhat thinner for casting. Testing magnesium chloride solutions with a hydrometer is necessary for a reading of 22° to 30° Baumé, depending on the consistency desired. A hydrometer is an instrument used to determine the density of liquids and consists of a glass tube, weighted at the bottom, which is placed in the fluid to be measured and allowed to sink. The level to which it sinks is compared with a scale at the side. The suspension is usually best at 24° and can be adjusted by adding water if the solution is more than 24°, or more magnesium chloride if reading is below 24°. The dry magnesium chloride salts are first thoroughly dissolved in a water-magnesium sulphate (10% by weight) solution and left to stand 12 hours before it is added to the dry magnesite.

A variation of the oxychloride cement, but with a similar character, oxysulphate cement is obtained by mixing the calcined magnesite with a solution of magnesium sulphate (Epsom salts) instead of the chloride solution. Both the magnesium oxychloride and oxysulphate cements result in a hard mass which increases in compressive strength with time.

DIRECT PLASTICS

Of the multiple types of plastics in use by industry at this time (with hundreds of trade names), only a few can be adapted to studio use. The majority of industrial plastics need factory conditions for their manufacture, as they require high temperatures and pressure, generally limiting the mold size and shape.

Polyester polymer resins (unsaturated) have proven superior to other types of reinforced plastics in industrial production and usage by sculptors. It is a versatile material allowing for many molding and casting techniques and equally applicable to small (electronic) objects and large objects, such as boats. Other advantages are: (1) ease of application; (2) rapid curing without toxicity of fumes (with proper ventilation); (3) application without use of pressure molds; (4) dimensional stability (little shrinkage); and (5) responsiveness to varied surface treatments through additives and fillers.

Polyester resins are polymerized by dissolving in the monomer *styrene*, incorporated into the liquid resin by the manufacturer. In addition to the styrene, an inhibiter has been added which retards spontaneous polymerization, prolonging shelf life and gel or working time. Also present is the activator cobalt, which acts upon the catalyst to cross-link the polyester without pressure or heat. *Catalysts* consist of organic peroxides which are added to cross-link molecules in the polyester chain and are then incorporated into the copolymer. Since a great range of polyester resins are available which are designed for specific purposes, it is well to get information from the manufacturer about the working characteristics as well as the weather resistance and durability of the cured material.

Epoxy resins are superior to polyesters in respect to strength, shrinkage resistance, water, weather, and chemical resistance, and an unlimited shelf life.

They are less clear than polyesters in their transparent form, more toxic in the fumes produced, and are more expensive. A great variety of epoxies are produced as a result of the cross-linking possibilities of the curing agents which are used, which include amines and acids. Epoxies may be combined with fiberglass to produce extremely strong laminates, or with paste-type or liquid hardeners for strong adhesives and bonding.

Fiberglass reinforcement, literally fibrous or extruded glass filament, contributes invaluable structural strength when imbedded into polyester

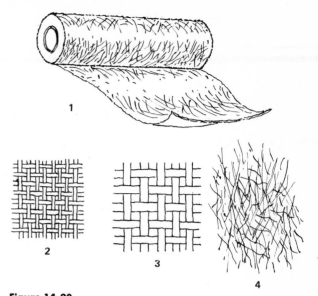

Figure 14-20
Forms of fiberglass reinforcement; (1) fiberglass mat;
(2) woven mat; (3) tapes; (4) chopped strands.

or epoxy resin (see Figure 14-20). With this reinforcement, plastics acquire more tensile strength and can be applied in thinner layers than plaster or cement, resulting in lighter-weight pieces. Employed where optical clarity is not an important factor, as in solid acrylics, fiberglass is incorporated into the resin as woven mat, tapes, or chopped strands which come in the form of mats, or as bundles of loose fibers (the latter acts as filler). The strongest reinforcement for plastic, and the most costly of the fibrous glass, are the woven fabric and tapes, which are manufactured in a variety of weights and thicknesses in both fine and coarse weaves. A primer known as a finish is applied which helps bond the resin to the fiberglass fabric. Conventional fabrics such as burlap must be backed with fiberglass for strength if they are incorporated into the resin.

Fillers are mixed with resins to give textures, color, strength, and bulk, which lowers the cost of production. Filler materials include talc, cement, dry pigment, glass fibers, silica flour (flint) dyes, stone chips, stone powder, wood flour, soybean meal, wood bark, clay, chalk, cork, perlite, and metal filings. Metallic powders of 150- to 300-mesh aluminum, brass, steel, or copper produce a strong, metalliclike material sold as liquid metal. These compounded resins are useful for patching auto bodies, etc.; types such as *liquid bronze* are sold as a synthetic bronze for sculptors. Latexes and polyvinyl latexes harden more rapidly than polyester and epoxy resins and are sold as sealing and self-hardening modeling compounds.

The proportion of filler to resin depends on the particular filler resin, and the desired qualities of the finished work. Strength will decrease proportionately as the resin is oversaturated. Fillers are generally not used with fiberglass laminates as they are superfluous and might impede saturation of the fiberglass.

Fillers help control shrinkage in resins cast into molds, and many, such as Cab-O-Sil® increase their thixotropocity, the resistance to the gravitational pull of a liquid on a vertical surface. Carbon black and china clay act as retarders, while calcium carbonate accelerates setting in thin coats of resin. Fillers generally tend to retard the setting of the catalyzed resin in thin applications, and accelerate setting in thicker applications of the resin. Pigments can be used in conjunction with fillers to impart colors and minimize the harmful effects of ultraviolet rays in work stationed out-of-doors. Commercial additives also are available which filter the ultraviolet light but impart no color or affect the clarity of the resin.

Armatures for plastic may be any lightweight dry material such as cardboard, glued and pinned together; crumpled newspaper held together with tape and string; dried paper-mache; chicken wire and/or wood; and muslin stretched over a wood frame (see Figure 14-21). Armature materials for plastics must be completely dry, as water inhibits

polymerization of catalyzed polyester resin. Polystyrene and polyurethane foam, clay (dried first) and water-soluble materials (such as a dried flour and water mix) are effective as armatures, disposable after the first thin layer of fiberglass and resin are applied and the surface becomes strong enough to be self-supporting. When polyesters are applied over polystyrene foam armatures, the foam should be sealed with a coating of epoxy, latex paint, white glue, or tissue paper. Armatures built to approximate dimensions of foam, wood, or cardboard may be modeled more precisely with plaster, spackling compound, and wood fillers. Lightweight fillers such as perlite or glass nodules can be mixed with resin and Cab-O-Sil® for building to ¼" less than the completed form, followed by applications of clear resin.

Basic Equipment and Supplies

1. Polyester resin
2. MEK peroxide (hardener)
3. Styrene monomer
4. Acetone
5. Fiberglass mat
6. Fiberglass cloth
7. Pure bristle brushes and scissors
8. Roller and squeegee
9. Sandpaper
10. Tin cans and stirring sticks

Auxiliary Equipment and Supplies

1. Additives (sanding aids and thixogel)
2. Melamine-coated fiberglass mat
3. Chopped fiberglass strands
4. Fiberglass tape
5. Metallic powder—bronze, aluminum, copper
6. Coloring agents
7. Fillers: sawdust, calcium silicate
8. Nylon yarn
9. Heat lamp
10. Measuring beaker
11. Metal shears
12. Spatulas, modeling tools, wood rasp
13. Mold release

MIXING AND APPLICATION

Methods of application to the armature vary, depending on the specific characteristics of the material and surface desired. Modeling—paste-type

Figure 14-21
Armatures for plastic: (1) drape over wood frame; (2) wood or cardboard armature (wire extension); (3) cloth over cardboard construction; (4) newspaper, chicken wire.

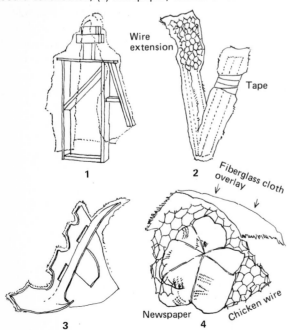

plastics formed of catalyzed resin and powders can be applied with a spatula or trowel. Fillers for polyesters are added and considered part of the total volume before calculating catalyst amounts. The filler is added until a pastelike consistency is reached, the specific amount depending on the particle size of the filler and the viscosity of the resin. Dense, nonabsorbing particles in a plastic of low viscosity will accept the largest amount of filler.

Methods of applying fluid plastics are brushing, flowing, spraying, and rolling. These may be combined with the working of the modeling paste and use of resin-saturated fiberglass laminates. Direct plastic does not adapt itself to the highly machined, finished forms possible in casting but is rougher in surface effect. For refined surfaces it is more expedient to make a cast into a mold made off a clay or plaster original.

Mixing Procedures

1. Have ready clean cans and paper cups, mixing sticks, paper towels, and newspapers, resin, catalyst (MEK) solvents, and cleaners.

2. Catalyze only as much resin as can be saturated at the time. A mix of 3 oz. of resin may take as much as 30 minutes to apply. At 70°F, most polyesters call for 18 drops MEK peroxide catalyst to the ounce or 20–30 drops (3 good squirts) to 3 oz. Add catalyst to resin after filler has been mixed.

3. Fiberglass cloth requires 2 oz. of resin to saturate one square foot of 7½ oz. weight fiberglass.

4. Brush thoroughly mixed and catalyzed resin and work it into fiberglass cloth. Fiberglass can be dipped by pieces into resin or brushed while laying flat on a nonabsorbent surface before applying to armature.

5. A reinforcing mat, also of fiberglass, is placed over the saturated cloth and the resin worked into the mat by pressing and pouncing the brush (watch to see mat fibers do not push up and bunch if brushed). Fiberglass cloth is laid over the mat and again saturated with resin. Air bubbles can be worked out with a brush roller or squeegee. Alternate layers of mat-cloth-mat are built up before application to an armature (see Figure 14-22).

6. Fiberglass cloth can be suspended and pulled into free drape effects and held in place with strings or clothespins. Balloons can be covered and used as a disposable armature (see Figure 14-23).

7. Texturing materials such as sawdust and sand can be applied to dry and freshly coated surfaces before resin sets. After setting and particles are secured to the surface, resin should be applied as a protective sealer. Textures are obtained from saturating cloth fabrics of cotton, burlap, and linen. The cloth ma-

Figure 14-22
Layering fiberglass over mat.

terial becomes brittle when the resin sets and must be reinforced with fiberglass laminates.

8. Additional laminations are possible over either gelled or hard and cured fiberglass. Sanding the protruding fibers of glass is sometimes necessary to permit complete contact between old and new surfaces. Slippery fiberglass can be held to surfaces by tying with string or wires looped through holes in the material (see Figure 14-24). Thickness of fiberglass laminates depends on area to be spanned, the weight and engineering of the forms. A general rule to follow is using 3 layers of glass in every part of the sculpture, the total ranging from ¹⁄₁₆″ to ½″.

9. Cutting of fiberglass is best done after resin gels, when dry to touch but rubbery. Thin sections can be cut with a knife; thicker sections require a hacksaw blade.

Figure 14-23
Suspending and shaping fiberglass using strings, balloons.

Figure 14-24
Tying fiberglass with string.

10. Since catalyzed resin takes 30 to 40 minutes to set up, planning should take into account the amount of resin which can be utilized in that time. For that reason it's a good idea to have more than one resin sculpture going on at one time. Due to generated exotherm, thick coats set up faster than thin coats and need less catalyst. Too little catalyst and resin will not gel; too much increases generated heat (exotherm), causing cracking and warping. Fillers will cut down on generated heat and reduce shrinkage.

11. An alternative method of application is the spray application of resin and chopped fiberglass. An all-materials or industrial type of spray gun can be used to alternate layers of resin and fiber.

Urethane foam can also be sprayed or poured directly into molds or built up without molds (see Cold Casting, chapter 9). A two-component system, the liquids are mixed in equal proportions, causing foaming and increase in volume. When hardened, the foamed polyurethane is a rigid, high density material, unlike open, cellular styrofoams. The material can be left rough or finished by drilling, sanding, and machining with woodworking tools and the surface painted, if desired.

PAPER-MACHE
(see Figure 14-25)

Paper-mache slurries are made by first soaking or boiling paper in water to make a glutinous mass to which glue and a small amount of preservative are added. Another method consists of dipping strips or sheets of paper into a water-glue mixture. When modeling over a positive form the adhesive is omitted from the layer in direct contact with the positive, which should be treated first with a shellac sealer, followed by a separator of oil or wax. A pulp mixture can be made capable of producing fine detail which can be modeled like clay. The pulp is prepared by blending bits of paper and water, drying the mixture completely, after which it is ground to a powder and mixed with glue into a paste. Additives are sawdust, whiting, plaster of Paris, borax, pumice powder, and egg white. These contribute qualities of strength, waterproofing, and reduction of combustibility. When dry, paper-mache can be painted with acrylic or oil paint, after which a protective layer of shellac, lacquer, varnish, or oil can be applied.

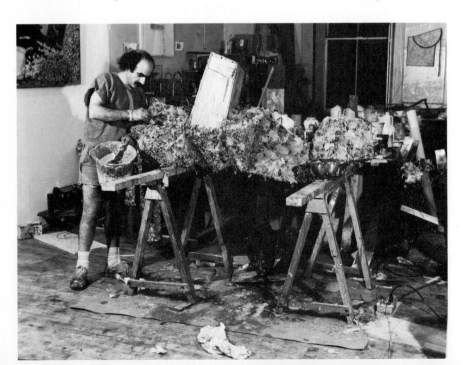

Figure 14-25
Zigi Ben Haim, *In Silent Sound.* 1982.
Mixed media—direct paper, wire mesh, rope, pigment, on concrete and steel. H. 60 in., L. 23 in., D. 40 in.

PLASTER MIXING FORMULAS

(See chapter 7, Rigid and Flexible Molds,
for plaster mixing process.)

Methods of Accelerating Plaster Mix

1. Heat the mixing water.
2. Add 1 teaspoon of sodium chloride to each quart of mix water.
3. Add 1 teaspoon of potassium alum to each quart of mix water.
4. Add 1 part of a saturated solution of potassium sulphate and water to each 10 parts of mix water.
5. Add 10% lime.

Methods of Retarding Plaster

1. Add 1 part saturated solution of borax and water to each 10 parts of mix water.
2. Add carpenter's glue to the mix water.
3. Add ½ teaspoon of calcined lime to each quart of mix water.
4. Add citric acid, alcohol, or sugar to the mix water.

Plaster—Surface Hardening

1. Brush with lime water.
2. Brush with a hot saturated solution of potassium alum and water.
3. Immerse in boiling 2% solution of borax or in a saturated solution of sodium bicarbonate.

Plaster Hardening

1. Add magnesium fluosilicate to the mix water, from 4% – 5%.
2. Add 1 part white dextrine or gum arabic to 100 parts plaster.
3. Add 5% white portland cement to the plaster.

Plaster—Sealing for Outdoor Use

Mix the plaster with lime water. When dry, coat with hot boiled linseed oil at least three times. Paint with linseed oil varnish and cover with white oil paint. Every part of the plaster must be sealed, including the bottom.

Plaster—Sealing with Wax

Dry and warm the plaster. Coat with a solution of stearin and turpentine.

15

Assemblage and Installation: Combined Media—Background and Recent Developments

NEW HYBRID FORMS OF THE 1960'S

The decline of the Minimalist and Conceptualist school of the mid-1960s marked a time when sculpture, reduced during this formalist period to the purely geometric and anonymous, returned to a vigorous use of personal symbolism and imagery. The immediacy and importance of the gesture and the specific nature of the materials and process assumed a vital role once again, renewing an interest in Dada and Surrealism and the assemblage form to which these movements gave birth. From this form, devised to project particularly personal and poetic associations, emerged the uniquely experimental expressions of the 1970s and 1980s.

The terms identifying these new forms were coined during the period of origin—the late 1960s—and refer less to style than to process. They represent a hybrid of sculpture with the art of theater, dance, landscape architecture, architectural design, crafts, industry, and technology. *Happenings* or *performance art* were the terms applied to the integration of the visual and performing arts; the integration of landscape and the visual was labeled *site specific, earthworks,* or *environmental art.* The term *installation* was devised to designate either interior or outdoor assemblages of materials, techniques, and processes, with elements of both performance and environmental art.

HISTORY

The roots of the assemblage form grew out of the development of the Cubist collages of Picasso, Braque, and Juan Gris by the Cubist, Dada, and Surrealist artists of the early twentieth century. Foremost among them were Henri Laurens, Kurt Schwitters, Hannah Hoch, Marcel Duchamp, Jean Arp, Joan Miró, and Man Ray (see Figure 15-1). The term *assemblage* actually originated with the French artist Jean Dubuffet for a series of two-dimensional collages, first of butterfly wings, later of mixtures of leaves, wood, and natural materials.[1] It was his wish to preserve the term collage strictly for the early Cubist works.

The assemblage form using three-dimensional material rather than newspapers, photos, and prints

started with the early Picasso in works such as *Still Life*, of painted wood and upholstery fringe (1914), and *Guitar* (1912), of paper and string, and the Futurist Boccioni in *Fusion of Head and Window* (1911), of plaster and wood. Motivated by the antirational and ironic, these artists sensed the need for a form that transcended traditional bounds of painting and sculpture and reflected the new age of fragmentation, technology, destruction, and transience. The term *collage* and the broader designation *assemblage* have come to mean more than a process of putting together disparate objects in either the visual, performing, or literary arts, but a new way of thinking which allowed that all objects and selected aspects of the environment could become the raw material of art. With selection and reordering, new meanings can emerge which may be more reflective of our time than traditional or single materials.

The idea of creating a medium which dealt with the process of relating disparate materials or ideas also invaded the literary and musical arts, as in the poetry of Apollinaire, the music of Erik Satie, the plays of Jean Cocteau, and the poetry of Stéphane Mallarmé. In 1897, Mallarmé cut a sentence into fragments and placed them as topical headings through the poem, while Apollinaire used as poetic material any words or word combinations in his ideograms, or calligrams, with snatches of conversation, routine phrases, and clichés following one after another without transition or thematic connection. The aesthetics of juxtaposition, that is, interruption or disassociation (without resolution of disparate elements) were adapted by André Gide in the novel *The Counterfeiters*, and by the poets Eliot, Joyce, Pound, the playwright Ionesco, and the composers Webern, Satie, Varèse, and John Cage.

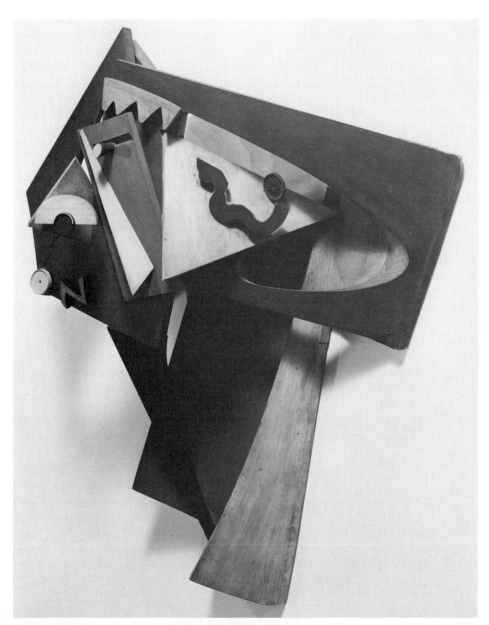

Figure 15-1
Henri Laurens, *Head*. 1918. Wood construction, painted. 20 × 18¼ in. Collection Museum of Modern Art, New York. Van Gogh Purchase Fund.

THE "CLASSIC" ASSEMBLAGE

Two prominent practitioners of the assemblage form in the visual arts have been Joseph Cornell and Louise Nevelson. Cornell's unique small-scale box constructions contain wide-ranging bits from sea life to mirrors, instrument parts, glasses, printed illustrations and cards, jars, small machine parts, balls, rods, and rings. They are poetic, magical miniworlds reminiscent of silent films or special, esoteric collections, succinct and mysterious in their visual associations and allegory. Cornell's boxes, executed from the early 1940s through the 1960s, generally correspond in time to the works of Louise Nevelson. Actively showing since the 1950s, Louise Nevelson produced primarily geometric, medium- to large-scale grid reliefs in wood of all types—balusters, moldings, wood planks of all sizes and types—all assembled in a classic modular system as formal and complete as an altarpiece, to which, in fact, she alludes with titles such as *Dawn's Chapel*. The feeling in these works is less spiritual than romantic and magical, and, like Cornell's work, has had an enduring appeal.

DEVELOPMENT OF THE SERIAL PIECE

From the large-scale assemblage it was a short step to an environmental use of found materials in often sequential or serial pieces, developed in the early 1970s. The installations set up by Carl André were minimalist in concept and consisted of laying out mathematically determined repeat patterns of machine-made, generally modular materials, such as bricks or sheet metal. Multicomponent fabricated pieces were produced by Robert Smithson in such works as the stainless steel piece of seven identical sections called *Alogon*, executed in 1966; also by Linda Benglis in *Pinto*, in which five separate polyurethane foam units cantilever in varying repeat motions from the walls; and in the thirty-six part *Variability of Similar Forms*, executed by Nancy Graves in 1970, using wax, acrylic, marble dust, and steel to successfully mimic animal leg skeletons which are juxtaposed evocatively in spatial groupings.

THE TABLEAU

The simultaneous nature of the serial pieces contrasts sharply with the centralized focus of the tableau, another direction which assemblage took during the 1960s. Despite the differences, the two forms share the same concerns of relating to space and time through a sense of action or movement taking place, often by the spectator's direct involvement. The concept of direct physical participation was foreseen in the work of the German Dadaist Kurt Schwitters. His architectural constructions, the *Merz* constructions of 1921 to 1933, included, in addition to wood, paper, wire mesh, and cardboard, the elements of theater, architecture, poetry, and music, creating a precedent for today's multimedia installations.

The dramatic and theatrical extension of assemblage can be seen in the tableaus of Edward Kienholz, whose works include debris from old wood, fabric, machine parts, and domestic paraphernalia such as silverware, shoes, wheels, clocks, ropes, dolls, and mannequins, giving great verisimilitude to his compositions. The calculated authenticity of the materials and their naturalistic juxtaposition belie Kienholz's craftsmanship and background as a cabinetmaker (see Figure 15-2). It is more evident in the folk art quality of such early pieces as *John Doe* (1959), consisting of two halves of armless male mannequins in a child's perambulator, oil paint, wood, metal, and plaster, and *Jane Doe* (1959), made of a wooden sewing chest, a mannequin's neck and head, and a skirt of a white bridal dress. Kienholz's tableaus grew in complexity and social commentary, simulating reality in the shocking *The State Hospital* (1964–66). With its use of abstraction and symbolic shapes, and its transparent vacant head forms, Kienholz goes beyond reality to the surrealistic attitude characteristic of our times. Other works such as *The Wait* (1964–1965) may be poignant, nostalgic, and satirical, but always contain strong human and literary content.

Two other notable contemporary sculptors working in the tableau form are George Segal and Escobar Marisol. Segal casts plaster figures directly from life and usually leaves them, or reproduces them, if cast in bronze, with their original white surface color. He combines his figures with associative objects and architectural forms, developing compositions such as figures entering a bus station, working at a steel plant, sitting in a garden, at a gas station, etc. The effect is one of anonymity but is also humanistic, evoking a sense of poetry in the ordinary (see Figure 15-3). Marisol combines plaster, wood, resin, and found items of all types in her brilliant commentaries on conformity, fashion, and the isolation of the human condition, fashioning these materials with wit and irony into unique figurative images.

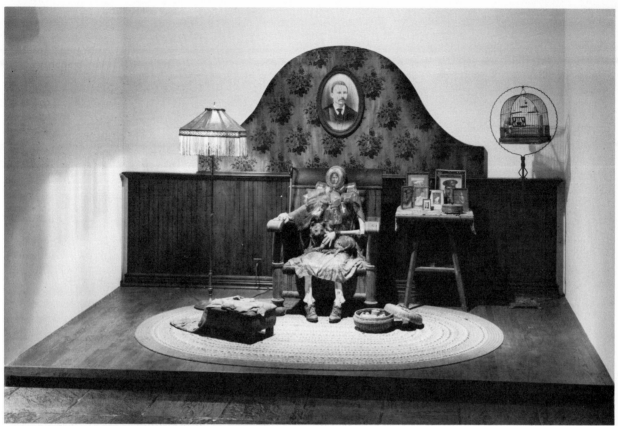

Figure 15-2
Edward Kienholz, *The Wait.* 1964-65.
Tableau: epoxy, glass, wood, and found objects. H. 80 in., W. 148 in., D. 78 in.
Collection Whitney Museum of American Art, New York. Gift of the Howard and
Jean Lipman Foundation, Inc.

"JUNK" SCULPTURE

The dehumanization of our technological society is a theme echoed in the assemblages euphemistically referred to as *junk sculpture.* With an eye for irony in the use of castoffs and disposables, everyday industrial junk was transformed by Lee Bontecou, César, John Chamberlain, Richard Stankiewicz, and Jason Seeley, among others. Stankiewicz welded pipes, César and Chamberlain used crushed cars, Jason Seeley assembled chrome car bumpers, and Lee Bontecou welded metal scraps which she spanned with burlap and other fibrous material. Their works and others of the 1960s deal with the love-hate relationship with the automobile, needing its function, loving its form, but hating its lethal potential and ugliness when its usefulness is over. When Picasso adapted a miniature auto body to simulate the head of an ape in the bronze of 1951, *Baboon and Young,* society was enamored with technology. By the 1960s the car is portrayed with symbolic love-death overtones, from the erotic and comic to the diabolic, degenerative and sinister; finally, as with Jason Seeley's elegant car bumper assemblages, the car as subject reaches regeneration and elevation, that is, validity as both aesthetic matter and means (the subject *and* the material).

Incorporating found metal parts with other detritus of society, pop artists Robert Indiana and Robert Raushenberg followed the path of earlier Dadaist Man Ray, Rauschenberg in the *combine-paintings,* and Indiana in the combination of found objects with fabricated forms, lettering, and graphics. These works synthesized folk, rustic, and pop imagery with sophisticated painting and graphics, and created a unique contemporary American statement. Akin to this, the disposable, everyday castoff material was projected to heroic size in the pop sculpture of Claes Oldenburg. In such works as the *Soft Toilet* he raises the mundane and castoff to the status of ironic icon, caricaturing it by the use of soft vinyl, the ultimate in contemporary society's castoff material.

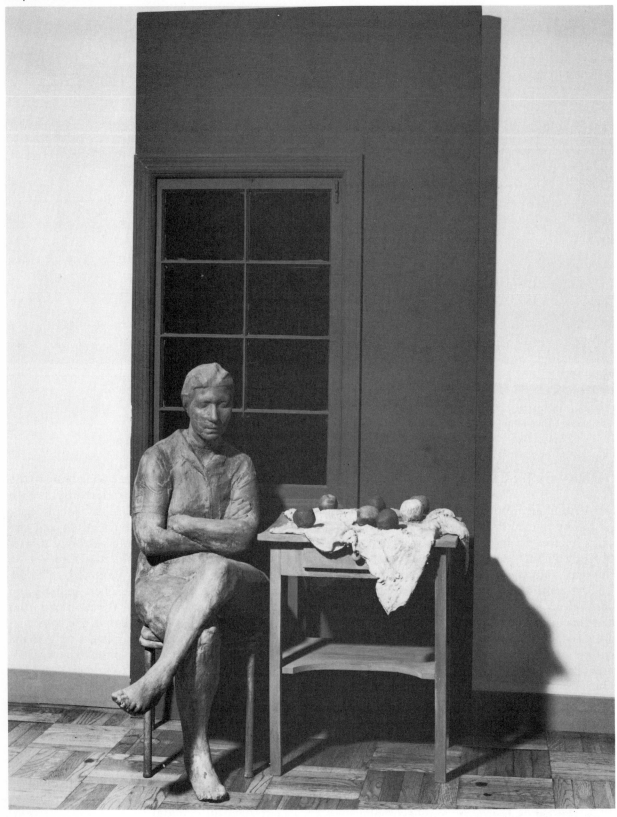

INSTALLATIONS

Installations such as Red Grooms' *New York Subway*, *Wall Street*, or *Chicago* are personal funhouses of sometimes mechanized multimedia devices, ramps and interior spaces, designed for active rather than passive participation. Affiliated with the theatricality of these Pop-Expressionist installations, but minimalist in feeling, are works such as Vito Acconci's *False Center for L.A.*, in which four simplified chair forms are accompanied by a taped monologue by the artist poet, and the recent installation of boats, cement blocks, and painted background of the same by Jennifer Bartlett (see Figure 15-4). As an art form, installation appears to be in its infancy, since so many expressions can now be enhanced by multimedia technological effects such as kinetic moving parts, lighting with laser beams, music, dance, and video, in effect an assemblage that is now blown up to lifesize or above, and animated.

PUBLIC WORKS— ENVIRONMENTAL ART

Through funding and a recognition of the need to humanize our environment, an active and authentic response by the public for diversified forms of art has taken the idiosyncratic and personal experiment out of the private and into the public space. An interesting example of this transition is the work *Stone Field Sculpture* by Carl André, commissioned by the city of Hartford in 1977 for a downtown site. André related the triangular green site adjacent to a church to the nearby burial ground and assembled locally quarried glacial boulders, placing them in rows of diminishing size and increasing numbers across the triangle. Before eventual acceptance, criticism of the work was rampant, with the local media taking the neutral stand that the sculpture made people think, question, and involve themselves.

Many other experimental public works have

Figure 15-4
Jennifer Bartlett, *Sea Wall*. 1985.
Oil on canvas, painted wood, concrete, and corten steel. 7 ft. × 30 ft. × 9 in. (overall).
Photo courtesy Paula Cooper Gallery, New York.

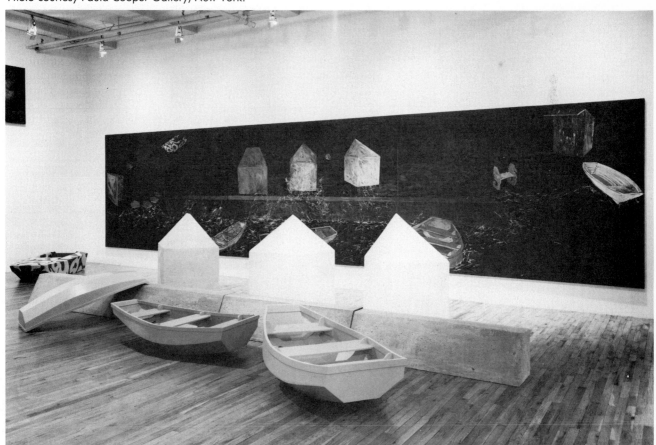

experienced the same pattern of angry reaction, eventually giving way to gradual acceptance, as, for example, Michael Heizer's *Adjacent, Against, Upon*, a series of three groups of granite blocks commissioned in 1977 by the city of Seattle for the Myrtle Edwards Park on Seattle's waterfront. Other unusual commissions have been Mark di Suvero's midstream sculpture for the St. Joseph River in South Bend, Indiana, and Joseph Kinnebrew's *Grand River Sculpture* in Grand Rapids, Michigan. The Kinnebrew work is an environmental sculpture which acts as a dam across the river at Grand Rapids, for the purpose of establishing a fish ladder for spawning fish and preventing them from traveling upstream. It also functions as a walkway for viewers to overlook

the dam and the river expanse, and a pleasing architectural adjunct to the park and river's edge. In contrast to the river setting, Robert Morris' environmental work *Grand Rapids Project* (1974) is set in an eroded hillside of a park. The Morris design functions practically as well as aesthetically, and, with its complex of intersecting asphalt ramps and recontoured slopes, is a place of activity as well as serving as an ecological device to preserve the landscape. Another unusual work is a sound sculpture by Max Neuhaus designed for the central rotunda of the St. Paul, Minnesota Beaux Arts style conservatory, in which sound rather than structure has been designed to create an environment, using plant walls and the domed shape in which to form the sound.[2]

Figure 15-5
Brent Jenkins, *Relief*. 1976. Central Multnomah County Library, Portland, Oregon, 3rd floor lobby. Designed about and for the library, the work displays visually the knowledge and information which the library houses and conveys, as well as the human inspiration which gives it meaning. The 20 brass and stainless "pages" were inspired by illuminated manuscripts. Images were first etched into metal, each color then sprayed and baked on. Representing people as conceivers of ideas rather than as specific portraits, the sculptures in the boxes are made of wood, clay, and plastic. Like the metal "banners" of "pages," the box takes the traditional library form of shelves and files. Sculpture achieved through the cooperation of the Library Association of Portland, Oregon, and the Ceta VI Program, and Western Color Graphics.

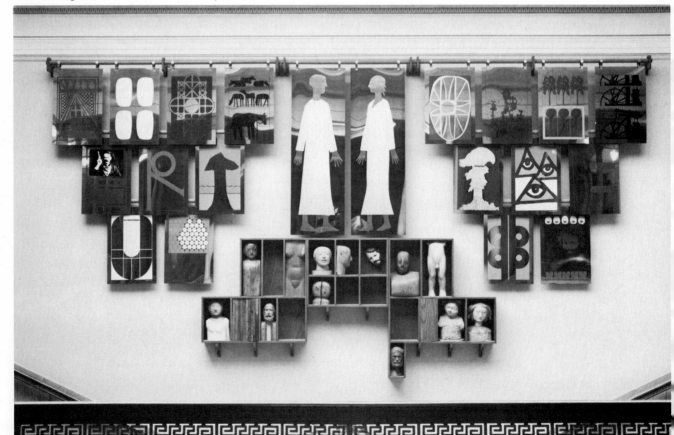

ENVIRONMENTAL AND INSTALLATION ART ON COLLEGE CAMPUSES

College campuses have demonstrated an enormous commitment to the enriching effects of sculpture, with large and prominent collections of contemporary art, sometimes funded in conjunction with a local allocation for art projects. One campus piece, the environmental *Chain Link Maze* (1978) by Richard Fleishner, at the University of Massachusetts in Amherst, creates a mysterious and disturbing transparent maze of concentric rectangles through the use of chain fencing. Nancy Holt's *Rock Rings*, installed at Western Washington State College in Bellingham, Washington, consists of two concentric, circular, handhewn masonry walls pierced by round windows and arched entryways which provide views of the surrounding landscape. This work is among others by such sculptors as Isamu Noguchi, Lloyd Hamrol, and Robert Morris on that campus. Other campuses with extensive collections include the University of Pennsylvania, with works by Louise Nevelson, Tony Smith, Alexander Liberman, and Claes Oldenburg; and Northern Kentucky University, with sculpture by Donald Judd, and a painted steel installation by Red Grooms, *Way Down East*, of D.W. Griffith at work on a film. A neon installation for a ceiling over a swimming pool by Stephen Antonakos at Hampshire College in Amherst, Massachusetts consists of suspended red neon tubes visible day and night from the glass-walled building; a 135-foot-long steel and sod geometric work by Beverly Pepper, *Thel*, was commissioned for Dartmouth College, Hanover, New Hampshire; and a 75-foot-long redwood and iron environmental sculpture, *Reading Garden* by Siah Armajani, graces the campus of Roanoke College, Salem, Virginia, among many works on college campuses across the United States. From schools to town squares and public parks, waterfronts and malls, sculpture is entering the mainstream of American life, enriching it aesthetically and functionally (see Figure 15-5).

16

Mounting, Presentation, and Documentation (Photography)

Mounting is the traditional means of formally presenting a sculptural work, performing the dual function of support and of setting the piece apart from its surroundings. The architecturally inspired plinth, or mount, adds a sense of weight and scale, particularly when the work is set above eye level. It also acts as a support when the work is not physically stable. Historically, Rodin represented a departure from this classic method of presentation when he placed his multifigured monument to the burghers of Calais on the same level as the spectator. The effect of having such naturalistic figures share the same space as the viewer heightened the dramatic intensity and emotional impact of the group, and created a new sensibility to sculpture's expressive potential. It was an attitude which contributed to the immediacy of modern sculpture, and the development of kinetic and environmental approaches to form. Like Rodin, contemporary figure sculptors often place their baseless figures in the same space as the viewer, a confrontation situation which invites involvement, and often shock as well.

BASES—MATERIALS AND TYPES

The primary consideration in designing a base is whether the added shape or material enhances rather than detracts from the finished work. It is wise to start comparing materials and experimenting with shapes and dimensions before the work is complete. Integration of the base to the work is vital, even if the purpose of the base is primarily functional rather than aesthetic.

If a subordinate element, the base must be well coordinated with the sculpture in shape, size, color, and material. Base materials are most often of wood, hardwoods such as walnut, cherry, and mahogany being preferred. Aside from its beauty and availability, wood may be shaped easily to coordinate with the work to be mounted. Brancusi mounted his wood carvings on richly carved wood columns which became sculptures in themselves. Since it is often difficult to find large pieces of wood, thick boards of wood might be laminated, resulting in a desirable textured effect. Formica may be laminated to wood if slick, clean surfaces are desired.

Stone, particularly marble slabs, are also used as a base material. Since stone is such a beautiful and conspicuous material in itself, it must be used modestly so that it will not dominate the work mounted on it. Concrete cast with stone aggregate makes an inexpensive and versatile base material which can easily be shaped by the mold into which it is poured. Smooth, polished surfaces can be obtained in concrete by casting against plate-glass molds (window glass will crack under the strain and heat of the setting). Plexiglas has come into use and, though beautiful with materials having refined surfaces, it may not be appropriate for other, rougher materials.

The shape and size of a base is difficult to determine and necessarily becomes a matter of observation and experience. In size, the base should not only be supportive but should *look* as if it

Figure 16-1
The Henry Moore Sculpture Center, Art Gallery of Ontario. Installation of original
plasters by Henry Moore given to the Gallery by the artist.
Photo courtesy of Art Gallery of Ontario, Toronto.
Traditional mounting on similar rectangular plinths in simple, undistracting surroundings
has the effect of dramatically emphasizing the relationship of the sculptural forms.

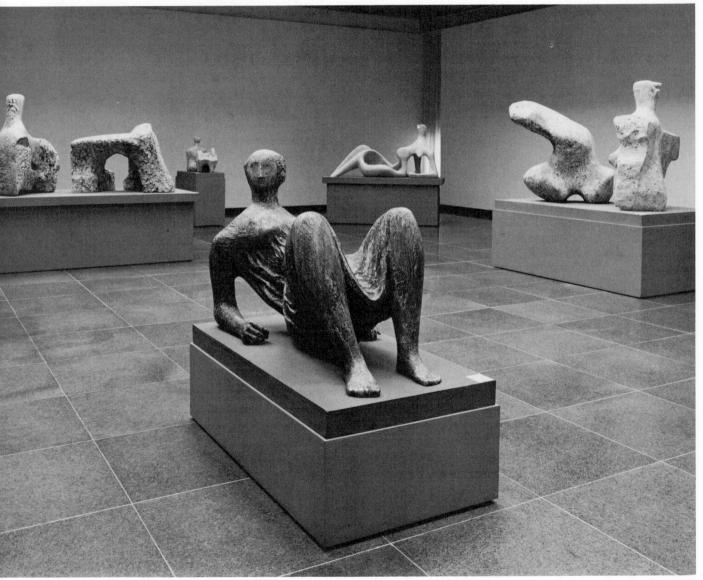

gives support, though it should not be so large that it makes the work look lost and insignificant. Judging whether the base should be contoured into an oval, an irregular shape, or remain a regular rectilinear form can best be done by cutting shapes out of paper and/or making trial forms from cardboard.

Height becomes an important consideration, contributing greatly to the effect of the work. Rather than a full height on one block, making the base look heavy and clumsy, a double base might be tried. The combination of a smaller piece mounted on a larger one is elevating yet light looking. The two levels bring interlocking design possibilities, particularly when two different shapes are combined (see Figure 16-2).

Also possible is a large base form mounted on a slightly smaller one, giving the top piece a floating look. Small sculptures may be effectively grouped together, particularly if related in theme, by mounting on bases of contrasting heights which are then combined into a single base (see Figure 16-3). Dramatic effects can be obtained with mirrors, illuminated bases of translucent materials, such as Plexiglas, and motorized bases which slowly rotate. Ball bearings adhered to the base provide a simple system for manual rotation of the work.

ATTACHING BASE TO WORK

If the sculpture has enough contact area with the base to hold firm, it is possible to glue the work to the base without the use of a support rod. Once

Figure 16-3
Grouping small sculptures on single multi-level base.

glued, the piece cannot be transferred to another base without possible damage.

Aside from providing stability, the use of a rod, bolt, or pipe support allows for removal of the work to a new base, if necessary. The upright, usually a ¼″ to ½″ bolt or rod, holds the sculpture firm to the base with a flange or a nut screwed into the threaded end of the bolt. The reverse method is to insert the screw from the base into a hole threaded into the bottom of the sculpture. To accommodate the screw head, washer, and nut, or flange, it is necessary to countersink, that is, cut or drill a well in the bottom of the base (see Figure 16-4).

The material into which the bolt or pipe will be fixed generally dictates the manner of attachment. Thick-walled castings of concrete and resin can be cast with a large nut imbedded in the wall,

Figure 16-2
Mounting work on two-level base.

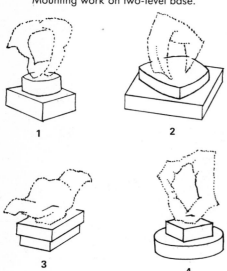

Figure 16-4 Mounting
1. Imbedding bolt in plaster.
2. Bolt through wall extension of work.
3. Fastening piece to base with theaded pipe and flange. Exposed pipe collared.

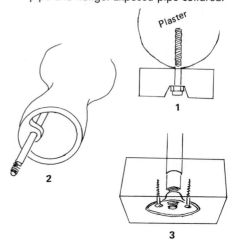

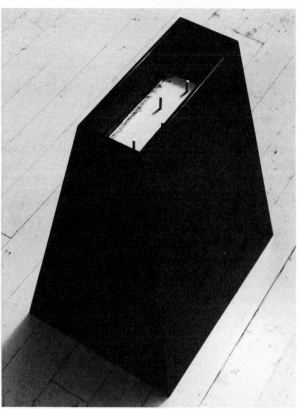

Figure 16-5
Mounting a resin piece. Bolts are inserted into a wood platform which has been anchored to the interior of a hollow poured resin base. The resin piece, with holes drilled and threaded, will be lowered into the base, with connections hidden by the collar above the platform. Photo by Dianne Kornberg.

Figure 16-6
The underside of the wood platform showing the method of anchoring the bolts with washers and nuts. The platform itself is attached to the sides of the poured resin base with metal angle irons. Photo by Dianne Kornberg.

into which a bolt is later screwed. If mounting a hollow work of plaster, cement, or fired terra cotta, a bolt or pipe may be set in permanently. A poured plaster mixture is usually adequate for fastening the upright, reinforcing at the base with burlap strips dipped in plaster. When using a bolt, set the head into the sculpture, as this will allow removal of the work from the base, if necessary. The protruding bolt, preferably in nonferrous metal, and oiled to resist corrosion, is passed through a clearance hole in the base or wall and secured with a washer and nut. Rather than adding a bolt later, the supporting rod may be either cast as part of the sculpture or welded to the metal reinforcement, depending on the process and material. A length of exposed screw or bolt between sculpture and base may be covered with a collar of metal or wood.

A work in wood, bronze, stone or resin may have holes drilled and threaded with different size "tapers" on a drill. Pointed screws or bolts, depending on the size of the work, are then inserted from the base up into the work, with the head side

in the base and only a washer for tightening. The position and direction of the holes can first be determined with templates made from the sculpture base. In bronze and terra cotta a hole can be made for mounting in the original wax or soft clay. (See Figures 16-5 and 16-6.)

The following procedure can be used for mounting a solid sculpture of wood, stone, or cast stone (see Figures 16-7 and 16-8):

1. Determine base size and shape by making a cardboard mock-up and/or template.
2. Line up the stone on the base and chalk around base contour.
3. Remove the stone, mark the chalk spot for the rod (or rods) on the part of the stone that contacts the base. Place the stone on the base to impress (with the chalk marks) the location of the rod on the base.
4. Drill the base hole (or holes).
5. Using the chalk contour, align the sculpture on the base and drill through the base holes into the sculpture.
6. Place the rods into the base.
7. Position the stone over the rods and lower to the base.

DISPLAY

The installation of an exhibition presents exciting opportunities for design. Wide-ranging possibilities exist in the manipulation and treatment of such factors as space, lighting, and the design and

Figure 16-7
Mounting a stone piece. Rod size and placement indicated within outline of sculpture on base. The holes are initially drilled through the base only. The stone is then placed on the base and drilling is done through both the base and the stone. Photo by author.

Figure 16-8
Stone is lowered onto inserted rods. Photo by author.

placement of display stands and cases (see Figure 16-9). These may be standard rectilinear modules or custom-built forms adapted to a particular work. Modules of plywood or pressed board may be graduated in size and shape, the most versatile ranging from 1ʸ to 4′ square and high. Stands can be mounted with Plexiglas covers, the larger cases with sliding front panels to facilitate loading. It is possible for stands and cases to depart from the

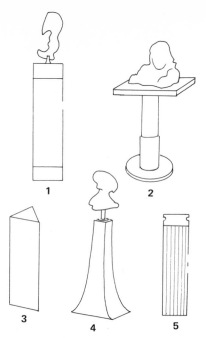

Figure 16-9 Sculpture stands
1. Plexiglas (transparent)
2. hydraulic (can be raised or lowered)
3. triangular
4. molded cement
5. laminated wood

standard rectangle and assume the more unusual shapes of trapezoids, triangles, hexagons, cylinders, etc. Showcases can be combined with varied types of pedestals of steel, chrome, acrylic, wood, stone, or precast concrete. They may be designed to appear to be floating from the wall or suspended from a floor-to-ceiling post or ceiling tracks. Movement can be incorporated by use of a swivel base or hydraulic lift, with a pump for the lift housed behind a wall.

Sculpture display stands may be built of combinations of contrasting materials. Pedestals of welded steel, acrylic, wood, and precast concrete might be topped with platforms of wood, stone, Formica, acrylic, or concrete. Additional textural effects are obtained by covering wood with tile, felt, or Formica or incorporating exposed aggregate and utilizing the texture of the wood forms in cast concrete. Groupings of cases and stands should be designed for maximum dramatic impact and connections between works, as well as for visual variety. The incorporation of mirrors, lenses, and projection devices such as light boxes, as well as the cautious use of color and dramatic spotlighting, afford further opportunities for experiments in theatrical effects (see Figures 16-10–16-12).

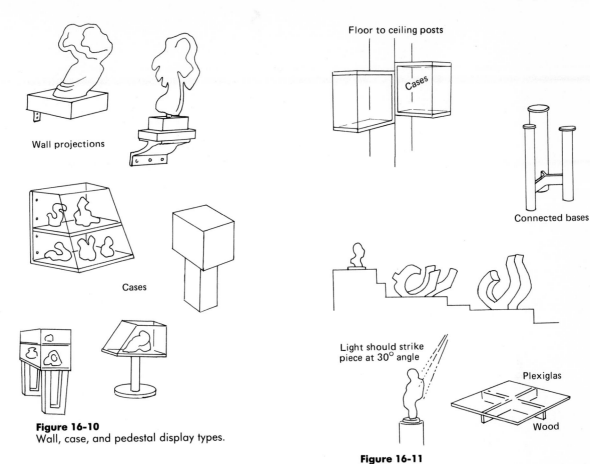

Wall projections

Cases

Figure 16-10
Wall, case, and pedestal display types.

Floor to ceiling posts

Cases

Connected bases

Light should strike
piece at 30° angle

Plexiglas

Wood

Figure 16-11
Bases, cases, pedestals and lighting.

Figure 16-12
Cases and pedestals.

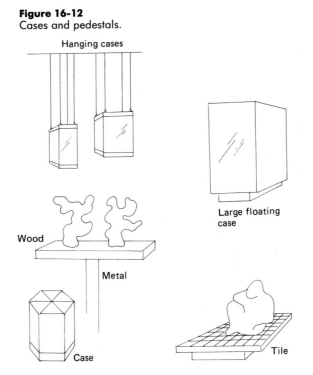

Hanging cases

Large floating
case

Wood

Metal

Case

Tile

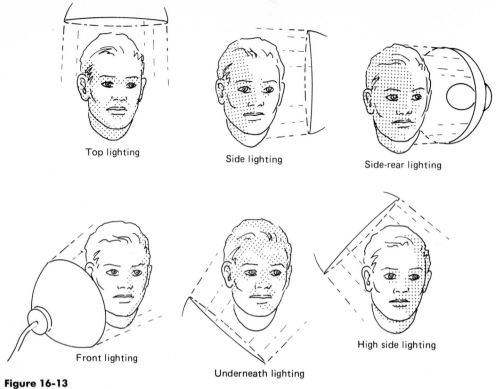

Top lighting

Side lighting

Side-rear lighting

Front lighting

Underneath lighting

High side lighting

Figure 16-13
Effects of lighting on form.

LIGHTING AND PHOTOGRAPHY

The basic lighting system for sculpture display utilizes two to three spotlights located above and to the side, angled to bounce off a reflective surface such as a ceiling or a wall. Additional overhead illumination can balance the spotlights, with soft side lights as effective supplements. If lighting is too broad and bright, such as direct lighting from above, below, or the front, the forms will wash out. Side lights used exclusively, on the other hand, will cause loss of sharpness and blurring of the form. (See Figure 16-13.)

In photographing work (see Figure 16-14) use soft natural or artificial light on one side balanced by a second light above and to a 45° angle, preferably reflecting back from a white surface. Set the work on a backdrop which will not confuse the work with the background, checking (especially in black and white) for enough tonal contrast so the piece doesn't fade into a similar toned background. A studio set up for a moderate-size work would be placing the work on a table covered with a large white cloth or sheet of paper (like butcher paper in rolls) which is large enough to act as a background as well as drop down to cover the front of the table. The sides of the table can be fenced off with white shields or reflectors, above which the two side lights aim down and reflect off the white background and side reflectors. Always use a tripod for maximum camera sharpness. Some points to remember are:

1. For black and white take a meter reading in the shadows and let the highlights take care of themselves. For color slides, expose for the highlights instead.
2. Use adequate lighting.
3. Use correct film, which will result in fine-grained prints.
4. Focus and frame the work properly, looking for balance and avoiding cut-off parts.
5. Avoid hard shadows if confusing.
6. Incorporate a clue to scale such as a doorway, a tree, a window, a brick wall, a person, if not distracting.
7. Photograph from several angles.
8. Work-in-progress or installation shots are useful.

For publication or publicity purposes take black and white photos and print 8″ × 10″ glossies, remembering to crop the photo to feature the sculpture. Thirty-five mm. color slides or occasionally black and white are best for exhibition and slide

banks for dealers and commissions. Label each slide completely with artist's name, title, medium, dimension, date of execution, present location, and the number of the slide in a series. Matching slides to cards in an index file is an excellent system of keeping track of the history of a piece. The cards should contain information on the sale price, the buyer, sales and resales, loans, press coverage, repair, insurance, and exhibition history.

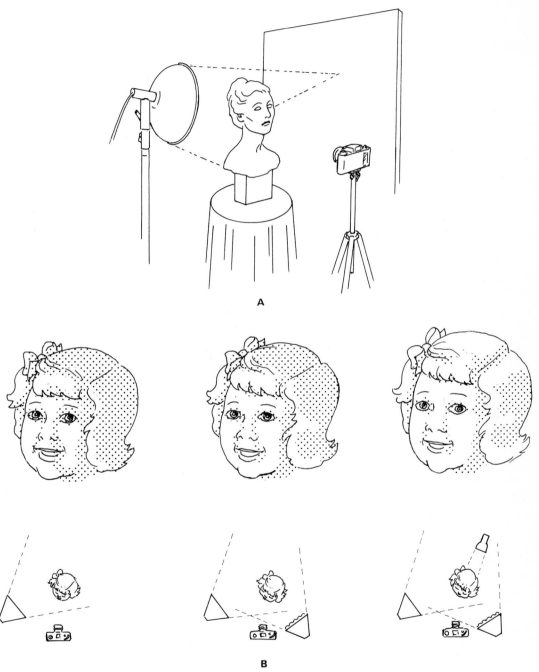

Figure 16-14
Photographing sculpture: (a) Set-up for photographing;
(b) Lighting effects when photographing sculpture.

Notes to the Text

Chapter 2

1. Andrew Ritchie, *Sculpture of the Twentieth Century* (New York: Museum of Modern Art, 1952), p. 15.
2. *Ibid.*, p. 15.
3. Eduard Trier, *Form and Space*, rev. ed. (New York: Praeger, 1965), p. 278.
4. László Moholy-Nagy, *Vision in Motion* (Chicago: Paul Theobald and Co., 1965), p. 219.
5. Albert E. Elsen, *Origins of Modern Sculpture: Pioneers and Premises* (New York: George Braziller, 1974).
6. Charles Seymour, Jr., *Tradition and Experiment in Modern Sculpture* (Washington, D.C.: American University Press, 1949), p. 9.
7. *Ibid.*, p. 11.
8. Stanley Casson, *The Technique of Early Greek Sculpture* (New York: Hacker Art Books, 1970), pp. 102–103.
9. Jacob Epstein, *Autobiography* (New York: Dutton, 1955), p. 70.
10. *Ibid.*, p. 14.
11. Emery Grossman, *Art and Tradition: The Jewish Artist in America* (New York, London: Thomas Yoseloff, 1967), pp. 91–100.
12. *Ibid.*, pp. 91–100.
13. *Ibid.*, pp. 91–100.

Chapter 3

1. Daniel Rhodes, *Clay and Glazes for the Potter*, rev. ed. (Philadelphia: Chilton, 1973), pp. 58–59.

Chapter 4

1. L. S. Maclehose, trans., *Vasari on Technique* (New York, London: Dent, 1907), p. 151.
2. C. R. Ashbee, trans., *The Treatises of Benvenuto Cellini on Goldsmithing and Sculpture* (London: Edward Arnold, 1898), p. 141.
3. John Addington Symonds, *The Life of Michelangelo Buonarroti* (New York: Modern Library, Random House, 193–), p. 66. Reprint of 1911 Scribner Edition. The method was used by Michelangelo to block out his sculpture *The Captives*, as described by Vasari. The sixteenth century preceded the pointing machine methods of transferring and enlarging the model.
4. Daniel Rhodes, *Clay and Glazes for the Potter*, rev. ed. (Philadelphia: Chilton, 1973), pp. 58–59.
5. *Ibid.*, p. 58.

Chapter 6

1. Reg Butler, *Five British Sculptors Talk* (New York: Caedmon Records, 1965).

Chapter 7

1. PVC compounds are variously called *Vinagel* and *Koroseal* (T.M. Reg. U. S. Pat. Office by Perma-Flex Mold Co., Columbus, Ohio, and the B. F. Goodrich Co.) and *Korogel* from B. F. Goodrich.
2. Information supplied by Smooth-On, Inc., Gillette, N.J.

Chapter 8

1. Information bulletins provided by U. S. Gypsum Company, Chicago, Ill. The symbol ® signifies that it is a company trademark.

Chapter 9

1. Information from the Society of the Plastics Industry, Inc.
2. *Ibid.*
3. Information bulletin provided by Eastman Chemical Products #TBU-1 G on Uvex sheets.
4. Information supplied by Smooth-On, Inc., Gillette, N.J.

Chapter 10

1. Chintamoni Kar, *Indian Metal Sculpture* (London: Alec Tiranti, Ltd., 1952), pp. 30–31.

Chapter 12

1. Stanley Casson, *The Technique of Early Greek Sculpture* (New York: Hacker Art Books, 1970), and Carl Bluemel, *Greek Sculptors at Work* (London: Phaidon, 1954), pp. 29–34, 34–37.
2. Gisela M.A. Richter, *The Sculpture and Sculptors of the Greeks*, 4th ed., revised and enlarged (New Haven and London: Yale University Press, 1970), p. 123.
3. Bluemel, *Greek Sculptors*, p. 39.
4. Richter, *Sculpture and Sculptors of the Greeks*, p. 129.
5. John Addington Symonds, *The Life of Michelangelo Buonarroti* (New York: Modern Library, Random House, 193–), p. 66. Reprint of 1911 Scribner Edition.

Chapter 14

1. George P. Bankart, *The Art of the Plasterer* (London: B.T. Batsford; New York: Scribner's, 1909), p. 4.

2. Jack C. Rich, *The Materials and Methods of Sculpture* (New York: Oxford University Press, 1947), p. 86.

Chapter 15

1. William C. Seitz, *The Art of Assemblage* (New York: Museum of Modern Art, 1961), p. 63.

2. John Beardsley, *Art in Public Places* (Washington, D.C.: Partners for Livable Places, 1981), p. 76.

Appendix

BASIC STUDIO REQUIREMENTS AND EQUIPMENT

In locating and designing a studio, the most important consideration is the type of sculptural activity which will be carried on—and the concentration on the space to accommodate it. The individual's studio needs require a simpler setup than a school, with its many students using a wide range of media. The attempt here is to outline the basic requirements of physical space and equipment, covering the materials and processes referred to in this volume.

Ideally, separate areas can be maintained for modeling and carving, cold casting, resin casting, plastic and metal fabrication, and metal casting. If processes and materials are limited, separation of areas is not vital. A sculpture studio can have many amenities and refinements but what counts, basically, is a large space with good heating, lighting and ventilation, high ceilings, and access to the outdoors. A listing of equipment is organized by material.

Basic Studio Requirements:

1. Sufficient space with access to the outdoors directly or by freight elevator and wide entrance doors. For an individual, a 500 to 1000 square foot minimum; to meet the needs of a sculpture department 5000–8000 square feet of space.

2. High ceilings.

3. Solid floor to hold weight, the portion of it used for plaster or cement casting to be a cement floor with a drain so it can be cleaned by scraping and washing with a hose.

4. Good lighting with daylight on the north side for modeling and drawing in particular and natural lighting from at least one, preferably two other sources. Artificial lights should be a combination of both fluorescent and incandescent.

5. Running water, a deep-welled sink with a heavy-duty trap and a threaded tap for a hose.

6. A venting system is needed in addition to window air flow. Effective ventilation requires forced air through a motor-driven suction system which sends fumes directly outdoors. It can take the form of an exhaust fan with added vents to the kilns. A hood type of vent can be fitted over a window to carry out kiln exhaust. Venting should be located specifically where heat, dust, or vapors cause poisonous fumes, for example, kiln, wax, plastic, silica dust in clay, cement, moldmaking for wet wax casting, and in the sanding and grinding of any material. To test an exhaust system, ignite a rolled newspaper, blow it out, and hold the smoking paper torch near exhaust and watch where smoke rises.

7. Sufficient electrical power and outlets (115- and 230-volt lines, plugs, and wall receptacles).

8. Built-in storage bins and workbench.

9. Ideally, a courtyard immediately accessible, part of which can be covered over for outdoor carving or casting, storage of wood and stone, and trash disposal.

10. A separate clean office area which can be closed off to photograph work and view slides, for drawing and record keeping as well as a relaxation area.

Shop Equipment (Some basic, some supplementary)

Ceramics/Wax

1. Kilns—1 small test, 1 large gas or electric. These can serve as burnout kilns with proper venting.

2. Pug mill.

3. Clay storage bins.

4. Potter's wheel (optional).

5. Wedging table.

6. Slab rolling table.

7. Metal slab former.

8. Damp box.

9. 1–2 rotating modeling stands.

10. Damp box for greenware.

11. Shelves for bisque and glaze if any.

12. A roller for plastic sheeting.

13. Wax melting pot and/or lights.

14. Hand tool storage.

Plaster and Cement

1. Plaster and cement storage bins.

2. Plaster and cement—hand tool storage—shears, pliers, wrenches, hammers, files, taps, dies.

3. Portable power tool storage—drill, sander, jigsaw, grinder.

4. Rollers for fiberglass, metal screening (chicken wire, hardware cloth).

Plastics

1. Resin casting booth with separate venting and temperature control.

2. Fireproof storage for resins and solvents.

3. Vacuum table.

4. Band saw.

5. Portable sanders, buffers, jigsaw—storage.

6. Hand tools and storage—saws, files, clamps, shears.

7. Large table.

8. Wall rollers for fiberglass sheet.

Metal Casting and Welding

1. Burnout kiln (preferably gas).

2. Gas or electric melting furnace placed in pouring pit.

3. Metal or brick tables.

4. Metal-cutting band saw.

5. Bridge crane and overhead rails for carrying molds from the furnace and kiln areas or heavy carving stones.

6. Vises—8″ open to 12″, located 32″ above floor.

7. Gas torches and heliarc and stick welder.

8. Air compressor—outside building or in basement.

9. Anvils (175 lb. on dolly).

10. Drill press.

11. Rod cutter.

12. Bending brake.

13. Metal shear.

14. Sand casting booth.

15. Metal forming bench with stake holders and stakes.

16. Electric grinder.

17. Portable power tools—grinders, shears, sanders.

18. Hand tools; wrenches, vises, shears, punches, pliers, files, taps, dies, clamps.

19. Dollies, low platforms on wheels.

Wood and Stone Carving and Fabricating

1. Dollies, pallets.

2. Heavy modeling stand for carving stone, wood.

3. Portable power tools; drills, saws, sanders.

4. Table saw.

5. Radial arm saw.

6. Band saw.

7. Worktables, vises, clamps.

8. Hand tools: saws, mallets, chisels, files, axes, adzes, picks.

9. Forklift.

SAFETY

Protective and Emergency Equipment:

1. Fire extinguishers.

2. Venting systems as described above.

3. Respirators: A reliable respirator will have a cannister or cartridge filter and cost about $20. Choose a filter for the particular type of exposure, as filters differ. Look for the NIOSH* seal of approval. Check for tight but comfortable fit. Change filters when you notice odors entering the mask, or when it becomes hard to breathe.

4. Gloves.

5. Eye and face shields.

Hazards

Clay

Silica in clay dust (silica dioxide) is present in dry clay and in many glaze materials either as a component or contaminant. Inhalation may result in silicosis, permanent scarring of the lungs, which may incubate for 15–20 years.

Lead and *heavy metals* in glazes such as chromed manganese and vanadium. These are dangerous during firing and with lead, particularly on finished products used as food utensils. Manufacturers who term a glaze safe may not be referring to all three stages. Lead weakens the neuromuscular system, damages internal organs, can cause anemia, sterility, and birth defects. Copper carbonate can cause eye,

* National Institute for Occupational Safety and Health

nose, and throat irritation and possible ulceration and perforations of the nasal system.

Heat and *exhaust* from the kiln burnoff contaminants in the glazes and kiln wash. For kiln wash alumina and ball clay is safer than the usual formula of talc ball clay and flint, 50%–70% of which is silica.

Wax

The *fumes* produced by burning wax are toxic. The scale and sophistication of ventilation depends on the frequency of burnout, amounts of wax vaporized, and size of the room. Burnout fumes can be reduced by heat just enough to melt the wax in a catch tray at the bottom of a kiln, which is then removed before vaporizing the smaller residue of wax left in the mold.

Fire

Potential requires prevention of explosion burn and accidents by use of gloves, protective clothing, and fire extinguisher.

Plaster of Paris, Cement, Paper-Mache

Nuisance dust and drying of skin into plaster. Cement dust may be caustic. Wear mask and gloves when mixing. Instant paper-mache "celluclay" is pulp of ground magazine printed with lead chromate, which could lead to toxic poisoning.

Metal Casting

Molten metal requires protective gloves, face mask, boots, leather apron, long sleeves, and pants. A fire extinguisher should be nearby.

Flying metal is a hazard when chasing metal and requires gloves and face mask.

Noise when heavy grinding of metal requires earplugs.

Acids—Always add acids slowly to water, never water to acid. Wear protective face mask when mixing. When heating liver of sulphur and other chemicals mix according to directions. Do not allow mixture to boil. The decomposition of hydrogen sulfide can cause brain damage and suffocation.

Gas Welding—Keep hoses neat, and use gloves and goggles. Check for leaks in tank and hoses. Acetylene is a mild narcotic in small doses. Large doses cut off oxygen.

Zinc compounds in brazing or grinding brass or bronze can attack the central nervous system, skin, and lungs. Ventilate and wear respirator.

Metal chips when cutting or forging require protective face mask.

Arc Welding—Since it is electrical, watch for wet hands or wet work, which can cause shock. Light produced by arc will seriously damage the retina of the eye. Overexposure can cause skin cancer. Face guard should always be in place before applying electricity. Always check for screening of sparks from others.

Plastics

Polyester resins are a skin irritant. Some release toxic fumes when mixed with their binders. Wear gloves and ventilate. *Resins* have low flash point. Never expose to naked flame. Store resins and catalysts in cool fireproof cupboard. Resin stored in large quantities or bulk may smoke.

Catalyst and acetones cause drowsiness; acetones are one of the least toxic solvents. Catalyst is an oxidizing agent, causing skin and eye irritation. Catalyst and accelerator will explode when mixed together. Most resins are now preaccelerated, so only catalyst is added.

Finishing rigid plastics causes irritation with dust particles, danger to eyes, skin, and lungs. Wear mask, goggles, and protective clothing. Liquid coolant helps absorb dust when power sawing or sanding, but is not as practical with handsawing.

SAFETY EQUIPMENT SUPPLIERS

Binks Manufacturing Co.
9201 W. Belmont Ave.
Franklin, IL 60131

Eastern Safety Equipment
5920 56th Ave.
Pittsburgh, PA 15235

Mine Safety Appliances
608 Penn Center Blvd.
Maspeth, NY 11378

De Vilbiss Co.
Box 913
Toledo, OH 43692

Suppliers

Clays and Glazes (Chapters 3, 4, 5)

East Coast

Engelhard Industries, Inc., Hanovia Liquid Gold Division, 1 W. Central Ave., E. Newark, NJ 07029. Metallic-luster glaze materials.

Hammill and Gillespie, Inc., 225 Broadway, New York, NY 10007.

Jack de Wolfe Co., Inc., 724 Meeker Ave., Brooklyn, NY 11222.

Mandl Ceramic Supply Co., RR 1, Box 369 A, Pennington, NJ 08534.

Pottery Arts Supply Co., 2554 Greemount Ave., Baltimore, MD 21218.

Sculpture House, 38 E. 30th St., New York, NY 10016.

Sculpture Services, Inc., 9 E. 19th St., New York, NY 10003.

Stewart Clay Co., 133 Mulberry St., New York, NY 10003.

United Clay Corp., Trenton, NJ 08606.

Midwest

American Art Clay Co., Inc. (Amaco), 4717 W. 16th St., Indianapolis, IN 46222.

Kentucky-Tennessee Clay Co., Mayfield, KY 42066.

Western Stoneware Co., Monmouth, IL 61462.

Zanesville Stoneware Co., Zanesville, OH.

Southwest

Denver Fire Clay, 2401 E. 40th Ave., Denver, CO 80217. Chemicals for glazes, clays, and refractories.

Trinity Ceramic Supply Co., 9016 Diplomacy Row, Dallas, TX 75235.

West Coast

Garden City Clay Co., Redwood City, CA 94064.

Interpace Corp., 2901 Los Feliz Blvd., Los Angeles, CA 90039.

L. H. Butcher Co., 15th and Vermont St., San Francisco, CA 94107.

S. Paul Ward, 601 Mission St., South Pasadena, CA 91030.

Westwood Ceramic Supply Co., 14400 Lomitas Ave., City of Industry, CA 91744.

Western Ceramic Supply Co., 1601 Howard St., San Francisco, CA 94103.

Extrusion and Mixing Machinery (Clay) (Chapters 3, 4, 5)

East Coast

Essick Manufacturing Co., 850 Woodruff Lane, Elizabeth, NJ 07201. Cement and plaster mixers, useful also for clay.

Midwest

Bonnot Co., P.O. Box 390, Canton, OH 44701. Extrusion machines.

Essick Manufacturing Co., 350 E. Irving Park Rd., Wood Dale, IL 60191.

Patterson Foundry and Machine Co., East Liverpool, OH 43920. Extrusion machines.

U. S. Stoneware Co., Akron, OH 44309. Ball mills.

Walker Jamar Co., Inc., 365 S. First Ave., East Duluth, MN 55806. Small extrusion machines (pug mills).

West Coast

C.O. Fiedler, Inc., 553 N. Mission Dr., San Gabriel, CA 91778. Extrusion machines.

Essick Manufacturing Co., 1950 Santa Fe Ave., Los Angeles, CA 90021.

Fernholtz Machinery Co., 8468 Melrose Pl., Los Angeles, CA 90069. Extrusion machines and ball mills.

Ceramic Tools and Equipment (Chapters 3, 4, 5)

East Coast

Craftools, Inc., 1 Industrial Rd., Woodridge NJ 07075.

National Sculpture Service, 9 E. 19th St., New York, NY 10003.

Sculpture Associates, 101 St. Marks Pl., New York, NY 10003.

Sculpture House, 38 E. 30th St., New York, NY 10016.

Sculpture Services, Inc., 9 E. 19th St., New York, NY 10003.

Standard Ceramic Supply Co., P.O. Box 4435, Pittsburgh, PA 15205.

Midwest

De Vilbiss Co., 300 Phillips Ave., Toledo, OH 43601. Spray equipment.

Tepping Ceramic Supply Co., 3517 Riverside Dr., Dayton, OH 45405.

West Coast

L.H. Butcher Co., 15th and Vermont St., San Francisco, CA 94107.

M. Flax, 10846 Lindbrook Dr., Los Angeles, CA 90024 and 250 Sutter St., San Francisco, CA 94108.

Paul Soldner, Box 917, Aspen, CO 81611. Kick and electric wheels.

Robert Brent Corp., 128 Mill St., Healdsburg, CA 95448. Electric wheels and tools.

Kilns and Kiln Supplies

East Coast

Jenkins Wholesale Co. (Jen-Ken Kiln), 4569 Samuel, Sarasota, FL 33577.

L and L Manufacturing Co. (Econo-Kiln), 142 Conchester Rd., Chester, PA 19016.

Unique Kilns, 530 Spruce St., Trenton, NJ 08638. Electric kilns.

W.H. Fairchild, 712 Centre St., Freeland, PA 18224. Electric kilns.

Midwest

A.P. Green Firebrick Co., Mexico, MO 65265. Firebricks and castable refractories.

Southwest

Denver Fireclay, 2401 E. 40th Ave., Denver, CO 80217.

Paragon Industries, Inc., Box 10133, Dallas, TX 75207. Electric kilns.

West Coast

A.D. Alpine, Inc., 353 Coral Circle, El Segundo, CA 90245. Gas-fired ceramic and burnout kilns.

California Kiln Co., 3036 Oak St., Santa Ana, CA 92707.

Cress Manufacturing Co., 1718 Floradale Ave., South El Monte, CA 91733.

Duncan Kiln and Equipment, Div. of Duncan Enterprises, P.O. Box 7609, Fresno, CA 93727.

Kilns and Kiln Supplies (Chapters 3, 4, 5)

West Coast

Nordstrom Kiln Co., 9046 Garvey St., South San Gabriel, CA 91777. Gas.

Skutt and Sons, 2618 S.E. Steel St., Portland, OR 97202. Electric.

Smith Engineering Co., 1903 Doreen Ave., South El Monte, CA 91733. Gas.

West Coast Kiln Co., 635 Vineland Ave., La Puente, CA 91746. Gas.

Mold-Making Materials (Chapters 6, 7)

East Coast

Adhesive Products Corp., 1660 Boone Ave., Bronx, NY 10460. Silicone rubber, polyesters, filling, releases, latex, foam-in-place polyurethane.

Cementex Co., 226 Canal St., New York, NY 10013. Latex and polysulfide rubbers.

Defender Industries, Inc., 255 Main St., New Rochelle, NY 10801. Fiberglass epoxies, polyurethane, polystyrene foam blocks.

Du Pont de Nemours, E.I. & Co., 1007 Market St., Wilmington, DE 19898. Neoprene and synthetic rubbers.

H.V. Hardman Co., Inc., 600 Courtlandt St., Belleville, NJ 07109. Flexible mold materials.

L.D. Caulk Co., Milford, DE 19663. Jeltrate alginate molding compound.

National Sculpture Service, 9 E. 19th St., New York, NY 10003. General sculpture tools and supplies.

Sculpture Associates, 101 St. Marks Pl., New York, NY 10003. General sculpture and casting supplies.

Sculpture House, 38 E. 30th St., New York, NY 10016. General sculpture and casting supplies.

Smooth-On, Inc., 1000 Valley Rd., Gillette, NJ 07933. Flexible urethane mold material and epoxy casting compounds, PVA and other release agents.

The Plastics Factory, 18 E. 12th St., New York, NY 10003. Polyesters and acrylic-polyesters, epoxies, fiberglass, moldmaking materials and releases.

Midwest

Dow Corning Corp., Midland, MI 48741. Silicone rubber.

B.F. Goodrich Industrial Products Co., 500 S. Main St., Akron, OH 44318. Latex rubber.

General Latex and Chemical Corp., Box 351, Ashland, OH 44805. Denscal high-strength industrial plasters.

Perma-flex Mold Co., 1919 Livingstone Ave., Columbus, OH 43209. Silicone, urethane, vinyl molding compounds.

Polyproducts Corp., 13810 Nelson Ave., Detroit, MI 48227. Mold materials, resins, additives, fiberglass pigments.

Ramco Hemp Fiber Co., 6272 W. North Ave., Chicago, IL 60639. Hemp fiber for plaster casting.

U.S. Gypsum Co., 300 W. Adams St., Chicago, IL 60606. Casting and moldmaking plasters, hydrostone and hydrocal plaster investment materials; technical bulletins on products.

West Coast

Hastings Plastics Co., 1704 Colorado Ave., Santa Monica, CA 90404. Silicone rubber and other molding compounds.

M. Flax Artists Supplies, 10846 Lindbrook Dr., Los Angeles, CA 90024. General sculpture and casting supplies.

Shell Chemical Corp., Synthetic Rubber Div., 19253 S. Vermont, Gardena, CA 90247. Latex rubber.

Smith and Co., 1220 S. 49th St., Richmond, CA 94804. Silicone rubber.

England

Alec Tiranti Ltd., 72 Charlotte St., London, W-1, England. Sculpture equipment and cold-casting compounds.

Local building materials companies are sources for plaster, cement, sand, sisal fiber, and burlap for reinforcement.

Plaster, Plaster Aggregates, Plaster Tools (Chapters 8, 14)

East Coast

Craftools, Inc., 1 Industrial Rd., Woodridge, NJ 07075. General sculpture tools and supplies.

National Sculpture Service, 9 E. 19th St., New York, NY 10003. General sculpture tools and supplies.

Sculpture Associates, 101 St. Marks Pl., New York, NY 10003. General sculpture tools and supplies.

Sculpture House, 38 E. 30th St., New York, NY 10016. General sculpture tools and supplies.

W.R. Grace and Co., Construction Products Div., 62-T Whittemore Ave., Cambridge, MA 02140. Plants also in Newark, Los Angeles, and major cities. Zonolite expanded mica plaster and concrete aggregate.

Midwest

Crystal Silica Co., Oceanside, CA 92054, subsidiary of Ottawa Silica Co., Ottawa, IL 61350. White silica sands, graded for mesh size.

General Latex and Chemical Corp., Box 351, Ashland, OH 44805. Denscal high-strength industrial plasters.

P.S.H. Industries, Inc., 3713 Grand Blvd., Brookfield, IL 60513. R2 plaster and plastic spray gun, flocking gun, plaster, and plastic supplies.

Ramco Hemp Fiber Co., 6272 W. North Ave., Chicago, IL 60639. Hemp fiber for plaster casting.

U.S. Gypsum Co., 101 S. Walker Dr., Chicago, IL 60606. Largest manufacturer in the U.S. of industrial and building plasters.

West Coast

Georgia Pacific Gypsum Corp., Box 311, Portland, OR 97207. Dense high-strength industrial plaster.

Redco, Inc., 11831 Vose St., North Hollywood, CA 91605. Permalite pumice aggregate.

Cements (Chapters 8,14)

East Coast

Joseph Dixon Crucible Co., Jersey City, NJ 07300. Refractory cements.

H.K. Porter Refractories, 300 Park Ave., New York, NY 10022. Refractory cements.

Medusa Portland Cement Co., 104 E. 40th St., New York, NY 10016. Information booklets available.

West Coast

American Cement Co., 2404 Wilshire Blvd., Los Angeles, CA 90059.

Atlantic Cement Co., 2404 Wilshire Blvd., Los Angeles, CA 90059.

California Portland Cement Co., 612 S. Flower St., Los Angeles, CA 90017.

Harrison-Walker Refractories Co., 6444 Fleet St., Los Angeles, CA 90022. (Also Pittsburgh, PA 15222). Refractory cements.

Red-E-Crete Pre-Mixed Products, premixed dry con-

crete and mortar, available at local building and hardware stores.

Sakrete Dry-Mixed Products, premixed dry concrete and mortar, available at local building and hardware stores.

Cement Aggregates and Additives (Chapters 8, 14)

East Coast

Anti-Hydro Waterproofing Co., 271 Badger Ave., Newark, NJ 07100. Manufacturer of concrete waterproofing compounds.

Evercrete Corp., 315 W. 39th St., New York, NY 10018. Manufacturer of concrete waterproofing compounds.

Larsen Products Corp., 5420 Randolph Road, Rockville, MD 20852. Special bonding agents and acrylic latex.

W.R. Grace and Co., Construction Products Div., 62 Whittemore Ave., Cambridge, MA 02140. Set retarders, water-reducing admixtures.

Zonolite, Division of W.R. Grace & Co., Newark, NJ 7237 E. Gage St., Los Angeles, CA 90039. Vermiculite (expanded mica) lightweight aggregate.

Midwest

Owens-Corning Fiberglass Corp., Fiberglass Tower, Toledo, OH 43659. Fiberglass cloth and fibers. Glass-reinforced concrete.

West Coast

Crystal Silica Co., Oceanside, CA 92054. Subsidiary of Ottawa Silica Co., Ottawa, IL 61350. White silica sands graded for mesh size.

Frank D. Davis Co., 3700 E. Olympic, Los Angeles, CA 90023. Pigments for coloring cements.

Redco, Inc., 11831 Vose St., Los Angeles, CA 91605. Permalite lightweight pumice aggregate.

Tools, Cement

Frank Mittermeier Inc., 3577 E. Tremont Ave., Bronx, NY 10465. Chisels, rasps, riffler rasps, tile and mosaic hammers.

Plastics (Resins, sheets, films, fiber) (Chapters 9, 11)

East Coast

Adhesive Products Corp., 1660 Boone Ave., Bronx, NY 10460. Polyesters, clear, filled, colorants, moldmaking latex and rubbers, fillers, releases, foam-in-place polyurethane.

Ain Plastics, Inc., 160 Macquesten Pkwy S., Mt. Vernon, NY 10550. Acrylic sheet, rod, tubes, plastic film, mylar, polyethylene, acetate, vinyl, high-impact polystyrene.

Allied Plastics Supply Corp., 895 E. 167th St., Bronx, NY 10459. Acrylic sheet, rod, tube, plastic film, mylar, polyethylene, acetate, vinyl, high-impact polystyrene.

Allied Chemical Corp., Box 365, Morristown, NJ 07960. Epoxies and urethanes.

American Cyanamid Co., Plastics Division, Wayne, NJ 07470. Manufacturers of acrylic sheet and alkyd, melamine, polyester, and urea molding compounds, polyester resins, and other materials.

Amplast Corp., 3020 Jerome Ave., New York, NY 10468. Varied forms of plastic sheet, rods, tubes, and films.

Burlington Glass Fibers, 1345 Ave. of the Americas, New York, NY 10019.

Canal St. Plastics, Inc., 115 Cedar St., New Rochelle, NY 10801. Acrylic sheet, rod, tube, etc., cut to size. Acrylic tools.

Du Pont de Nemours, E.I. & Co., 1007 Market St., Wilmington, DE 19898. Lucite, acrylic sheets, rods, tubes.

Eastman Chemical Products, Inc., Box 431, Kingsport, TN 37662. Tenite cellulose acetate butyrate and cellulose acetate sheets and films.

Ferro Corp., Fiberglass Div., 200 Fiberglass Rd., Nashville, TN 37211.

Furane Plastics Inc., 16 Spielman Rd., Fairfield, NJ 07007. Epoxies and urethanes.

Industrial Plastics, 324 Canal St., New York, NY 10013. Acrylic and phenolic sheets, rods, tubes.

Pantasote Co., 277 Park Ave., New York, NY 10017 and Box 1800, Greenwich, CT 06830. Vinyl films and sheets.

Rohm and Haas Co., Independence Mall W., Philadelphia, PA 19105.

Midwest

Argo Plastic Products Corp., 7711 Grand Ave., Bldg. 6B, Cleveland, OH. Acrylic sheets, rods, tubes; cellulose acetate sheets and films; polycarbonate, nylon, and phenolic sheets, rods, and tubes.

Dow Chemical Co., Midland, MI 48640. Epoxies and urethanes.

Guston-Bacon Mfg. Co., 210 W. 10th St., Kansas City, MO 64105. Fiberglass cloth.

Owens-Corning Fiberglass Corp., Fiberglass Tower, Toledo, OH 43659. Fiberglass cloth, mat, roving, glass flakes.

3-M Co., 3-M Center, St. Paul, MN 55101. Epoxies and urethanes.

West Coast

Argo Plastic Products Corp., 417 Lesser St., Oakland, CA 94601. Acrylic sheets, rods, tubes; cellulose acetate sheets and films; polycarbonate, nylon, and phenolic sheets, rods, tubes.

Furane Plastics, Inc., 5121 San Fernando Rd., Los Angeles, CA 90030. Epoxies and urethanes.

Hastings Plastics Co., 1710 Colorado Ave., Santa Monica, CA 90404. Polyesters, epoxies, and fibers.

Pantasote Co., 4703 E. 48th St., Los Angeles, CA 90058. Vinyl films and sheets.

Plastic Mart, 2101 Pico Blvd., Santa Monica, CA 90404. Acrylic, vinyl, polyester.

Transparent Products, 1739 W. Pico Blvd., Los Angeles, CA 90006. Transparent and aluminized mylar sheets and rolls.

Foam

East Coast

American Petrochemical Corp., Lenoir Div., Box 390, Lenoir, NC 28645. Urethane foaming systems.

Flexible Products Co., Box 996, Marietta, GA 30060. Flexible and rigid urethane foaming systems.

Pittsburgh Corning Corp., 800 Presque Isle Dr., Pittsburgh, PA 15239. Rigid urethane foam boards and slabs.

Reichold Chemicals, Inc., 525 N. Broadway, White Plains, NY 10603. Urethane foaming systems.

Smooth-On, 1000 Valley Rd., Gillette, NJ 07933. Urethane casting compound C-1500.

Midwest

Cadillacs Plastics and Chemical Co., P.O. Box 810, Detroit, MI 48232 and 9025 Lenexa Dr., Lenexa, KS 66215.

Dow Chemical Co., Midland, MI 48640. Styrofoam boards and slabs.

Upjohn Co., 7000 Portage Rd., Kalamazoo, MI 49001.

West Coast

Cadillacs Plastics and Chemical Co., 2305 W. Beverly Blvd., Los Angeles, CA 90057. Styrofoam boards and slabs.

Diamond Foam Co., 459 S. La Brea Ave., Los Angeles, CA 90036. Flexible foams.

Pacific Foam Products, 4200 Charter St., Los Angeles, CA 90058. Rigid styrofoam and urethane boards, slabs, bars, and shapes.

Upjohn Co., 555 N. Alaska Ave., Torrence, CA 90503. Urethane foaming systems.

Bronze Foundries (Chapter 10)

East Coast

American Industrial Casting, Inc., 185 Sherburne St., Providence, RI 02905.

Art Studio Casting, 234 Huron St., Brooklyn, NY 11222.

Belmont Metals, Inc., 330 Belmont Ave., Brooklyn, NY 11207.

Colson Sculpture Casting Service, 1666 Hillview, Sarasota, FL 33579.

Excaliber Bronze Sculpture Foundry, 89 Adams St., Brooklyn, NY 11201.

Hoheb Studios, 38-62 11th St., Long Island City, NY 11101. Specialists in enlargements to any size.

Joel Meisner and Co., Inc., 120 Fairchild Ave., Plainview, NY 11803.

Johnson Atelier Technical Institute of Sculpute, 60 Ward Ave. Ext., Mercerville, NJ 08619.

Modern Art Foundry, Inc., 18-70 41st St., Long Island City, NY 11105.

Modern Bronze Foundry, 520 W. 22nd St., New York, NY 10011. Bronze and aluminum, French sand, lost wax casting, rubber molds.

New Arts Foundry, 2006 Clipper Park Rd., Baltimore, MD 21211.

Paul King Foundry, 92 Allendale Ave., Johnston, RI 02919.

Sculpture House Casting, Inc., 38 E. 30th St., New York, NY 10016.

Tallix, 175 Fishkill Avenue, Beacon, NY 12508.

Weisman Art Foundry, 819 N. 2nd, Philadelphia, PA 19123.

Midwest

Detroit Sculpture Foundry, 6460 Theodore St., Detroit, MI 48211.

The Studio Foundry, 1001 Old River Rd., Cleveland, OH 44113

Southwest and West Coast

Artworks Foundry, 729 Heinz Space #5, Berkeley, CA 94710.

Blue Heron Foundry, 907 W St., Port Townsend, WA 98368.

Classic Bronze Div., J.H. Matthews Co., 2230 N. Chico Ave., S. El Monte, CA 91732.

Downtown Sculptor's Foundry, 2065 E. 37th St., Los Angeles, CA 90058.

Nordhammer Foundry, 8305 15th St., Oakland, CA 94606.

Oregon Brass Works, 1127 SE 10th, Portland, OR 97214. Commercial, decorative, bronze, brass, and aluminum casting.

Prescott Alloy Castings, Inc., 7359 2nd St., Prescott Valley, AZ 86301.

Shidoni Foundry, Inc., P.O. Box 250, Tesuque, NM 87574.

The Maiden Foundry, 16600 S.E. 362nd, Sandy, OR 97055.

West Coast Sculptor's Foundry, 1941 Pontius Ave., Los Angeles, CA 90025.

England

The Morris Singer Foundry, Ltd., Bond Close, Basingstoke, Hants RG 24 OPT, England.

Italy
Pietrasanta Foundries (west of Florence)

Bel Fiori

Fratelli da Prato

Mariani

Tesconi

Versilliese-Beani e Cacia

Tommasi

Canada

Bossiso Bronze Corp., Box 91456, W. Vancouver, B.C., Canada V7UPL.

Art Foundry, 640 Merton St., Toronto, Ontario, Canada M45 1A3.

Artcast Inc., 14 Armstrong Ave., Georgetown, Ontario, Canada L7G4R9.

Bronze Casting—Equipment (Chapter 10)

East Coast

Granite City Tool Co., Barre, VT 05641.

Inductotherm Corp., 10 Indel Ave., Rancocas, NJ 08073. Induction furnaces.

P.K. Lindsay Co., Inc., Nottingham Road, Deerfield, NH 02037. Sandblasting units.

Pyrometer Instrument Co., Inc., Bergenfield, NJ 07621. Pyrometers.

Ross-Tacony Crucible Co., Tacony, PA 19135. Crucibles and base blocks.

The Joseph Dixon Crucible Co., Wayne St., Jersey City, NJ 07303. Crucibles, base blocks, refractory materials.

Waage Electric, Inc., 720 Colfax Ave., Kenilworth, NJ 07033. Electric wax tools and melters.

Midwest

Alnor Instrument Co., 420 N. LaSalle St., Chicago, IL 60600.

Johnson Mfg. Co., 2829 E. Hennepin Ave., Minneapolis, MN 55413. Furnaces, tongs, shanks.

Lindberg-Fisher Div., Lindberg Engineering Co., 2443 W. Hubbard St., Chicago, IL 60612. Furnaces.

Sta-Warm Electric Co., Ravenna, OH 44266. Electric wax and lead melters.

The Campbell-Hausfeld Co., Harrison, OH 45030. Furnaces.

West Instrument Corp., Subsidiary of Gulton Industries, Inc., 3860 N. River Rd., Schiller Park, IL 60186. Pyrometers and thermocouples.

West Coast

A. D. Alpine, Inc., 3051 Fujita St., Torrence, CA 90910. Kilns, ovens, furnaces.

Dick Ells Co., 908 Venice Blvd., Los Angeles, CA 90015. Foundry equipment and supplies.

Modern Equipment Co., Box 266, Port Washington, WI 53074. Crucible shanks, ladles, pouring devices.

Aluminum Casting—Materials (Chapter 10)

East Coast

American Smelting and Refining Co. (ASARCO), 120 Broadway, New York, NY 10005.

Aluminum Co. of America (ALCOA), 1501 Alcoa Bldg., Pittsburgh, PA 15219.

Reynolds Metals Co., Box 2346, Richmond, VA 23218.

Midwest

Apex Smelting Co., Division American Metal Climax, Inc., 2537 W. Taylor St., Chicago, IL 60612.

West Coast

Apex Smelting Co., Division American Metal Climax, Inc., 2211 E. Carson St., Long Beach, CA 90801.

Harvey Aluminum, 19200 S. Western Ave., Torrence, CA 90509.

Iron Casting

East Coast

Associated Metals and Minerals Co., 733 3rd Ave., New York, NY 10017. Ferro additives.

Woodward Iron Co., 2151 Highland Ave., Birmingham, AL 35205. Pig iron, coke, iron foundry supplies.

Midwest

Miller and Co., 332 S. Michigan Ave., Chicago, IL 60604. Pig iron, coke, iron foundry supplies.

West Coast

Miller and Co., 282 Corina Ave., Long Beach, CA 90803. Pig iron, coke, iron foundry supplies.

Foam-Vaporizations

Midwest

Full Mold Process, Inc., 27224 Southfield Rd., Lathrop Village, MI 48075. A patented foam-vaporization process.

Ottawa Silica Co., Boyce Memorial Dr., Ottawa, IL 61350.

Thiem Products, Inc., 9800 W. Rogers St., Milwaukee, WI 53227. Styro-bond, styro-fill, styro-kote for styrofoam casting pattern.

West Coast

Ottawa Silica Co., Crystal Silica Co., Box 1280, Oceanside, CA 92054. Pure silica sand.

Equipment for Casting Iron (Chapter 10)

East Coast

Foundry Systems and Supply, Inc., 3400 Peachtree Rd. N.E., Atlanta, GA 30326. Foundry equipment and supplies.

International Foundry Supply, Inc., 400 Orrton Ave., Reading, PA 19603. Foundry equipment and supplies.

Alexander Saunders and Co., Box 265, Cold Springs, NY 10516. Induction furnaces, fluidizing beds, foundry equipment.

Midwest

M.A. Bell Co., 217 Lombard St., St. Louis, MO 63102. Cupolas, foundry equipment.

Whiting Corp., 157th and Lathrop, Harvey, IL 60426. Cupolas.

West Coast

Independent Foundry Supply Co., 6463 Canning St., Los Angeles, CA 90040. Foundry equipment and supplies.

Metal—Welding and Forming (Chapter 11)

East Coast

Airco, 150 E. 42nd St., New York, NY 10017. Gas and arc-welding equipment and supplies.

All-State Welding Alloy Co., Inc., White Plains, NY 10600. Brazing fluxes and alloys.

Eutectic Welding Co., 40-40 172nd St., Flushing, NY 11358. Brazing supplies and other welding materials and tools.

Handy and Harmon Co., 850 Third Ave., New York, NY 10022. Brazing fluxes and alloys.

Jelco Finishing Equipment Co., 20 W. 22nd St., New York, NY 10011. Metal finishers—supplies and plating products.

Plating Products Co., 840 Colfax Ave., Kenilworth, NJ 07033. Forming metal, tank heads for spinning.

Union Carbide Corp., Linde Division, 270 Park Ave., New York, NY 10017. Gas and arc-welding equipment and supplies.

Midwest

Brighten Corp., P.O. Box 41192, Cincinnati, OH 45241.

Hobart Bros. Co., Hobart Square, Troy, OH 45373. Arc welders and electrodes.

National Cylinder Gas Co., 840 N. Michigan Ave., Chicago, IL 60611. Gas welding equipment and supplies.

Smith Welding Equipment Co., 2633 S.E. 4th St., Minneapolis, MN 55414. Gas welding equipment.

West Coast

Airco, 100 California St., San Francisco, CA 94111. Gas and arc-welding equipment and supplies.

All State Welding Alloy Co., Inc., South Gate, CA 90280. Brazing fluxes and alloys.

Victor Equipment Co., 3821 Santa Fe Ave., Los Angeles, CA 90058. Gas welding equipment.

Willson Safety Products, 111 Sutter St., San Francisco, CA 94104.

Stone

East Coast

Barre Guild and Rock of Ages, Barre, VT 05641.

Chioldi Granite Corp., Barre, VT 05641.

Deery Marble Co., Inc., Long Island City, NY 11101. Marble.

Elberton Granite Assn., P.O. Box 640, Elberton, GA 30635. Granites.

Gawet Marble Co., Rutland, VT. 05701.

Georgia Marble Co., Tate, GA 30177.

Heldeberg Bluestone and Marble, Inc., East Berne, NY 12059.

Indiana Limestone Co., 40 E. 41st St., New York, NY 10017. Limestone.

North Carolina Granite Corp., Mt. Airy, NC 27030. Granite.

Vermont Marble Co., 101 Park Ave., New York, NY 10017 and Proctor, VT 05765. Marble.

Smith Granite Co., Westerly, RI 02891. Granite.

Tompkins Kiel, 35-08 Vernon Blvd., Long Island City, NY 11106. Imported marble.

Midwest

Cold Spring Granite Co., 202 S. 3rd. Ave., Cold Spring, MN 56320. Also quarries in Raymond, CA; Lake Placid, NY; Marble Falls, TX; and Lac du Bonnet, Manitoba, Canada. Granite.

Colorado Alabaster Supply, 1507 N. College Ave., Fort Collins, CO 80524.

Indian Hills Stone Co., Bloomington, IN 47401. Limestone.

United Granite Sales Co., St. Cloud, MN 56301.

Vermarco Supply Co., 3321 Prospect Ave., Cleveland, OH 44101. Carving stones.

West Coast

Art Pak, 8106 N. Denver, Portland, OR 97217. Stones and tools.

Bruner Pacific, Inc., 843 S. Mission Rd., Alhambra, CA 91801. Marble and granite.

Carthage Georgia Marble Co., 8353 E. Loch Lomond Dr., Pico Rivera, CA 90660. Marble.

Marble Unlimited, 14554 Kenwick St., Van Nuys, CA 91405.

U.S. Pumice Co., 6331 Hollywood Blvd., Los Angeles, CA 90028. Lightweight pumice stone or feather rock.

Western Marble Co., 321 W. Pico Blvd., Los Angeles, CA 90015. Marble.

Western States Stone Co., 1849 E. Slauson Ave., Los Angeles, CA 90058. Granite, slate, sandstone.

Stone Carving Tools and Equipment (Chapter 12)

East Coast

Behlen and Brothers, Inc., 10 Christopher St., New York, NY 10014. Hand tools.

Ettl Studios, 213 W. 58th St., New York, NY 10019. Hand tools.

Granite City Tool Co., P.O. Box 411, Barre, VT 05641. Hand and power tools.

Sculpture Associates, 101 St. Marks Pl., New York, NY 10003. Hand tools.

Sculpture House, 38 E. 30th St., New York, NY 10016. Hand tools.

Sculpture Service, Inc., 9 E. 19th St., New York, NY 10003.

Standard Equipment Co., 3175 Fulton St., Brooklyn, NY 10456. Handling equipment (dollies, lifts, trucks, etc.).

Trow and Holden Co., Barre, VT 05641. Pneumatic tools, emery stones, finishing materials.

Midwest

Arrow Tool Co., 1900 S. Costner Ave., Chicago, IL 60623. Pneumatic tools.

Brunner and Lay, 727 S. Jefferson St., Chicago, IL 60607. Hand and power tools.

Granite City Tool Co., St. Cloud, MN 56301. Hand stone carving tools, pneumatic tools for wood and stone.

U.S. Industrial Tool and Supply Co., 13541 Auburn St., Detroit, MI 48233. Pneumatic tools.

West Coast

American Pneumatic Tool Co., 1201 W. 190th St., Gardena, CA 90249. Pneumatic tools.

Art-Pak, 8106 N. Denver, Portland, OR 97217.

City Tool Works, 425 Stanford St., Los Angeles, CA 90013. Blacksmithing and toolmaking.

Fillmore and Garber, Inc., 1742 Floradale Ave., S. El Monte, CA 91733. Abrasives, air tools, diamond wheels.

Ingersoll Rand Co., 5533 Olympic Blvd., Los Angeles, CA 90022. Pneumatic tools.

Union Carbide Corp., Linde Div., 30 E. 42nd St., New York, NY 10017 and 2770 Leonis St., Los Angeles, CA 90022. FSJ-6 stone-shaping torch.

Wood Equipment and Tools (Chapter 13)

East Coast

AEG Power Tools, 24-10 Jackson Ave., Long Island City, NY 11101.

Brookstone Co., 127 Vosefarm Rd., Peterborough, NH 03458. Hard-to-find tools.

Craftools, Inc., 36 Broadway, New York, NY 10013. Woodcarving tools, workbenches, etc.

Ettl Studios, 213 W. 58th St., New York, NY 10019. Woodcarving tools.

Frank Mittermeier, Inc., 3537 E. Tremont Ave., New York, NY 10065. Woodcarving tools.

Garrett Wade Co., 302 5th Ave., New York, NY 10001. Hand tools, Inca power tools.

Powermatic Division, Houdaille Industries, Inc., Highway 55, McMinnville, TN 37110. Manufacturers of quality woodworking and metalworking machines, drill presses, scroll saws, jointers, table saws, band saws, lathes, and planners.

Rockwell Manufacturing Co., Power Tool Division, 662 N. Lexington Ave., Pittsburgh, PA 15208.

Sculpture Associates, 101 St. Marks Pl., New York, NY 10003. Woodcarving tools and equipment.

Sculpture House, 38 E. 30th St., New York, NY 10016. Woodcarving tools and equipment.

Skil Corp., 75 Varick St., New York, NY 10013.

Stanley Power Tools, 119 W. 23rd St., New York, NY 10011. Division of the Stanley Works, 77 Lake St., New Britain, CT 06050.

Woodcraft Supply Corporation, 313 Montvale Ave., Woburn, MA 01801.

Midwest

Broadhead Garret Co., E. 71st St., Cleveland, OH 44101. Power tools, workbenches, woodcarving tools.

Woodcarvers Supply Co., 3112 W. 28th St., Minneapolis, MN 55416. General woodcarving tools and supplies.

West Coast

Andrews Hardware, 1610 W. 7th St., Los Angeles, CA 90017. Tools, power tools, workbenches.

Art Media, 902 S.W. Yamhill St., Portland, OR 97205. Wood and stone carving tools.

M. Flax, 10846 Lindbrook Dr., Los Angeles, CA 90024, and 250 Sutter St., San Francisco, CA 94108.

Woodcrafters, 212 NE 6th, Portland, OR. Clamps, glues, sharpening, stones, power tools, specialty woods.

Glossary

abstract The generalization and simplification of forms, found primarily in nature, sometimes to the degree of becoming unrecognizable.

academic Stemming from academy, which was a place of study. The word comes from the Greek name of a garden near Athens where Plato and later Platonic philosophers held philosophical discussions from the fifth century B.C. to the sixth century A.D. Founded in 1563, the first academy of fine arts was the Academy of Drawing started in Florence by Giorgio Vasari. Later academies were the Royal Academy of Painting and Sculpture in Paris (1648) and the Royal Academy of Arts in London (1769). Their purpose was to systematically foster the arts through teaching, discussion, and exhibitions.

accelerator The chemical added to polyester resin to speed hardening. Sometimes called promoter.

acrylic A medium for pigments developed in 1960 consisting of a plastic binder that is soluble in water. Also a synthetic resin prepared from acrylic acid or a derivative of acrylic acid. Lucite and Plexiglas are trade names of acrylic products.

African wonderstone A soft, easy-to-carve metamorphic stone.

aggregate The inactive substances added to cohesive or adhesive materials for the purposes of increasing strength or bulk.

air vents Tube in a mold for the escape of air and gases when the mold is filled with molten metal.

alabaster A metamorphic stone often with some translucence, color, and marbleized effect.

alloy A metal formed by the fusion of two or more metals to obtain physical characteristics unlike either of the original metals.

altar A mound or structure on which sacrifices or offerings are made in the worship of a deity.

altarpiece A painted or carved work of art placed behind and above the altar in a Christian church.

anneal The controlled heating and cooling of metals to alleviate internal stress which causes fracturing.

armature A supporting framework upon which is built a work in clay, wax, or plaster of Paris.

assemblage The technique of combining related or unrelated objects or scraps into an artistic arrangement.

Aurignacian The term for describing artifacts of an Upper Paleolithic culture preceding the Magdalenian. The word comes from Aurignac (Haute-Garonne), a site in southern France where such work was found.

baptistry A building or part of a church, often round or octagonal, in which the sacrament of baptism is administered. It contains a baptismal font, a receptacle of stone or metal which holds the water for the rite.

binder A material which causes a state of cohesion.

bisque ware The first heating of unglazed clay which turns the ware into a hard, consolidated mass.

blunge To mix, forming a liquid suspension.

boucharde A metal stone carving hammer with striking ends divided into rows of metallic points or teeth—also referred to as a bushhammer.

braze To join metals using heat and a foreign metal as a binding agent.

bronze A compound of copper and tin to which is sometimes added other metals, particularly zinc.

Bronze Age The earliest period in which bronze was used for tools and weapons. In the Middle East the Bronze Age succeeded the Neolithic period in c. 3500 B.C., and preceded the Iron Age, which began c. 1900 B.C.

bronzing A term used to describe the process of coloring a plaster cast in imitation of bronze. It is also employed to describe the methods of imparting a bronze appearance to other metals and materials.

burnout The heating of a flask in order to drive out water and other volatile materials, especially wax.

butterfly Two pieces of wood bound together with wire in the form of a cross. Butterflies are suspended from the armature and serve to support weight and prevent excessive sagging of plastic earth masses.

calipers Measuring compasses.

cameo Relief carving in which the image stands above the background.

carborundum stone Rough surface stone used as an abrasive (silicon carbide); a crystalline compound of carbon and silica.

carrara A marble, usually white, of statuary quality, indigenous to the Italian city of Carrara.

caryatid A sculptured female figure used as an architectural support (the male figure acts as an atlas).

casting to reproduce a given shape by pouring or pressing a temporarily fluid material into a mold. The solidified material is the reproduction.

cast iron A hard, brittle iron produced commercially in blast furnaces by pouring it into molds where it cools and hardens. Extensively used as a building material in the early nineteenth century, it was superseded by steel and ferroconcrete.

cast stone A highly refined casting mixture of cement, aggregate, and water. The term is also used broadly to include other casting materials, such as hydrocals and aggregates.

catalyst A chemical additive to polyester resins, causing a cross-linking of molecular structure to form a three-dimensional solid.

ceramic Referring to all which is related to the consolidation of silicates of aluminum through heat of fusion, including glass and clay.

chalk Calcium carbonate is finely ground to make a white substance used in gesso. It may be pressed in sticks and used in white form, or mixed with colored pigments to make pastels.

charge To fill a negative mold with the positive material.

chasing A mechanical process of finishing a metal surface. Tools for finishing are called "chasing tools."

ciment fondu Aluminous cement, made from alumina.

cire perdue process A process of casting metal in which the modeled wax form is melted away and the space left between the core and the outer mold is filled with the molten metal. Also referred to as the lost-wax method.

clay wall A technique of molding using clay strips to divide the mold sections.

composition clay An artificially compounded oil or wax—base plastic modeling material.

concrete A mixture of sand or gravel with mortar and rubble, small pieces of building stone, and brick. Invented in the ancient Near East and further developed by the Romans. Generally ignored during the Middle Ages, it was revived by Bramante in the early sixteenth century for St. Peter's.

cone (pyrometric) Clay bodies employed in determining and controlling kiln firing temperatures and duration of exposure, as they react similarly to the ceramic bodies being fired.

contrapposto Italian word for set *against*. A method developed by the Greeks to represent freedom of movement in a figure. The parts of the body are placed asymmetrically in opposition to each other around a central axis with attention paid to balance and distribution of weights.

crazing Small cracks caused by uneven shrinkage and expansion through the thickness of the material.

crucible A container made of refractory material or metal used to heat substances to high temperatures.

cupola A small furnace lined with refractories used for melting metals.

cure Final hardening of a material, usually by heating; also called "set."

dead plaster Plaster that has lost its life by being exposed to dampness and therefore will not set hard when mixed with water.

deoxidation Removal of excess oxygen from molten metal by adding materials with a high affinity to oxygen.

diorite A granular igneous rock consisting essentially of plagioclase feldspar and hornblende.

direct carving (taille directe) Working in the material without recourse to copying from a three-dimensional model.

draft/draw The taper which enables pieces of mold to draw from the mold case or cast surface without causing injury to the mold; a shallow groove.

dross Metal oxides and other scum on the surface of the molten metal.

earthenware A low-fired baked clay, less dense and hard than stoneware.

elastomer A rubberlike elastic material such as natural or synthetic rubber.

electrolyte A substance that when added to a slip in small quantities increases the fluidity of the slip.

electroplate To cover or give a metallic coating to an object by means of an electric current.

emery stone A stone of considerable hardness consisting of silicon carbide mixed with an oxide of iron, used for grinding and polishing.

engobe A white or colored coating of clay over a terra cotta body.

epoxy A thermosetting plastic. Epoxy resin is used for making patterns. Resin and hardener mixed sets chemically at room temperature.

facing coat The first layer or intimate application of the negative mold investment material which comes into direct contact with the object that is to be cast in metal.

faience A word derived from Faenza, an Italian center for the manufacture of majolica. The term is broadly applied and has several meanings: tin-glazed pottery, any variety of glazed pottery except porcelain, and a general descriptive term embracing all types of glazed stoneware.

ferroconcrete Reinforced concrete, strengthened by steel rods and mesh placed before hardening. It was introduced in France c. 1900, and is widely used today.

fiberglass Slender fibers made from spinning glass into filaments which are then woven, spun, chopped, or matted.

filler The inert ingredient used to supply physical body or bulk to the formula.

firebrick Brick made from refractory clays used in lining furnaces.

fire scale A metal oxide surface scale resulting from a hot pour.

firing The process of baking an earth clay mass or heating or burning objects in a controlled situation.

flash Excess material introduced into the seam line of a cast.

flask The metal ring in which sand moldings are packed.

flux The substance mixed with metals for welding, brazing, etc. to promote fusion and free run of the molten metal. It is also used as a cleansing agent to dissolve or float out oxides that form on the surface of a metal during heating.

forge To shape metal by preheating, then hammering, twisting, and bending.

form In sculpture, the uniting of diverse elements such as shape, line, texture, subject, mass, color, etc. until clear relationships exist and each element functions at its optimum.

French chalk Powdered talc or magnesium silicate used in the casting process of sand casting.

frieze A continuous band of painted or sculptured decoration; an Ionic frieze is usually decorated with continuous relief sculpture.

gate Portion of the runner or sprue in a mold where molten metal enters the casting or mold cavity. The gating system is the complete assembly of sprues, runners, gates, and individual casting cavities in the mold.

gelatin Jelly made from stewed bone matrix used for making flexible molds.

gel coat The first application of resin to a mold, making the true reproduction of the surface.

gesso A smooth mixture of ground chalk of plaster and glue, used as the basis for tempera painting and for oil painting on panel. More recently gesso has been made of white pigment and a synthetic binder.

gilding A coat of gold or of some gold-colored substance applied mechanically or chemically to surfaces of a painting, sculpture, or architectural decoration.

glue size A glue or binder made from boiled hide and bones.

glyptic Retaining the visual quality of a material and the basic geometric nature of the mass (a carved rather than manipulated mass).

granite A natural igneous rock formation with a visibly crystalline texture. Very hard and durable, takes a fine polish.

green sand A naturally bonded sand or sand mixture tempered with water; used damp or wet.

greenware Dry unfired clay.

gypsum Hydrated calcium sulphate from which plaster of Paris is made.

heliarc An electric welding machine that surrounds the area of the weld with inert gas to prevent oxidation of the metal in the weld.

heroic Larger than lifesize. About six or seven feet in height for full figures.

hieroglyph A picture of a figure, animal, or object standing for a word, syllable, or sound. These symbols are found on ancient Egyptian monuments or in their written records.

hydraulic cement A cement capable of hardening under water.

igneous Formed by the action of fire.

illusionistic To misrepresent a medium to the extent that images created through the medium appear to be real.

indirect carving A method of carving in which the approach is indirect and involves the use of a previously prepared three-dimensional model as a guide.

ingot A mass of metal cast to a convenient size and shape for remelting or hot working.

in situ On site.

intaglio relief A relief in which the forms of the image are sunk below the surface.

investment A flowable mixture poured around patterns that conform to their shape and sets hard to form the investment mold. Made from refractory materials such as plaster and grog sand.

ivory The hard white substance of the tusks of certain animals such as the elephant.

key The method of making perfect registration.

killed plaster Plaster that has been permitted to remain too long under water before it is mixed; used for patching defects in a plaster cast.

kiln A stove or oven that may be heated for drying, baking, or hardening earth-clay forms.

lamination Layers of material built up and glued together.

lapidarist One who works with gems and precious stones and understands the art of cutting them.

latex Formerly raw rubber, now any rubberlike plastic mass.

leather-hard The state of clay before it becomes hard and dry; best stage for burnishing.

life mask A casting made from a mold taken from the living head.

lifesize Equal to life in all proportions, etc.

lignum vitae A heavy hardwood ranging in color from orange to dark brown.

limestone A rock consisting chiefly of calcium carbonate and yielding lime when burned. Crystalline limestone is called marble.

lost pattern The process of making a metal casting using a wax positive.

lost wax (cire perdue) See *cire perdue process.*

Lucite Trade name for a form of acrylic (see *acrylic*).

lunette A semicircular or pointed wall area above a door or window. When is it above the portal of a medieval church it is called a tympanum. Also a painting, relief sculpture, or a window of the same shape.

luto Used investment which has been crushed to be reused.

male mold The positive or cast.

mallet A metal or wood hammerlike tool for driving points and chisels into the material to be carved.

maquette Three-dimensional sketch.

marble A crystallized form of limestone.

matrix A material that gives foundation to something embodied or enclosed in it.

metamorphic rock Igneous and sedimentary stones that have changed physically by the natural forces of pressure, heat, and chemistry; marble, slate, soapstone, alabaster, onyx, and many gemstones.

mild steel Steel containing just a little carbon. Not easily tempered or hardened.

model 1. The preliminary form of a sculpture, often finished in itself but preceding the final casting or carving.

2. The preliminary or reconstructed form of a building made to scale.

3. A person who poses for an artist.

modeling The building up of a figure or design in a soft substance such as clay or wax.

monochrome A work with a single color or hue.

monolithic A mass which is solid, not composed of smaller units.

monumentality Applies to the condition of the sculptural—which, despite actual size, may give the appearance of hugeness or massiveness. May also refer to the grand quality of the idea; also a commemorative sculpture.

mortar A mixture of sand and cement.

naturalism A close adherence to reality.

neat cement Portland cement mixed with water only.

negative The shell-like impression or mold into which the positive casting material is poured or pressed.

negative space The open spaces or areas that allow light to penetrate the sculpture.

Neolithic The new Stone Age, thought to have begun c. 9000–8000 B.C. The first society to live in settled communities, to domesticate animals, and to cultivate crops, it saw the beginning of many new skills such as spinning, weaving, and building.

opaque Not transparent, without the ability to transmit light.

oxides Compounds of oxygen and some other elemental substance, most of which occur abundantly and are widely distributed in nature, such as sand and quartz (compounds of silicon and oxygen). Oxides are catagorized as acid, alkaline, base and amphoteric (react with both acids and bases).

oxidizing flame A flame with an excess of oxygen.

paper-mache Pulped paper used as a sculptural medium.

parting agent or compound Material spread on mold halves or patterns or castings from molds. Also separating agent.

patina Originally the natural color of oxidized metal surfaces; more recently, the surface coloring given to various materials such as metal, wood, and plaster when used in relation to sculpture.

pick A pointed metallic stone carving hammer used to crack and chip away large masses of stone.

pickle An acid bath used to remove burned sand, scale, or specific impurities from the surface of metal.

piece mold A mold constructed in sections to be used repeatedly.

plaster of Paris Fine white powder made of gypsum which sets hard when mixed with water. Used for moldmaking and working directly.

plastic 1. A material malleable enough to be manipulated by hand.

2. A synthetic, coherent material.

plastic/plastic earth An earth clay employed for modeling purposes.

plinth A support or pedestal which displays the sculpture at the correct height and position.

plumb bob A weight on a string used to indicate vertical direction.

point The punch, a simple, pointed metal stone carving tool.

polychromatic Colored sculpture, using many colors.

polyester A thermosetting resin with a syrupy consistency.

polystyrene A colorless thermoplastic composed of bonded beads used in casting for making patterns.

porcelain A variety of terra cotta which fires pure white and translucent at a high temperature range.

portland cement A fine type of hydraulic cement, simulating portland stone.

pot metal White metal, for example, lead, tin, and cadmium-based metals.

pour The action of filling a mold with a liquid or molten material.

promoter The chemical agent that speeds the action between various resin ingredients.

proportional dividers A measuring tool which mechanically adjusts size ratios.

pug mill A machine similar to a meat grinder which prepares plastic clay.

pumice A material used for smoothing and polishing made from lava which has been aerated by escaping gases.

punch A broader point used for roughing out softer stone.

PVA Polyvinyl acetate.

PVC Polyvinyl chloride.

pyrometer An instrument used for measuring temperatures above the average range of liquid thermometers.

pyrometric cones Used to determine kiln temperature, ceramic cones are designed to collapse at a predetermined temperature indicating the firing temperature at that point. See *cone*.

quarry water The moisture frequently present in a freshly quarried porous stone.

quenching Quickly cooling a heated metal tool by immersion in brine or oil.

ram Process of packing sand in a mold.

rasp A metallic abrasive tool with sharp, pyramidal teeth.

reducing flame A flame with insufficient oxygen to support complete combustion.

refractory Nonmetallic heat-resistant material used for furnace linings.

reinforced concrete Concrete physically strengthened by metal bars or a network of iron or steel internally incorporated in the mass while it is in a soft and plastic state.

release agent Parting solution to separate resistant surfaces.

relief A design in which figures or forms project from a background to which they adhere.

repoussé A form of sculpture in which sheets of metal are shaped into desired forms by means of pressure or hammering from one or alternating from both the front and back of the sheet.

resin A solid or semisolid mixture used as a binder. It has no definite melting point and shows no tendency to crystallize.

riddle A screen device used to remove coarse particles from molding sand.

riffler Tools with curved file surfaces used on stone, wood, plaster of Paris, metals, and resins.

roman joints Joints devised and made to produce sections of casts which fit with perfect registration.

rubbing A process of smoothing surfaces such as stone by the application of abrasives and friction.

runners The channels made in an investment mold through which the molten metal runs to fill the mold.

sand molding A process of casting metal utilizing a mold of fine claylike sand packed into flasks (called cope and drag) into which the molten metal is poured.

sarcophagus A large stone coffin usually decorated with sculpture and/or inscriptions. The term is derived from two Greek words meaning flesh and eating which were applied to a kind of limestone in ancient Greece, since the stone was said to turn flesh to dust.

sculpture-in-the-round Free-standing, three-dimensional, carved or modeled forms.

seam lines The dividing lines of a mold.

sedimentary The results of deposits of sediment such as fragments of other rocks transmitted from their sources.

setting In casting, the hardening of a material such as plaster of Paris or cast stone.

shim The brass fencing used to make the divisions of a waste mold.

short The term applied to a clay body which is not tenacious and is liable to break while modeling.

shuttering A mold constructed in situ, usually of wood, into which concrete can be poured to make a casting.

silica Silicon dioxide, the primary ingredient in sharp sand and acid refractories.

skimming Removing or holding back dirt or slag from the surface of molten metal before or during pouring.

slag Foreign substances separated from the pure metal when molten (must be removed before pouring).

slake To soak in water.

slip A semiliquid material made of finely ground clay mixed with water to a creamy consistency. Used for applying a layer of different colored clay to another and for decorating clay forms.

slip casting The process of casting with slip in absorbent negative molds.

slurry A watery, mudlike substance.

softwood The timber obtained from coniferous trees.

solder 1. To bond metals using heat to melt in the joint between them.
 2. Low temperature alloys of lead which adhere to the two adjoining metal surfaces.

solvent A substance capable of dissolving another substance.

spalls Fragment, chips, or splinters, usually of stone.

sphinx In ancient Egypt, a creature having the head of a man, animal, or bird, and the body of a lion; frequently sculpted in monumental form. In Greek mythology, a creature usually represented as having the head and breasts of a woman, the body of a lion, and the wings of an eagle. It appears in Classical, Renaissance, and Neoclassical art.

stake Shaped metal tool which fits into a square hole on an anvil or similar base, and which serves as an extension of the anvil, for the creation of selective shapes through impact.

steatite Soapstone, commonly gray or grayish green in color.

stoneware A hard, dense, fired clay made from very siliceous clay and fired at high temperatures.

stratification Layers of rock as encountered in shale; slate and other sedimentary rocks.

stun To cause a change in the arrangement of molecules in a rock that may result in a bruise.

stylus From the latin word *stilus*, the writing instrument of the Romans. A pointed instrument used in ancient cultures for writing on tablets of soft material such as clays.

taille directe See *direct carving*.

tamping The act of consolidating a granular material such as concrete or sand.

tap drill To make a threaded hole in metal into which a bolt can be screwed.

tempering The process of scientifically regulating the hardness of tool steel.

tensile The strength of a material.

terra cotta Hard, fired earth clay. The term means baked earth.

thermocouple A thermoelectric couple used to measure temperature differences.

thermoplastic Material that softens when heated and hardens as it cools.

thermosetting A substance that becomes a solid when heated.

truth to materials The concept that the inherent qualitites of a material be explored and used to full potential and not be imitative of another material.

undercut The portion of a three-dimensional object or mold that prevents the safe and easy removal of the positive impression of the negative mold.

vent In casting, a channel or passage through which gases can escape from a mold. The act of fashioning channels or passageways in a mold.

vibrating A mold is vibrated to encourage air to escape from the casting substance and to assist the consolidation of the casting material.

viscous Of a thick, sticky consistency.

volume The space occupied by a sculpture.

warning coat The colored layer of plaster incorporated into the waste mold, indicating the nearness of the cast when chipping out.

waste mold A negative mold destroyed or wasted in freeing the positive cast.

water of crystallization Water associated with a substance in the formation of crystals.

wedge To mix plastic clay by cutting and squeezing.

welding The joining together of two metals by causing the edges to become molten by electrical or oxyacetylene apparatus.

wet mix The state of the mixture of ingredients for concrete, cement, and aggregate when water is added.

wetting down A method of testing a block of stone to discover veins and specks by flooding the surface of the stone mass with water.

Bibliography

Historical and Philosophical

ADAMS, PHILIP RHYS, *Antoine Bourdelle*. New York: Charles E. Slatkin, 1961.

AMAYA, MARIO, ed., Catalogue of the exhibition: *A Tribute to Samuel J. Zacks from the Sam and Ayala Zacks collection*. Toronto: Art Gallery of Ontario, 1971.

ASHTON, DORE, *Modern American Sculpture*. New York: Harry N. Abrams, 1968.

AUBOYER, JEANNINE, *The Oriental World*. Landmarks of the World's Art Series. New York, Toronto: McGraw-Hill, 1966.

BALDINGER, WALLACE S., and HARRY B. GREEN, *The Visual Arts*. New York: Holt, Rinehart and Winston, 1960.

BAUER, JOHN I.H., *The Sculpture and Drawings of Elie Nadelman*. New York: Whitney Museum of American Art, 1975.

Bauhaus. Publication by the Institute for Foreign Cultural Relations. Stuttgart, Cambridge, Mass.: Massachusetts Institute of Technology, 1968.

BAZIN, GERMAINE, *The History of World Sculpture*. Greenwich, Conn. and New York: Graphic Society LTD, 1968.

BEARDSLEY, JOHN, *Art in Public Places*. Washington, D.C.: Partners for Livable Places, 1981.

BORGHESE GALLERY, Catalogue (9th ed.), M.E. Stanley, trans. Instituto Polygrafico Dello Stato, 1955–59.

BOTHMER, DIETRICH VON, *Greek and Roman Art*. New York: Metropolitan Museum of Art Guide to the Collections, 1964.

BOWDOIN COLLEGE MUSEUM OF ART, *Catalogue of Leonard Baskin Exhibition*. Brunswick, Maine: Bowdoin College, 1962.

BOWNESS, ALAN, *Modern Sculpture*. New York: Dutton; London: Studio Vista, 1965.

BURNHAM, JACK, *Beyond Modern Sculpture: The Effects of Science and Technology on the Sculpture of the Century*. New York: G. Braziller, 1968.

CANNETTI, NICOLAI, *The Rodin Museum of Paris*. New York: Peebles Press International, 1977.

CASO, JACQUES DE, and PATRICIA B. SANDERS, *Rodin's Sculpture: A Critical Study of the Spreckels' Collection, California Palace of the Legion of Honor*. San Francisco: Fine Arts Museum of San Francisco, Calif., 1977.

CASSON, STANLEY, *The Technique of Early Greek Sculpture*. New York: Hacker, 1970.

CHENEY, SHELDON, *Sculpture of the World—A History*. New York: Viking, 1968.

Civilization, A Guide. Prepared for the National Gallery of Art. New York: Time-Life Films, 1970.

COLLIER, GRAHAM, *Form, Space and Vision*, 3rd ed. Englewood Cliffs, N.J.: Prentice-Hall, 1972.

COLLIER, GRAHAM, "On Moral Art," *Apelles: The Georgia Arts Journal*, 1, no. 1 (Fall 1979), 27–34.

DE YOUNG, M.H., *Selected Work from the Collection of the Museum*. San Francisco, Calif., 1950.

DUERDEN, DENNIS, *African Art*. Feltham: Paul Hamlyn, 1968.

DUPRÉ MARIA GRAZIA CIARI, *Small Renaissance Bronzes*, trans. Betsy Ross. London, New York: Paul Hamlyn, 1970.

ELSEN, ALBERT E., *The Sculpture of Henri Matisse*. New York: Harry N. Abrams, 1971.

ELSEN, ALBERT E., *Origins of Modern Sculpture: Pioneers and Premises*. New York: George Braziller, 1974.

EPSTEIN, JACOB, *An Autobiography* (rev. ed.). New York: Dutton, 1955.

FAGY, WILLIAM, *African Tribal Art*. New York: Tudor, 1960.

FIRST NATIONAL BANK, Catalogue of Art Collection. Chicago, 1974.

FOCILLON, HENRI, *Life and Forms in Art*. New York: Wittenborn, 1942.

FORMA, WARREN, *Five British Sculptors Work and Talk*. Transcriptions of tape recordings of sculptors discussing their work. New York: Grossman, 1964.

GARBINI, GIOVANNI, *The Ancient World*. Landmarks of the World's Art Series. New York, Toronto: McGraw-Hill, 1966.

GEORGE, WALDEMAR, *Despiau*. New York: Universe Books, 1959.

GIEDION-WELCKER, CAROLA, *Contemporary Sculpture, An Evolution in Volume and Space*. Documents of Modern Art XII. New York: Wittenborn, 1955.

GOLDWATER, ROBERT, *What is Modern Sculpture?* New York: Museum of Modern Art, 1969.

GOMBRICH, E.H., *Art and Illusion, A Study in the Psychology of Pictorial Representation*. A.W. Mellon lectures in the Fine Arts. Bollingen Series. Princeton, N.J.: Princeton University Press, 1956.

GROSSMAN, EMERY, *Art and Tradition: The Jewish Artist in America*. New York, London: Thomas Yoseloff, 1967.

GRUBE, ERNST, *The World of Islam*. Landmarks of the World's Art Series. New York, Toronto: McGraw-Hill, 1966.

GUGGENHEIM MUSEUM, *International Exhibition Catalogue*. New York: Solomon R. Guggenheim Museum, 1967.

HALL, DONALD, *Henry Moore*. Harper and Row, 1966.

HAMMACHER, A.M., *The Sculpture of Barbara Hepworth*. New York: Harry N. Abrams, 1968.

HAMMACHER, A.M., *Evolution of Modern Sculpture*. New York: Harry N. Abrams, 1969.

HARRIS, J.R. *Egyptian Art*. London: Spring Books, 1966.

HAWLEY, HENRY, *Neo-Classicism: Style and Motif*. Cleveland: Cleveland Museum of Art; distributed by Harry N. Abrams, N.Y., 1968.

HEPWORTH, BARBARA, *A Pictorial Autobiography*. Wiltshire, England: Moonraker Press, 1970.

HERBERT, ROBERT, ed., *Modern Artists on Art*. Englewood Cliffs, N.J.: Prentice-Hall, Spectrum Books, 1964.

HIBBARD, HOWARD, *Masterpieces of Western Sculpture from Medieval to Modern*. New York: Harper and row 1966.

HUNTER, SAM, and JOHN JACOBUS, *Modern Art from Post-Impressionism to the Present*. New York: Harry N. Abrams (pub. in association with Alexis Gregory), 1976.

Indonesian Art. Catalogue of a loan exhibition from the Royal Indies Institute, Amsterdam, the Netherlands. New York: The Asia Institute, 1948.

JAMES, PHILIP, ed., *Henry Moore on Sculpture: A Collection of the Sculptor's Writings and Spoken Words*. London: MacDonald, 1966.

JANSON, H.W., *History of Art: A Survey of the Major Visual Arts from the Dawn of History to the Present Day*, 2nd ed. Englewood Cliffs, N.J.: Prentice-Hall, and New York: Harry N. Abrams, 1977.

JIANOU, IIONEL, *Brancusi*. New York: Tudor, 1963.

KELEMEN PAL, *Medieval American Art—Masterpieces of the New World before Columbus*, Vol. I, 3rd rev. ed. New York: Dover, 1969.

KEPES, GYORGY, *Language of Vision*. Chicago, Ill: Paul Theobald, 1965.

KIDSON, PETER, *The Medieval World*. Landmarks of the World's Art Series. New York, Toronto: McGraw-Hill, 1966.

KIRSTEIN, LINCOLN, *The Sculpture of Elie Nadelman*. New York: Museum of Modern Art, 1948.

KRAMER, HILTON, ed., *The Sculpture of Gaston Lachaise*. New York: Eakins Press, 1967.

KULTERMAN, UDO, *The New Sculpture: Environment and Assemblages*. New York: Praeger, 1968.

KUNO, TAKESHI, *Album of Japanese Sculpture*, vol. III and IV. Toyko: Bijutsu v Shuppan-sha, 1952.

LASSUS, JEAN, *The Early Christian and Byzantine World*. Landmarks of the World's Art Series. New York, Toronto: McGraw-Hill, 1966.

LICHT, FRED, *Sculpture of the 19th and 20th Century*. Greenwich, Conn. and New York: Graphic Society, 1967.

LOMMEL, ANDREAS, *Prehistoric and Primitive Man*. Landmarks of the World's Art Series. New York, Toronto: McGraw-Hill, 1966.

LUCIE-SMITH, EDWARD, *Art Now from Abstract Expressionism to Superrealism*. New York: William Morrow, 1977.

LYNTON, NORBERT, *The Modern World*. Landmarks of the World's Art Series. New York, Toronto: McGraw-Hill, 1966.

MACLEHOSE, L.C., trans., *Vasari on Technique*. New York, London: Dent, 1907.

MARCKS, GERHARD, *Catalogue of Retrospective Exhibition*. Los Angeles: University of California Press, 1969.

MARTINDALE, ANDREW, *Man and the Renaissance*. Landmarks of the World's Art Series. New York, Toronto: McGraw-Hill, 1966.

MARYHILL MUSEUM, *Catalogue of the Rodin Collection*. Pullman, Wash.: Washington State University Press, 1976.

MERILLAT, HERBERT, C.L., *Sculpture, West, East, Two Traditions*. New York: Dodd, Mead, 1973.

MESTROVIC, IVAN, *Sculpture*. Syracuse, N.Y.: Syracuse University Press, 1948.

MILLER, ALEC, *Tradition in Sculpture*. London: The Studio, Ltd., and New York: The Studio Publications, 1949.

MOHOLY-NAGY, L., *Vision in Motion*. Chicago: Paul Theobald, 1965.

MURRAY, PETER, and LINDA MURRAY, *A Dictionary of Art and Artists*. Middlesex, England: Penguin Books, Thames and Hudson, 1973.

POPE-HENNESSY, SIR JOHN, *Italian High Renaissance and Baroque Sculpture*. New York: Phaidon, 1963.

PRATAPADITYA, PAL, *The Divine Prince, Asian Sculpture from the Collection of Mr. and Mrs. Harry Lenart.* Catalogue of an exhibition held at the Los Angeles County Museum of Art. Los Angeles: Museum Association of the Los Angeles County Museum of Art, 1978.

RADIN, PAUL, and ELINORE MARVEL, *African Folktales and Sculpture.* Bollingen Series XXXII. New York: Pantheon, 1952.

RAGGIO, OLGA, *The Fire and the Talent, A Presentation of French Terra Cottas* (catalogue). New York: Metropolitan Museum of Art, 1976.

RAND, HARRY, *Seymour Lipton: Aspects of Sculpture.* Washington, D.C.: National Collection of Fine Arts, Smithsonian Institution Press, 1979.

READ, SIR HERBERT, *The Art of Sculpture.* Bollingen Series XXIV. New York: Random House, 1961.

READ, SIR HERBERT, *A Concise History of Modern Sculpture,* 5th ed. New York: Praeger, 1971.

REWALD, JOHN, *Maillol.* London, New York: Hyperion Press, 1939.

RICHTER, GISELA, *A Handbook of Greek Art: A Survey of the Visual Art of Ancient Greece.* New York, London: Phaidon, 1963.

RITCHIE, ANDREW CARDUFF, *Sculpture of the 20th Century.* New York: Museum of Modern Art, 1952.

ROBB, DAVID M., and J.J. GARRISON, *Art in the Western World.* New York: Harper and Row, 1963.

ROSENFELD, RACHEL, *Frederic Littman, Themes and Variations* (catalogue). Portland, Oregon: Portland Art Museum, 1978.

SCHNIER, JACQUES PRESTON, *Sculpture in Modern America.* Berkeley: University of California Press, 1948.

SEITZ, WILLIAM C., *The Art of Assemblage.* New York: Museum of Modern Art, 1961.

SELZ, JEAN, *Modern Sculpture, Origins and Evolution.* New York: George Braziller, 1963.

SEUPHOR, MICHAEL, *The Sculpture of This Century.* New York: George Braziller, 1960.

SEYMOUR, CHARLES, *Tradition and Experiment in Modern Sculpture.* Washington, D.C.: American University Press, 1949.

SHARP, LEWIS I., *New York City Public Sculpture by 19th Century American Artists.* New York: Metropolitan Museum of Art, 1974.

SILVER, JONATHAN, "The Classical Cubism of David Smith," *Art News,* 82, no. 2 (February 1983), 100–103.

STRONG, DONALD, *The Classical World.* Landmarks of the World's Art Series. New York, Toronto: McGraw-Hill, 1966.

SYMONDS, JOHN ADDINGTON, *The Life of Michelangelo Buonarroti.* New York: Random House, Modern Library, 193–.

TAYLOR, HAROLD, *Art and the Intellect: Moral Values and the Experience of Art.* New York: Museum of Modern Art (The National Committee on Art Education), 1960.

TOMKINS, CALVIN, and Eds., Time-Life Books, *The World of Marcel Duchamp.* New York: Time-Life Books, 1966.

TRIER, EDUARD, *Form and Space.* New York: Praeger, 1962.

TUCHMAN, MAURICE, *American Sculpture of the Sixties.* Greenwich, Conn. and New York: Graphic Society, 1967.

TUCHMAN, MAURICE, *Art and Technology.* New York: Viking, 1971.

TUCKER, WILLIAM, *Early Modern Sculpture.* New York: Oxford University Press, 1974.

VALENTIN, CURT, *Catalogue of Rodin Exhibition.* New York: Curt Valentin Gallery, 1954.

WEISBERG, GABRIEL P., "Rodin Unmasked," *Art News,* 80, no. 8 (October 1981), 172–76.

WIDENER COLLECTION, *Catalogue of Paintings and Sculpture.* Washington, D.C.: Smithsonian Institution, 1959.

WHITNEY MUSEUM OF AMERICAN ART, *Catalogue of the Collection.* New York: Whitney Museum, 1973–74.

WITTKOWER, RUDOLF, *Sculpture Processes and Principles.* New York: Harper and Row, 1977.

Bibliography—Technical (General)

CELLINI, BENVENUTO, *The Treatises of Benvenuto Cellini on Goldsmithing and Sculpture,* trans. C.R. Ashbee. London: E. Arnold, 1898, p. 141.

CLARKE, GEOFFREY, and STROUD CORNOCK, *A Sculptor's Manual.* New York: Reinhold, 1968.

COLEMAN, RONALD L., *Sculpture, A Basic Handbook for Students.* Dubuque, Iowa: William C. Brown Co., 1968.

DAWSON, ROBERT, *Practical Carving in Wood, Stone, Plastics, and Other Materials.* New York: Watson, 1972.

DAWSON, ROBERT, *Practical Sculpture: Creating with Plastic Media.* New York: Viking Press, 1970.

ELISCU, FRANK, *Sculpture: Techniques in Clay, Wax, Slate.* Philadelphia: Chilton, 1959.

HOFFMAN, MALVINA, *Sculpture, Inside and Out.* New York: William Norton and Co., 1939.

IRVING, DONALD J., *Sculpture, Material and Process.* New York: Van Nostrand, 1970.

NICOLAIDES, KIMON, *The Natural Way to Draw.* Boston: Houghton Mifflin, 1941.

RICH, JACK C., *The Materials and Methods of Sculpture.* New York: Oxford University Press, 1947.

SLOBODKIN, LOUIS, *Sculpture, Principles and Practice.* Cleveland and New York: World Publishing Co., 1949.

STRUPPECK, JULES, *The Creation of Sculpture.* New York: Holt, 1952.

VASARI, GIORGIO, *Vasari on Technique*, trans. L.S. Maclehose. New York, London: Dent, 1907, p. 151.

VERHELST, WILBERT, *Sculpture, Tools, Materials, and Technique.* Englewood Cliffs, N.J.: Prentice-Hall, 1973.

ZORACH, WILLIAM, *Zorach Explains Sculpture, What It Means and How It Is Made.* New York: American Artists Group, 1947.

Clay, Ceramic Sculpture

CHARLESTON, ROBERT J., ed., *World Ceramics.* Secaucus, N.J.: Chartwell Books, 1976.

COTTIER, ANGELI FIORELLA, *Ceramics.* New York: Van Nostrand Reinhold, 1972.

FORD, BETTY DAVENPORT, *Ceramic Sculpture.* New York: Van Nostrand Reinhold, 1964.

HAMILTON, DAVID, *Manual of Pottery and Ceramics.* New York: Van Nostrand Reinhold, 1974.

KENNY, JOHN, *The Complete Book of Pottery Making.* New York: Pitman, 1949.

MEYER, FRED ROBERT, *Sculpture in Ceramics.* New York: Watson-Guptill, 1971.

NELSON, GLENN C., *Ceramics, A Potter's Handbook*, 2nd ed. New York: Holt, Rinehart and Winston, 1966.

RHODES, DAN, *Glazes for the Potter*, rev. ed. Philadelphia: Chilton, 1973, pp. 58–59.

ROTHENBERG, POLLY, *The Complete Book of Ceramic Art.* New York: Crown, 1972.

Metal Casting and Fabrication

AMERICAN FOUNDRYMEN'S ASSOCIATION, *Recommended Practices for the Sandcasting of Nonferrous Alloys.* U.S.A., 1944.

BALDWIN, JOHN, *Contemporary Sculpture Techniques—Welded Metal and Fiberglass.* New York: Van Nostrand Reinhold, 1967.

CLARK, CARL DAME, *Metal Casting of Sculpture.* Butler, Md.: Standard Arts Press, 1948.

FAULKNER, TREVOR, *Direct Metal Sculpture.* London: Thames and Hudson Ltd., 1978.

HALE, NATHAN CABOT, *Welded Sculpture.* New York: Watson-Guptill, 1968.

JACKSON, HARRY, *Lost Wax Bronze Casting—A Photographic Essay On This Antique and Venerable Art.* Flagstaff: Northland Press, 1972.

KAR, CHINTAMONI, *Indian Metal Sculpture.* London: Alec Tiranti Ltd., 1952.

MEILACH, D., and DENNIS KOWAL, *Sculpture Casting.* New York: Crown, 1969.

MEILACH, D., and DON SEIDEN, *Direct Metal Sculpture,* New York: Crown, 1966.

NALCO CHEMICAL COMPANY, *Investment Casting.* Chicago: Metal Industry Chemicals, n.d.

ROOD, JOHN, *Sculpture with a Torch.* Minneapolis: University of Minnesota, 1963.

WEYGERS, ALEXANDER G., *The Modern Blacksmith.* New York: Van Nostrand Reinhold, 1974.

The Figure

BARASHI, CONSTANTIN, *Sculpture of the Nude.* London: Abbey Library, 1972.

CLARK, KENNETH, *The Nude: A Study in Ideal Form.* National Gallery of Art, Washington, D.C. Princeton: Princeton University Press, 1972.

LANTERI, EDOUARD, *Modeling and Sculpture, A Guide for Artists and Students*, Vol. I, II. New York: Dover, 1965.

LENSSEN, HEIDI, *Art and Anatomy*, 3rd ed. New York: Barnes and Noble, 1955.

SCHIDER, FRITZ, *An Atlas of Anatomy for Artists.* New York: Dover, 1947.

Casting and Modeling

AUERBACH, ARNOLD, *Modelled Sculpture and Plaster Casting.* London: T. Yoseloff, 1962.

MILLS, JOHN, *The Technique of Casting for Sculpture.* London, Batsford; New York: Reinhold, 1967.

Concrete

MILLS, JOHN, *Sculpture in Concrete.* New York: Praeger, 1968.

Stone

BATTEN, MARK, *Stone Sculpture by Direct Carving.* London: Studio Publications, 1957.

GORDON, JOHN, *Isamu Noguchi.* New York: Whitney Museum of American Art, 1968.

MEILACH, L., *Contemporary Stone Sculpture.* New York: Crown, 1970.

MILLER, ALEC, *Stone and Marble Carving: A Manual for the Student Sculptor.* Berkeley: University of California Press, 1948.

Wood

Masterpieces in Wood, 20th-century Masters (catalogue). Portland, Oregon: Portland Art Museum, 1975.

MEILACH, DONNA, *Contemporary Art with Wood—Creative Technique and Appreciation*. New York: Crown, 1968.

Plastics

BUNCH, CLARENCE, *Acrylics for Sculpture and Design*. New York: Van Nostrand Reinhold, 1972.

FRADOS, JOEL, ed., *The Story of the Plastics Industry*, 13th revised ed. New York: Society of the Plastics Industry, Inc., 1977.

Kodak Technical Bulletin, Thermoforming Wax Plastic Sheet. Eastman Plastics Products.

NEWMAN, THELMA, *Plastics as Sculpture*. Radnor, Penn.: Chilton Book Co., 1974.

ROUKES, NICHOLAS, *Sculpture in Plastics*. New York: Watson-Guptill, 1968.

SOCIETY OF PLASTICS ENGINEERS, 26th Annual Technical Conference 100 years of American Plastics, 1968.

Index

Sculptors — Illustrations